The Smith Tapes

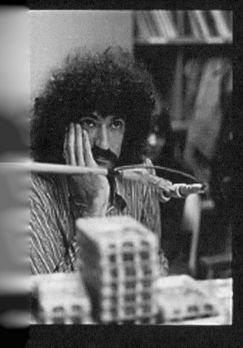
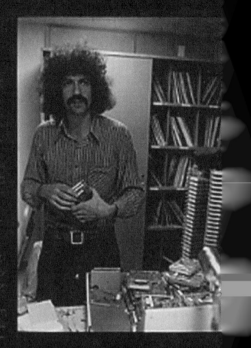
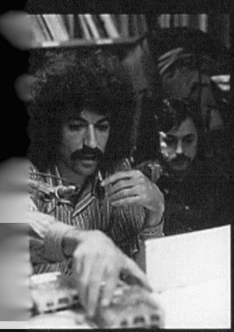

The Smith Tapes

Lost Interviews with Rock Stars & Icons 1969–1972

EDITED BY EZRA BOOKSTEIN

Princeton Architectural Press, New York

Published by
Princeton Architectural Press
37 East Seventh Street
New York, New York 10003

Visit our website at www.papress.com

Project Editor: Barbara Darko
Interior Design: Jan Haux
Cover Design: Paul Wagner

Special thanks to: Nicola Bednarek Brower, Janet Behning, Erin Cain, Tom Cho, Benjamin English,
Jan Cigliano Hartman, Lia Hunt, Valerie Kamen, Simone Kaplan-Senchak, Stephanie Leke,
Diane Levinson, Jennifer Lippert, Sara McKay, Jaime Nelson, Jimin Park, Rob Shaeffer, Sara Stemen,
Kaymar Thomas, Joseph Weston, and Janet Wong of Princeton Architectural Press
—Kevin C. Lippert, publisher

Library of Congress Cataloging-in-Publication Data
Smith, Howard, 1936–2014.
The Smith tapes : lost interviews with rock stars & icons 1969–1972 /
edited by Ezra Bookstein.
 pages cm
ISBN 978-1-61689-383-5 (paperback)
1. Rock musicians—Interviews. 2. Celebrities—Interviews. 3. Motion picture actors and actresses—
Interviews. 4. Interviews—United States. 5. Counterculture—United States—History—20th century.
I. Bookstein, Ezra, editor. II. Title.
ML385.S5924 2015
781.66092′2—dc23

 2015017557

Transcription services provided by SMG Transcription.

page 2: Howard Smith in the WABC/WPLJ studio, N.Y.C., 1971
pages 4–5: The original reels

Photography credits:
A&M Films / The Kobal Collection: 139; Bizarre Records: 355; Ezra Bookstein: 4–5;
Tim Boxer: 210, 215; Kurt Lavenson: 13; Ray Leong: 352; John Olson/The LIFE
Picture Collection/Getty Images: 75; Howard Smith: 35, 110, 146, 151, 157, 161
top and bottom, 304, 393; The Howard Smith Collection: 2, 62, 195, 284,
and all images of the reels/tapes and ephemera

Table of Contents

1970

1971

1972

Introduction

As the 1960s collided against the 1970s, there was an overwhelming feeling that the United States was a country on the brink. Social, cultural, and artistic forces were crashing together in a sea of building frustration, the naive spark of '60s optimism extinguished in its icy waters. That great swell of limitless possibilities had crested, stagnated, and soured; anger and disillusionment were taking its place. Broadly, there was Vietnam, the antiwar movement, Black Power, Red Power, women's liberation, gay liberation; Woodstock and Altamont; unchecked racism, police brutality, drug proliferation, narcs; the Manson murders, the Chicago 8 trial, *Roe v. Wade*, Watergate, the draft; SDS (Students for a Democratic Society), the Weathermen, the "silent majority," and the first black mayors elected to major eastern cities.

Howard Smith sat squarely at the nexus of it all. His weekly *Village Voice* column, "Scenes," which ran from 1966 through the '70s, helped define the paper's influence within the counterculture. His beat was "the cultural revolution—sex, drugs, rock 'n' roll, art, fashion, changing mores and new ideas," delivered as scoops, reviews, and first-person prose. Smith realized both the importance and the power of youth culture very early on, but he never pandered to it. He chronicled and analyzed the moment as both a participant in and a critic of popular culture.

In 1969 Smith was hired to do a weekly radio show for WABC/WPLJ, intended to re-create his *Village Voice* column for the new FM airwaves. This put him in the unique position of having a concurrent voice in print and on-air, which he used to his advantage: "Because of my column and my radio show, I had a lotta clout. And everybody wanted to announce anything new that they were doing in my column, and *hopefully* on my radio show too." This leverage kept him right where he wanted to be—in the know—and afforded him incredible access to the personalities who were defining the era.

Between 1969 and 1972, Smith recorded hundreds of interviews with rock stars, celebrities, artists, politicians, writers, revolutionaries, and other architects of the counterculture. These conversations were loose and unscripted, and the vast majority of them were never intended to be heard in their entirety. In keeping with his "Scenes" style, Smith would edit a few sound bites from an interview to play during his radio show. Occasionally, the interviews were broadcasted live on-air, complete with

callers' phoned-in questions. Smith then stored the original, recorded audio reels of the interviews in the back of his West Village loft, with the plan that he'd one day use them for a memoir. Instead they lay there frozen in time, buried under decades of life, until his son Cass Calder Smith unearthed them.

These interviews are time capsules, each holding a clear, unobstructed view into the past. They're intimate, uncensored, and unrushed conversations without an agenda. Though recorded more than forty years ago, they have an incredible immediacy to them—yet there is a prescience as well. They often catch stars at definitive moments in their careers, coinciding with the release of a seminal album or career-changing film, before the interviewees themselves knew who they would go on to become: Dennis Hopper and Peter Fonda's first American interview after *Easy Rider*'s premiere at Cannes; Janis Joplin's last interview, four days before her death; Eric Clapton on his first time fronting a band, the day he recorded Derek and the Dominos's *Live at the Fillmore*—the list goes on.

In those days, Smith was booked up with concerts, openings, protests, readings, festivals, interviews, and party after party. On the scene, he was known to be outgoing, insightful, and, notably, sober. While so many were "dropping out," he made the choice to drop *in*, and saw himself as a key journalist of the times. As the underground press sprang up across the country, it defined itself by promoting the politics of its staff, and feigned no journalistic objectivity. The *Village Voice*, however, defined itself as being outside of the mainstream media yet it was not part of the underground. So as Smith's mandate was to cover the moment, he was never caught up in the moment. He didn't go to a demonstration to shout, he went to report—always curious, and always skeptical.

The counterculture promised imminent change, but it's now more than forty years later and, in many ways, things haven't changed at all. Our country is bogged down by brutal ground warfare on the other side of the world, in which no "victory" is possible and no end is in sight. Racism in the police force, though it has never waned, is increasingly front-page, with the killings of unarmed black men at the hands of police, sparking broad protests and rioting in the streets of our cities. Society is politically polarized and increasingly reactionary, and the groundswell of young optimism—which elected the first black president—has succumbed to the corrosive force of disappointment. These conversations cut to the bone, highlighting the divisive lacerations in American society, which still have not healed, and evince why this book is more pertinent today than ever before.

In choosing which of his collection's interviews to include in this volume, I adopted Smith's mandate: cover the moment. From wide-angle to close-up, these conversations frame a time that was both raw and unapologetic. The language has not been curbed toward today's sensibilities—that, after all, is the point. My aim is to transport you back there, to sit you down in the room with Howard as it all unfolds, in the present tense. This is not a history book telling you about the time—this *is* the time. It's 1969 to 1972, and it speaks for itself.

<div align="right">

EZRA BOOKSTEIN, 2015

</div>

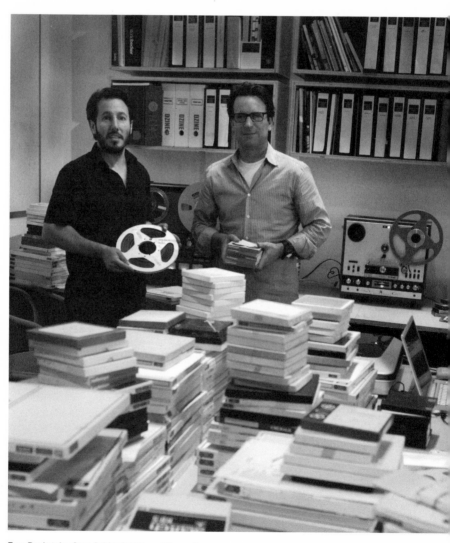

Ezra Bookstein, Cass Calder Smith, and the reels

Timeline

1968

Jan 30	The Tet Offensive begins in Vietnam
Feb 2–10	New York City sanitation workers go on strike
Mar 8	The Fillmore East opens in N.Y.C.
Apr 2	*2001: A Space Odyssey* film release
Apr 4	Martin Luther King Jr. is assassinated in Memphis, TN
Apr 8	President Lyndon B. Johnson creates the Bureau of Narcotics and Dangerous Drugs
Apr 10	40th Academy Awards—Dustin Hoffman nominated for Best Actor
Apr 11	President Johnson signs the Fair Housing Act, prohibiting discrimination by sellers or renters, as part of the Civil Rights Act
Apr 27	*Dance to the Music* album release (Sly and the Family Stone)
May 6	Playboy's 20th club opens in Lake Geneva, WI
May 14	Apple Records is founded in London
May 12–Jun 24	Poor People's Campaign, D.C.—Rev. Ralph Abernathy, Jesse Jackson, and thousands of Americans build a shantytown, Resurrection City, on the National Mall on May 21
Jun 3	Andy Warhol is shot by Valerie Solanas at the Factory in N.Y.C.
Jun 5	Bobby Kennedy is assassinated
Jun 14	*In-A-Gadda-Da-Vida* album release (Iron Butterfly)
Jun 21	*Bare Wires* album release (John Mayall's Bluesbreakers)
Jun 24	*Time Peace: The Rascals' Greatest Hits* album release
Jul 5	The Fillmore West opens in San Francisco
Aug	*The Electric Kool-Aid Acid Test* book release (Tom Wolfe)
Aug	*Say It Loud—I'm Black and I'm Proud* single release (James Brown)
Aug 20–21	The USSR invades Czechoslovakia
Aug 22–30	Protests at the Democratic National Convention, which runs Aug 26–29
Sep	Huey Newton sentenced to 2 to 15 years for voluntary manslaughter
Sep	*Life* album release (Sly and the Family Stone)
Sep 8	*The Confessions of Nat Turner*, by William Styron, has spent 44 weeks on the *New York Times* Best Sellers list
Sep 9	The United Federation of Teachers launches a series of union strikes across N.Y.C. that lasts more than 2 months
Nov 1	The MPAA film rating system goes into effect
Nov 5	Richard Nixon is elected president
Nov 6	*Head* film release (Jack Nicholson)
Nov 22	*The Beatles* (White Album) album release
Oct	*Revolution For The Hell Of It* book release (Abbie Hoffman)
Oct 2	Tlatelolco massacre of protesters in Mexico City
Oct 16	*Electric Ladyland* album release (The Jimi Hendrix Experience)
Dec 6	*James Taylor* album release
Dec 26	*Monterey Pop* film release (D. A. Pennebaker)
Dec 28–30	Miami Pop Festival, FL

1969

Jan	**D. A. Pennebaker interview**
Jan 8	Benefit show for the *New York Free Press* at the Fillmore East (David Amram, Charles Mingus, Norman Mailer, The Fugs, and others)
Jan 12	*Led Zeppelin* album release
Jan 12	*Portnoy's Complaint* book release (Philip Roth)
Jan 13	*Yellow Submarine* album release (The Beatles)
Jan 16	The first express train service between N.Y.C. and D.C. commences
Jan 28	Allen Klein becomes John Lennon's manager
Jan 28	Union Oil Platform A blows out, spilling 200,000 barrels of crude oil off the coast of Santa Barbara, CA

Feb	**David Amram interview**
Feb	**Kenneth A. Gibson interview**
Feb 7	The Fugs, the Velvet Underground, and the Grateful Dead share a bill at the Stanley Theatre in Pittsburgh
Feb 9	*Goodbye* album release (Cream)
Feb 9–11	Snowfall from a huge nor'easter shuts down N.Y.C. for 3 days
Feb 11–12	Janis Joplin and the Grateful Dead play the Fillmore East in N.Y.C.
Feb 20	**Felix Cavaliere interview**
Feb 22	*Kick Out the Jams* album release (MC5)
Feb 24	Johnny Cash plays San Quentin State Prison, CA
Mar	*Slaughterhouse-Five* book release (Kurt Vonnegut)
Mar	**Vidal Sassoon interview**
Mar 5	Arrest warrant issued for Jim Morrison on indecent exposure charges
Mar 12	11th Grammy Awards
Mar 12	*The Velvet Underground* album release
Mar 17	*Freedom Suite* album release (The Rascals)
Mar 20	John Lennon and Yoko Ono get married in Gibraltar
Mar 26	**Lou Reed interview**
Apr	**Norman Mailer & Jimmy Breslin interview**
Apr	**Andy Warhol & Paul Morrissey interview**
Apr 9	*Nashville Skyline* album release (Bob Dylan)
Apr 14	41st Academy Awards
Apr 23	*With A Little Help From My Friends* album release (Joe Cocker)
May	Kathleen Cleaver joins her husband, Eldridge Cleaver, in exile in Algeria
May	*Home* album release (Delaney & Bonnie)
May	*The Meters* album release
May 3	*Stand!* album release (Sly and the Family Stone)
May 5	*Lonesome Cowboys* film release (Andy Warhol, Paul Morrissey)
May 13	*Easy Rider* premieres at the Cannes Film Festival
May 23	**Sly Stone interview**
May 23	*Tommy* album release (The Who)
May 23–25	Northern California Folk-Rock Festival II, San Jose, CA
May 25	*Midnight Cowboy* film release (Dustin Hoffman)
May 26–Jun 1	John Lennon and Yoko Ono's "Bed-In for Peace" in Montreal, Canada
May 29	*Crosby, Stills & Nash* album release
May 30	"The Ballad of John & Yoko" single release (The Beatles)
May 30–31	Detroit Rock & Roll Revival, MI
Jun	**Bill Graham interview**
Jun	**Dennis Hopper & Peter Fonda interview**
Jun	Valerie Solanas pleads guilty to charges of "reckless assault with intent to harm"
Jun 15	*Airport*, by Arthur Hailey, has spent 63 weeks on the *New York Times* Best Sellers list
Jun 17	N.Y.C. mayoral primary election
Jun 18–20	Air-traffic controllers go on strike
Jun 18–22	Students for a Democratic Society's 9th Annual National Convention, Chicago
Jun 20–22	Newport '69 festival, CA
Jun 21–22	Toronto Pop Festival, Canada
Jun 28	The Stonewall riots begin in N.Y.C.
Jul	*The Original Delaney & Bonnie & Friends* album release
Jul 5	The Rolling Stones play a free concert to 400,000 people in Hyde Park, London
Jul 12	**John Mayall interview**
Jul 12	John Mayall records *The Turning Point* live at the Fillmore East
Jul 14	*Easy Rider* film release (Dennis Hopper, Peter Fonda, Jack Nicholson)
July 16–20	Newport Folk Festival, RI
Jul 21	Neil Armstrong and Buzz Aldrin walk on the moon
Jul 21	*Blue Movie* film release (Andy Warhol, Paul Morrissey)
Jul 31	Police raid Warhol's theater, seize the film, and arrest the staff on obscenity charges

Jul 28	John Sinclair is sentenced to 10 years in prison after giving 2 joints to an undercover narc
Jul 31	Elvis, on a comeback, plays Las Vegas for the first time since 1956
Aug	**Arlo Guthrie interview**
Aug	*Blind Faith* album release
Aug	*Santana* album release
Aug 1	*The Things I Notice Now* album release (Tom Paxton)
Aug 1–3	Atlantic City Pop Festival, NJ
Aug 5	*The Stooges* album release
Aug 9–10	The Manson Family murders, CA
Aug 14–17	The Gallup Inter-Tribal Indian Ceremonial is held in Gallup, NM
Aug 15–18	Woodstock Music & Art Fair, NY
Aug 16	*The Light Side The Dark Side* album release (Dick Gregory)
Aug 17	Hurricane Camille hits land in the Mississippi Gulf Coast with a 26-foot storm surge, killing 15 people in the area out of a total of 259 casualties from Virginia to Cuba
Aug 19	*Alice's Restaurant* film release (Arlo Guthrie)
Fall	**Carole King interview**
Sep	*The Belle of Avenue A* album release (The Fugs)
Sep 17	Drake University's newspaper reports that Paul McCartney is dead
Sep 22	*The Band* album release
Sep 23	*Hot Buttered Soul* album release (Isaac Hayes)
Sep 24	The Chicago Eight trial begins
Sep 26	*Abbey Road* album release (The Beatles)
Sep 29	*The Seven Minutes* book release (Irving Wallace)
Oct	**Tom Paxton interview**
Oct	**John Roberts & Joel Rosenman interview**
Oct	*The Selling of the President 1968* book release (Joe McGinnis)
Oct 5	*Monty Python's Flying Circus* premieres
Oct 14	"Someday We'll Be Together" single release (Diana Ross & the Supremes)
Oct 17–18	The Kinks play the Fillmore East
Oct 18	**Raquel Welch interview**
Oct 20–25	The Who play the Fillmore East
Oct 20	**Mick Jagger interview**
Oct 21	*Running Down the Road* album release (Arlo Guthrie)
Oct 22	*Led Zeppelin II* album release
Oct 29	The first message is sent and received across ARPANET
Oct 31	*Time* magazine runs the cover story "The Homosexual in America"
Nov	**Sandi Morse interview**
Nov	*Woodstock Nation* book release (Abbie Hoffman)
Nov	*Joe Cocker!* album release
Nov	*Volunteers* album release (Jefferson Airplane)
Nov 3	President Nixon gives his "Silent Majority" speech
Nov 5	Bobby Seale held in contempt of court and given 4 years in prison
Nov 6	**Jim Morrison interview**
Nov 9	Jim Morrison pleads not guilty to indecent exposure charges in Miami, FL
Nov 10	*Sesame Street* premieres
Nov 10	*Live/Dead* album release (The Grateful Dead)
Nov 15	Over 500,000 people attend the antiwar Moratorium March on Washington, D.C.
Nov 20	Richard Oakes and 89 other Red Power activists occupy Alcatraz until June 11, 1971
Nov 21–23	First Congress to Unite Women, N.Y.C.
Nov 21	**Joe Cocker interview**
Nov 24	**Dick Gregory interview**
Nov 25	John Lennon returns his MBE medal in protest of Britain's support of the Vietnam War
Nov 26	**Jerry Wexler interview**
Nov 26	The draft-lottery bill is signed into law
Dec 1	First draft lottery for military service
Dec 4	Chicago Police murder 2 Black Panthers

Dec 5	*Let It Bleed* album release (The Rolling Stones)
Dec 6	The free concert at Altamont Speedway, CA
Dec 15	John Lennon and Yoko Ono, George Harrison, Eric Clapton, Keith Moon, Billy Preston, Delaney & Bonnie, and others play UNICEF benefit concert in London
Dec 15	Billboards reading "WAR IS OVER! If you want it—Happy Christmas from John & Yoko" go up internationally in 12 cities
Dec 17	**John Lennon & Yoko Ono interview**
Dec 18	*Diana Ross Presents the Jackson 5* album release
Dec 29	*The Dick Cavett Show* premieres in the late-night spot on ABC

1970

Jan	*Ain't It Funky* album release (James Brown)
Jan	*American Woman* album release (The Guess Who)
Jan 1	Jimi Hendrix records *Band of Gypsies* live at the Fillmore East
Jan 1	President Nixon signs the National Environmental Policy Act
Jan 4	Keith Moon's chauffeur, Neil Boland, is killed outside an English pub in skinhead incident
Jan 9–10	Ike and Tina Turner play the Fillmore East
Jan 15	The Biafran war of independence ends after 2½ years, and the Republic of Biafra is reabsorbed into Nigeria
Jan 13	A guard at Soledad State Prison, CA, kills 3 black inmates, beginning the Soledad Brothers saga
Jan 15	*A Brand New Me* album release (Dusty Springfield)
Jan 26	*Bridge Over Troubled Water* album release (Simon & Garfunkel)
Feb	**Artie Kornfeld interview**
Feb 1	*Sweet Baby James* album release (James Taylor)
Feb 1	*Morrison Hotel* album release (The Doors)
Feb 11	**Jerry Garcia interview**
Feb 14	Student Mobilization Committee Conference, Cleveland
Feb 15	Sammie Dunn is the first woman to complete the Matterhorn hill climb at Saddleback Motocross Park in Orange County, CA
Feb 18	Abbie Hoffman and 4 others of the Chicago Seven are sentenced to 5 years in prison
Feb 28	*Moondance* album release (Van Morrison)
Mar	**Pete Bennett interview**
Mar	**James Taylor interview**
Mar	**Jack Valenti interview**
Mar	*On Tour with Eric Clapton* album release (Delaney & Bonnie & Friends)
Mar 1	*Everything You Always Wanted to Know About Sex* (*But Were Afraid to Ask)* book release (David Reuben)
Mar 5	The Treaty on the Non-Proliferation of Nuclear Weapons goes into effect
Mar 6–7	Neil Young & Crazy Horse and Miles Davis Quintet play the Fillmore East
Mar 6	The Weather Underground's bomb factory, operating in the basement of a Greenwich Village townhouse, explodes and kills 3 Weathermen
Mar 11	12th Grammy Awards
Mar 11	*Déjà vu* album release (Crosby, Stills, Nash & Young)
Mar 13	*Feast of Friends* film release (Jim Morrison)
Mar 22	**Dick Cavett interview**
Mar 27	*Sentimental Journey* album release (Ringo Starr)
Mar 27–28	Joe Cocker records *Mad Dogs & Englishmen* live at the Fillmore East
Spring	**Michael Benson interview**
Apr	Jane Fonda, Donald Sutherland, and Fred Gardner organize the Free the Army tour
Apr	*Bitches Brew* album release (Miles Davis)
Apr 7	42nd Academy Awards—Dustin Hoffman nominated for Best Actor, Jane Fonda nominated for Best Actress, Jack Nicholson nominated for Best Supporting Actor
Apr 9	*Remedies* album release (Dr. John the Night Tripper)
Apr 10	*Elton John* album release
Apr 10	Paul McCartney announces the breakup of the Beatles
Apr 19	*One Hundred Years of Solitude* English-language book release (Gabriel García Márquez)

Apr 20	*McCartney* album release (Paul McCartney)
Apr 22	The first Earth Day is nationally commemorated—1 million people march in N.Y.C.
Apr 26	**Gary A. Soucie interview**
Apr 30	The United States expands military actions into Cambodia, withdrawing 2 months later
May 1	**George Harrison interview**
May 1	Second Congress to Unite Women, N.Y.C.
May 1	*Writer* album release (Carole King)
May 4	National Guardsmen kill 4 student protesters at Kent State University, OH
May 8	Hard Hat Riot in Lower Manhattan
May 13	*Let it Be* film release (The Beatles)
May 15	Police kill 2 student protesters at Jackson State University, MS
May 16	*Live at Leeds* album release (The Who)
May 18	*Let It Be* album release (The Beatles)
Summer	**Floyd Red Crow Westerman interview**
Jun	**Michael Costello interview**
Jun 7	The Who perform *Tommy* at the Metropolitan Opera House in N.Y.C.
Jun 8	**Pete Townshend interview**
Jun 14	*Workingman's Dead* album release (The Grateful Dead)
Jun 14	Derek and the Dominos' first concert, London
Jun 16	Mayoral runoff election in Newark, NJ—Ken Gibson is elected mayor
Jun 22	The U.S. voting age is lowered from 21 to 18
Jun 24	*Myra Breckenridge* film release (Raquel Welch)
Jun 25	**Abbie Hoffman interview**
Jun 25	Special Agent Costello testifies at the 91st Congress' Select Committee on Crime
Jun 27–Jul 4	Festival Express tour in Canada (Janis Joplin, The Grateful Dead, The Band, Delaney & Bonnie, and others)
Jul	*Free Your Mind...and Your Ass Will Follow* album release (Funkadelic)
Jul	*John Barleycorn Must Die* album release (Traffic)
Jul 3–5	Atlanta International Pop Festival, GA
Jul 7	*Osmium* album release (Parliament)
Jul 17–19	New York Pop Festival at Randall's Island
Jul 22	**Dr. John Interview**
Aug	Lou Reed quits the Velvet Underground
Aug 3	*Performance* film release (Mick Jagger)
Aug 26	Women's Strike for Equality—20,000 people march in N.Y.C.
Aug 26–31	Isle of Wight Festival, England
Fall	**Jim Fouratt interview**
Sep	**Howard Sheffey interview**
Sep 5	First Black Panther Party Revolutionary People's Convention, Philadelphia
Sep 6	Members of the Popular Front for the Liberation of Palestine hijack 4 N.Y.C.–bound airliners; another attempt failed en route to London
Sep 12	*Five Easy Pieces* film release (Jack Nicholson)
Sep 18	Jimi Hendrix dies in the Cumberland Hotel in London
Sep 19	*After the Gold Rush* album release (Neil Young)
Sep 22	Former Newark Mayor Addonizio found guilty on 63 counts of extortion
Sep 23	*Loaded* album release (The Velvet Underground)
Sep 27	Pink Floyd plays the Fillmore East
Sep 30	**Janis Joplin interview**
Oct	National Indian Student Conference, D.C.
Oct 4	Janis Joplin is found dead in the Landmark Motel in Los Angeles
Oct 5	*Led Zeppelin III* album release
Oct 23–24	Derek and the Dominos play the Fillmore East
Oct 24	**Eric Clapton interview**
Oct 27	President Nixon signs the Controlled Substance Act
Nov	*The Worst of Jefferson Airplane* album release
Nov 1	*American Beauty* album release (The Grateful Dead)
Nov 9	*Layla and Other Assorted Love Songs* album release (Derek and the Dominos)

Nov 12	The Bhola cyclone hits East Pakistan (now Bangladesh) and East India, killing 500,000
Nov 19	**Steve Winwood interview**
Nov 21	Sly and the Family Stone *Greatest Hits* album release
Nov 26	American Indian Movement activists take over the Mayflower replica ship in Plymouth, MA, and paint Plymouth Rock red
Nov 27	*All Things Must Pass* album release (George Harrison)
Nov 27	*Lola Versus Powerman and the Moneygoround, Part One* album release (The Kinks)
Dec	*Soul Rebels* album release (The Wailers)
Dec	*In Our Terribleness* book release (Imamu Amiri Baraka)
Dec	The People's Peace Treaty is drafted
Dec	**Harry Richardson interview**
Dec 2	The National Environmental Policy Act is restructured to include the powerful Environmental Protection Agency
Dec 11	*John Lennon/Plastic Ono Band* album release
Dec 11	*Yoko Ono/Plastic Ono Band* album release
Dec 18	**Dustin Hoffman interview**
Dec 27	Charles Reich's *The Greening of America* reaches no. 1 on the *New York Times* Best Sellers list
1971	
	N.Y.C. becomes the first city in the nation to distribute free male condoms
Jan	**Marjoe Gortner interview**
Jan	*We Are Everywhere* book release (Jerry Rubin)
Jan 11	*Pearl* album release (Janis Joplin)
Jan 24	**Sammie Dunn interview**
Jan 31	**Amiri Baraka interview**
Feb 2	The Newark Teachers Union goes on strike
Feb 7	NBC's *Experiment in Television* series airs "Buckminster Fuller on Spaceship Earth" episode
Feb 10	*Tapestry* album release (Carole King)
Feb 13	Taj Mahal records *The Real Thing* live at the Fillmore East
Mar	**Jane Fonda interview**
Mar	**R. Buckminster Fuller interview**
Mar 1	The Weather Underground bomb the Capitol building, D.C.
Mar 12–13	The Allman Brothers Band records *At Fillmore East* live
Mar 16	*Mud Slide Slim and the Blue Horizon* album release (James Taylor)
Mar 16	13th Grammy Awards
Apr	**Anselma Dell'Olio & John L. Schimel interview**
Apr	The first American Indian–run food co-op opens on the Pinon Indian reservation
Apr 15	43rd Academy Awards—Jack Nicholson nominated for Best Actor; *Woodstock* wins Best Documentary
Apr 19–Apr 23	Vietnam Veterans against the War March on Washington, D.C.
Apr 23	*Sticky Fingers* album release (The Rolling Stones)
Apr 24	500,000 people participate in the Peace March Against the War in Vietnam in D.C.
Apr 25	**Country Joe McDonald interview**
May	Derek and the Dominos break up
May 1–3	The May Day Protests against the war, D.C.
May 2	The Entertainment Industry for Peace and Justice march, Hollywood Boulevard, CA
May 21	*What's Going On* album release (Marvin Gaye)
May 23	**Taj Mahal interview**
May 30	*Bury My Heart at Wounded Knee*, by Dee Brown, reaches no. 1 on the *New York Times* Best Sellers list
Jun	*Steal This Book* book release (Abbie Hoffman)
Jun	"Ain't No Sunshine" single release (Bill Withers)
Jun 5–6	Frank Zappa and the Mothers play the Fillmore East
Jun 6	John Lennon and Yoko Ono join Zappa and the Mothers on-stage for an encore set

Jun 6	**Jack Nicholson interview**
Jun 6	**Frank Zappa interview**
Jun 13	*Drive, He Said* film release (Jack Nicholson)
Jun 13	The *New York Times* publishes the "Pentagon Papers"
Jun 22–26	The first Glastonbury Festival is held in Somerset, England
Jun 22	*Blue* album release (Joni Mitchell)
Jun 25	*Klute* film release (Jane Fonda)
Jun 27	The Fillmore East's closing night (The Allman Brothers, The J. Geils Band, The Beach Boys, and others)
Jun 30	*Carnal Knowledge* film release (Jack Nicholson)
Jul 2	*Shaft* film release
Jul 3	Jim Morrison is found dead in his apartment in Paris
Jul 4	The Fillmore West's closing night (The Grateful Dead, Santana, Creedence Clearwater Revival, and others)
Jul 7	*Two Lane Blacktop* film release (James Taylor)
July 24–26	James Brown records *Revolution of the Mind: Live at the Apollo*
Aug 22	Kerry Kleid receives the first American Motorcycle Association professional competition license ever issued to a woman
Aug 1	George Harrison's Concert for Bangladesh at Madison Square Garden, N.Y.C. (Bob Dylan, Ravi Shankar, Leon Russell, Eric Clapton, Ringo Starr, and others)
Aug 2	*Fillmore East—June 1971* album release (Frank Zappa and the Mothers)
Aug 14	*Who's Next* album release (The Who)
Aug 25–Sep 6	32nd Venice International Film Festival
Aug 31	*The Sun, Moon & Herbs* album release (Dr. John)
Sep	Valerie Solanas released from prison
Sep 9	*Imagine* album release (John Lennon)
Sep 9–13	Attica State Prison riot, NY
Sep 14–16	Freddy Hubbard records *First Light* live at Carnegie Hall with Herbie Hancock, Ron Carter, and others
Sep 26	**Dennis Hopper interview**
Sep 28	*The Last Movie* film release (Dennis Hopper)
Oct	**Jerry Rubin interview**
Oct 24	*Grateful Dead* (Skull & Roses) album release
Oct 29	Duane Allman dies in a motorcycle crash in Macon, GA
Nov 5	*Rabbit Redux* book release (John Updike)
Nov 8	*Led Zeppelin IV* album release
Nov 10	*200 Motels* film release (Frank Zappa, The Mothers)
Nov 14	**Kathleen Cleaver interview**
Nov 17–18	Allen Ginsberg, Bob Dylan, and friends record the unreleased album *Holy Soul Jelly Roll* in N.Y.C.
Nov 20	*There's a Riot Goin' On* album release (Sly and the Family Stone)
Nov 21	**Ravi Shankar interview**
Nov 23	*Raga* film release (Ravi Shankar, George Harrison)
Dec	*Music* album release (Carole King)
Dec 1	"Happy Xmas (War Is Over)" single release (John & Yoko/Plastic Ono Band)
Dec 8	*Black Unity* album release (Pharoah Sanders)
Dec 10	John Sinclair Freedom Rally and Concert, Ann Arbor, MI (Abbie Hoffman, Jerry Rubin, John Lennon, Yoko Ono, and others)
Dec 16	The Indo-Pakistani War ends, creating the state of Bangladesh
Dec 17	John Lennon and Yoko Ono perform at a benefit concert for the families of the Attica State Prison riot victims at the Apollo Theater in N.Y.C.
Dec 17	*Hunky Dory* album release (David Bowie)

1972

Jan	**Allen Ginsberg and Bhagavan Das interview**
Jan 2	Senator Edward Kennedy meets with Navajo Indians in Farmington, NM
Jan 16	**Xaviera Hollander interview**

Jan 17	*The Happy Hooker* book release (Xaviera Hollander)
Jan 22	*Live!* album release (Fela Ransome-Kuti and Africa '70 with Ginger Baker)
Jan 24	*Young, Gifted and Black* album release (Aretha Franklin)
Jan 24	*Got to Be There* album release (Michael Jackson)
Jan 30	Bloody Sunday—British soldiers kill 13 unarmed demonstrators in Northern Ireland
Jan 31	The Federal Aviation Administration institutes a mandatory screening of all airline passengers
Jan 31	*Let's Stay Together* album release (Al Green)
Feb 14	*Harvest* album release (Neil Young)
Feb 16–19	Robert F. Kennedy Symposium, University of Missouri–Kansas City (Susan Sontag, Ken Kesey, Paul Krassner, and others)
Mar 3	*Music of My Mind* album release (Stevie Wonder)
Mar 6	The FBI and INS begin deportation proceedings against John Lennon
Mar 15	14th Grammy Awards—Carole King wins Record of the Year, Album of the Year, Song of the Year, and Best Female Pop Vocal Performance; James Taylor wins Best Male Pop Vocal Performance
Mar 22	The Equal Rights Amendment bill passes the Senate
Mar 24	*The Godfather* film release
Apr 10	44th Academy Awards—Jane Fonda wins Best Actress
Apr 12	"Lean on Me" single release (Bill Withers)
May 12	*Exile on Main St.* album release (The Rolling Stones)
Jun 1	*The Fall of America: Poems of These States 1965–1971* book release (Allen Ginsberg)
Jun 1	*Eagles* album release
Jun 6	*Ziggy Stardust* album release (David Bowie)
Jun 12	*Some Time in New York* album release (John Lennon)
Jun 16	*Roxy Music* album release
Jun 17	Five men are caught breaking into the Democratic National Committee headquarters in D.C.
Jun 18	*Elvis: As Recorded at Madison Square Garden* album release
Jun 19	Bob Woodward and Carl Bernstein's first Watergate article appears in the *Washington Post*
Jun 25	Thomas Harris, MD's *I'm OK, You're OK* reaches no. 1 on the *New York Times* Best Sellers list
Jul	Jane Fonda travels to Hanoi, Vietnam
Jul 1	*Hair* closes on Broadway after 4 years and 1,750 performances
Jul 24	*Marjoe* film release (Howard Smith)
Aug 21–23	Republican National Convention held in Miami, instead of San Diego
Sep 5	The Black September faction of the Palestine Liberation Organization take the Israeli delegation hostage at the Munich Olympics and kill all 11 members
Nov	*Can't Buy a Thrill* album release (Steely Dan)
Nov 7	President Nixon is reelected
Nov 20	"Crocodile Rock" single release (Elton John)
Nov 21	Chicago Seven ruling overturned
Dec 23	Survivors of the Andes flight disaster are rescued after 72 days, having sustained themselves by cannibalizing dead passengers

1973

Jan	*In Concert* album release (Derek and the Dominos)
Jan 5	The FAA begins electronic screening of airline passengers and their carry-on luggage
Jan 22	*Roe v. Wade*: the Supreme Court declares abortion a constitutional right
Jan 27	The Paris Peace Accords are signed, ending the war in Vietnam
Mar 1	Navajo activist Larry Casuse is killed in Gallup, NM, after taking the mayor hostage
Mar 1	*The Dark Side of the Moon* album release (Pink Floyd)
Mar 3	15th Grammy Awards—*The Concert for Bangladesh* wins Best Album (George Harrison and Friends)
Mar 27	45th Academy Awards—*Marjoe* wins Best Documentary Feature (Howard Smith and Sarah Kernochan)

Hear Howard Smith Scenes

WABC FM STEREO 95½

"Scenes" radio show advertisement, 1969

1969

D. A. Pennebaker
January 1969

In making the 1960 film Primary, *D. A. Pennebaker, Robert Drew, Richard Leacock, and Albert Maysles pioneered a film style that enabled audiences to experience cinema with an unprecedented immediacy. This handheld, fly-on-the-wall method of nonfiction storytelling, Direct Cinema, drew packed theaters for Pennebaker's most recent feature film about Bob Dylan's 1965 tour in England,* Dont Look Back. *His latest,* Monterey Pop, *opened last month in New York City. Pennebaker, together with his partner, Chris Hegedus, will continue to make films for more than forty-five years.*

SMITH: You make mainly documentaries, right?

PENNEBAKER: No, I wouldn't call them documentaries at all. I'd say I make movies. I really see there's a difference. One, I don't like the word *documentary*. It connotes something that's already preconceived. The thing that's interesting about a movie is that the people going to it are going to find out some kind of news or the people who made it find out some kind of news. That's roughly the two areas that movies break down into, and documentaries don't fall into either.... The way that I set out to make a film is pretty much the way a reporter would set out to write a story. I don't know anything about the situation except that it interests me. So I go out with a camera and a recorder and another person, to find out what's going on. Then I sit down with a lotta film and start to make my film. But until I've *filmed* it—I don't have any script; it would be presumptuous to write a script—I don't know anything about it. And if I wrote a script first and came back, it would be another movie, because things never happen twice.

SMITH: How do you know where to start and stop, then?

PENNEBAKER: I don't really, except that something starts you usually.... A lotta times somebody just tells you for some reason and you get into it. Sometimes, very seldom, you initiate something out of your own volition. But I'm really much more of a reporter and I have a very disciplined form that I have to work within. Although it looks like you just go out and shoot anything you want for ten days and bring it back, the

fact is that all the films that I've done that really interested me came out of a direct response for something. Albert Grossman wanted a film on Dylan—for totally different purposes, but he wanted to do something. John Phillips wanted a film on the Monterey festival. I didn't say, "God, now I'm gonna do a film on a pop festival."

SMITH: With Dylan, you were approached?

PENNEBAKER: Albert and Dylan wanted to do a film. They wanted to do two things, and, you see, Dylan and most people never go at things straight. They always sorta go around, so they can look at it first. I think Dylan wanted to make a film himself and figured that by having me make a film with him, he'd find out how to make a film and then he could embark on his own project. So in fact that one film was really two films. And there was another film shot, which has never been released. I'd been sitting there for three months thinking about doing a film on a singer, and we talked to Mick Jagger and we talked to Joan's manager.... Then suddenly one day Albert walked in the office and said, "I'd like to show some films of yours to Bobby," and that's how it started. But you do have projects, I'm sure, like every newspaper writer has a novel he's working on or thinking about in the back of his head.... If something is important to you and matters to you, you find a way to bring something out of it into whatever you're doin'. So it really doesn't matter so much if I'm working on a film totally of my own choosing or one which solves somebody else's problem.

> **It's hard as hell. It's like building an ocean liner in your backyard.**
> —D. A. Pennebaker

SMITH: You're listed as director.

PENNEBAKER: I guess so. That word is kind of meaningless in our parlance, because we don't have directors any more than we have scriptwriters, but it's something to call people.... I wouldn't call myself a director. I'm not a director, in that the strength of our films comes from the people we're filming directing themselves. If I attempted to direct 'em, it would be interfering in that strength. It would be presumptuous for me to tell Dylan, "Look, would you not sit that way?" Or to tell Kennedy, "Would you mind walking in the door again? I was out of film." You can't talk that way to interesting people, because the process you're doing doesn't interest 'em and shouldn't. I mean, they're doin' whatever they're doing, and you're just watchin' 'em—and if you miss it, that's tough shit. It's a double game. You don't talk to them about this, but in the beginning you can't ask for anything to happen again. You get no help from 'em—you shouldn't get

it or expect it. The same way if he does something and it didn't come off too well and you shot it, he can't ask you not to use it. It's a funny, complicated unspoken arrangement and I've never had it violated.

SMITH: Why did you distribute it yourself?

PENNEBAKER: We had a problem with getting a distributor to handle it. Most of 'em felt they were doing us a favor. The deals with big distributors, when you got down and examined them, there was almost no possibility that you'd ever make any money out of it. I felt the film should make money—it was the basis on which we were gonna be able to continue to make films. The system is a corrupt system as it now exists for filmmakers. Even people with fairly successful films find at the end of two years that they don't have much money. It's partially because the cut everybody takes is so huge, all the way down the line, that the guy who owns the film is almost spurious. Everybody considers he's had his fun making the film. One of the things that's changing, and gonna be changed more, is the method by which films are distributed.

> **All you need is a camera and a recorder.**
>
> —D. A. Pennebaker

SMITH: Having distributed your own film, was it very hard?

PENNEBAKER: It's hard as hell. It's like building an ocean liner in your backyard. You get all through and it's a fantastic thing to have done. But there it is. It's not floating. It's not doing anything. It's just in your backyard. And that's what having a major film's like. So you go around to United Artists and RKO, and they say, "That's great, kid." Or a lotta times they walk out. I've had screenings that by the end of the first reel there was no one in there but *me*. The guys just have too many things of their own to do, too many projects—and their business isn't vision. Their business is makin' money with what they've got.

SMITH: How're you able to work with such a small crew, just two people?

PENNEBAKER: All you need is a camera and a recorder. What you're trying to do is have an absolute minimum of static or outside pressure put on your participants. If you get a person who's interesting and doing something interesting, he's not gonna spend a lotta time worrying about the camera. He's got something else to do. Doesn't matter whether he's a statesman or an actor or a drug addict; he's got his business to do....To find a way to use the technique of shooting a thing that happens once—in a sense *performance*. Performance is the thing it all comes down to, whether it's the president performing his duty or whether it's Dylan performing for his friends or on a stage or whether it's an actor performing a role.

I think the essential, really, virtue of this kind of filming is that you bring the camera to the performance rather than, as in Hollywood, you bring the performance to a camera.

SMITH: Why doesn't the camera stop for a minute?

PENNEBAKER: Well, I don't know, style, technique. It actually *does*, probably, but...you're used to a relatively *static* camera in Hollywood. Even when a Hollywood camera pans or trucks, it does so in a very precise way; it does so on oiled bearings. The sense that you get is that you, the viewer, are very secure. It has a kind of absolute assurance to it. *Our* problem is that when that camera's on your shoulder, most of the time you don't know *exactly* what's happening; you're responding the way when you dance. You're kinda responding to a whole large battery of incoming things. It's very hard to predict it....If there was a machine I could put on the camera that would make it focus perfectly and keep the picture absolutely steady, I'd certainly use it if it didn't cost too much money.

SMITH: Do you ever use a tripod?

PENNEBAKER: Very seldom. It's just a big pain in the neck. You can imagine with two people, a tripod is the last thing you wanna carry around.

SMITH: So it's all handheld.

PENNEBAKER: Well, your problem is that here you are, you're with a guy, you have your camera with you...and a Nagra and enough tape, you have ten thousand feet of film in bags all around the floor, and the guy says, "Listen, I forgot to tell you this morning, but we're going to Hong Kong." You don't say, "Would you mind driving back by my studio so that I can get my camera crew and all the tripods?" You get in a cab with him or you don't go to Hong Kong. I mean, you have that problem constantly happening. What we've got is kind of a half-assed solution to them. It's not the *best* solution but at least we get to Hong Kong with him. We have a certain set of priorities and the number one is, of course, that you don't lose your guy—you don't lose your story. 'Cause you can imagine, a story like Dylan—you could be two-thirds of the way through it, and if you lost it, you just don't lose a little scene—that's the *end*. Everything you've done up to then, everything you've thought was possible, just goes. It's blown. So it's like roulette: you're putting it all down each time, double or nothing.

David Amram
February 1969

David Amram was at the center of the New York City Beat scene's cross-pollination of music, art, and writing. He collaborated, performed, and/or drank with friends Jack Kerouac, Allen Ginsberg, Jackson Pollock, Willem de Kooning, Arthur Miller, and Thelonious Monk, to name a few. Amram straddles the worlds of both jazz and classical music: he is a multi-instrumentalist and pioneer of the jazz French horn, and was the New York Philharmonic's first composer-in-residence. His memoir, Vibrations, *was published last year, just as he was finishing the score for Elia Kazan's film* The Arrangement.

SMITH: Dave, everybody's saying that jazz is dead or dying. Is it?

AMRAM: To quote the late, great Dave Lambert, he used to say, "People have been saying jazz is dying for the last sixty years." I think the fantastic part about jazz is that every time it looks like the patient is about to expire, it seems to come back stronger than ever. Commercially, in terms of record sales of what is called jazz, certainly jazz is not doing nearly as well as it was in the fifties. However, artistically, I think it's doing much better. There are more good young players of all different kinds of jazz. There's more interest in the blues as a result of rock 'n' roll and the resurgence of the blues, which are the basis of jazz. There's more interest in schools and in colleges and in concert music in jazz than there's ever been. It's just that jazz is assuming a different kind of form and is having a different kind of exploitation than it's ever had before, and it makes it very difficult for those of us who are practitioners of it to do it for a living. But as an art form, I think it's better and more appreciated and becoming more a part of our culture than it's ever been, because the music is simply too strong and expressive to ever go away, even if the music industry would like to *will* it away.

SMITH: But if it's that expressive and strong, then why did the people stop buying jazz records or stop goin' to jazz concerts?

AMRAM: They stopped buying jazz records in the amount that they were buying them at one point, and this was because when jazz did become

popular—or became popular again, since it goes in cycles—suddenly every record company in the world became a jazz company as well. And as I described in my book *Vibrations* during one of its more woeful sections, when I was really struggling, we would go to a studio in New Jersey. The A&R man would say, "Okay, fellas, let's just play the blues. Just relax and get in there and cook." So we would play the blues for an hour without stopping. Then we would be paid for one record session and the performance would be used on two or three different records under different people's names. Now aside from cheating the musicians out of a pitifully small amount of money, although it was money that we needed, more important, perhaps, what we played during that hour was simply music that we were using to warm up towards what we thought would be the best that we could do in a three-hour session. Yet there was no artistic considerations on the part of the people who put out these records. They would simply put out the entire amount of music, whether or not the quality warranted a record. As a result, a lot of poor records were put out by people who weren't really prepared to make their own records and the quality was not as high as it had been previously. Because it seemed that there was a market and the fast-buck operators have destroyed a great

Jazz was the kind of music that was played by musicians for one another.
—David Amram

many things in American culture, from cars that proved to be shoddy and unsafe to music. I think that this is changing now, and as a result, to have a jazz recording, it really has to be something of extraordinary quality, since there's not a large market.

SMITH: So you're blaming the demise of jazz on the industry, not on the changing taste of the listener?

AMRAM: No, I think that the taste of the listener has changed. But I think that the generation today is more receptive to all kinds of music, and I have more hope as a thirty-eight-year-old musician and composer of so-called serious or classical symphonic music, and as someone who plays jazz, for my music now than I did when jazz was in its heyday. Because there's a whole generation of people who were turned on and tuned in to music and are really able to hear and respond to music, and we no longer need these categories. That's why when I played it to the Fillmore two or three weeks ago, I found that the audience really was listening to our group so much that it really made us play better. When I played at the very end with Jeremy Steig and Charlie Mingus, the people

were listening. And they listened to the Fugs and they listened to the Silver Apples and they listened when Norman Mailer spoke. All these different kinds of music were presented in the same place to the same audience and people seemed to respond to it in a beautiful, natural way, because their ears and their minds were opened up. They don't listen to jazz to be *hip*, but because it might be a good musical experience. And this is very encouraging for those of us who will continue in jazz, whether or not we can make a living at it.

smith: Is it very hard?

amram: It's probably harder than it's been for quite some time. But traditionally, jazz was the kind of music that was played by musicians for one another. That's how jam sessions came into being, because musicians, when they were finished with their regular jobs, still wanted to play. And their best playing often would be done after they were done working with different bands and they would get together and play for fun. And this sense of fun and joy is something which is an essential part of jazz. No matter how serious jazz gets, and how cerebral, it still has to have this kind of spontaneity and magic to make it what is unique about jazz, which is the quality that you're hearing something being done which is really spontaneous. This is the beautiful thing about jazz, and it's what makes it so exciting to listeners when they can really hear people playing who still have this spirit.... It's going to be incorporated as our native art form. And there'll be concerts where rock 'n' roll musicians, folk musicians, jazz musicians, bluegrass musicians can all get together and play on the same program. When they do, it will give the audience a chance to see the great wealth and diversity that we have in America and our musical culture.

> **There was no artistic considerations on the part of the people who put out these records.**
>
> —David Amram

smith: If jazz doesn't completely die.

amram: Something I heard Ravi Shankar say—someone asked him why the kind of music he played seemed to be more popular than ever, and that other kinds, like Kabuki, had almost disappeared. He said, "The music has to be so strong that it can never die, because of the strength inherent in the music."

Just in the blues there's something which is *so* powerful that I find myself having gone from that source into much more abstract kinds of music, that is to say, way beyond the basis of three chords of twelve bars,

which is not what the blues *is*, but which is one of the structures of the blues, a very simple kind of a thing. When I get back and play, as I was doing just at a bar last night in my neighborhood where I go around the corner and play every night, I was playing and some people came in and started singing. And we spent about an hour and a half just playing the blues. And it was so moving, not only to us but to everybody in the place, just as a very elementary kind of music that really still has a tremendous amount of power.

And to see people playing jazz nowadays, since jazz is having its harder times, in a way is a more moving experience and more interesting than it ever was, because it's not something that's established. As a result, the people who are doing it are those who really love it. And there's so many good players that are going to continue playing, even if it's only for their own amusement, that the music will never die, just as bagpipe music in Scotland never died and it was forbidden for nearly three hundred years....

Whether or not it's commercially acceptable, it's too much a part of our culture and there are too many important people who have performed it. It's just that it'll be different than as we knew it when we were kids in the fifties. It has a different meaning now, because our whole culture has changed, and I say, "Hurrah!" Because the age of masochism and of the sourpuss representing some kind of Dostoyevskian figure of an artist is over, and it's been replaced simply by people who play music and are judged on the music that they play. And this is healthier, ultimately, for all kinds of music, including jazz.

DAVID AMRAM

Kenneth A. Gibson

February 1969

Ken Gibson is running for mayor of Newark, New Jersey. He ran a very brief losing bid in 1966, but a lot has happened since then. In '67 Newark was devastated by a week of race riots and, last year, Carl Stokes and Richard Hatcher became the first black mayors of major U.S. cities (Cleveland, Ohio, and Gary, Indiana, respectively). Gibson will win the upcoming election in a runoff and go on to serve four consecutive terms in office.

SMITH: Are there going to be any other black candidates running for mayor of Newark?

GIBSON: That's a $64 million question now, Howard. I don't think there'll be any strong black candidates; let me put it that way.

SMITH: The population of Newark, I think you said, is 70 percent black at this point?

GIBSON: We don't have an exact count these days, but the last study that was done, by Rutgers University, came up with 52 percent, 10 percent being Puerto Rican. So if you talk about the minority population or the nonwhite population, you were talking about, then, 62 percent. I say that the black and Puerto Rican population is closer to 70 percent.

SMITH: It would seem so easy, then, like you can just win.

GIBSON: Well, you're talking about the total population. Many of the young people are under twenty-one. The blacks, of course, and Puerto Ricans have young families. So even though we may have the 70 percent total population, more than half of the black and Puerto Rican population is under the age of fifteen.

SMITH: So how do the voting rolls break down?

GIBSON: There're 130,000 registered voters in Newark. And I will be appealing to the entire 130,000.

SMITH: But obviously, your major support will be from the black community, right?

GIBSON: Obviously, right. The voting rolls break down to about fifty-fifty: about sixty-five thousand blacks, sixty-five thousand white. What a black

candidate has to do in order to win, really, is to solidify the black community and get a percentage of the white community.... Stokes did it in Cleveland. Hatcher did it in Gary. And both won, by the way, using the same tactic.

smith: The thing I'm always struck with with cities is, are they worth saving?

gibson: People in cities get together to provide themselves with services more efficiently. And there's no reason why it can't be done in the future, even though city services in Newark have degenerated to the point where, in many cases, we don't get them. I still think that cities can be saved and should be saved, because that's where people are going to congregate at. The problems are immense, of course, but it can be done.

smith: Is most of the city government of Newark run by whites now?

gibson: Yes, substantially so. I can't think of any city department that is not controlled and directed by whites, generally, from the top to the bottom.

smith: Would that change if you won the election?

gibson: Not necessarily. What we're talking about is providing services. *Who* provides the services is not important. The people of the community are the ones I'm concerned about, not who happens to sit behind a desk and type. Whether the kids get the education is what I'm concerned about. Whether or not they die in childbirth is what I'm concerned about. And the girl that types out the application for the hospital death certificate is not my concern.

smith: If you, as a black, get elected, will the remaining whites all flee?

gibson: They didn't leave Cleveland. They didn't leave Gary. And I don't think they would have left Los Angeles if [Tom] Bradley had won. We didn't run away when Addonizio was elected.

smith: With all of the corruption coming to light in New Jersey, all the gangster influences, and that against a background of assassination in this country, is it dangerous for you to run for public office?

gibson: Listen, it's dangerous to be black if you're not running for public office. It's dangerous to be born black. So it's not new.

smith: You're not going to be taking special precautions—

gibson: John F. Kennedy was assassinated, and he had special precautions taken. I'm not saying that you make it easy. But you don't run your life worried about whether or not somebody's gonna take a potshot atcha.

smith: What do you do when you're not running for mayor?

gibson: I'm a civil engineer.

KENNETH A. GIBSON

SMITH: For the City of Newark?

GIBSON: Yep, civil service.

SMITH: So you've seen the workings inside—

GIBSON: Inside, outside, and all kinds of ways. But I'm not the only one. People in Newark know what's going on. It's just a question of whether or not they have the strength and the power to change it. Most people are dealing from a situation of their own personal survival from day to day....

> **I don't think there's any black person in the country who is willing to wait for what he's entitled to.**
>
> —Kenneth A. Gibson

SMITH: And that can be reversed?

GIBSON: Certainly. There was a time in Newark when everybody wasn't scuffling to eat, to make sure that the kids were warm....If we can get the kind of administration that provides services to people, we can reverse that trend.

SMITH: The tendency for white people is to just think of the black ghetto as if it's one thing. But it must be quite diverse—people who want to go slow, blacks who want to go very fast. Is that true?

GIBSON: I don't think that's true. I don't think there're any blacks in the country who want to go slow toward an equitable situation. I think they'd all like to have it instantaneously.

SMITH: In other words, all people in the black ghetto are militant?

GIBSON: If you consider that militancy, yes. I don't think there's any black person in the country who would say that they want to have equal treatment from the police department next year or next month or next week. They'd like to have it tomorrow. They would also like to have equal employment rights tomorrow. I don't think there's any black person in the country who is willing to wait for what he's entitled to. It's just a question of whether or not he has the energy, after dealing with his day-to-day survival, to *force* instantaneous change. That's where the problem comes.

SMITH: What kind of changes would you bring about in the police department?

GIBSON: Probably the first action that I would take is replace the police director, who has been indicted, by the way, for not doing his job.

SMITH: What percentage of the police department are white and black?

GIBSON: It's roughly fourteen hundred policemen and about 1 percent of it black.

SMITH: One percent of it black and 70 percent of the population? How can you change the way white policemen treat people in the black ghetto?

GIBSON: It's very easy. They get prosecuted for any violations of *their* law that they're supposed to be enforcing....People are afraid of punishment,

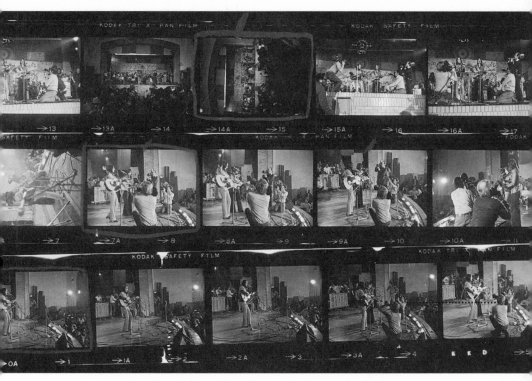

Joan Baez and Mimi Farina, Thanksgiving Day concert at Sing Sing Prison, NY, 1972

afraid for their jobs, the economic situation. A policeman knows that he's gonna be fired possibly? That he's not going to make that $10,500 a year if he mistreats somebody? He'll start calling black people on the street "mister," like he should.

SMITH: You have more faith than I do.

GIBSON: No, it's not a matter of faith. It's a matter of being able to make the change, the power to make the change. I'm not saying he's going to do it because he's gonna fall in love with people. For his own self-interest, he'll do it. To maintain his job position, he'll do it. I've seen a lot of people do things to keep their jobs. And what I'm going to be asking them to do is what they should be doing anyway.

KENNETH A. GIBSON

Felix Cavaliere
February 1969

Arguably the first white crossover band, the Rascals (formerly the Young Rascals) write music that's becoming more and more influenced by R & B and gospel. This newly dubbed "blue-eyed soul" is at the forefront in the group's latest hit, "People Got to Be Free," which, alongside their latest album, Time Peace: The Rascals' Greatest Hits, *just spent five weeks at number one. But this is the last time they'll enjoy the view from the top: next month, their fifth studio album,* Freedom Suite, *will mark the end of their string of gold records.*

CAVALIERE: When we recorded "People Got to Be Free," some people thought it was controversial, and some people are of the opinion that a group's purpose is to sell records. But we kinda injected into that the purpose of a message...or getting a point across. Our record company, Atlantic, were kind of afraid of the commercial value of this song and they gave us static. Turned out to be our biggest record.

SMITH: That was heavily played on black stations also, wasn't it?

CAVALIERE: Most of our music is. We've been fortunate enough to have *all* America listen...Black, white, some yellow people tune in once in a while—

SMITH: How did the Rascals come about?

CAVALIERE: I had a little dream or an idea for a group that would be the best musicians that I knew. My area at that time was New York, New Jersey, and these three fellows that I met I consider to be the best around. Two of them had been friends of mine, Dino and Eddie, and when the right time came, when I was more or less free militarily, we started the group. I had a friend mention to me once in a club that I had worked that "whatever kind of group you have, if you ever need employment, we'll give it to you." So I took him up on that. As a matter of fact, we just celebrated our anniversary Saturday. February 15 was our fourth year of existence. We rehearsed for two days and then we went to work that Monday. From that point on everything was just like you hear *dat dah dah dah dah dah*! It just was together, man. We were very fortunate, because we know a lot of people out there trying to make it.

SMITH: How come? Why, do you think?

CAVALIERE: Well there's a little bit of God involved. It's supposed to be fate. There's a lot of talent involved. It's just being in the right place at the right time with the right thing. When we first started there was only one, two other American groups that were even doing anything. The Byrds, who we had tremendous respect for, and the Spoonful—they started about two months before us. So there was no competition; there was nobody around. From that point to now, there's quite a few groups: the Fudge, people like that. They were young kids then.

No, it's not groovy; it's not pretty. It's dirty right now.
—Felix Cavaliere

SMITH: You make it sound like you're an old man.

CAVALIERE: Well, sometimes you feel like it when you've gone around the world a couple a times. I'm only twenty-six, but you've seen a lot, it makes you feel a little older.

SMITH: What was the turning point when you said, "We're gonna make it"?

CAVALIERE: We had our second or third job—a place called the Barge in Westhampton, Long Island. This was such a far-out place; it was so happening, you could just feel it. Like the Peppermint Lounge was at one time or Fillmore was out on the West Coast. People like Capitol Records, Atlantic Records, Columbia Records, ABC, they were all surrounding us with offers and you could feel it was gelling. And then we came into contact with our manager, Sid Bernstein, and when this man entered the picture, it was sort of like the steering wheel on this huge mass of energy. I think the first time I sat down and played with Dino, there was some kind of magic involved. It was something that was right, and it has a kind of feeling, because the whole group seemed to fit like that together. We go through our changes, believe me, but...

SMITH: A lot of groups have been splitting up. Four years is a long time. Has it been closer ever?

CAVALIERE: There's tension to varying degrees. See, the main problem is ego. I think that most of these groups, for example, Cream, they mix a little drugs in with their ego and it makes their ego so big and huge with each other....."Who's the most important?" What's the difference, man? Like, you're doing something; it's benefiting everybody. But people, they've got these egos. I think the purpose of our life is to conquer this ego and to get it under your control rather than you under it. This is how the groups go into all their changes. "I'm the one, man; it's me. I'm the one who gets all

the women; I'm the one who makes all the music." And yeah, we have our share of that too. But we've got a certain thing that, perhaps, it comes out in the form of the word *soul*. We operate like a family.

SMITH: Is this the closest you've come to splitting or has this happened before?

CAVALIERE: No, it's never happened before but we've gone through some pretty rough things. Four years is a long time. You got to understand it's like being married. We live together when we're away. We're bound to each other—not by any formal agreement, by choice. Somebody doesn't wanna be there, then they have every freedom to leave...

SMITH: Have you all been involved closely with Swami Satchidananda?

CAVALIERE: Not all of us, but to some degree. I've been very involved, and it goes from very to just fond of him. Last time we went to Hawaii we spent, like, two weeks out there and we brought him with us and he lived with us. You know, musicians are not exactly the holiest people in the world, but when you have a swami living with you, you've gotta really be cool. You've gotta toe the line. And the environment out there while he was living with us was like an ashram. It was really something to see, because we're musicians—we're supposed to be bad and degenerate and all that.

SMITH: Have you been to India?

CAVALIERE: Yes, I just came back, as a matter of fact. I was there in December and January.

SMITH: Just traveling around?

CAVALIERE: I was traveling around with Swami. He has many centers all over the world and we visited about five of them. It was outta sight. It was really amazing to see people who have nothing smile.

It was the best concert I've ever even been to, never mind played in.

—Felix Cavaliere

SMITH: A lot of musicians have gone through involvements with different swamis, gurus, and then have fallen out with it.

CAVALIERE: Yeah, well, it went out of vogue. See, for a while there the Beatles, being the powerful force that they are, turned on the world to this idea that there is a guru-disciple relationship. You can get a teacher to teach you how to be a human being. By that, it's a very vague way of saying what they teach you is how to become perfect. Perfect by the standards that *they* set rather than how much money you have or how many cars you own. But when this publicity came out, it became a fad. *Life* magazine picked up on it. *Look* magazine, they said, oh, dig this,

maharishi this, maharishi that—and it's not a fad. It's not the kinda thing that you should advertise…So in the same token, a lot of people picked up on the fad—like bell-bottoms. "They're in so let's go and get a guru and get turned on." But they weren't approaching it with a clear mind; they were doing it *because* everyone else was doing it.

When the fad went, which I think the Beatles put Maharishi down… then the people who were not enlightened enough to realize where this is at split and they went into the next thing. The next fad, well, it's not acid—we went through acid now, right? We went through God. Now let's see, what's next? I think it's curly hair now, right? So they went to curly hair and that's the level that they exist on. But that's cool—I'm not putting them down….But if more people were aware that there's something other than materialism, then this might be a little better place. It's a great place now, but I'm saying better 'cause I'm an idealist.

SMITH: Isn't it easy being an idealist being very wealthy, to say we should think of other things than materialism?

CAVALIERE: Here we're going into philosophy. I don't know if I should burden your airwaves with my thoughts. Yeah, it's easy, of course, but see, you have to set your goals in life. And these goals have to be set very carefully, because as soon as you say, "I want," then you have to have; otherwise, you're not going to be at peace. Say, "I want a Ferrari." Well, every time a Ferrari goes by, you're going to say "ooh," and this is not what I call a state of peace, a state of calmness, serenity, which I believe is where it's at. We set a goal that we wanted to be successful in the music business. We accomplished that goal. But this didn't bring this serenity… This didn't bring this calm to our minds. As a matter of fact, it brought varying degrees of pleasure and pain. Perhaps more pleasure and more pain than other people go through…So I looked elsewhere. I set another goal. Now maybe a person who doesn't have anything can say, "He can say that because he's got everything." Well, then they're gonna have to find out, man. So don't make your goals too materially high and it's easier to find out. Go for, like, a nice Toyota, $2,000.

SMITH: Your music's changed a lot from when you started, from lyrics like in "Groovin'" to your current songs. Was that conscious, to write more meaningful songs?

CAVALIERE: No, these things are not conscious. As you're living, you're changing, and so is everything that you do….If we're happy, it comes out happy. If we're sad, it comes out sad. If we're in pain, it comes out in pain. If we're groovin', it comes out groovin'—because at that particular

time we were groovin', man. It's just a picture of you and it's as personal as you want it to be. And you can mask it and go into something that is not you, but it's still going to be you no matter what, because you're doing it.

When Martin Luther King and Robert Kennedy, who I was really an admirer of, were killed, were assassinated, my mental outlook on life changed. No, it's not groovy; it's not pretty. It's dirty right now and it needs a nice bath, a nice cleansing. And no, I'm not happy. I'm aggravated, which is a nice way of saying it, and that's reflected in our music. People *got*; the *got* was underlined in that. It's a product of our changes.

SMITH: You recently decided that you would not appear in any live concert unless there were Negroes also appearing on the bill.

CAVALIERE: Any major concert that we do, this has become *a rule*, so to speak. There's a lot of reasons for this.... We enjoy it more when there's Negroes on the bill and in the audience. Right there, it's as simple as that. We enjoy it more. We feel we're accomplishing something. We hear good music when we go to work. We had Young-Holt with us the other day and they get a chance to be seen by our audience. And we get a chance to be seen by more people, so I mean, it benefits everybody. We did a thing in Madison Square Garden, a Martin Luther King benefit with Aretha Franklin, Sam & Dave, Sonny & Cher.... It was *fantastic*! It's the only word I can say. It was the best concert I've ever even been to, never mind played in. We try to create these kinds of things again, because it was so groovy—it was so beautiful to watch people get together like that. We did the same thing on a smaller scale out in Minnesota for RFK with Joe Tex, Tiny Tim.... So we're trying to re-create that feeling of the harmony between the races, between the music and the audience.

SMITH: Making this a condition of your big concert appearances, has that affected you economically?

CAVALIERE: In a way. We do a lotta work down South. Surprisingly enough, down South they really dig us. Now this has kinda set that a little, "Oh, rumble, rumble." But they still dig us. See, most of the kids are okay, so they're gonna come to the concerts. The promoters, they might not like our policy but they're in this business, unfortunately, for one thing: to make money. So they've got to go with our policy. So far we haven't had any violent... We had some people like, [in a southern accent] "Who the heck do you think you are, man?" But we expect that. We don't want those people as our audience; that's why we turn them off. We don't need their bread. Let 'em keep it. Let 'em donate it to Mr. Wallace. And this has affected us in a way, but dirty money's no good anyway.

Vidal Sassoon
March 1969

Vidal Sassoon opened his first hair salon on London's New Bond Street in 1954 and has since transformed the industry. Designed to be simple and low-maintenance, his haircuts have freed women from the standard back-combing and lacquer of the day. He now has four salons and a hairdressing school in London, and a salon on Madison Avenue in New York City. Soon he'll go global, opening salons in Toronto, Chicago, San Francisco, Los Angeles, and Hamburg.

SMITH: You became famous as a hairdresser for the short geometric cut, right?

SASSOON: Yes, I guess I became known through developing a style of hair-*cutting*. It was at the time when the whole *young London* thing was happening in a big way and I was working with Mary Quant—I was doing her show; she was doing ours—and we were developing this whole thing, in a sense, together, even though we didn't know we were doing it at the time. We were just doing a fun thing to amuse ourselves, because we thought it was right. But it turned out that a lot of people wanted it and utilized it, and it went on from there.

We have done a curly look as well, but the basic cut is still used whether the hair is straight or curly. Whatever you have, you've got to have a great shape. Whether it be a pair of shoes, a pair of trousers, architecture…the whole thing is the eye seeing a shape that it likes. And as far as hair is concerned, a hair shape must be visually good on a bone structure—it must *work* for that bone structure. I guess it is really as simple as that, or as difficult as that, because most simple things are difficult to do.

SMITH: But yet, when your style of haircutting became a fad, almost every girl wanted to get that style and got it. Is it that all their bone structures were right for it?

SASSOON: Well, this is a common mistake. You're talking about cut as a style—it isn't. It's a way of cutting. It's a way of working. It isn't a *haircut*. It's a series of haircuts that are cut in a *specific way*. Does it make sense?

SMITH: Is long hair gonna come back?

SASSOON: It never went out. You see, although short hair came in with a big bang and suited many people, there are always the people that look better with that long head of hair. Unfortunately, in the early stages of the long look that models were wearing, I was working on Jean Shrimpton at the time for *Vogue* and we had to give her a different look. The idea was to make it as raggedy as possible, because everybody else is wearing it beautifully chunky straight-cut and she wanted to look very different. The girls thought this was *in*, unfortunately, and many of them wanted it. What happened then was that they didn't go to hairdressers at all; they just let it grow very straggly and badly. Then you found that their ends were splitting and the hair looked very tatty and dry and nasty. And eventually when they *had* to have it cut, they had to have it cut very short. If they had only taken the trouble to have had their hair cut, say, at half an inch every six weeks, or even a quarter of a inch just to tip the ends, to strengthen the hair, none of these problems would've happened for them.

The whole thing is the eye seeing a shape that it likes.

—Vidal Sassoon

SMITH: Who cuts your hair?

SASSOON: One of our fellows in the salon. They're all very good so whoever's free....I like a haircut for myself that is a little longer at the sides and the back. I think men should have their hair styled to suit their face just as much as women. This whole nonsense about the very short back and sides for men, or the crew cut because it looks masculine, is ridiculous. And the same assumption that every guy you see in the street who grows his hair long because he thinks that's *in* is also ridiculous. It should be styled to suit his bone structure and his features.

SMITH: Do your various salons cut men's hair?

SASSOON: We've opened up a men's salon in London, and I'd love to do the same here in New York. Eventually, I think we will. But it's against the law; you have to have separate licenses to cut men's hair and a separate floor. We're working on it now.

SMITH: You yourself had some license trouble, didn't you? What was that all about?

SASSOON: Wow, that's an old story. But in America one has to have licenses to do almost everything. It's a beautiful country and I love it here, but it's a great bureaucracy as well. I guess it's good to be licensed to do a job, if the teaching of that job is efficient and works. If the teaching that people are getting is bad, then it makes a mockery of the whole licensing. I went through a whole hassle having to take a certain test, which I thought was

below standards. The New York City cosmetology board won by technical knockout and eventually I had to take the test. I made my point, though.

I'm very strong about the trade as an art form, a minor art form. I think it has a lot to offer. Although many people look at hairdressing and hairdressers as somewhat of a joke, I know what I had to go through from a fourteen-year-old shampoo boy to the present day to achieve any real standard of artistry in the work, which took many, many years. I would say fifteen years before I developed a standard or a style, a look that I could call my own, and a way of working. And because of the amount of time and energy and what I know of the business, I feel it's worth more than many people put into it and the standards should be much higher. You see, it's a job well worth doing, and done at its best, it gives one immense pleasure to do.

SMITH: Do you get to do much of it yourself now? Or are you primarily a businessman at this point?

SASSOON: No, I'm having a lot of fun at the moment. Last two days I taped five shows with Lauren Bacall for *Match Game*.

SMITH: What is the next style coming in, in hair?

SASSOON: Well, we're working on a long and a short look at the moment. The hair is definitely getting straighter again, which I'm very happy about, because you can tell good cutting from bad more readily when the hair is straight rather than when it is curly. The geometric looks are coming back. It's a softer version, a more rounded version and I think they'll have great success.

SMITH: Men seem to generally like long hair on women and seem to be aghast when a woman cuts off her hair.

SASSOON: I think what has happened is this: the bad hairdressers butcher short hair far more easily than they can butcher long hair—

SMITH: What I meant is that women seem to have their hairstyles done to please themselves as opposed to pleasing men.

SASSOON: Oh, I think this is important.

SMITH: That they should?

SASSOON:: Yes, because by pleasing themselves it gives them the necessary self-esteem. And we can go into the whole cybernetics now of this thing if you like, but if somebody—not talking women or men, just people—does things to please other people, they become very unsure people within themselves. You *have* to do things that you feel are right for you. If it pleases other people at the same time—all well and good. I find that if you're doing things that you feel good about, you automatically please

other people, because you become a better person for it—whether it be hair or whatever.

SMITH: You moved recently from London to New York, right? This is now your home?

SASSOON: New York is my base now. We have more businesses in London… but I personally find America very exciting.

SMITH: Is that why you moved here?

SASSOON: Absolutely. It's a great challenge. And I'm not ready to sit back and say, "Well, I've done it." Because I think once you do that, you're back to square naught.

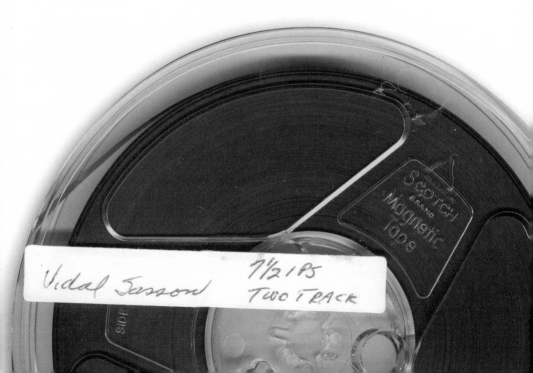

Lou Reed
March 1969

The Velvet Underground's third, self-titled album has just been released, and it marks some very significant changes for the band: John Cale, Nico, and Andy Warhol have left the group, Lou Reed is sober, and the album will be a critical success. The Underground spent the last month playing Boston and South Deerfield, Massachusetts, and are making a quick pit stop in New York City en route to play Cleveland this Friday. Although they live here, Reed and the Velvet Underground haven't played their hometown in almost two years.

SMITH: The Velvet Underground started with Andy Warhol? How?

REED: Well, we had started doing these light show kind of things behind, like, a scrim at the *old* Cinematheque on Lafayette Street. Then that theater closed and they were gonna move uptown and we went to the Cafe Bizarre and we played there and we were fired. But before we were fired, Barbara Rubin had brought down people like Al Aronowitz and Nico and Gerard. And Gerard, who's really kind of fantastic, brought Andy down, and Andy had an idea about putting lights with a rock 'n' roll band. He was lookin' for, like, a rock 'n' roll band and we were oriented that way anyway before we met him. We were very excited by the idea so we did it. They built the new Cinematheque and it was Andy's turn with Jonas; you know how they go—everybody gets a week to be an avant-garde filmmaker—and we put on a show. It was called *Uptight with Andy Warhol*.

SMITH: Were you already called the Velvet Underground?

REED: Oh, we'd always been called, 'cause I was in a bookstore and I saw this dirty book and it said *The Velvet Underground*. I said, "What a pretty name" and I read it. It had an introduction by a psychiatrist about the velvet underground depravity of Germany in the prewar years. Then he said, "Come inspect the velvet underground" and I couldn't figure out what he meant, and then he explained what he meant and he made something that was really so magic sound so boring that the name stuck with us.

We played Philadelphia at a club that's now closed. We for a long time seemed to close clubs, which, it was like, if you wanted to get your

insurance money a certain way, you could book us and you could bank that the club would not last long....But in Philadelphia the girl who was downstairs taking tickets, somebody told us her father wrote *The Velvet Underground*. So we said, "Oh, it's a message, right?" Because I'm into receiving messages so I said, "Somebody's trying to tell me something." So we sent somebody downstairs and said, "Hey, can you get your father to autograph the book for us?" She said, "No, he's dead of cancer." Right, then the club closed. So that was how we got the name.

SMITH: So how many years is that now?

REED: Four or five. We were playin' in '64. Like, we were performing "Heroin." We used to go out [on] 125th Street, Seventh Avenue, and John had a viola and I had a guitar and they threw money at us. It was really fantastic—it was a reverse of the blues revival now, you know, *we'd* go up to Harlem, and get money by playin' in the streets....This is about the time the Beatles were doing "I Want to Hold Your Hand."

See, we never *became* hip or aware; it had never been anything other than that. Whereas everybody else has kind of *grown* to it. See, that's not where our situation was. We're just like a prism that's constantly revolving. But we didn't suddenly get into it as I think a lotta people have suddenly gotten into it. What they're gonna get into now is that nothing's going on, that a lotta people are lying to them.

SMITH: How come the group hasn't made it bigger?

REED: Well, we don't get played on the radio—that has a lot to do with it.

SMITH: Why not?

REED: I'm not in radio; you are.

SMITH: What do *you* think?

REED: Because I think the first two albums weren't as accessible as they could've been to a median awareness. Therefore, we approached them on a certain energy level that was incorrect at the time. It was correct for a certain buncha people, but it wasn't correct for median level, see, because it wasn't what was required—we did what was required of us then so that we could do what we're doing now, which will be more accessible, which will make the first two more accessible. I think the new one will get played on the radio and that it deserves to be played on the radio more than the other two, precisely because even if the first two had been played on the radio, it wouldn't have been liked that much. So there'd have been no point.

> **See, we never became hip or aware; it had never been anything other than that.**
> —Lou Reed

THE SMITH TAPES

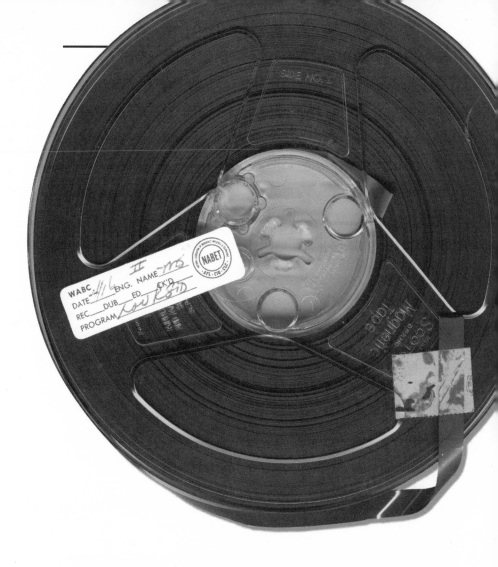

In other words, maybe the people who didn't play it were correct not to play it, because the time and space didn't perhaps match them. See what I mean? Whereas now perhaps it does and those who wanted to hear the first two can hear 'em anyway. They'll be around forever; I mean, they're not that kind of record that's not gonna be here or that was topical. We've never been topical. Some people write songs that have to do with the moment. Like, we recorded for the moment, but what was written wasn't for the moment. You understand the line I'm drawing? So that's why we weren't on the air, 'cause the moments we were dealing with and moments they were dealing with weren't matching. Although

it was matching for us to record it, the level was equal enough for us to be able to get it recorded, but it wasn't equal enough for us to be able to get it played. Yet now things have moved up to where I think people are approaching where they are…

I feel the single most powerful art form right now is radio and rock records. Films mean nothing; absolutely they don't mean anything. TV is—

SMITH: Films mean nothing?

REED: Absolutely. Not gonna have any effect on anybody. The *real* thing is radio. Radio is what they carry to the beaches, my man. Just go to Jones Beach; there they are—zap. All the little kids wired in, in Central Park. I mean, they take it for granted—they go to movies with *radios.* So the real form is radio sound. I'm sure you know the magic notes. You know mantras aren't a joke. I mean, sound is what everything is based on and therefore you have records.

SMITH: I think at this point, film is more powerful than radio.

REED: Oh, that's interesting…because I truly feel you're wrong on that and maybe I could show you why. Not so that maybe you'd change your mind, but maybe you'd understand why I think it's different. The ballrooms, the amplifiers, the transistor headsets—the kids are so amazing today. You go and do a show for them and they're wired. They've got tape recorders in this pocket; they've got a radio over here….And films, where you have to sit in one place for, like, two hours to watch this thing, that's not the future. It's not what's gonna be. People like mobility.

SMITH: Take those big ballrooms, though—people have stopped dancing a lot.

REED: That's true.

SMITH: The same kids that you're talking about, that like mobility, are now sitting down and listening to the groups….The kids just stopped dancing.

REED: This is just a thing that's going on now, unfortunately, I would say, because of drugs. See, now the drug revolution has come and gone, and we're stuck with the residue, which is mainly lying on the floor at light shows. But this too will pass. Because what the kids are gonna be interested in and what's gonna be fabulous is not drugs, because drugs are very, very boring. I know the kids are hip to this, that the quickest way to bore yourself is take a drug and examine *you*….The thing that's most fun is working very, very hard on something that's good. As hard as you can, to make things as best as you can in whichever way, because it doesn't matter if it's a big thing or little thing: they're all equal. No one does more good than anybody else if everybody does good. There's no *measuring* stick. You can't put a ruler to it. And the kids are into this and

they're not gonna spend all their time on the floor smoking pot. Like, I'm one o' the people that say pot should be illegal, you understand?

SMITH: That's funny; you've had a long involvement with drugs—a long, notorious involvement.

REED: "A long, notorious involvement" isn't what you're apparently stating it to be. I'm telling you what I think of drugs, for what it's worth, which may be nothing. I'm also tellin' you what I think the *kids* think of drugs, for what's it worth, which also may be nothing. I think the kids are arriving at a conclusion that I got to maybe a different way, only they may be smarter than I am and a lotta them really are. A lotta things I had to find out, they already know. I mean, they just know it right off the bat, automatically. You talk to these little fourteen-year-old kids—they're beautiful. They're like little *elves*. A lot of 'em—say, two years ago when we were touring around—were killing themselves with this dope. And their so-called idols who were sayin' really hip things like, "Oh, everybody should do what they want," like when they're referring to dope. Well, that's true up to a point, but somebody should also mention to them that, yeah, you should do whatever you want, but think about it before you go off and do your...I think they're not gonna be lying on the floors of ballrooms. They're gonna be out and having a lotta fun, because that's what young people are supposed to do...which means no dope, because it's a distraction.

The drug revolution has come and gone, and we're stuck with the residue, which is mainly lying on the floor at light shows.
—Lou Reed

SMITH: You sound like a reformed alcoholic.

REED: No, does it really? I just think I'm someone who likes reality a lot. I think anybody that distracts themselves from reality is cheating themselves from what really exists. Because there's nothing more fantastic than what you're seeing right in front of you. Anybody who distorts it for a minute is lowering the whole level of everybody else around 'em.

SMITH: The Velvet Underground for *so long* was called "the drug group."

REED: Who cares what the Velvet Underground was called? I don't care what it was called.

SMITH: Are you saying that that was all untrue?

REED: I'm not saying anything was true. You have to ask me a specific question to say that's true. It was true we were called a "big bad dope group." Yeah, that was true. So, what does that have to do—

SMITH: Was it true that you were a big bad dope group?

REED: I don't think we were a big bad dope group. I don't understand what a big bad dope group would be.

SMITH: Your phrase. Was the Velvet Underground personally very involved with drugs?

REED: No, I wouldn't say very involved. I would say we were as high as you'd wanna go. But I would also say that it was part of the times that was goin' on then. And we happened to be right up front with it—and so we're reporting back.

SMITH: You're saying, "We've been there and we didn't like it"?

REED: I'm saying it's a poor way to bore yourself. There are better ways of boring yourself than dope. The only reason I'm mentioning that, in particular, is 'cause it's something we run up into with the kids. You understand? I don't care what I've done, because I don't particularly matter. I'm saying the kids that you meet at the shows wanna know about things like that. You understand? It's something they bring up. In other words, I'm not rapping about the army and saying, "Well, I beat the draft; I did this, this way." I don't 'cause no one asked me, so I'm not saying anything. Okay. But I do know that the kids are listening. They wanna know about dope and they wanna know that it's lousy, and I'm just saying I include pot and I include liquor. I say anything, *anything* that disorients you or distracts you—anybody tells you you're gettin' closer to reality is lying. They're people who aren't very strong, that's all.

SMITH: You don't use anything anymore?

REED: No. As a matter of fact, I use vitamins. I use homeopathic cell-tissue salts and things like that. I go to Kiehl's and I get little roots and I brew things at home, right? I get high off honey. You know what I mean? What level do you think high is? How high do you really wanna go? I mean, do you really wanna be straight or do you wanna kid around and really get down to it? You really wanna get down to it, you'll say that the kids should know that some people think that it's bad stuff, up to and including pot. That means marijuana. Bad because anything that disorients you... Yet if anybody wanted to do something, they should be allowed to. That's why it should be legal, just so people could not do it. Understand?

Norman Mailer and Jimmy Breslin
April 1969

It's been a rough few years for City Hall, as New York City has faced a run of major union strikes: transit, Broadway, sanitation, and teachers. Garbage piled up for nine days last spring while the schools stood empty, and snow removal was badly mishandled after this February's blizzard, furthering the public's perception that the city government is inept and that Mayor John Lindsay is uninterested in the outer boroughs' worst-hit, poorer populations. In the wake of all this, Village Voice *cofounder and journalist Norman Mailer has decided to run for mayor, with fellow journalist Jimmy Breslin on his ticket for city council president. In a few weeks Mailer will win the Pulitzer Prize for his 1968 novel* The Armies of the Night, *but despite that, his campaign will not be taken seriously by the press. The upcoming primary will take place in June.*

SMITH: Are you definitely going to announce?

MAILER: I think we can blow a few minds if we do it now. I think we can really open the city....See, we're running from left to right. We have ideas that will appeal to everyone, not 'cause we're trying to sell a salad, but because the practical difficulties in New York are quite beyond politics.

SMITH: Do you really think people will vote for you even though they disagree with you on Vietnam?

MAILER: I'm going to try to show them that it doesn't matter what I think about Vietnam or what they think about Vietnam. If they're getting the lungs of a coal miner living in this town, what the hell do they care what my opinion is about Vietnam? Neither of us has any power over Vietnam. They can't win the war in Vietnam. I can't end it. But in the meantime we're both breathing this filthy air day after day. It gets worse all the time. Everything gets worse in this town.

SMITH: Why do you feel that your constituency has to be young people?

MAILER: That's where the energy is and that's where the remaining hope is. Everybody who's my age, forty-six, is pretty depressed by now. They're

worn out; they're cynical. I thought it'd be the greatest pleasure the people of New York have by now is to laugh at the city, at how horrible it is, how badly it runs. It's a joke to us. It's a bitter, grim, grisly comedy and we laugh at it all the time. It's only the kids who are just furious, pent-up, because they feel their lives are going to be extinguished in some dull way. They're all blowin' their minds on acid because they just can't take what's right there before them every day. It's too dull. It's too deadening. It's too inhuman. I think those kids have got a fantastic energy to cut loose with, and I don't mean for stunts or capers.

I mean, I think one of the reasons why kids are throwing themselves into fires and be-ins in Central Park is because that's how crazy we're all getting. But if we recognize that the enemy is not each other, it's that abstract federal government which is telling us how to solve our problems from hundreds of miles away...We want to go exactly in the opposite direction. We want to decentralize the city. We want to turn the city back into townships. This is the biggest idea we have: we want to make New York City the fifty-first state.

Now once we do that, we've got an enormous shift in our financial problems vis-à-vis the federal government, because there's much more control over the money that comes to us.

SMITH: You talk about the young people. Will they trust you?

MAILER: They don't have to trust me. I'm ignorant of twenty thousand things about the intimate nitty-gritty of municipal government. I'm starting out as a man who knows very little about this. I'm going to have to conduct my education publicly. Every time I make a mistake, everybody's gonna see it. So those kids will be able to trust me, because they will see every place in which I'm phony and crooked. And besides, I don't run as a man who's pure or holy. I don't pretend to be any better than anybody else. I'm just as full o' shit as the next guy. And I'm running on that.

SMITH: How about your writing? How is this going to affect it?

MAILER: It's either going to make it a lot better or a lot worse. I may not have a chance to write again. If I ever become mayor, I might not be able to write for eight years. Anyway, that's not the point right now, because what we have before us is the eight weeks of the primary campaign. Let's see if we win that one and then we can go on.

SMITH: How about poverty? Is this another myth that it can be solved?

MAILER: Well, if we become a city-state, then I'd try to have referendum after referendum to turn this town into separate townships with their own rights. They'd be running their own government again. Greenwich

Village would be a township. Chelsea in Manhattan would be a township. Flatlands would be a township out in Brooklyn. Flatbush would be a township. Brooklyn Heights would be a township.

SMITH: Harlem?

MAILER: Harlem would be something else again. It'd be a separate city within our city with absolute autonomy from us. I don't think the blacks are going to listen to any white man tell them how to run their affairs. It's their baby. They have their own police, own firemen, own school. They'd do their thing their way. I don't see how I, as mayor, can ever tell the blacks what to do with their lives. I'll say to them, in effect, "Here's the money. You want to come to us and talk about things, fine. You don't want to talk to us, it's your affair. You want to build your style of life, build it." Maybe we've got a lot to learn from you.

SMITH: Is it a joke? Are you guys really running?

MAILER: You have to assume that no matter what I'm sayin', I'm a liar if I'm in politics. So I'll just ask people to judge it for themselves. Running for mayor in this violent, hate-filled, troubled, dirty, filthy, pain-ridden city—it's not a joke. It's going to change my life one way or the other, for better or for worse.

BRESLIN: It can't be a joke. I think anyone who toys with the city of New York in its present situation is committing a mortal sin. This city is grievously wounded and must be treated as such. This is a *patient*; this isn't a city.

MAILER: What we want to do is instead of trying to bring in a new oxygen tank for that patient, we want to get the patient out on the street and walking. The first way we're going to do that is clean the air. I'd like to tell you about my favorite idea. Bill Buckley

It's a bitter, grim, grisly comedy and we laugh at it all the time.
—Norman Mailer

had one marvelous notion in his mayoral campaign—that was the bikeway. He was gonna build a special little promenade in which people were going to ride their bikes from Eightieth or One Hundredth Street all the way down to Forty-Second Street. So you could bike to work. I would go further. I'd say build it all the way down to Wall Street. Our idea is for "Sweet Sunday," which is one Sunday a month everything in New York would stop, everything. No cars would be allowed and no electricity. There'd be a blackout, which means no television, no radio; no airplanes would come in or out. That'd give the air a chance to clean itself.

BRESLIN: At times you sit in the city and you feel like ringing the bell for the nurse.... We lost East New York; we've lost the South Bronx. I don't see

how those areas ever can be brought back to be fit for human beings to inhabit. I mean, this city is up for grabs right now. It's a disgraceful situation. The idea isn't so much are *we* serious—are the *people running* it serious?

SMITH: How are you going to get more black cops?

BRESLIN: If they're running their own place, they're going to have to police it.

MAILER: Exactly. If there's a black New York, as well as a white New York, then policing is their affair. They may have a completely different idea how they wanna police it. They may know much more about policing than we do.

BRESLIN: They're the last people who live in high-density neighborhoods in this city in Harlem, Bedford-Stuyvesant. They're used to crowds. They're used to the problems of people. What we take is a white fellow in his late twenties who lives in Massapequa, Long Island, with a lawn and three children and, all of a sudden, on a four-to-twelve shift, you throw him onto 116th Street in Harlem. It's not going to work. He's frightened. He's never seen this many people except for his eight-hour tour. You need somebody from the neighborhood that knows that isn't a commotion down there; it's just a normal flow of traffic on a sidewalk. They are the best at it, because they're the ones that must live packed closely together.

> **Running for mayor in this violent, hate-filled, troubled, dirty, filthy, pain-ridden city—it's not a joke.**
>
> —Norman Mailer

MAILER: Yeah, but also blacks got a kind of, I mean, I really have the impression they have a kind of... You know how they used to say they got rhythm? What I think they got, I think they've got a kind of instinctive communication with each other. It's beautiful to watch. Their marvelous self-discipline, when it's their game. That's why blacks are so great at disruption, because they know an awful lot about how to handle themselves with discipline.

SMITH: Up in Harlem the junkies rob from the black people too.

MAILER: I'm not pretending black people are saints. I'm not even pretending that I know that much about them....I don't feel I have a moral right to go in and police blacks.

BRESLIN: We've been trying it, very unsuccessfully. Give them the power. Give the neighborhood the power to police itself. You give East Harlem, West Harlem, Central Harlem, give each area its own power; they'll be less apt to let things run as loosely as the "great white fathers" from downtown have been letting it run for the last hundred years.

SMITH: How about education?

MAILER: Complete decentralization of the schools. Look, the great cry of the UFT, United Federation of Teachers, was that "here were these ignorant blacks insisting on putting their own people in who didn't have the credentials, and they were turning away expert teachers." Well, anybody who knows anything about learning knows that you learn only when you feel enthusiasm.

SMITH: How are you going to bring that about?

BRESLIN: Here's the typical textbook they give a kid in a Bedford-Stuyvesant [school]. It'll be written by a white woman, it'll be purchased by a white woman at the Board of Education, and they'll give it to a kid who comes from Greene Avenue, Bedford, Fulton, and it'll say, "Dick caught the ball. 'I did. I did,' said Dick." With a white woman standing in front of the room teaching it to them and the reader filled with lovely green fields and a dog named Spot, and then they go back to the tenement. This is insanity. Do you mean to tell me you have to get a master's degree to teach kids in the first and second grades? Why not have a black man stand up in front of them? If he doesn't have the greatest college degrees in the world, if he can follow a curriculum and excite these kids, they can identify with a black man. This business of bringing another Erasmus Hall and Brooklyn College ed major into the school system to teach black kids…Either that goes or we go.

SMITH: How're you going to suddenly convert thirty thousand teachers to be more interested?

MAILER: I'm not interested in converting them. I'm for decentralization. I'm for having each community handle its educational problems. Everybody walks along assuming that they've got a good system to begin with. They don't. What I want to do as mayor is turn back more and more power to the people. I don't want to run all of New York from City Hall.

BRESLIN: I'd rather have the wisdom of the streets in this city than the wisdom of some commuter from Princeton, New Jersey.

MAILER: Or some government bureau in Washington.

NORMAN MAILER AND JIMMY BRESLIN

Andy Warhol and Paul Morrissey
April 1969

Last June Andy Warhol was shot by Valerie Solanas and pronounced clinically dead, but surgeons at Columbus Hospital were able to revive him. Since the shooting, life at his art/film studio, the Factory, has been slow. Warhol recently underwent a follow-up surgery and has created little work since he and film partner Paul Morrissey produced Lonesome Cowboys. *The movie opens in New York City next month.*

...

SMITH: How many movies have you made to this point?

WARHOL: We didn't make any movies this year.

SMITH: How come?

WARHOL: Well, I lost a year.

SMITH: But how many altogether do you figure you've made?

WARHOL: Well, there's short ones and long ones. So I don't know.

SMITH: Twenty? Fifty?

MORRISSEY: It's so hard to estimate. There's so many that were never shown. If you took by hours, you would have to come up with about two hundred hours or two hundred films. But for theaters, I think only twelve films have played actual commercial theaters and maybe twenty more for nontheatrical showings.

SMITH: Do you still do artwork?

WARHOL: No.

SMITH: Are you going to?

WARHOL: No. We're just trying to do movies and television. We were really working on this show called *Nothing Special*. It was gonna start at 1:00 AM and go on till 7:00 AM, and we're still waiting to hear about that.

SMITH: For television?

MORRISSEY: To go on after Johnny Carson.

SMITH: On [channel] four?

MORRISSEY: Some people were trying to promote it for that station to buy, but it was supposed to be hours of nothin' happening, people doin' what

they wanted to do, talkin' if they wanted to. See, most of Andy's early movies were geared for more television than a movie theater. It would be much better to have that kinda thing in your home, on TV, where you don't *have* to watch it if you don't want to. A more easygoin' kind of thing, less self-important.

SMITH: It was called *Nothing Special*?

MORRISSEY: That's if it's done once. It would be a special. But then if it was popular, Andy really wants to do it every night.

WARHOL: It's like those apartment-house TV stations that you just wait to see who comes in the door, and nobody ever does. Have you seen them? On channel six.

SMITH: Would you have anything planned?

WARHOL: No.

SMITH: Literally anybody could just drop by?

WARHOL: Ultra Violet would have planned something. She's the only one that thinks about things.

SMITH: Did you realize when you started doing the movies that you were gonna stop doing art?

WARHOL: No, I just bought a camera and went to Hollywood and that's what started it. No, I didn't know it was gonna happen. But we really want to do TV.... Well, all-day television is more like one program than a whole bunch of different programs.

SMITH: Have all your movies made money?

WARHOL: No, just the ones that we've been showing the last year.

SMITH: Like *Chelsea Girls*?

WARHOL: Yeah, and *Lonesome Cowboys*.

MORRISSEY: But *Chelsea Girls* really. It was a company that made it and the company didn't make any money at the end of the year, because they made other films that were never shown. So it really didn't make any money.

> **I just bought a camera and went to Hollywood and that's what started it.**
> —Andy Warhol

SMITH: You mean *your* company?

MORRISSEY: Yeah.

SMITH: But *Chelsea Girls* itself, how much did it gross?

MORRISSEY: You mean in ticket sales? It might have grossed around half a million dollars.

SMITH: What'd it cost to make?

WARHOL: Fifteen hundred, I think. And plus all the million-dollar suits.

MORRISSEY: We had a lotta lawsuits connected. Somebody sued for a million. Somebody sued for two million. But they all settled for a hundred dollars.

SMITH: Why did they sue?

MORRISSEY: They thought the film was making a lotta money. And then when they found out it wasn't making any money, they were glad to get the hundred dollars.

SMITH: Did the Chelsea Hotel sue?

WARHOL: Yes.

MORRISSEY: They said it gave the hotel a bad name. But we found out they wouldn't be able to prove that, because the hotel was booked up for the past year and they didn't lose any business.

WARHOL: They said if we gave them money or somethin', they would let us give it a bad name.

MORRISSEY: So they accepted the bad name and it's still hard to get a room there.

SMITH: I hear you're gonna make a 3-D movie?

WARHOL: Oh, yeah. We were out in California and they showed us some 3-D...beavers and that's what we're gonna make.

SMITH: Really?

WARHOL: Oh, yeah, it's really terrific. It really works. The girl takes off her clothes and throws it out at you and you feel like it's coming at you. And she picks up her leg and tickles your nose. Have you seen it? It's really terrific.

MORRISSEY: We have a new movie comin' out called *Lonesome Cowboys*.

SMITH: When is it gonna open in New York? I got two letters this week at the *Voice* sayin', "You wrote up this movie. Does it exist? Or is it another Warhol myth?"

MORRISSEY: It's a theater jam. We're supposed to open in Lyceum Theatre in early May. It's been playin' in Los Angeles, San Diego, San Francisco. It's been very popular in California.

SMITH: Like, really grossing a lot?

MORRISSEY: It's already grossed around $200,000, in three theaters. It cost around $10,000.

SMITH: Ten thousand?

MORRISSEY: That was a big, expensive film. We might go to California, make a film. But I don't know. We might make a film in a month as soon as the Western film opens in New York.

> **Somebody sued for a million. Somebody sued for two million. But they all settled for a hundred dollars.**
> —Paul Morrissey

smith: I want Andy to answer this one. How do you make movies that cheap?

warhol: We just turn on the camera and have the right people and so there's never any mistakes.

smith: What d'you mean there's never any mistakes?

warhol: Well, whatever anybody does is a mistake.

smith: So you don't edit anything?

warhol: No.

morrissey: We're looking for mistakes. So if they make a mistake, that's good—that's what we want. There are some people who can't do anything wrong. And you put those people in front of a camera, then you can't go wrong and it works.

smith: Most people shoot ten to twenty feet of film for every foot they use. What's *your* ratio?

warhol: We're using more film now, but...

morrissey: It's still a one-to-one ratio.

smith: One to one?

morrissey: Each thing is only done once, but we film a lot more than what we actually put in the theaters now. We used to put everything in the theaters that we filmed, one to one. But we never do anything twice, because we don't ask for anything to be done, so whatever is done is done.

smith: Do you edit at all?

warhol: We just eliminate.

smith: But you don't edit in a scene?

morrissey: It's not really editing—it's shortening. But in movies editing is something different. It's putting together shots that were supposed to be put together in a certain way and keeping the best shots of the best takes. Editing to us is just shortening.

smith: Andy, what goes on every day in your life? Like up at the studio, what do you *do*?

warhol: Yesterday was the first time I'd really been there for a long time. It was sort of exciting....Oh, Ingrid came in and began cryin' and...Then the rock 'n' roll group from Rochester came down and we might do a rock 'n' roll opera with him. It's called...*Armand Schaubroeck Steals.* He came to see us a year ago. I told him to write an opera and we might be able to do it, so he spent a whole year doing it and he brought it down yesterday and it was sorta good.

morrissey: And who else was there? There was a Swedish man.

warhol: Oh yeah, the Swedish man was there.

MORRISSEY: There's always some reporters there for some reason, writing a story for some European capital. Magazines are very popular in Europe, I guess. More popular than here.

SMITH: Do you have some ultimate goal of movies? What would you really like to make?

WARHOL: Well, yesterday I also went to see a new opera that Virgil Thomson was doing, and they were so different. It was at the Metropolitan Opera House and it was all so organized. And it was the first time I thought, "Well, maybe if we had a little more money, we could make a better movie."

[After a pause in the recording, the tape recorder is turned back on mid-conversation to a discussion of Valerie Solanas.]

MORRISSEY: They said we just have to put her away and that the only way to do it is to give her a plea that we can hold, like second-degree assault, which would only put her away for a maximum of four or five years.

WARHOL: Or less than that.

MORRISSEY: She'd be out in one. We said, "What is assault in the first degree?" and they said, "It'd be too hard." But *then* it turned out he must have asked her lawyer to ask her to accept a plea of assault in the first degree, which she then did accept.

SMITH: No, her lawyer says they asked her to accept a plea of assault in the second degree, which she agreed to. But then when they arrived in court, it was changed to assault in the first degree.

MORRISSEY: Because she went to court the next morning, *after* we saw the DA.

SMITH: But that was a *shock* to Valerie. She felt like, "There it is again. They screw me again."

WARHOL: But how could he do that?

SMITH: He just changed it. And there she was standing in court, and before you knew that was it.

MORRISSEY: He tried to resign us to the fact that it was assault in the second degree, and we were just so nasty to him. We told him that he was just tryin' to get off the hook, and he felt guilty.

SMITH: He tried to make it sound to you like he gave in to pressures from her side, and to her he made it sound like he gave in to pressures from your side, when actually he was making *all* the decisions.

WARHOL: Yeah, that's what it was all about. That was sort of good then, wasn't it?

SMITH: You should speak with her lawyer. She's very interesting.

WARHOL: No, there's no reason for us to talk to the lady, because I don't know....

MORRISSEY: Why did you have to say that, though?

SMITH: She made some interesting points; that's all.

MORRISSEY: I think it might be good, because she's gonna help her for her parole and maybe we could persuade the lawyer woman not to let her on parole for as maximum of whatever she's…

SMITH: Talk to her for whatever reasons you want to. But what I'm saying is she's not just some lawyer who automatically assumes her client is right.

MORRISSEY: Is she appointed by the court?

SMITH: Yeah.

WARHOL: This was a newer one. The last one, she…

SMITH: You should do it. Even if you do it *after* the sentencing.

MORRISSEY: One thing we have to do is keep in touch with—certainly not the DA, because he wouldn't bother to tell us, but maybe her lawyer'll at least tell you whether she's being paroled, so you know enough to keep clear.

SMITH: She didn't know a lotta the things that I told her.

MORRISSEY: I don't think she's quite aware of how crazy Valerie is, because when she encounters Valerie, she thinks Valerie's maybe a little bit of a mental patient who's suffering from bein' in the mental hospital or who's suffering from havin' done a terrible thing that's put her in this certain way. But the point about Valerie—she's always the same.

But we didn't encourage Valerie—I mean, she wasn't one of the people we knew very well.
—Andy Warhol

That thing about Sirhan—that DA prosecuting him said that you can't listen to any of that mental garbage. It's just a lot of talk, means absolutely nothing. He said the man is sick, but he knew exactly what he was doing…. Anybody who does that is sick in the first place, but that doesn't say that he's completely free from any kind of guilt. It's such a stupid thing. They had what, five or six weeks of psychiatrists sayin' that Sirhan was under some sort of pressure? That's such bullshit. It's the same case.

SMITH: When that happened with Valerie, a lotta people said they'd almost expected something like that, because so many of the people involved with you are crazy.

MORRISSEY: The people are high-strung, a lotta them.

SMITH: It's almost like you encourage everybody so much to do their own thing that where do you stop?

WARHOL: But we didn't encourage Valerie—I mean, she wasn't one of the people we knew very well.

MORRISSEY: She only came around two or three different times, and she was never on a social basis.

WARHOL: It's that same thing—how people think about you and you don't even know them or even think about them. I guess she just thought about me in a funny way and put so much on it, where we never even thought about her or ever really saw that much of her. She came once to see me about her script and oh, I thought she was too peculiar. So I never saw her. And then somebody was interviewing us and happened to tell us that she was so talented, so that's how we just started up again. We thought, well, maybe she is talented and so we used her in the movie—just because she needed some money and it didn't take more than a minute to do. Then she got peculiar again.

MORRISSEY: She used to call up a lot and say she had a problem with her publisher, Maurice Girodias, and try to talk to Andy about her problem—

WARHOL: She thought I was...

MORRISSEY: She created the problem.

WARHOL: She thought I had something to do with it and I didn't even know anything. So it just got worse and worse and it'd never even occurred...

MORRISSEY: No, but then she disappeared and then came back after a year and then that was it. Didn't even see her for almost a year. It's hard to think about people acting like that, but people do. Famous people do get in people's minds. I mean, the classic case is the Kennedys or Bob Dylan. I mean, almost any famous person, somebody gets in other people's imaginations. You never know what's gonna happen to you.

SMITH: Yeah, you were very lucky.

WARHOL: Well, I have old scars and I've gotten some new ones.

MORRISSEY: They opened Andy up again.

SMITH: Really?

WARHOL: And you can't tell which one hurts more. It's really funny.

Andy Warhol, Nico, and Paul Morrissey, N.Y.C., ca. 1960s

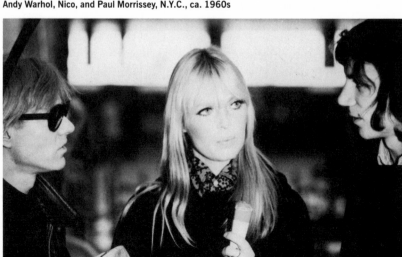

Sly Stone
May 1969

Sly and the Family Stone are in New York City to play two nights at the Fillmore East. Last year they had a taste of success with their album Dance to the Music, *but with the release of their fourth album,* Stand!, *two weeks ago, things are about to change. Their new track, "Everyday People," will hit number one, and their sunrise performance at the upcoming Woodstock festival will skyrocket them to stardom. Soon after, however, Sly's and other band members' drug use will become a serious problem, derail their momentum, and break the Family apart.*

SMITH: Where does the name come from, Sly?

STONE: I was in the third or fourth grade…This guy Edward made a mistake on the blackboard. My name was Sylvester and he confused the first three letters…I've just been called that all my life, almost.

SMITH: How about the "Family Stone" part?

STONE: Well, my brother plays guitar in the group—my brother's name is Freddie—and my sister plays electric piano. Her name's Rose. The bass player, Larry Graham, is Cynthia Robinson's cousin—[Cynthia] plays trumpet. And Jerry Martini, the saxophone player, is related to the drummer: they're cousins.

SMITH: Do you operate like a family also?

STONE: We're pretty close. We never had any arguments among anybody in the group about anything—

SMITH: Really?

STONE: We've never had any argument whatsoever—about any song, about any key, about any clothes, about any money, about anything.

SMITH: That's amazing.

STONE: I know. It's beautiful.

SMITH: How long have you been together?

STONE: About two years.

SMITH: How fast did you make it? At what point did you have a hit?

STONE: I guess about six, seven months.

SMITH: That's pretty fast.

STONE: Yeah. It's for real. And if it's for real, somebody's gotta dig it. You know what I mean? It seems like it took a long time, because when we got together, it was such a great feeling that to me it should have been happening then, the next day....

SMITH: What did you used to do before?

STONE: I played guitar. The place that I played then started having topless. As a matter of fact Carol Doda—she started doing the topless right above me. I just didn't understand why I should play in a topless joint. So I split...And then all of a sudden the group happened. And I've never been so happy....And we'll always be together, I believe.

SMITH: What was the key thing in you really making it?

STONE: David Kapralik. Well...were at the Winchester Cathedral, which was then operated by Rich Romanello. Rich Romanello, the first guy that started out managing us, did not understand us. Chuck Gregory, a promotion man in San Francisco at that time, called me and said, "I got this guy and I want you to meet him." He brought David Kapralik out to the gig. We were playing six o'clock in the morning, after hours. Playin' anything; just wanted to play...And he signed us up and we signed him up....And I can't imagine anybody else that could do us any more good, because he knows how to talk to the straight people.

SMITH: Can a group make it without a manager?

STONE: I believe that all you got to do to make it, if you can sustain, is to just have money to stay together and play. But the problem is it's hard. You gotta have money in order to eat, to have energy to blow and to say what you gotta say....It takes a good manager to show off a *for real* group in its commercial aspect. But if you don't have a manager, then you have to show it off yourself. It's just harder, that's all. But I believe it can be done.

SMITH: The money must be pouring in at this point, right? What's the main thing you're doing now? Another album? Or dates all over?

> I don't wanna turn into the kinda person that because of an extra dollar turned into the kinda person because of an extra dollar.
>
> —Sly Stone

STONE: Doing an album and we're gonna do dates—concerts. And we're getting a lotta money. And it's nice to have a lotta money. My time now is spent figuring out the things that I wanted to do before I had any money. Because I know there are a lotta groovy things to do. I know that I won't, but I don't wanna turn into the kinda person that because of an extra dollar turned into the kinda person because of an extra dollar.

SMITH: Have you gone through changes with all the money comin' in, different than you thought you would?

STONE: Yeah. Well, the values changed a little bit. Ask me that question later, okay? Would you do that?

SMITH: All right. I'd never seen you perform live, and I liked your records twice as much after seeing you on television.

STONE: Thank you.

SMITH: What is that dancing? Where does that come from? Because it's not like you see people dancing anywhere else like that.

STONE: Gettin' together with Larry Graham—I keep mentioning the members of the group because they aren't here, and sometimes people have a tendency to single me out and give me more credit than I'm due. Although I appreciate it and it feels good on the inside, it feels better to distribute it in the ways that I see fit. And for that reason I'm the leader. 'Cause I will see to it that everybody is taken care of. You know what I mean?

Larry Graham is a fantastic dancer...Freddie is a fantastic dancer, man. I can go on and on. Now you got all these people. All you gotta do is get 'em together, inspire them in the right way, and let 'em go. And they won't do anything wrong. And there's no dance style that's followed. There's no name of any dances. When you hear it and you like it, and if you feel like moving, then you move with the way your muscles are designed...I think the closest thing to it is freaking out, really.

SMITH: Do you plan it? Or you just started dancing?

STONE: On 80 percent of the things when we're dancing, it just happens that way. When I start dancing or if Larry starts dancing or Rose starts dancing, somebody else in the group is going to dance, because you get that feeling. And you just do it....Am I answering your questions, man? I have no idea. I'm just rappin'.

SMITH: Dancing seems to have gone out, though, in New York in the big places....Whereas a year ago—

STONE: Because people relate dancing to people that aren't saying anything. And people relate those groups and those artists that don't dance with people that are saying things....People follow trends. It should be a very spontaneous thing...there should be a group of people standing that wanna stand and a group of people dancing that wanna dance. And if that were so, then dancing would not be either in style or outta style. Dancing would just be dancing.

At the Fillmore, they dance. And the people that don't dance, don't dance. And that's beautiful. But there are places where you can't dance,

because if your hair is long and you got pretty nice sideburns and you got a pretty groovy mustache and your clothes are semihip, you can't dance because if you dance, that makes you a Temptation rather than a Cream.

smith: Can you describe the kind of music you play?

stone: It's a combination of rhythm and blues, jam music, psychedelic music, and rock 'n' roll and hard rock and church music, a lot of it, and on and on. There's no bag. I like all of it.

> **It's for real. And if it's for real, somebody's gotta dig it.**
> —Sly Stone

smith: What does the church music part come from? Do you have a background in that?

stone: Yeah, all my life. I used to go to church six, seven times a week, three times on Sunday. My parents still do....Sometimes *five* times on Sunday. So if this happens to you over a period of fifteen years, you remember some of that.

smith: Did you used to play in church too?

stone: I played guitar and bass and drums. And it was happy, man. I'd love to go back.

smith: You've played in front of a lotta different kinds of audiences.

stone: I play in front of anybody.

smith: Is it different playing for an all-Negro as opposed to an all-white audience?

stone: Yeah. Because people expect different things from you by the way you look, first. Before they hear you say anything, they expect certain things by the way you look. Sometimes if we didn't do a tune that was R & B *enough*, there were some black people that had to wait for the next two or three songs before they decided that they'd stay, even. And then there were some primarily white audiences that if we didn't play a tune and got into a jam quick enough, then they would split. You just gotta just go and play and let all those people that are gonna split, split. And just hope most of the people wanna stay.

smith: You don't change what you're gonna do?

stone: You can't. You just go out and do it.

Bill Graham
June 1969

*Bill Graham owns three of the most successful rock clubs in America:
the Winterland Ballroom and Fillmore West in San Francisco, and the
Fillmore East in New York City. He's known to be a magnetic, if contro-
versial, promoter who specializes in attracting huge acts and pairing
diverse genres of music on one bill. Although it's only been open a year,
the Fillmore East is already known as the "Church of Rock 'n' Roll," and
its pioneering sound system and acoustics, designed by Bill Hanley, have
made it a favorite venue for recording live albums.*

SMITH: The Fillmore West—I heard that it's gonna be closing down. Is that
right?

GRAHAM: In its present location it will definitely be closing down, because
the property that it's on was bought by the Howard Johnson corporation,
and they're gonna build another lovely motel there for people to sleep in.

SMITH: Are you moving to another spot?

GRAHAM: I don't know yet. Haven't gotten over the idea of being replaced
by twenty-eight flavors, really. I make a joke out of it now; it's not really
a joke. It's like being asked to leave your home. It's not just a business
with us. I mean, it's a business—we make a lotta money there, employ a
lotta people, hopefully present a lotta good music, and have a lotta people
enjoy themselves. For a thing like that, it's like somebody hitting you.
Life hits you below the belt a number of times. And you get up and it hits
you again and you get up and it hits you again and you get up. And once
in a while, you get a *real* kidney punch. And you don't get up so quickly.
That's what this is. It's the first one I've ever been through. There've been
a lotta punches but this one hurts. I don't know what I'm gonna do, really.

SMITH: Do you have the energy to start up again like that?

GRAHAM: That's one of the questions. It's the energy, the desire, the chal-
lenge. It leaves certain scars. It's business, as anybody who's in it is
aware. It eats at you. You have to be a volunteer madman. You can't just
be an involuntary maniac. You have to have maniacal drive and pursuits.
It's not that you want to beat the other man. You live in an eat-or-be-eaten

society, the business of entertainment and agencies and management and equipment and musicians and artists and technicians. The business end of it is the ugliest business I've ever known. I don't know if there is a dirtier, not ugly, *dirtier* business. I don't know if any business has more shady characters in it. Maybe the underworld, which I don't see....But in order to fight for the permits and the police department and the sanitation department and the building inspectors, my main concern really is what would happen to the people that've been working with us all these years in the Fillmore, and the people who have been comin' there all these years. I would feel much more at ease right now in making my decision if I knew that when this particular location goes out next year, there is another place that will carry that on. Not because we've done such a great job, but I think San Francisco or any town needs one like that. I'm talking about *a* Fillmore, the adjective, whatever you wanna call it. But if it serves the function that we've tried to serve, and if it has someone to run it, that someone is never gonna win a popularity contest. You need those two ingredients. If you win it with the heads, you're gonna lose downtown. If you win downtown, you're gonna lose it with the heads.

> **I don't know if there is a dirtier, not ugly, *dirtier* business.**
> —Bill Graham

SMITH: How do you mean?

GRAHAM: When I renew my dance permit, I put on my suit and tie and go downtown and get my dance permit, because it's easier than going down: "Hey, like, dig it—turn it over to me." Because it may take me a half hour the other way, I put on my shirt and tie and it cuts out all the bull. The end justifies the means there. I put on my shirt and tie: "Hello, chief. How are you? Best to your cousin. Good, thank you very much." I go back, I take off my suit and put it in the closet for another year, and I do *my* business. Well, if I'm seen going downtown with my shirt and tie picking up my permit: "Hey, look at him, man, Mr. Cop-out." "Okay, later." I don't have the time to explain to you why I've got a suit on today. And then you have the man that I used to work with in an office before I got into this, when I used to wear a shirt and tie. Now I dress comfortably. I don't wear beads or way-out frocks, but I dress for comfort and sometimes I let my hair grow long and don't shave for a week or two. He says, "I know you when you used to dress the way I did. But now you gotta fall in with those people that come to your place so you can look like you're *in* with them...But we know where you're really at, Bill. Like, three days on the

THE SMITH TAPES

beach and then on the weekend you just open up your psychedelic haunt and make your dollar." The man has to accept the fact—so long as he can look himself in the mirror, that's the important thing. And I can.

smith: You said the business is very dirty business. And your reputation is very interesting. On one hand, you're considered a really tough cookie. And on the other hand, you're known as a very nice guy. And the two don't seem to go together.

graham: The eat-or-be-eaten philosophy of American business, or the capital way of doing business, forces you to be on your toes. I would love to be able to negotiate amicably with all the agents, with all the evil necessities of the industry. It would be nice to tell a musician all the time, "Hey, cat, nine o'clock you're on. Groovy." And the first day he comes in at quarter to ten, and the next day he comes in at nine o'clock but he forgets his axe. I ain't a nice guy because the public is out there and it has to put up with your crap because *you* have no respect for *it*. I *do*. The end result may be that you will get there on time out of fear for my tirade. And you may leave not thinking the world of me. But again, it's like the man downtown and the man on Haight-Ashbury. I have a job to do.

smith: How about in dealing with agents? Is it as terrible as it seems to be? I mean, is it dishonest?

graham: No, it's a little worse. It's taken a few years for the agencies to realize that the breed we're dealing with now, the rock 'n' roll musician, isn't just like the guy who's been studying violin for ten years. It's not Charlie Spivak or Phil Spatone and the Argo Orchestra. You're dealing with a lovely, insane madman like Mike Bloomfield, or a beautiful, lovely guy like Eric Clapton or Paul Butterfield or the [Jefferson] Airplane. But there are some—like, the Grateful Dead have to be the most insane group of people in rock. I'm involved with them. I love them like my brothers. But, you know—we have plane tickets to go from San Francisco perhaps to Los Angeles, and they get up in the morning but instead of going to the airport, they rent cars, because "It's a nice day today so why don't we drive?" They forget it's an afternoon gig and they get there when it's over. Well, there was a slight oversight somewhere. And it shouldn't be tolerated, and sometimes I do, because when they start playing they blow my mind. They blow a lotta people's minds. They're great musicians. So you take some you shouldn't.

I got away from the agents. Slowly, very slowly but surely the agencies or the heads of the agencies are beginning to realize that you cannot deal with the rock 'n' roll people in the industry the way you dealt

with the touring bus Norman Granz Jazz at the Philharmonic days. These kids are not earning two, three hundred a week. They're earning $10,000, $15,000 a night. But they're doing it after one year or six months. A year ago strummin' along in a coffeehouse, today a couple of hits, Ed Sullivan, there you are. How do you deal with those kids? How do you feed their ego but don't let them get away with it? How do you talk to them in a way that they don't say, "Down on your knees, boy"? It's very difficult.

The agencies haven't learned yet. They're finally beginning to hire some people…A college graduate isn't enough. A business degree isn't enough. Just having been raised in the Garment District isn't enough. It would be better if the prerequisite was having lived in the jungle, having worked in the gutter for a while, and having a business acumen of some sort so you know how to deal with percentages and know how to deal with shady promoters. You don't learn at Sierra Mountain College how to deal with that sleazy promoter in Puget Sound or whatever, who's gonna *take* the group and *take* you and come in with an eighty-dollar sound system. So the good agent has to know about sound and has to know the PC, the percentages for the group. And by the same token, if the group is going through one of its neurotic trips, how do you talk to them to get them to perform well? Because that's also important if you're a good agent. Not just "Is the house full? Screw 'em. Do thirty minutes. Do your hits. Got the limo waiting for ya." He's a very important man, the agent and the manager.

And you also have to remember one of the dangers of the industry now is some of the managers of groups. The way a manager becomes a manager these days, in many cases, is that half a dozen guys are hangin' out somewhere and doin' whatever they're doin' these days and it's, "All right, hey, let's get together. You're the drummer. You're the guitarist. You're the rhythm player. You, you don't play? You're the manager." And it's okay so long as you're doing local gigs. You're lifting the stuff into a truck and you're goin' down the road to another place. But what happens when you got planes and you got publishing deals and you're talking about points to RCA or Elektra? And these guys are sitting there and they twiddle their wax mustache and they *got* you, man. Because you don't know what they're talkin' about—you're gonna get buried.

So you have people in this industry who haven't been trained to deal with this world. And you got 'em on both ends. You got the fifty-year-old agent who knows nothing about rock and you got the twenty-year-old hippie who was hired as an agent to be able to communicate with the

rock kid…Neither knows enough of the other man's world. So hopefully, you're gonna come along with guys who are good agents, honest agents. You have to be twenty-five, thirty, knocked around a bit. Hopefully he was a waiter in the Catskills. Hopefully he drove a cab. Because when you get down to it, what's the business all about? Some taste, common sense, hopefully integrity.

I was fortunate. I got a very good education in the United States of America. But if you were to ask me, "Where did I learn what I do for a living?," 90 percent of it by working eleven summers between Grossinger's and the Concord, and by taking up to six hours to drive back to New York City and shooting crap in the Garment District on Thirty-Seventh Street off Eighth Avenue with some o' the heavies, by driving a cab in New York City…Playing half-court basketball on West Fourth and gettin' my head kicked in by some great ballplayers who never saw a high school, by putting up with the *muck*!—the atrocities of the Concord dining room, nine thousand people [gorging] down fifty-seven thousand main dishes and then asking you to go into the kitchen to heat up the water, and while you're in the kitchen, they'll do something that they don't have the guts to do when you're standing there: they take their napkin and stuff cookies and fresh fruit in it to take up to their room, which they would get free anyway, but it'd have to be through room service and they'd have to tip the guy. So when you get into that bag, and you learn about people and tastes and mannerisms and dealing with the public, you ain't gonna learn it in no college.

SMITH: Is it possible to be honest and successful and rich?

GRAHAM: If I *had* an analyst and if my analyst asked me that, I would say yes…I get most of the headaches and I get all the credit for what we do. But there are a lotta people involved; it's a pretty big family. It's a good family.

SMITH: But you know what I mean about honesty…I mean the sort of stretching of ethics that goes on in the business world.

GRAHAM: I think you can be honest and come out ahead and earn a good deal of money. Rich? It depends on how many figures you're talking about. I'm not gonna say we, because there is no partnership—the people I work with, I think the remuneration is good. But it's a pleasant dictatorship. I'm honest. I make mistakes but they're not made without, hopefully, integrity. And I made a good deal of money, yeah. I live much better than I used to. Six months ago I bought the first new car I ever had. Until then I had a 1956 Lambretta [scooter]. Now I have this new car and I live in this nice house.

SMITH: What is it?

GRAHAM: It's a 1968 Mercedes. The big one with the roof that goes back. It's a very capitalist car. I want to make that statement. You'd have to kill me to take it away from me. It's a pride and joy for me.

SMITH: Have you made really a lotta money? I mean, if everything stopped for you tomorrow, both places, you could stop forever?

GRAHAM: Yes. If I wanted him to go to a nice private school, then my son could, yes. And I could take the suite next to Jenny's at Grossinger's, yes. The monies that were invested in things that worked out for me were earned in what I do, but the next dollar was through acquisition of stock or real estate or overseas investments or gushing ice cream parlors or oil or shoes or whatever it is. But I have nothing to do with war toys. I want to make that statement so that we don't have a picket line around both coasts.

SMITH: Has money changed you at all?

GRAHAM: Nice questions. *I* don't think so. If there's anything I have to be thankful for to the good Lord, it's that he blessed me with adrenaline, which I have nothing to do with: I was born this way and I can work hard. I've never been sick, which is very nice. And somehow or other, I don't think the money's ever gotten to me. Of course I *live* differently. But my friends are my friends, not because I wanna show the world that I don't forget my old friends, but that they're the same ones that I've had for years and years. I've tried to take care of my family. I have a large one: five sisters. The people I work with—it's hard for me to say, because I'm quite sure it hasn't changed me, except that today when I walk into a restaurant...Even when I didn't have it, when I wanted to eat a good meal, I ate a good meal. But now I can do things which I couldn't do years ago. I've had a bad habit. It's a stupid habit. Even if I didn't have it, if I was sitting someplace and my friend joins me for dinner, I pick up his tab. I have a thing about not owing anybody anything at any time. It's a very dangerous habit to have. Today if four or five or six people join me and I say, "Would you care for something to eat?" and if ten people join me and the bill is eighty-nine dollars, I can pay it. Years ago if two people sat down, I was busted for the week. But I've always picked up the tab. I don't think it was a popularity contest. I never wanted to have the feeling like he sat down and he expected me and I didn't. Oh my God. But the luxuries of life? I have a nice home and the car. The clothing is basically the same clothing. The shoes are still ragged, not because I'm trying to stay with the lower middle class and hoard my money in a pillow...

I'll tell you my opinion of luxury. My old lady and I both work very, very hard. At one time Bonnie was working in the office with me. She's not now, with the baby. But we may work three or four weeks at a clip, day in and day out. And on some obscure Wednesday night I'll get through at nine o'clock and I'll call her. "What should we do? All right, put on your slacks and we'll take a ride to Mill Valley and we'll have dinner." And if we go to the country and have some wine and we order a filet, and if the waiter comes back and says, "Mr. Graham, I'm sorry, there're only two filets left but they are the two specials that we saved for the last nine hundred years and it'll cost you $10,000," I'll say, "Bring it." Because at that particular moment, I want that steak. And man, if you want the world I'll give it to you. That's luxury...The awareness that you can have it is the luxury to me.

SMITH: How about buying groups for the place? Does it go over into that area too?

GRAHAM: The real point we're trying to make, I think, is "Bill, will you pay more than an act is worth relative to its draw?" The answer is yes. We're really saying, if on a weekend when we have Jimi Hendrix and the next group could be Yackamamie and the Putt-Putts, I will not bring in Yacky. I'll bring in someone like Gary Burton, who on that particular bill, isn't gonna—I don't need that draw. And he may cost me X. That X is $2,000 more than Yacky. That's the luxury of a position also. It means that on a weekend when I know I can net five grand, I'll bring in an act where we'll only net three. Am I a nice guy? No.

> If you win it with the heads, you're gonna lose downtown. If you win downtown, you're gonna lose it with the heads.
> —Bill Graham

I'm not gonna lose money; I'll net two less. But I'm very much aware of the fact that it does two things. It'll present a better group to the public, and it'll also enhance the continuing attempt on our part to create an image for *us*, meaning that we present good shows. And we do not misuse the opportunity of an opening act.

SMITH: What's the most you've paid for a group?

GRAHAM: For a night? $10,000 a night.

SMITH: It sort of sticks in your throat.

GRAHAM: Yes, very much so. I would say that being as Jewish a merchant as I am, I would never think of paying an act $10,000 unless I felt 90 percent sure that it was gonna sell out, meaning that we would get our end also. Because I don't like to fall that heavily. I had one bombastic loss on the

coast some years ago and I learnt my lesson. I miscalculated. I made a mistake. In San Francisco we use two places: the Fillmore West, which is a 2,300-seat dance place, and a larger place, which holds four thousand. And we had Jimi Hendrix in the bigger place. In the little place, I didn't wanna just let the rent go. So I had this brilliant idea I was gonna book Buck Owens into the place. And I didn't realize until it was over, until it bombed, that the place used to be known as the El Patio Ballroom, the Fillmore West. As the Fillmore, the kids that come frequent it dig the place. But the Fillmore for the straights has a certain dangerous air about it. You know, "That's the place where they do those strange things and they wear those funny clothes and they look so strange and they're in never-never land." So the straight man—who's straighter than the Buck Owens guy or the Johnny Cash guy?...I advertised, one poster said the Jimi Hendrix at Winterland and we did monstrous business. And the same night we had Bill Graham presents the Buck Owens country western show at Fillmore West and it was a disaster. I realized after, if it had said Bill Graham presents the Buck Owens show at the El Patio or at the Hoochie Club, we would've filled up, because a month later, he went to Oakland, which is ten minutes across the bridge, drew fourteen thousand people. I learnt my lesson right there. It was the only monstrous loss I've ever had. And he got big money.

SMITH: Do you have to make deals for groups? Like you have to sign twice or a manager says...

GRAHAM: If you want this group, you have to take the schlock group? Never.

SMITH: Never?

GRAHAM: *Never.* Let me make something clear. Bring any man into focus in front of me and let him tell you that I made that kind of a deal and prove it to you—I can't blackmail the whole world. Or let any manager or musician say they didn't get what they were contracted for or that they weren't paid or that we owe them something, whether it was a shady deal of any kind, I will give you both Fillmores. No deals.

SMITH: There was some talk that you were gonna start a record company.

GRAHAM: Yeah. We'll have two different labels with our logo and some groups will come out through Columbia and some groups will come out through Atlantic. The Columbia logo is Fillmore on Columbia. And with Atlantic it'll probably be Fillmore West on Mish Mosh or some name....

SMITH: Are you recording right at the Fillmore?

GRAHAM: No. We're using studios in the San Francisco area.

SMITH: Isn't there a recording facility in the Fillmore East basement?

Bill Graham onstage at the Fillmore East, N.Y.C., January 1, 1970

GRAHAM: Yes. That's the people that do our sound—I let them use it for whatever. If any groups wanna be recorded, I have nothing to do with that. I allow them to handle it. It's a sound company and it's their equipment and anybody that they wanna…If Epic or Columbia or whatever record company has a group in on any weekend, if they wanna negotiate with Bill Hanley to run the sound, I have nothing to do with it. The only credit I want is album credit that we cut it live at the Fillmore. But that's not my bag. That's not my equipment.

SMITH: I've heard it around that you're going to open a place in Los Angeles.

GRAHAM: Not true, no more Fillmores. We're not into that business of franchising and having X number of shoe stores. I leave that to Howard Johnson and all the other mercantile organizations. No. Besides, rather than put down a city, let's just say I'm not interested in Los Angeles.

SMITH: On the underground scene, the people not involved in the business, to a lot of those people you have a bad reputation. There's this thing about "Bill Graham is just sucking money off of us. That's all he wants to do." What about that?

GRAHAM: I'm sorry for that feeling, but I'm more sorry for their stupidity. Because I think if any one of them took time enough to sit down and think about what they're saying, or if I had the time, I'd sit down with them gladly, and I'm open to the challenge at any given time...

SMITH: But they say you're exploiting the lifestyle. You charge so much money to get into the places.

GRAHAM: Isn't that ironic that Bill Graham is knocked for making all this money? Is it ever questioned what *Joe Superstar* makes? Let's not mention any names. Take any one of the men who make $10,000 or $20,000 a night. No, let's mention the name. Does anyone say, "Hey, Jim Morrison, why don't you give me some of your money? Hey, Jimi Hendrix. Hey, Rascals. Hey, Simon & Garfunkel." They make a lotta money. They're entitled to it for a very simple reason: they earn it. Your question would be, "Well, if they're willing to play for half, and if a promoter is willing to make half, why isn't that done?" Okay. I'll do it anytime. I'll go you one step further—let the government subsidize my operation. I'd only work for $200 a week, which I need for my family. Gladly, I've lived on $120 a month for too many years before I got into this. But when they say, "Look at what he's charging," I strongly suggest they go to any other city.... We charge three, four, and five in New York City. You go to any operation—you go to Westbury; you go to Cockamamy—it's five, six, seven....

It's the spare change syndrome. And if you talk long enough to the people who are making these accusations, you're gonna see a very interesting pattern. Who are they? Are they people who are earning a living? Are they people who will pay a dollar for something they really want? Are they people who have failed *without* attempting? Are they people who *lean* on society?

SMITH: These people also say the least you could do is have a free night.

GRAHAM: *Free night?* It was tried in New York City. It's a tragedy. Let's take thirty seconds to get into free night. What is free night? Meaning turn your place over to the community. It was done. What did the community do with

> **Because when you get down to it, what's the business all about? Some taste, common sense, hopefully integrity.**
>
> —Bill Graham

the free night? I will keep the boiling level low. Whoever represented the community missed that opportunity and disrespected our position.

SMITH: No, I didn't mean that whole thing.

GRAHAM: I'm talking about there *is* no community spirit. There *is* no community in the East Village and I'll challenge anybody—I'm talking about the community. And if anybody wanted the use of that theater to expose a dance group, a jazz group, films, discussions, a political platform once a week, a town hall...I can tell you about meetings that I've had down there that if you're really open to it, you won't *believe*. It was there. We have it in San Francisco all the time. And it's there to be used for beneficial purposes, for civic functions, for community platform, whatever. But when you tell me, first of all, that I *have* to—uh-uh. If you say, "If you don't, we will," you better shoot me. Because you can't do that, you see. And when we finally agreed with certain members of the community to turn over the place, we were abused. X number of microphones were stolen. Screens were ripped, just for the sake of playing around. The place was left a mess. It's not a sanctuary. The law states you can't *turn on*. That's what the law states—I'm not here to make a moral viewpoint as to what I think. But when you come in and say, "This is our sanctuary; we *will* turn on here," and then the law says to me, "It's your responsibility. You allow them to turn on, we take your permit," I say to you, "We're not here to discuss whether or not grass is good or not for you. Let's accept the fact that it's illegal. Let's accept the *reality* of that fact, not that it *should* be. And unless you curb it, you can't have the place. What am I gonna do? Join you in your fight? Not in that way. You want to legalize marijuana, let's sit down and discuss. How do we go about legalizing the use of marijuana? But don't you tell me you will use us and crush us in your pursuit of happiness. *Uh-uh*.

SMITH: I've heard some people on the scene who feel that it's hard for the so-called community to pull together and put on an event and you're the expert in it. So they wonder why shouldn't you, one night a month, one night a week, whatever, put on a free show for the community.

GRAHAM: Good. Let me tell you about two summers ago in San Francisco very briefly. I was open six nights a week. One night a week I decided, every Wednesday. My shows ran Tuesday through Sunday—the Wednesday night will be free. It was Country Joe and the Fish. I forget who else it was. From nine o'clock to two in the morning, free. Instead of $2.50 or $3, free. By five o'clock that afternoon, I had 3,000 people outside the place. It held 1,500. We let the people in at six o'clock.

There were *10,000* people outside. We let the first 1,500 in. I went out on the steps and I said, "Hey, I'm sorry." I never came so close to being mutilated in my life. "You said it was free. You son of a bitch bastard, I spent fifteen cents getting here on the bus. Who the hell do you think you are?" I quit. Did the same thing here. The record companies wanted to expose a group. They give out free tickets; X number of free tickets go out to the community. They fill the place. There are other members of the community who didn't get the tickets who say, "Well, he got a free ticket; I didn't. Free is free. We want in." Management statement: there are X number of seats. That's what the law says. "We want in! We want in! Might makes right!" *Uh-uh.* You want to break down the doors? You're gonna have to walk over me. It's very simple. You have no right to *assume* that I *must* do anything.

SMITH: So what are you saying? That free doesn't work?

GRAHAM: Sure it works, within a framework. When you're dealing in business, when you pay rent, when you have payroll, when you have technical responsibilities within the building, there has to be mutual respect. Free works if both sides accept certain responsibilities. But you can't get up onstage and take out a knife and just for the hell of it scratch across a table, or take a microphone and throw it at somebody, or leap from the balcony into a seat and break the damn thing. Because it's free? It ain't free. The microphone cost me $176—four of 'em. And when we discussed the platform on which we would have this night, this was done the evening the Living Theatre was appearing there, and here we were, 2,500 people saying, "All right, Graham, front and center on the stage." They say, "We're taking the theater. What do you got to say?" I said, "Well, this is no way of discussing it" and there are 500 of them on the stage, and they give me the microphone and said, "Well, what have you got to say?" I said, "We're never gonna get anywhere with this." "Well, we're taking over." I said, "No." And it started at ten o'clock in the evening and at four o'clock in the morning, and they got to be pushy. I said, "I think I have to explain to you what this theater means to me, which is the only way you're gonna find out what you're gonna have to do. We pay the rent in this theater. We're gonna run this theater *our* way. We will discuss with you the possibilities of working with the community. But never on the basis of threat. But the only way to prove to you that you're not gonna take it this way is to tell you what it means to me. You're gonna have to kill me. That's the only way you can *take* this theater from me." And for some reason or another, they understood that. And on that basis they agreed that the following Wednesday we

would all get together and talk about it. I said, "Let's get an intermediary." They said, "Who?" I said, "Ed Sanders, the Fugs."

[To] make a long story short, I flew to San Francisco, flew back to New York for that particular evening, got to the place at about seven o'clock that night....Food was coming in, bands, the community presented itself—or the members of the community who happened to want to be there that evening. Tables were set up. It was gona be a town meeting. I set up two tables on the stage with eight microphones. Five minutes to eight, Ed Sanders was on the stage; I was on the stage. Okay, let's go. Certain members of the community came up on the stage, grabbed the microphone and said, "This is a lot of bleep. We don't wanna talk. We want a bleep-in. We're gonna eat. We're gonna love. We're gonna *turn on*. This is *our* theater. This is our crash pad for the winter." No, it ain't, mister. No, it ain't. And for the next five hours, I just got off the stage and I sat in the audience. And you know what they did for the next five hours? It was a *mic-in*. Because everybody grabbed the mics and *aaahhh*, yelling and screaming, which, if that's what you booked, is very nice. You want to charge admission? It wouldn't work. But if that's what you booked, okay. I didn't book that. I didn't fly to New York for that bullshit session.

SMITH: I was there that night. I remember at one point there was talk about all the money you've made. You said, "I'll show you my books anytime you want." Did they ever do it?

GRAHAM: No.

SMITH: Would you have shown your books?

GRAHAM: Sure. You want to see it today? I'll show it to you today. You'll see profit. We're entitled. We take the chance every week. Any honest businessman who, to himself, thinks he is giving a fair shake to the patron is entitled to what he makes until the framework of our society is changed. You get the government to support it, I'll run it for you. But make sure I have my soup on the table every day.

SMITH: How do you decide to book the place? Do you book it on your personal taste?

GRAHAM: To a great extent, yeah, but there again, to extend the point, when you're running fifty-two weeks outta the year, there aren't that many *great* acts that every act is gonna be just right. That means 150 fine acts. There aren't that many. But we have to run every week. And I'm not crazy about every act that we bring in. But there's a problem: if you're a once in a while promoter, you wait for the plums to fall.

SMITH: I mean literally, how do you decide? Do you sit down with a list? Do you take *Billboard* magazine and look through it?

GRAHAM: You see, you can't headline a group that you think is great but has no draw. So your headline group has to be a group that will attract a mass, which is ten thousand people on a weekend. And you just pray to God that they're also good. Then you work off of that. The joy of a Jimi Hendrix or the [Jefferson] Airplane or Crosby, Stills & Nash or the Grateful Dead is that they draw, but they're also good. And that's lovely. What's even lovelier is that the house is full—now I can take a plum that nobody knows and expose 'em. A Charles Lloyd or Staple Singers or Clarence Carter, who I think is a fine singer, or a folk singer that not too many people know: Tom Rush or Tim Buckley. But unless you have those *giants* to fill the place, you couldn't book 'em. So the headline, your draw group, has to be a combination of that which the public is aware of and is also good. It doesn't happen all the time. But in the end, how do we book the place? It's personal taste and an awareness of what the public wants and should want.

SMITH: How far ahead do you book?

GRAHAM: Three or four months, depending on the group, depending on where they're comin' from. If I know an English group is coming in the end of July or August, then I'll book way ahead. But I always leave some, because you never know. A star might fall. A group may break. Needless to say, if a group is good, and very, very good, it just doesn't happen. The only slot they can fit in is the opening act, the opening act for Jimi Hendrix or Doors or whatever it is. And they go higher based on mass appeal. Because the end result of your bill has to be draw. The tragedy of non–state subsidy or government subsidy is that everything is based on draw. As great as they are, I cannot have a bill with Archie Shepp, Miles Davis, and Dizzy Gillespie. Great music. One of them can fit in with a Creedence Clearwater. As good as Creedence Clearwater is, isn't it incredible that Miles Davis plays for X dollars a week and Creedence Clearwater plays for X dollars a night? Why is that? Not because one is better than the other. One sells eight million records and appears on *The Ed Sullivan Show*. That's not knocking them. That's just what life is all about.

SMITH: What is your personal taste in music?

GRAHAM: Now I've gotten into rock and blues quite a bit. But until I got into this, I was one of the authentic Latin American mambo freaks of New York City. Very much so. One o' the true die-hard aficionados of Wednesday night at the Palladium and Friday at Hotel Taft; Saturday,

Queens Boulevard; Saturday night, Hotel St. George; Sunday afternoon with the sunglasses and the cardigan jackets. [Tito] Puente, Machito, José Curbelo, [Rafael] Cortijo, [La Sonora] Matancera...

SMITH: How did you get from that into becoming one of the main impresarios of rock?

GRAHAM: The draw. It doesn't draw.

SMITH: How did you get into, literally, what you're doing now? How did that happen?

GRAHAM: I went from a very straight, good office managerial position... Schooling was in New York City and then after school I tried the acting game in the mid-fifties, and I did the circuit like everyone else in New

You're gonna have to kill me. That's the only way you can take this theater from me.
—Bill Graham

York City. Gene Frankel Studios and Lee Strasberg, and I thought he was God like everyone else did at one time in the acting game. And then went to L.A. and to Europe and knocked around like everyone else does who's trying to find their place—in theater, especially. And went back to office managing. Any time I had money I went back to statistical analysis work and time-and-motion study and industrial psych and office management and whatnot. And after a couple years of that, I became friendly with people who were working with the San Francisco Mime Troupe, which is a radical, very talented, very gifted group headed by Archie Davis. And after a couple of years, we needed money. And this was now '65, and we're getting to know most of the other people who wanted to be creative in San Francisco: poets and artists and musicians and cinema people and rock 'n' roll people. And I had the idea of putting on a benefit for the mime troupe in our loft on Howard Street. To make a long story short: Ferlinghetti; the Fugs; Mothers of Invention; Sandy Bull; the Charlatans; Jefferson Airplane; the Warlocks, who became the Grateful Dead; Ginsberg; Peter Orlovsky; casts of thousands...But to this day, it was the greatest thing I've ever witnessed and the nicest.

SMITH: You liked that and then?

GRAHAM: Then we got hundreds of letters and we did another one and another one. Along the way the loft got too small. We had thousands of people up there. I started looking for another place and here in the middle of this ghetto of the Fillmore District was this auditorium which wasn't being used and I rented it the first night for sixty dollars on a Saturday night and rented it again and the guy who had it said, "My lease is up.

Why don't you take it?" It was a little hassle with the landlord and we took the place.

SMITH: When was that?

GRAHAM: [It was] '65, December.

SMITH: If you could change anything in your business, what hassles would you remove?

GRAHAM: A more professional attitude from the musicians, the artists. More respect on both sides, from the audience to the artist. They've learnt that. I'd like to see more respect for his position by the musician, what he is and what he can do in this society, rather than what he seems to be doing.

SMITH: Why do you think the musicians are the way they are?

GRAHAM: On a general basis, too much too soon. And no roots, no dues. Generally speaking—we're not talking about Muddy Waters or Mr. Butterfield or some o' the others. We're talking about Ed Sullivan's child. I saw a group in Westbury. Somebody dragged me out to this Valhalla of hair curl. And there was a group appearing there and the kids—this is in wherever Westbury is—the kids out there and the mothers with the children were throwing beads and gifts, throwing them on the stage, which is their relationship to love. "We love you and we communicate with you." And this one girl came down to the edge and a cop stopped her, and she had this picture of this star of this group. And he took it and kissed this little girl on the cheek. And while he was singing the song, he took this picture, held it up and it was in the round. And he went around the place and showed it so that everybody else could see it. I had to leave. I really had to leave. I either would have vomited or kicked the shit outta the kid.

> **I really had to leave. I either would have vomited or kicked the shit outta the kid.**
>
> —Bill Graham

SMITH: Sounds like Eric Burdon.

GRAHAM: No, it's somebody who is much richer and sells many more records. Needless to say, if that kid didn't do that and didn't make those kinda records then he wouldn't be selling that many records. He probably can't be blamed for that, because that's his ace. See, all he *can* do is shuck. But I'm talking about the guys who are so much better than what they're doing, but don't have to do any better. That's my first choice. There are many other choices but that's my first one.

SMITH: I've been at the Fillmore when you've been booed, yourself. Why does the audience do that?

GRAHAM: I'm sorry—I don't know. Obviously, they're misinformed about something, I think. That makes it sound like they're all wrong. Why are you booed? There are times when I get nasty, behind the scenes mainly, that the public doesn't see. But you have a very spoiled society, and you get things like…Again, no defense, but there have to be certain facts made aware to the public. That if an act does a set—and of course you read *Wall Street Journal* and all your other trade magazines—Graham grossed so much; Graham grossed forty-five. "My God, that act must have cost $200. He netted $44,800." So he's making all this money. Then the act performs and it does two encores and refuses to come back out. I'll go out and before I can say anything, "You capitalist bitch, why don't you just pay them more money? Why can't you pay them overtime?" And you really want to say, "Well, later. I can't explain it." "We want something free!" The booing really comes from a great minority. Again, I'm not saying…

SMITH: No…that's true. It's a minority.

GRAHAM: If one guy says, "All right, Graham, off the stage," or whatever it is. "We don't need you." I am not a performer. I'm not an emcee. I get up on the stage and say here's whatever band I introduce. If you stop me in front of the Fillmore, if you stop me anywhere in the Village, and you say to me, "Spare change?" and I look at you and you are six foot one and you weigh 190 pounds and you don't limp and you don't have any crutches, I will say to you, "What did you say?" And you will say, "Spare change?" And I will say, "What is it? What is spare change? It's money that you don't need. If I didn't need it, I wouldn't have it on me. Are you a cripple? What is the matter, you lowlife scumbag?" And I'll tear into the guy, because I can't help myself. I cannot, for the life of me, understand why a man has to *beg*. Or a girl has to beg. Go out and work. Go out and *deal*. But don't beg, man, because cripples beg and blind people beg. So you take that one kid, the next time he sees me is on the stage of the Fillmore, and he don't like me. And I really don't have too much respect for him. I don't like him? I can't say that, because I don't know him. I know one thing. I disrespect you, because you're not a man. A man doesn't beg. That's only one kind of person that may boo Bill Graham.

The other one is the guy who…Last weekend the band didn't want to play anymore. And I had to go out on stage and say, "Listen, that was it." What do they see? Only this is also the man who doesn't give a free night, and the mother f'ers couldn't get the place from him, and he makes nothing but money, and when we came in we asked for a benefit and he asked us what it was for and we wanted a benefit to raise money to buy

paint to paint the subway stations. I said no, because the reason wasn't valid enough. They hated me.

SMITH: This thing of encores, how does that work? Is it really spontaneous? Like, they go off and everybody is applauding and you say to them, "Hey, do you wanna play another one?"

GRAHAM: Let me tell you about encores. No place is freer about encores than we are. Except for the first show...If you have two shows, the first show starts at eight and has to be over at, let's say, eleven fifteen. That's three hours and fifteen minutes, which gives each act almost an hour. We can't let it overlap when you have three thousand people standing outside sometimes. The second act, we've got until five in the morning sometimes. It's up to the act. It has nothing to do with money. Nothing. But in some instances, with some groups, you get audiences that play a game. They don't really wanna hear the group. You know what they wanna do? "Watch, I bet you we can get them to come out again. Encore eleven, hey, we got 'em. Encore ninety-three." They don't wanna hear the group. "I puts down my money. I gets what I wants." And they're making another human being walk out and serve them. "Feed me more grapes." Sometimes I'll stop that, because you get a feeling for applause and you get a feeling for crowds....With the band last weekend, they *loved* the band. The band played for an hour and they did four encores. Then that was the end of it. We will *never* stop a group from playing. I can tell you—I have a bad habit of getting defensive without meaning to get defensive, just to explain a point—that on the West Coast, we have to hire a certain number of security, the sound people, when we use the bigger place, Winterland. In the minute we run after two o'clock, it'll cost me $400 an hour. I have run till four o'clock, till four thirty, till five o'clock....Until the law comes in. When the law comes in, we have a problem. But we have never, ever stopped a concert because of time. *Never.* But do we go out to the public and say, before you say "J'accuse!" do you ever think? And once you accuse, do you ever give that horrible, nasty, capitalist mother dictator a chance to answer you? You sit up there in your bloody seat and you're knocking the man. What do *you* know, *boy*? What do you really know about this *lovely* business? Very, very little. Because if you did, you wouldn't yell that loud. That doesn't mean I don't like it. The challenge of beating the ugliness is what makes it all interesting in the dirty game.

THE SMITH TAPES

Dennis Hopper and Peter Fonda
June 1969

Easy Rider *just premiered at the Cannes Film Festival and won Dennis Hopper the first-time director's award. He and costar Peter Fonda arrived back in New York City this week and are giving their first American interview about the movie. In a few weeks it will open in theaters across the country and instantly become an iconic film.* Easy Rider *will be nominated for two Academy Awards and make more than $40 million at the box office.*

...

[*The recording begins mid-conversation.*]

HOPPER: Now, we expected to get a certain response from younger people, right, but we didn't expect to get the establishment. But they *like* it. It's all crazy. So many different types of people like the film or respond to the film, whether they like it or not.

SMITH: You mean even the standard Hollywood producer?

HOPPER: Right, suddenly saying, "Hey, you kids made an art film and it's commercial and we don't believe it, but it's happened!" We sort of look at each other and say, "Wait a second. What happened?"

SMITH: You've been co-opted.

HOPPER: Yeah, we've been sucked in.

FONDA: I don't feel sucked in yet.

HOPPER: Let's say they got the hook in our mouth and they're pulling us into shore.

SMITH: A lot of offers now?

FONDA: The same offers, just the money's gone up.

HOPPER: People that snarled at you before are now patting you on the back and handing you things.

FONDA: It's still all baloney. The type of material that they offer is all unreal and all dishonest.

SMITH: What was it like at Cannes?

FONDA: There's two different stories. Dennis stayed for the whole time; I made it for three days and then really freaked out and ran. But it was like a big dentist convention. The films themselves are great to see, but they had booze in the lobbies and they were hawking their wares. And I would go down and hear "moo." I thought, "Wow, I could walk through that door, someone'll hit me over the head, I'll be drawn and quartered and sold as hamburger".... All those people around me selling and buying. It freaked me right out.

HOPPER: It was a nightmare.... There are thousands of photographers following you around like birds of prey screaming out at you, "Dennis, for me now. For me now." I mean and there's so many "for me nows".... You just say, "Wait a second."

FONDA: I ran.

SMITH: Why did you produce the movie yourself?

FONDA: Why not?... I wanted to be the man between the film and the establishment so that I could at least know that mistakes made were *our* mistakes and that we had our chance to do it our way.

HOPPER: This is unheard-of in Hollywood...that you can get a cut of a picture, that you can do what you want to do, that you don't have to have constant meetings where you discuss "Why was this line changed?" rather than being able to feel free enough to say any line you want in front of the camera.

FONDA: It was fun to do it this way. To have our own shot at it. None of us took any money for it; we all did it for nothing.

> **I could at least know that mistakes made were our mistakes and that we had our chance to do it our way.**
>
> —Peter Fonda

SMITH: If you stay in the business end, as a producer, can you stay honest?

FONDA: You can. You run a great risk of alienating the rest of not only your partners, but the rest of the business that you have to deal with. As a producer, I can't distribute the film. So I have to deal with a distribution outfit like Columbia. Now, they've been very groovy to us. I know other people who *aren't* that I wouldn't be willing to take a chance with. I don't have to act if I went and found a film to produce and somebody else could act it out. I would like the challenge of producing and keeping the establishment away from it.

SMITH: What I meant, I'm talking about ethics.

FONDA: I get my kicks from acting. And from thinking up ideas and rapping story with Dennis. As a producer, I've got no kicks. It's just that I

feel relaxed, because I know that it's my company making the movie. Not somebody else's company that I don't know what's happening underneath the table.

SMITH: Did you come out with your morals intact or did they bend?

HOPPER: We didn't have to compromise. The reason that Peter was producer was so that we wouldn't have to argue with anybody, fight with anybody and compromise. A producer has the final say and so we made a situation where we had the final say.

SMITH: Did you have any trouble while filming similar to what was in the plot of the movie?

HOPPER: We had a couple occasions that it got pretty rough. The only thing that really saved us was that there were twenty-three of us. And, like, suddenly when the whole restaurant stands up, they realize that they better just cool it. Or at one point they literally kicked all twenty-three of us out of a restaurant. And brought guns and took out clubs and said, "Get out."

Another instance: We were in Baton Rouge, and we stayed overnight in a place called the White House. We didn't know at the time, but [it's] where all the Louisiana senators come. Next door were playing the Vanilla Fudge and we rushed over to see the Vanilla Fudge. We saw all these beautiful young teenagers, came up and said, "Oh, look at your long hair, wow. We'd really like to grow our hair long but our parents…But we will when we get outta school." You know, really beautiful kids and a beautiful concert.

We went back over to eat and came in and all these senators who had been drinking started whistling, said, "Boy, is it a girl? Hubba-hubba." You know, all nonsense. And we were sitting at a big table and finally this one senator came over and said, "What do you people do?" "We're from Los Angeles." "Oh, friend of mine, Bob Kennedy, was just shot out there. And now that damn Rockefeller's suggested that he's going to put in some nigger in Kennedy's place." He says, "I'll tell you, if that nigger ever comes down here, we'll shoot him." And I said, "Would you get your hand off our table?" I said, "First of all, Bob Kennedy was never a friend of yours, with that attitude. I can't believe that. Get your hand off our table and get outta here." He says, "Who do you think you are with your long hair, Jesus Christ?" I said, "No, but I'm director of this company and I want you to get your hand off my table." He says, "I'm a senator of this state. I'm a powerful man! *I don't care if you are Jesus Christ. I'm not afraid of you.* You understand? I've got power." And he's screamin', "Tell them who I am!" And a coupla big bodyguard types just

took him off screaming—and, like, you adjust to this and you say, "Wait a second. I mean, is this guy really saying all this?"

FONDA: He said it all.

HOPPER: I mean, can he hear himself? Can he hold a mirror up and look at himself? It's such a contradiction of everything.

SMITH: Were you nervous after seeing that?

HOPPER: Actually, I get much more relaxed. I mean, at least you confront it. But to see all these beautiful kids, and they really wanna live and they have none of this uptightness and they really *feel*—and then you wonder what happens in the next five or ten years to these kids if they become that. Let's hope that they don't. But, you know, where does the change come over?

SMITH: You take a very pessimistic view in the movie. Is the country in that bad a shape, you think?

FONDA: Yes. Do you think it isn't? We have fantastic things happenin' here too at the same time. Probably this is one of the freest countries I know. Maybe Sweden and this country, but—

HOPPER: The herd's uptight.

FONDA: The big herd is uptight. I think we reflect it honestly, not only this southern part of America, but the northern part of America. We could've shot the Algiers Motel incident—it's the same gig whether it's taking place in Louisiana or in Detroit. I think it's an honest appraisal of a certain part of America, a certain attitude America has. I also think that we photographed America beautifully, because we happen to think that as a country, not as a political entity, it's a beautiful place. No, seriously. You guys here in New York, all you see is these buildings and the movies that we send in to you. You know what I'm saying—

HOPPER: We wanted to make a movie about what was going on at this moment, and the experience of traveling across country *with long hair*. You realize pretty soon that it doesn't have to do with whether your skin's black or whether it's brown or whether you have dark eyes or blue eyes or blonde hair or whatever—anything that's different from that herd that keeps talking about themselves as "free individuals." Well, the line in the movie…They talk about free individuals, but when they see a free individual, it scares them. And Billy's reply to that is, "Well, it don't make 'em runnin' scared." And Jack [Nicholson] says, "No, it makes 'em dangerous." And I think the herd is getting dangerous, because they don't admit to themselves they're a herd. They don't admit that they really wanna dress alike, wanna look alike, think alike, love alike, and have

children that look alike. I mean, they all wanna be alike and yet they keep talking about this free individual that they are.

SMITH: Isn't it a basic psychological thing that people are afraid of people who aren't like them?

HOPPER: And yet, you look at the beach and you say, "That's beach." And you look at humanity and you say, "That's humanity." Maybe every individual piece of sand in the beach says, "I'm an individual piece of sand," but, like, it's really just beach. Humanity's humanity, but every human being says, "I'm an individual." But basically, we need each other constantly in every sort of way, just like a herd of animals. And so you go into a little town and the cows send for the bulls and the bulls come and take care of whatever is interfering with the herd.

FONDA: And the herd is in danger of extinction, or so they tell me.

HOPPER: Or so they feel.

SMITH: What's the answer?

FONDA: What's the next question?

SMITH: It's been like for this for a long time.

HOPPER: We never made any answers. That was one thing about the movie: we tried not to make answers. We tried to just present questions and say, "Why is this going on?" I think it would be presumptuous of us to *answer*. I think the first thing to start with is to accept the *reality* of what it is....I'm as free as the group of people or the group of animals that I'm involved with. I can't

> I said, "No, but I'm director of this company and I want you to get your hand off my table."
> —Dennis Hopper

go out and make a movie by myself. Peter can't go out and make a movie by himself. We could interview each other but, I mean, it would be ridiculous. We need you. I mean, we all *need* each other....And they need us. We may have individual ideas, but they have to become collective the second that we tell another person, because already you're telling another person means that it's not just enough for you to have those ideas or to make a movie. You don't make movies to show to your friends in a little room, and even if you're doing that, you're trying to show your idea to someone. But you wanna show it to as many people as possible.

But I think when people start realizing that they need other people, that's a step. Not that they need other people to shut people out or to put down other people....That's what the movie's about. The movie's about that group who refuses to allow anything different than its own self to come in, whether it's long-haired hippies in a commune, or a

business type comes in and suddenly surrounded by antagonistic hippies. Or whether it's long-haired hippies who are surrounded by antagonistic short-haired southerners, northerners, Russians, Chinese....It doesn't really matter. It's a question of the *difference* of a group not accepting other things, other ideas, other people.

[Constantin] Stanislavsky said something which I think applies to the film and I always hoped that it would apply to the things that we would make eventually. He's talking now about Moscow, but the times haven't really changed. He's saying that you could go see a great musical comedy and feel happy, and you go out to a cocktail party after and say, "It's great," and forget about it and never think about it again. But when you go to a great tragedy, or something that has meaning or something that reflects life, you *can't* get away from it. You go out to the cocktail party and you're still *troubled*. Or you say, "I've got to see it again, because did that really happen?" I mean that kind of thing that gets into your subconscious. And I think that *Easy Rider* gets into people's subconscious, whether they like it or not.

I've heard business types saying, "Well, it's a good movie, but I'm not those guys in the truck who kill you." But yet, in their mind they're trying to put themselves in and the only place they can put themselves in is either in the restaurant or in the truck, because they can't put themselves on the motorcycle.

FONDA: And they refuse to put themselves where they really are: buying the dope from us.

HOPPER: But, you know, you've got to remember...that *we are* the people in the truck, as well as the people on the motorcycle. I mean, the parts are interchangeable.

SMITH: You made an awfully angry movie and now it sounds like you're making nice or something.

HOPPER: No, I don't mean it as a nice thing. I mean it as let's look at it as a full, rounded thing.

We wanted to rattle the cage and we wanna keep rattlin' the cage.
—Peter Fonda

FONDA: We wanted to rattle the cage and we wanna keep rattlin' the cage. We don't need to be nice about it. The comedy that we have is human comedy; it's divine. To laugh at that, it's great.

HOPPER: And the tragedy is a total tragedy of this country. Not just the tragedy of the two guys on the motorcycle, but also the tragedy of the guys who shoot them in the truck.

John Mayall
July 1969

John Mayall's Bluesbreakers has acted as a finishing school for British rock guitarists, in which Eric Clapton, Peter Green (of Cream and Fleetwood Mac, respectively), and many others have perfected their craft. A case in point: Mick Taylor, the band's latest lead guitarist, left two months ago to join the Rolling Stones. Ever evolving, Mayall quickly assembled new musicians in search of a new acoustic sound. He's in New York City to play two nights at the Fillmore East, and tonight's show will be recorded live and released as his seminal album, The Turning Point.

..

[*The questions from the original interview reel were edited out by Smith in 1969; only Mayall's answers remain.*]

The whole purpose of blues is that it is storytelling, you know. The only difference here: this is my first attempt—on record, anyway—to put an *extended* piece, like in the concept of a novel which would have different chapters in order to tell one story, and *this* sort of idea behind *that* one. Rather than the traditional form, which has usually just been one number which would say a story. The *Bare Wires*' story is the story of my breakup of marriage. The thing about all the pieces on that *Bare Wires* suite, they're all traditional blues forms. I mean, they're basically all twelve-bar blues. They're just served in a new way, point of view about things, because blues isn't a thing which is necessarily sad or despairing; it's just a unique form of American music which encompasses great happiness, great everything. The extremes of any feelings.

But I don't know—you say people are going around in a sort of suicidal state or something, but I think most of that's due to drugs. I think if any person can know himself, you know, without use of drugs or *any* kind of stimulants, just be himself and face life and learn about himself. There're many messed-up people. It seems like drugs is one of people's way out of things, an escapist thing, and it's very easy for people who avoid issues to place the blame somewhere else for their own shortcomings.

I didn't start playing professionally until I was thirty and [had] four kids. That's dedication, you see, a wife and four kids there. But with

being a musician, particularly in the thing of blues...in order to experience everything life has to offer, you have to be free. It's a selfish kind of thing, in a way, so that without planning anything, you can just be free to explore anything that comes up, whether it be to do with the places you could go to, or just free to move around and *observe* life and observe people and observe how you react to them yourself.

Well, this is the thing that *gives* you the freedom—this is the life of a musician. And a musician is not, in the traditional sense, a person who is a star or anything. In the olden-day concept, he's a minstrel. Somebody who says things in music to and through the people. He's just one of them, you know; he's just a spokesman of some sort. And to tell you, you belong to the people. You know, you shouldn't separate yourself from the audience, because communication is the whole thing.

The only playing I ever do is with the musicians that I pick to work with. It's not like I have an act or anything or a show that I do. You get most of the groups who have a set act and they do that, and what they like most is to go somewhere with other musicians and jam. But that's in essence what I do all the time, because that's what it is. You...just find someone you can communicate with without even saying anything. I think understanding is probably one of the most important parts of it. Everybody is what he is and it's all a voyage of discovery.

Music's been around me all my life, through records. I started listening about 1947 and started playing around that time. My father was a musician as well. He played guitar so he had an extensive jazz collection from the twenties. So even as a kid in the house, any sounds that I'd hear were Django Reinhardt's entire works and things like that. Louis Armstrong. But the thing that first got me into it was boogie-woogie Albert Ammons and people like that.

Well, the blues is a personal release. It's an outlet for anything that might be on your mind. Like if you're feeling happy, then you just go to an instrument and you express it, because that's the way you feel. It's only a link, really—it's an outlet for whatever you're feeling at the time. And luckily, it's a form or has a tradition behind it, that it's done all these things and it lends itself to anything. Because it's basically just a "nothing" form: just about three chords in it and that's it. But there's so many permutations....The form itself is nothing—this is why so few people can play it. You can't, sort of, *learn* it. It's something that could never be a big craze or something. So everybody who tried it sounded good, because it's...As a form it has nothing; it's what the person puts into it, you know, and how much the person has a knowledge of it.

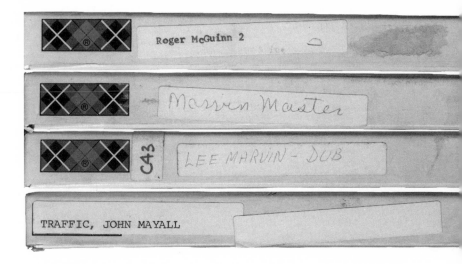

I think basically it's a different audience. Whereas before, a pop audience was the same audience that would basically appreciate all of these groups and be the audience for each of these groups, I mean, there were far more hysterics on the thing in those days. But since this blues thing has produced some great musicians who are operating now, I think the audiences that we've collected together come from a different background and they're not the same type of people as they used to be. They cover a wider age group, and they're sort of a selected *best* type of listening audience. They're a more understanding audience. There's almost classical music reverence, rather than screaming and tearing people's clothes off. There's a great deal of respect attached to it.

Arlo Guthrie
August 1969

At just twenty-two years old, Arlo Guthrie is already a prominent voice within the East Coast folk scene. The title track of his first album, "Alice's Restaurant," was a hit, and earlier this year the song's autobiographical tale was made into a film, with Guthrie playing the starring role. The next several weeks will change his life: Alice's Restaurant *will open in theaters and make over $6 million; he'll play a set at Woodstock; and he'll get married.*

SMITH: Do you like acting?

GUTHRIE: I didn't like it at the time. I didn't like to get up at six in the mornin' and work until eleven at night; that was stupid. But I got into it, as much as I'm ever goin' to....But I don't wanna be an actor.

SMITH: What do you want to do, just sing and write?

GUTHRIE: No, I just don't wanna be an actor. I'm a musician, really, in my soul, and I would dig to do that.

SMITH: What was it like making a movie up there? I know that area pretty well.

GUTHRIE: It's beautiful. I kind of guess it was like doin' a job, but I've never done a job so I don't know. I suppose it was the same thing. You get up and you do it and the guy tells you what to do, but it was more fun. I mean, all my friends were there and we got stoned a lot. It was great.

SMITH: Was it all true?

GUTHRIE: Well, a movie is never true and neither is a song. It was like a documentary of a fictional thing. It was somewhere in between and that was what was nice about it....On the whole, it comes off like a real thing. You could believe.

SMITH: How did the whole town take the movie bein' made?

GUTHRIE: Well, at first they were opposed to it, I guess, because they didn't want a story glorifying the garbage incident or makin' fun of Obie or makin' fun of the town. But I think they got into it. I think they were really interested. I know they want to see it. I don't think it really matters what they think of it, like it doesn't matter what an audience thinks of a song.

SMITH: It doesn't?

GUTHRIE: I don't think so.

SMITH: What matters?

GUTHRIE: Whether the guy that creates it thinks it's good enough or whether it's groovy to him.

SMITH: Does it bother you when you write a song that you really dig and it doesn't go over, people don't respond?

GUTHRIE: It hasn't happened. I haven't written that many songs yet. It's hard to tell for me too, because I just kind of get up and if nobody likes it, I don't really get concerned. I go on to something else. I mean, like, a concert is not just individual songs. And I think in terms of concerts as a whole or performances as a whole. It's always more or less worked out—

SMITH: Have you gotten tired of doin' "Alice's Restaurant"?

GUTHRIE: I haven't done it for about a year and a half, or two years maybe.

SMITH: When you do a concert, is that still what everybody yells out and wants?

GUTHRIE: I don't really care, man. People come to see what I'm doin', I think, not what I've done. I recorded it so I wouldn't have to keep singin' it. I didn't want to get into records and all that stuff; I just wanted to sing. But I had to put 'em down, because otherwise people just want to hear the same thing again. So I think everybody that's really dug it has heard it enough. I mean, I've heard it enough, anyway. I'm not about to sing it anymore.

SMITH: Are you makin' more records now?

GUTHRIE: I just finished one, just about. I don't know what I'll do after that. I want to get into music. I'm tired of rappin'. I'd like to get into spontaneous music as a science.

SMITH: Spontaneous music as a science?

GUTHRIE: Yeah, like not being there, lettin' it come through.

SMITH: You mean not writing it out?

GUTHRIE: No, it's not possible to really do that. Although I think that's also spontaneous when you write. It's just a different kind. But the thing about writin' is that you tend to want to do it again and again. I'm not that much into classical forms, like I don't wanna write although I love to play classical music or things that sound classical, progressions. But I'm not an innovator in that area so I don't get into it; I just do it for myself. You know, I would dig to try to get into it a little bit on stage, try to get into just bein' spontaneous sound in terms of the people that are hearin' it are no longer hearin' you, but hearin' what is goin' through you. And I think that's more important.

SMITH: I'm not sure I completely understand you.

GUTHRIE: Yeah, I'm not sure I do either. I know what I do best and what I do best is spontaneous, when I do things just out of my head. I know that they're not really comin' out of my head; they're comin' from other sources that work through me. I would dig to be able to let them work more freely.

SMITH: What do you mean by other sources?

GUTHRIE: Well, man, I don't know. There's a whole lotta world out there. Other sources in terms of my voice. My voice is mine. My body is mine. But a body is just a place. There's a lot in there. But my own body is made up of a lot of different people. I would dig to get 'em all comin' out. I would want to get my body moving and vibratin' with all the things that are possible.

SMITH: Do you still see lyrics as part of what you want to do?

GUTHRIE: Not forever. The reason I use lyrics now is because I'm not confident enough just musically. I'm writin' songs now; I'm not writin' music. Songs is not music and words, but a together kind of thing. It's like a lot of people take Dylan songs and take them into schoolrooms and study words and stuff. I don't think that's really where it's at. I think a song should be, or is, words and music that are inseparable and they should say the same thing. You know, I would dig to do that without words. I would even dig to do it without sound.

SMITH: Then what would you be doing?

GUTHRIE: I think I would just be *being*, really.

SMITH: What, sitting in front of an audience and *being*?

GUTHRIE: Yeah, but it would create a *being* there also; the audience would be *being*. I mean, everything would just be *being*. I'll do it. I know when I'll do it too. I mean, I'm not just rappin'; I'm not freaked out. I'll do it when I'm seventy-two, man. That's a long time, but I guess it's worth it.

SMITH: How old are you?

GUTHRIE: Twenty-two.

SMITH: What's your status with the draft?

GUTHRIE: 4-F.

SMITH: What kind of a scene did you have down there? Did you do it at Whitehall Street?

GUTHRIE: I got out at Fort Hamilton. I had a notice of induction, said come on down and bring the whole bag with you in case we want to take you. Then I got really uptight and said, well, no, I don't want to go, right? I started sending letters—man, you wouldn't believe how many letters I wrote. I

went to shrinks. I said, "Shrinks, I've been copping acid all my life. I'm a drug fiend. I'm a schizophrenic. I never did any good in school. I hate my mother." And they didn't believe me…They sent me a letter and they said, "Your induction is postponed. You'll have to have a confrontation with the shrink." What was it called—a "psychiatric consultation," right? So I went down there, and I walk in and I say, "Okay, where's the shrink?" They say, "He's not here. You'll have to take a physical first anyway, so why don't you just do that and then the shrink will be here." I said, "Well, no, the letter says come down for a psychiatric consultation. That's what I'm here for. If you want me to take a physical, you send me another letter." So they send me over to the head doctor and the guy says, "Listen, son, I'm the head doctor here and what I say goes. You got that?" I said, "Okay." He says, "Now, you are gonna take a physical, right?" I said, "Nope." He said, "Well, this is against the law. When we say take a physical, you gotta do that."

> **I don't really care, man. People come to see what I'm doin', I think, not what I've done.**
> —Arlo Guthrie

And I said, "I'm not gonna take it." He says, "Hmm. Okay, I'll send you up to the top guy." They send me up to the head of Fort Hamilton, who's a little old Gabby Hayes type, right? Beautiful. He doesn't really care, man, he's not interested. He said, "Okay, I understand. Why don't you go down and watch TV?" So I'm down there watchin' TV, I got my cowboy hat on, and *The Beverly Hillbillies* is on TV! Everybody's lookin' at them and lookin' at me and I'm freakin' out. Finally, an hour goes by and I go down and I say, "Listen, can I go? The shrink's not here." They say, "The shrink just walked in." So I go to this shrink and he says, "Son, take off your hat." So I took off my hat. He says, "What's your name?" I told him my name. He says, "How old are ya?" I said, "Twenty," because I was twenty. He said, "Okay, how old are you?" I said, "Twenty." He says, "All right, how old are you?" I say, "Wait a minute, man—I'm twenty." He said, "Okay, okay, just checkin'. What do you do?" So I said, "Well, I write songs and I sing 'em." He says, "Are they of social significance?" So I said, "Yeah, some of 'em." He said, "Okay, go home." But I knew, I mean, they put me through another physical. This big spade cat comes over, takes me by the arm, pushes everybody out the line….I had the fastest physical in New York history, right? They pushed me through, everything got shot and hit, and the whole thing took two minutes. I went down to the head doctor again. He says, "Okay, it's my duty to inform you that you are unfit for the military service at any time." I was about ready to say, "Great!" but I

thought maybe it was a trick, right? I was gonna start shoutin' and then he goes, "Aha! Get back in there." I didn't say nothin', I just looked at him, and he said, "Okay, go."

So I got dressed and I started goin' up the stairs, and I figured any moment now somebody's gonna be callin' me back. I knew they were just foolin' me. And I'm walkin' out the main door there and I had to go past all these guards....And I get to the door and I'm pushin' the door open and I'm waitin' for someone to come runnin' down the hall sayin', "Wait a minute!" I get outside and nothin' happened. I'm waitin' for somebody to come runnin' out the building to stop me. I get in my car and I look in the backseat; there's nobody there. I'm drivin' out of Fort Hamilton, man. Nothing's happenin', and I get to the gate and I knew that maybe the gate guy was gonna say, "Turn around. Get back in." I really thought that. Just to make sure, I stopped at the gate and asked the guard for instructions about how to get home, and I knew damn well how to get [out], I just wanted to talk to him, make sure he had nothin' to say to me. I'm drivin' down the road, eighty miles an hour on the Belt Parkway, waitin' for a cop to pull me over. I wanted to tell somebody that I really got out. I just had to tell *somebody*. And I'm just speedin' down the road waitin' for a cop to pull me over, give me a ticket, give me anything. The world's changed a different color. I'm goin' home and I'm never gonna have to worry about that stuff again, man—too much! Then I got home and they didn't believe me. They said, "No, man, we'll have to wait until it comes in the mail." I waited a couple days and it came in the mail and said I was 4-F. It was great.

You want to know something nice, though? When we went down to Whitehall Street to do some of the movie out front and some interiors, we got there and I recognized some of their faces, man. The *same bastards* who, like, two years before had put me through all them changes at Whitehall Street. The same guys, man, with the southern accents and the whole trip, said, "Could we be in the movie?" And I said, "Sure. *You* just be there. *You* walk up and down the stairs and *you* stand over here and *you* sit over there." And here I am tellin' 'em all what to do, man, and it just freaked me out. The same guys that made me wait an extra hour until a whole new bunch of guys came in and they finally gave me my stuff back. They just held me up and they were bein' shitty about it. They just all came back: "Can we be in the movie?" And I wanted them in the movie, because I thought it would be good for 'em. I thought it would be fun for 'em. And they're there: they were walkin' up and down the stairs. That's

gonna be fun when they go see themselves. That might do something for 'em. I don't know what.

SMITH: The movie stressed a lot your father slowly dying in the hospital. How many years ago did he die?

GUTHRIE: Not quite two.

SMITH: And the name of the disease?

GUTHRIE: Huntington's disease.

SMITH: What are the chances of you getting it? It's a genetic thing, isn't it?

GUTHRIE: Fifty-fifty. I'm not gonna get it, though.

SMITH: How old was he when he got it?

GUTHRIE: Well, you can't tell that either, because it's not how old you are when you get it, but how old you are when it becomes recognizable. It became recognizable about fifteen, seventeen years ago, maybe. It's hard for me to tell, because I wasn't around, or if I was, I was just kind of small.

SMITH: Your parents had split up, right, when you were a kid?

GUTHRIE: Well, my old man went into the hospital. You know, they were split up and then they came back together again. They were both artists and they went through the scenes together. He was payin' for some things he had done in some other lives, finishing up. That was his last time on earth. He's not comin' back anymore, because he made it and that's groovy. He was just finishing up some karma, makin' himself pure. That's what it was. So I don't feel bad about it at all; I think it's just beautiful.

SMITH: Did you learn to play from him?

GUTHRIE: Well, he gave me my first guitar but my mother taught me the first chords I knew. He taught her some chords and she taught me. Maybe he did but I don't remember.

SMITH: Is the church still going?

GUTHRIE: Yeah, two days ago I was up there....

SMITH: Did you know Louis and Bess Fowver? Owned the little antique place right around the corner from there? I heard he died last winter. Guy was about ninety, he said to me, "Something funny happenin' around there, Howard. I don't know what's goin' on but some people took over this church."

GUTHRIE: Well, it was so beautiful to grow up there, and the best things I've ever written I wrote there. It was just a beautiful place. And it's still beautiful and the movie doesn't do it justice in that sense. I mean, the movie shows how things... The movie is kind of like readin' the *I Ching*. You see a progression of things that are seemingly unrelated and how things work, how things change. But the movie stops and life goes on.

And they're beautiful people, all of those people, man, no matter where the film's at. You know, in that sense, it's to be separated from the reality of that. I mean, it's just a movie, and the real life is still goin' on and those are all, you know, people tryin' to do their thing. They're all beautiful.

SMITH: How long did you live up there?

GUTHRIE: I didn't live up there. Well, maybe I did—I had all my stuff up there a couple times. I was just in and out, all the time. I was livin' down on the street, MacDougal Street, for a while and I got tired of the city and gettin' dirty and all that and went up to the church. I hung out, took my chicks there, wrote my songs there, ate there, and stuff like that. It's off and on, man, for the last few years. You know, I haven't been up there for a while. There was no need for it.

SMITH: About the arrest in the movie—did that really happen?

GUTHRIE: What, gettin' busted for litterin'? Yeah.

SMITH: That part of it's really true?

GUTHRIE: Yeah. The funniest scenes were true.

SMITH: Have you been arrested any other time?

GUTHRIE: I get harassed a lot but I haven't been booked.

SMITH: What'd you get harassed for?

GUTHRIE: I was out in California, man; I was gettin' into Van Dyke Parks's VW bus. Every time I get in those buses, somethin' happens. And I was gettin' in this bus and I was with a friend who plays guitar for me—his name is John Pilla—and he was gonna drive so he got in, and he was gonna unlock my door but those weird VW locks, you know, he couldn't figure it out. So he's in there screwin' around with the door and I'm yellin' at him from across the roof how to open the door. And the cop car drives by and he hears me yellin' about how to open the door, right? So he figures, oh! Stealin' a car, right? So he backs up, two guys get out, one comes this way, and one comes around the other side. They put us up against the bus and they say, "All right, what kind of guns you carryin'?" I said, "Wait a minute." He says, "Shut up. You can't be carryin' very big guns. Those clothes are too tight." And he's lookin' for dope, right? It was really weird. He searched the whole place and asked me, "What's your name? Okay, what's his name?" And they switched us around with two cops askin' the same questions but a different cop. It was a whole trip—it was great. It blew my mind. I

> **And I figured any moment now somebody's gonna be callin' me back. I knew they were just foolin' me.**
>
> —Arlo Guthrie

think we blew theirs too. He was harassin' us there for about a half hour, just makin' us take our pockets out and all that, feelin' us up and goin' through his trips. They were diggin' it. By the end of the whole thing, he says, "So what do you do?" I said, "I'm a singer." He said, "Oh, what are you doin'?" I said, "We're goin' on tour." He said, "How much do you make?" So I said, "For the whole tour or just for one night?" "What do you get a night?" So I said, "Well, maybe six grand." So he says, "Wow, man, that's not too bad for one night." And he starts smiling and they start laughin' and then they let us go. It was kinda weird. I mean, they're freaks. They're really spaced-out Nazis. You know, if you rap to them about something like that, they forget all about what they're doin'. It's just incredible. It just blew his mind that some weird freak hippie kid could make that much bread and still be standin' there tryin' to rob a VW bus. You know, he just didn't know what to think anymore so he left.

SMITH: What other hassles do you get?

GUTHRIE: I got harassed on Taconic State Parkway there for—I forget what it was. He says, "Where are you goin'?" I say, "Up to Stockbridge." He says, "What do you kids do up there?" I say, "We're makin' a movie." He says, "Oh, one of those movies, huh? One of those new movies?" I said, "No, we're makin' a big movie. We're makin' a whole production, United Artists trip, good director, and it's in color." He says, "Oh, yeah, you need a cop?" So I said, "Nope, we got one. We don't need you." He just felt kind of bad about it and drove away.

SMITH: Why did he stop you?

GUTHRIE: He didn't have a reason. I think they ain't got nothing else to do. I think the best thing to do is just drive when it's rainin' out, because no cops bust you in the rain. They don't want to get out and get wet....I never got busted in the rain. Just kinda on those clear days, when cops are drivin' around real fast, screwin' off. It's weird. They all ask me for jobs, though. I don't know where they're at.

SMITH: I guess they watch TV all the time, all those police shows...and they see, like, wow! They probably really want to not be real.

GUTHRIE: Yeah, I think that's it. That's really too much, man, because they're not real. Boy, when they find that out. One of these days, man, the sky's gonna open, a face is gonna be up there and the whole trip's gonna go down and those cops, man, aren't gonna know what to do. That'll be fun, because they'll be shootin' at it maybe, right? Big face in the sky, right? *Pow.*

ARLO GUTHRIE

Carole King
Fall 1969

Carole King's marriage to longtime songwriting partner Gerry Goffin ended last year. Goffin was going to move to Los Angeles, which put King at a crossroads: either stay in New York and take Jerry Wexler's offer to sign her as a recording artist for Atlantic Records, or relocate so that her daughters could stay close to their father. King packed up and headed West. She's formed a band called the City, whose first and only LP, Now That Everything's Been Said, *is about to be released. The band will soon break up though, and King will finally take center stage. In two years, her second solo album,* Tapestry, *will win her four Grammys, including Album of the Year and Best Female Pop Vocal Performance.*

SMITH: About the different hits that you've had, can you recall them right offhand?

KING: My favorite ones: "Up on the Roof," "Go Away Little Girl," "Will You Love Me Tomorrow," "Some Kind of Wonderful," "I'm into Something Good," "Natural Woman"...There are more but those are the ones that I remember best.

SMITH: Did you ever have a hit with you singing?

KING: Yes, "It Might As Well Rain Until September." It was Top 20 in this country, number one in England.

SMITH: How long ago?

KING: 1963.

SMITH: Why didn't you continue doing that?

KING: I like the writing end of it better. I have more control over it that way. It's between me with an intermediary of not being seen; it's hard to explain but the directing of performing is, like, something that is sort of scary. That's something that I didn't really wanna get into, yet there it is. But that's why I stopped, because I like the writing end better.

SMITH: Back when you did that record, you weren't performing in public— it was just a record session?

KING: No, I did a couple, like *The Dick Clark Show* and things like that, but they're really less rewarding to me to do stuff like that. I think I could

dig performing *now*—I couldn't then, as much, but I could now. But only with the feeling of confidence. You have to acquire that and working with a group does that. I think that's why a lot of people form groups or band it together, because playing with people you dig, and people whose playing you dig, has got to make you feel confident, and has got to make you be able to say what you want to say a lot better.

SMITH: This new group—is it called the City or just City?

KING: The City.

SMITH: Have you performed in public at all?

KING: Not yet, just records. We're working towards performing, but we have a lot of things that we just want to get together, and we kind of enjoy playing so we just do it.

SMITH: How long have you been together?

KING: We've been together about a year and a lotta the time has been spent in writing, working up new material. But it takes a lot of time to get a record out, to get a single out, to get an album out, and to get things going. With things happening the way they were, we just wanted to wait to see how it was received to get some idea of what was happening generally.

SMITH: When you sit down to write—well, *do* you sit down to write?

KING: Always, I sit down to write.

SMITH: Do you make time to do it?

KING: Both. It's a disciplinary thing where you say, "Well, I'm gonna write at two o'clock today." And you get together with whomever you're writing with and you say, "Well, let's sit down and see if we can come up with something," and you throw ideas around and very often something does come out. Even if you don't particularly feel like writing that day or at that particular time, if you do it long enough, you know how to make yourself get really turned on and you do it. It works.

And also there are times of pure inspiration where you don't say, "I'm gonna sit down to write." But something drives you to the piano. Or in the case of the lyricist, to the paper and pencil, and you let it all come out. Then the discipline comes in, because you get out the emotion—the raw emotion and the raw inspiration—but you have to work it into something that can be communicated, rather than just disorganized pouring out of emotion. Because, very often, it's a good release for the person doing it but nobody else really particularly wants to hear it or be involved in it. But if you can direct it so that it can *reach* somebody, that's the discipline, so it's a combination of both.

SMITH: How did you learn how to do that, how to shape it?

KING: By doing it. That's the only way. By doing it, by saying, "Oh, that one reached people; that one didn't" and trying to understand why. And I like to do both—I like to let the emotion come out and let it be raw, but I also like to reach people. It's important. It's nice. It's kind of frustrating if you have something to say and nobody wants to hear it. So you've got to kind of try and come around to where people will want to hear what you have to say and will understand what you're trying to say. Which is kind of abstract for music, but I do have something to say even if it's "Hello, I'm here."

SMITH: When you sit down and write, do you do it at a piano or guitar?

KING: I primarily do it at a piano. For a while, though, I did it on guitar and that was…I'm not a very proficient guitarist, but you think entirely differently. Your musical progressions, your chords are entirely different on a guitar and they would be different on any instrument that you composed on. It's just the way it feels. And so that took me into other directions. Some of the songs weren't even very good, but they gave me new ideas and, like, I might come up with a riff on the guitar and then put it on the piano. It would give me a whole bunch of new ideas that's going in a different direction.

> **Because you get out the emotion—the raw emotion and the raw inspiration—but you have to work it into something that can be communicated.**
>
> —Carole King

SMITH: Do you write the music first and then somebody writes the lyrics?

KING: I knew that question was coming. That's the classic—but it works different ways with different combinations. For example, with Gerry, sometimes I used to write the music first; sometimes he would write the lyric first. But now it's kind of evolved into we'll sit down, both of us, with either nothing or just a fragment of a lyrical idea or a fragment of a musical feeling, and stuff will just start spouting between the both of us. And then again, that's the raw part of it; that's the inspiration. Then we both work to get it together and he might come up with a musical phrase that needs to be melodicized a little more. So I would do that. Or he might come up with a lyric that I can sense what direction he's trying to go and we do that.

In other cases, I write with another lyricist, Charlie Larkey, and he has been, up to now, writing lyrics first, completely. And I've sat with the lyric and just by looking at the lyric, the way he's got it laid out, I can sense what to do with it and I can take it and then we work together. You know, once I get a basic idea of what I wanna do with it melodically, then

we work together on refining the rough edges. But that's what we do; it's just different.

SMITH: How did "Natural Woman" come about?

KING: I don't really remember that. If you ask me about different songs now, most of them I don't remember. I do remember "Will You Love Me Tomorrow." Specifically, I just sat down with the Shirelles record *Tonight's the Night* in my head. I had it in my head and I liked it. I just… started to play and I came up with this really dumb metrical melody and it was right there. But that I remember coming up with the melody first; most of the other things I don't remember which came first or how they evolved, but I think it was mostly the working it out together thing.

SMITH: Do you ever write on demand, like you were hired to write a song for someone?

KING: We used to, but it's very hard now. That's the old "follow-up" concept. That's like, "Oh, the Drifters need a record or Bobby Vinton needs a record." So you try to think of what he's had in the past and you say, "Well, I'm gonna try and get this feeling in it." That's the old…

SMITH: They used to pay you up front?

KING: Oh no, but it was like, they'd say, "You've got to come up with something for so and so," and we would say, "Okay," and try to figure out what so and so did in the past and try to get that quality into a new song. But that wasn't the only motivation or the only thing we tried to do. We also tried to say something in our own way. But now it's very hard to do that at all. Now it's like songs just come out, and usually there's the inspiration but not usually directed towards anybody in particular. Like when the Beatles come out with a new record—usually they're always great, you know—at first there's a reaction to say, "Wow, that's just fantastic," and you just don't even wanna go near a piano or near a paper. And then you say, "Well, that's great, but I gotta do something. I've gotta say something." And you do it and you just get so turned on, because you say, "Wow…there's room for so much greatness." You've gotta do whatever you can.

SMITH: Do you like the way the performers end up doing your songs?

KING: Some yes, some no. Recently we haven't been doing that much for other artists other than the City. Or submitting things to a publisher, let's say, and letting him show the stuff to people that they think might wanna do it, or we might make suggestions. But on the whole, they usually use a lot of the ideas that we set down in the demo.

SMITH: That's how it happens: you do a demo?

CAROLE KING

KING: Yeah. Either we do it as a band—that's how the concept of the City started. Because we were doing demos and this was the basic combination of people. The idea was that we were…having so much fun doing the demos that we figured, why not be a group? So that's how it started. But either we do it as a group of musicians sitting down in a studio and we just put 'em down, or I'll sit down at the piano and do vocal overdubs to give an idea of what parts should be done. Or piano overdubs to lay out a string line…

SMITH: But it usually comes out fairly close to the way that you did it on the demo?

KING: It has. Like, "Natural Woman" is a good example. I did a piano/voice demo on that for Aretha Franklin and she kept essentially the basic feel on the piano; she changed the entire chorus melody and—my own personal feeling is—I don't know if it was better or I don't know if mine was better. But they were both really good. I liked my original one, but the way she did it was outta sight. And they added strings but they kept the integrity of the song. They kept the basic feeling that we wanted the song to have, so I was very happy with that record.

SMITH: How did you get to her? How did that come about?

KING: Well, I knew Jerry Wexler for a very long time and he's very receptive to good material. He has to listen to a lotta bad material to get to the good material, but he liked that song. As a matter of fact, he had suggested the title—and this is the song that we wrote, just inspired by that title. It was a really great title.

SMITH: How did it start? How did you get the first hit song?

KING: Well, I was writing in the early days, in the Alan Freed days when every high school in New York City had its little rock 'n' roll singing group. I was part of a group for my high school. And it needed material and the only thing to do seemed, at the time, was to write it. And I was writing music and lyrics myself and the lyrics were something like Frank Zappa's records, only they were not even *that* good. They sounded like satires, only they weren't—they were really bad. Then I met Gerry Goffin and his lyrics had a lot more to say than mine did. I kept on writing the music, because apparently that seemed to work.

And I used to go around, myself, before I met Gerry, just bringing the songs around, and it seemed it interested enough people—nothing ever happened, but it interested enough people for them to say, "Write some more, come back, and let's hear some more." Then when I started coming back with Gerry's lyrics, they said, "Yeah, sure." And what happened was

Don Kirshner, in his days with Al Nevins, had Neil Sedaka as an artist and as a writer and was just beginning to put together the concept of having a publisher with a stable full of really good writers, and he was signing people then. And so he signed Gerry and myself. I met him through Neil, who I knew, and he began to show our material around. And he was not known then as "the Man with the Golden Ear," but he seemed to know who should do what songs and also seemed to know to whom to assign songs. For example, if the Shirelles needed a hit, he would assign to Gerry and myself, because we like the Shirelles, let's say, or we like the Drifters. And that's a kind of disorganized version of how it happened.

SMITH: So what literally, how did it first happen?

KING: What literally happened is we had a lot of people recording our songs and no hit. And then the magic hit was "Will You Love Me Tomorrow." That's the first one that clicked, sold over a million records and got Gerry out of doing whatever it was that he was doing, some kind of chemistry to earn a living, and then he could just be a writer.

SMITH: How old were you both then?

KING: I was eighteen and he was twenty-one.

SMITH: So you came into a lotta money very young, huh?

KING: Well, it wasn't a lot at that time. That first record was not a lotta money itself, but then right on top of that came several Drifter hits, Tony Orlando hits…. The whole thing kind of exploded into a lot of hits and a lotta money and it was nice.

SMITH: Were you able to handle the money?

KING: No. But it's not…Money is neat. It's the greatest thing in the world but, you know, you get past the point where you're doing it for the money. I hope that happens to everybody that's got anything to say. Because the money makes it a hassle. Money makes it like, "I gotta have a hit, because I need money." But once you've got the money straightened away, then you've got to do it because you wanna do it, because you wanna say something.

SMITH: How did money change you, though?

KING: It made me able to spend it. Having money changes you 'cause it makes you not have to go through hassles with people, because not having money is a lotta hassle.

SMITH: What other songwriters do you like?

KING: The Beatles. Or I guess I don't know who writes what in the Beatles— nobody really knows, I guess—but I feel an affinity towards Paul McCartney's singing and towards what he writes. I focus on him as the writer, as the one

with whom I identify. I love Bob Dylan *now*. I never could understand him until recently, until he got a lot simpler. But I understand him in retrospect. Or nobody can say, "I understand another person," but I'm moved by what he said then, now. But I couldn't understand it then; it frightened me, I think. A lot of what he had to say is very frightening, which I think is what he intended. Who knows—with Dylan, you don't know.

As a writer, I hate to have people say what they think I mean or what they think any of the lyricists mean. Because very often they don't mean anything but what they say, and it's how you look at it. He's really said everything and he's gonna find more to say and he's gonna say it too. I like Laura Nyro a lot.

SMITH: As a singer too?

KING: As a singer too. Her writing has a very…It has a quality that is very *city* to me, very New York, urban. And yet there's something about it that reaches out and wraps around other things to me. And her vocal ability is incredible. I think she can do just about anything with her voice. I like Joni Mitchell too. Although she tends to be really pretty and sometimes just be really above a *raw* thing that I would like to hear more of from her. She gets into it sometimes…her music is really beautiful. And she does vocal work that is just very hard to do and she does it really well. And I like her writing because she's very poetic, and she's got good marriages between her words and her music.

SMITH: Do you ever write any lyrics anymore?

KING: Anymore? Not since I was fifteen. No. I have made several attempts, but not seriously—just to see if I could do it or what I could do. And I discovered that I simply can't do it that way. I think I know why, too, because music is an abstract way of saying what you wanna say and I like being abstract about it. With lyrics you really have to come out and say it, and if you don't come out and say what's really inside of you, you're being dishonest. So a good lyricist has also probably got to be really courageous, because he's really, or she, is really putting themselves on the line—in plain terms.

Another writer I forget to mention, that I really like, is Donovan. All these writers went through all these same stages. You know, the Beatles went through their psychedelic era and Donovan and Dylan—if he didn't *start* it—and they've all sort of come back down to just plain basic simplicity. But things go in cycles and I'm sure it's gonna get more sophisticated again.

SMITH: How do you mean?

KING: Simplicity in the sense of guitars, simple guitars. When the Beatles first came, they were an answer to all the strings and heavy orchestrations in popular music and rock. And they were raw and beautiful with all the just simple guitar arrangements, and then they and many others—the many others who followed in the whole general popular music—again built up on a level of sophistication, electronic sounds, psychedelic sounds....But it was more sophisticated. It wasn't just getting together and blowing; there was a lot more thought and a lot more time and trouble and development of stuff. And that came to a peak also. And then this recent return to blues and the recent trend towards country. It's all, again, reached, like, a peak and people want raw emotion again, I think. That is going to be built up a little more, to a little more sophisticated level. It seems to be in cycles and then some other kind of raw thing is gonna happen. But I think people—the audience, the listeners, the people who are receiving the communication of the people who are creating it—don't want it to get too far out of hand. They're saying, like, "I understand it but don't get too carried away. Keep talking to me so I can understand you."

SMITH: With your melodies, does one ever pop into your head at all? Like, you're driving along in a car or something and just [snaps fingers] a melody pops in?

KING: Usually I'm listening to the radio so someone else's melody pops into my head. But sometimes just before I

I don't remember where I was going, but I immediately turned the car around and headed down to Flash Records down in Watts...

—Carole King

go off to sleep, some really neat melody comes into my head and I try to remember it, and sometimes I can and sometimes I can't.

SMITH: Is that a key time for creativity for you?

KING: No, it's just the time when my head might be most empty of other stuff. It's, like, the most free...I've done that too waking up. It's a time of clean-mindness where you're not hassled with a million things that you're thinking about. But I don't think of stuff while I'm driving along. What usually happens is I'm driving along and listening to the radio and some really neat, great thing comes on and I'm about to have an accident. The last thing that did that to me was "Oh Happy Day" and I had no idea what was happening; this was just really thrilling for me. I was listening to the R & B station in Los Angeles and they just played it like they're gonna play a gospel record, which they always play. And this thing came on the radio: "*What is that*?!" I don't remember where I was going, but

I immediately turned the car around and headed down to Flash Records down in Watts, where I figured would be the only place I could get this obscure gospel thing. And a week later it was *the* biggest thing happening. So I was really proud of myself; I don't often pick the thing.

Could we erase this whole thing and start again?

SMITH: Nah! You're doin' very well.... Would it be harder to break in today as a new songwriter?

KING: Songwriters are breaking in today, usually as artists. It's not a songwriter's business in the old sense. Because in former years when I was first breaking in, five, ten years ago, there were many more artists who came to publishers and said, "Hey, I need material. I'm a singer, not a writer, and I need a good song...." *Now* most singers are writers too, or most groups are self-contained artists. Many of them have come to discover that they're not as good writers, let's say, as they are singers. And some have gone on to discover that they *are* good writers and have continued. But basically, its units are more self-contained. Which is—again...the reason for being for the City—because as a writer, if all the artists are self-contained and don't need writers, then you've gotta have some outlet for your material and some outlet that you feel is going to do it well. So the City was formed...to enhance the songs, to show the songs, to a public that might not get to hear them otherwise.

B.B. King and the Voices of East Harlem, Thanksgiving Day concert at Sing Sing Prison, NY, 1972

Tom Paxton
October 1969

A few weeks ago while touring the UK, Tom Paxton performed at the Isle of Wight Festival alongside Bob Dylan and the Who. For years he's been a staple on the Greenwich Village folk scene, but it's in England that he's found his strongest following. Paxton will return to the UK to play concerts every year for the next forty years.

SMITH: When did you come back from England?

PAXTON: I just got back about two weeks ago.

SMITH: How long were you there?

PAXTON: I was there about seventeen days. I lost track of time. We were going every day and I got about two nights off, so it all began to run together toward the end of it. I'm not used to really long tours. Mostly I just go on weekends over here.

SMITH: Did you tour by yourself?

PAXTON: No, I took my piano player, David Horowitz, with me and we used an English bass player.

SMITH: I meant at each performance, were you the only people on the bill?

PAXTON: With the exception of Glasgow, yeah, it was all solo spots.

SMITH: In this country you're pretty well known, but somebody told me that you're much more famous in England?

PAXTON: Yeah. I've been going over there; this was about my tenth time over there. And it's a smaller country, right? So you can get around pretty easily. Whereas hitting the major cities in this country is a whole big prospect. Also, over there you can do it in a concentrated dose...It's just that that audience and I got together a couple years ago and it's been building every time. Every time it's been bigger.

SMITH: What is the difference between performing there as opposed to here?

PAXTON: Mostly, I think, they listen harder. There's a quality of silence in an English audience when you're singing a quiet song. It's *silence-er* than what I find over here, although I must say that's changing: audiences seem to be getting hipper and hipper over here, and more eager to listen and get every nuance. But the English audiences were ahead of them.

SMITH: You're basically a folk singer, not rock. That's almost like an extinct bird these days.

PAXTON: Well, not really. After all, Judy Collins is basically a folk singer and José Feliciano started out as a folk singer.

SMITH: Do you see yourself moving more into that direction? Neither really made it very big until they got those grand symphonic arrangements.

PAXTON: I wouldn't be afraid of that. I've done it on a couple tracks, anyhow. I think that as your writing develops, changes, then the arrangements have to follow suit. I know my sense of my harmonies has changed in the writing so that I can look at a song that I write now and I see that here's plenty of room for more instruments in recording it. Besides, recordings are a different medium from a live performance. I don't ever feel that I have to duplicate on the stage what I do in a studio, because it's a different bag altogether.

SMITH: But a lot of times the audiences feel that way, don't they?

PAXTON: No, they don't really. I went to see a Simon & Garfunkel concert, for example. They use everything imaginable on their records, and hearing a concert, it was Paul Simon and Artie Garfunkel and one acoustic guitar, and that was it. Just the two of them, and the audience loved it. It's really what kind of communication you can arrange. That's really what a concert is, anyhow. That's all it is. It's a visit.

SMITH: Do you enjoy performing live?

PAXTON: I love it. I'm a terrible ham. I've been doing it for nine years now, so I don't get all hung up and terrified and nervous before I do a concert. I can relax and enjoy the contact myself. I can enjoy the songs and singin' them.

SMITH: You don't get nervous at all anymore?

PAXTON: Not very much. The most nervous I've been was at the Isle of Wight and that wasn't because it was so big, that was because it was very much a rock audience. I was apprehensive about how well they would accept what I do.

SMITH: How did it go?

PAXTON: Oh, incredibly. Just beautiful...I'll tell you where I do get terrified—well, not terrified, but tremendously uptight: doing some television. I was on *The Tonight Show* a while back, last spring. That is just the most incredibly uptight place I've ever been in my life. The tension is in the air. I don't know why. What's the big deal? Why should it be life and death? But I couldn't avoid this atmosphere that was there. I mean, it *got* to me. People were walking around like tonight's the night, make or break. Tremendous tension.

SMITH: I think they like that. It shows them why they're getting paid so much.

PAXTON: Yeah, and it's power, isn't it? It has happened in the past that certain people have created a *sensation* on *The Tonight Show* and can trace their superstardom back to an appearance on that show. But it's always people with absolutely unique talents: someone that you've never seen anyone like 'em before, like a Woody Allen or Bill Cosby or Joan Rivers. They come on and it's a smash. But I don't think any *singer* has ever taken off on *The Tonight Show*. I wonder what it must be like backstage at *The Ed Sullivan Show*. People must be cutting their wrists or something. That stuff can do you a lot of good but I really kind of wish that it wasn't necessary.

SMITH: You write almost everything you do, right?

PAXTON: Yeah, everything.

SMITH: How do you write? Music first? The words?

PAXTON: I always write the words first, and sometimes I'll have kind of a melodic idea in my head that I won't bother to straighten out until I've got the lyric finished. Then I pick up a guitar and work it out somehow. But I like to get the lyrics down first. They're the most important thing to me. If you've got the lyrics straight, the melodies kind of follow.

SMITH: In writing the words, do you have a very clear idea?

PAXTON: No, I sit down with no idea at all. Nothing at all, blank head and try to keep it blank. The nearest thing I can liken it to is—I sit down and shut up and listen. Because it's all there; it's around. And you have to learn to be quiet enough to hear it. Then you just borrow it and put it down on paper. There are songs everywhere and you don't *write* 'em; you write them *down*. You dig it? I used to sit down and say, "Right, today's the day I must write a song about Lyndon Johnson," and then I'd somehow write a song about Lyndon Johnson. But I've stopped doing that. Now I just sit down and shut it all out and turn my own mind off and try to listen. Then once you hear something and get started on it, then you bring your mind back to work on it. Then the craft comes back. That's where you need the experience to help the subconscious along.

SMITH: A lot of your songs have been about the war and the draft protests. Even then, you haven't sat down specifically to write that kinda song?

PAXTON: Exactly. I would say for the last two years, I haven't sat down with an axe to grind. The axe is in my subconscious, you see. My feelings about the war are just like everyone else. I feel very deeply about the war and there's a lotta noise going on in my subconscious about the war. So it's very likely to send somethin' up on the subject of the war. You never know what you're ordering when you push the button and say, "What d'you got for me today?"

TOM PAXTON

ALL FESTIVALS MANIFEST THE ENERGY CENTER OF THE NEW CULTURE

WHICH IS ROCK

We have called a special meeting of the underground press and
rock community leaders

* to discuss ways of developing and putting to practice
 methods for the preparation of safe and harmonious pop
 music festivals

* to insure that the California San Fernando Valley incident
 which took place over the weekend does not set a precedent
 for all other festivals this summer

* to set the tone for and discuss the significance of the
 event FESTIVAL

 FESTIVAL

 an entertainment taking place in a given amount of
 space for a given amount of time

For additional information resulting from this meeting contact
Wartoke Unlimited, 1545 Broadway, NYC 10036 - 212 245-5587

WOODSTOCK MUSIC & ART FAIR 513A AVE. OF THE AMERICAS, NYC 10011 (212) CH 3-6260

Notification of the June 26, 1969 Woodstock meeting

John Roberts and Joel Rosenman
October 1969

John Roberts and Joel Rosenman were young businessmen looking for a venture when they placed an ad in the Wall Street Journal *reading "Young men with unlimited capital looking for legitimate investing opportunities and business propositions." Artie Kornfeld and Mike Lang met with them this past Feburary and they quickly formed a partnership. After just seven months of planning, they managed to pull off the Woodstock Music & Art Fair. But in the two months since Yasgur's farm, the partnership has imploded and left the Roberts family holding the bag, with an enormous debt.*

...

SMITH: You're definitely running a festival next summer?

ROBERTS: I think that would depend on the climate of things next summer. We are preparing for one, but it's not clear that the time will be right for a monster festival.... With one stroke, we sort of created a tradition that we'd love to perpetuate.

SMITH: What other things are you moving into?

ROBERTS: We are exploring areas of talent booking, the possibility of a record label.... We're also looking into the field of advertising.

ROSENMAN: One of the reasons we're looking into advertising is because we mounted a promotion that has to go down as the greatest promotion in history. I think any organization that can speak to four hundred thousand people and assemble them in one spot and create an event to which another million more tried to get to *has got* to have some kind of inside line to the way these people are thinking. We feel we have it and we feel that we can reach that generation probably better than anybody else.

SMITH: Who would you want to reach it for?

ROSENMAN: I think that there's thousands of companies, promoters, creators in this country who are just dying to reach that market.

SMITH: But that's like selling out, isn't it? Would you hire yourself out to Coke and say, "Okay, we'll deliver kids to you"?

ROBERTS: We don't know right now what form our clients will take. We hardly think that Bethlehem Steel is going to pick up the phone. But a major recording company might be very interested in what we feel the approach should be in underground papers to effectively promote a product that this generation should be interested in, should want, and needs to be informed about.

It was clear that we couldn't work together, and it was clear that Woodstock was something that had to go on.

—John Roberts

ROSENMAN: Right. I think it's important for us to maintain the integrity of the name we've created, and we would not want to lend that name to any product or any promotion in which we didn't personally believe. I happen to think Coke's very tasty.

SMITH: The split-up from your partners—I'd heard that they were gonna try to buy you out?

ROSENMAN: They were trying to raise money to buy us out. I think had they been able to raise the money, we would have very seriously considered being bought out.

ROBERTS: They demanded the option. It wasn't a question of whether we had a choice. It was clear that we couldn't work together, and it was clear that Woodstock was something that had to go on. For that to happen, either one group or the other had to be at the helm.

SMITH: How much money would it've taken them to buy you out?

ROBERTS: At that point we weren't asking very much: primarily to have the tremendous burden that the Roberts family had assumed just shifted over to the side of the people who would be in control of the corporation.

SMITH: So they would've had to have raised enough money to pay off what your family had guaranteed.

ROBERTS: Whatever was necessary in the form of collateral or cash to replace the Roberts family as the debtor…

SMITH: So you're talking upwards of a million dollars.

ROSENMAN: Right.

SMITH: And they were unable to raise that.

ROSENMAN: They never presented us with the ability to pay.

ROBERTS: We've certainly been offered financial assistance in terms of new projects well in excess of that, and it's unclear to me why they were not able to get the same type of proposals from people.

SMITH: How did you finally split up? What did you have to do to gain total control?

ROBERTS: We released them from their financial obligations to me. According to our original contract, they were collectively responsible for 50 percent of the debt, and we released them from that and gave them a small sum of money apiece.

SMITH: What was the sum of money?

ROSENMAN: Thirty thousand dollars apiece.

SMITH: And you got the corporation and debts.

ROBERTS: The corporation and the debts and the potential.

SMITH: So what they got out of it was a fantastic seven months of planning, your checkbook to write checks with, and $30,000 profit.

ROBERTS: They did all right. But we feel that the residuals and the name that we're left with will eventually pull us out and make us a tidy profit. We also are left with the residual value from the movie and we feel that this is going to be of substantial value to us. And there is the merchandising and marketing possibilities of the logo as well.

SMITH: What do you mean?

ROBERTS: It's a symbol of peace, and there's been tremendous indication that people would like to have T-shirts or sweatshirts with this symbol on it.... We'd like to see this symbol spread all over, because we think it's a beautiful symbol and it's a very expressive symbol too.

SMITH: On the split-up, what basically is it that made it unable for you people to continue to work with each other?

ROBERTS: It's a combination of personality differences, business philosophy differences, and business procedures too. Add them all together and I think you have three times as much difference as normally causes a split-up among partners.... But we certainly agreed on a lot too. I don't think anyone could conceive of having an operation such as the music and arts fair was with all the partners in constant disagreement. There had to be agreement on a large number of things and there certainly was. In some crucial areas, though, we never quite came to terms with one another.

SMITH: I think I got all you're willing to talk about.

ROBERTS: That's all in the past. We have a big future ahead of us and we'll have to spend our time trying to get that together rather than with recriminations over the past.

Raquel Welch
October 1969

Raquel Welch is playing the title role in the film Myra Breckenridge, *an adaptation of Gore Vidal's recent bestseller about a transgender woman's escapades in Hollywood. Welch has often appeared scantily clothed on-screen, but this film's graphic sexual content pushes the limits both for her and for the new MPAA ratings system.* Myra Breckenridge *will open next June with an X rating and flop infamously. Vidal will declare that it's "the second worst film" he has ever seen.*

SMITH: You're touted as the new Hollywood sex queen. You're ultrafeminine. Does it bother you playing this kind of role?

WELCH: No, it just doesn't. I'm not really concerned about changing my image, because I don't think people have control over their image, really. It's not like when the studios used to control and protect all of us *little sweethearts*. That was back in 1940....I want people to like me and I think that makes me feel that I have some persuasive powers. But other than that...I obviously have a great need for acceptance and affection; otherwise I wouldn't be in this business, as an exhibitionist performing on-screen and magnified thirty times my life-size. I want people to like me. I want people to like what I *do*.

SMITH: Is it essential to be an exhibitionist to be an actress?

WELCH: In general, no, because we're people who hide a lot under the characters that we play. I always have felt that people who are actors are magnified personalities, and more fragmentized, because there's a part of us that is, when we're working, not like anything *specific*. In other words, we're a lot of different people. And we hide behind the things that we do. But that's true of people in daily life—our situation is just more magnified.

SMITH: How about nudity in films?

WELCH: It's very pleasing sometimes, and other times it's quite boring and a waste of time. I've never done any because I've never felt that it was necessary.

SMITH: You haven't done any?

WELCH: I've done a nude navel, legs, and some degree of cleavage, but not what you'd call a nude in its entirety.

SMITH: Are you against doing it?

WELCH: No. *Specifically* I have been, but generally no. I mean, the pictures I've been in so far have exploited my physical appearance enough for their box-office value and have given me very little in return to satisfy my own needs as an actress—pompous statement that it is. But it doesn't offer anything *to* me unless it would be true and absolutely important to a part, and it hasn't been so far.

SMITH: You've been in situations where it was in the script and you wouldn't do it?

WELCH: Oh, many. Mainly because I don't trust an awful lot of the peripheral activity that goes on in this industry. I realize that sometimes the vehicles that I'm involved in may not turn out to the aesthetic quality that I'd like. So rather than play some kind of a sucker rap, as it were, and have myself cut up on the floor and have just my bare ass in to sell the movie, I just don't do it—because they're not above that. I'm not victimized in any way, but I just feel that so far there's never been a real motivation for me. It's a personal thing. And so if I'm going to *do* that and give that personal thing away, it has to be for something....I give an awful lotta my time, my energy, my thoughts to my work. But something has to be *me*; something has to be private; something has to be without pretense. I don't want to have to worry about how it's going to affect my personal life with my husband. I just don't. Even if I weren't married, it has an effect on things. I'm affected in everything I do in my life while on this picture now. I'm a different person every picture I play—sounds a load of nonsense, but it's true. I wouldn't wanna be affected by that unless it was for a very good reason. In other words, it'd have to be *worth* it.

I obviously have a great need for acceptance and affection; otherwise I wouldn't be in this business.
—Raquel Welch

SMITH: Sounds like everybody has a price.

WELCH: It's not a monetary price; it happens to be trust in the people I'm working with and the material. If I were sure that it were going to be handled *well*. I don't wanna be part of something that is asexual on the screen, and I think that some of the nudity I've seen *is*. I thought [*I Am*] *Curious (Yellow)* was absolutely asexual. I never saw anything so anti-erotic in my entire existence.

SMITH: So if you do nudity, you'd like it to be erotic?

WELCH: I mean, it could be Mike Nichols, [Elia] Kazan, you know…but it ain't *100 Rifles* and *Bandolero!*—just doesn't quite make it.

SMITH: Were those movies you were supposed to do nudity in?

WELCH: I think *all* the movies I've ever been in, I was supposed to! It's, like, a stock scene in a script: all movies have them and then when you get in it, you just say no.

SMITH: When it comes to that scene, you just say, "I don't wanna do it"?

WELCH: No, they realize before we start. But there's always that wonderful *ego* that everyone has that they'll talk you into it.

SMITH: Are you familiar with the women's liberation movements that've started up?

WELCH: What, d'you mean SCUM? It's right on the tip of my tongue at every moment.

SMITH: That was just one of 'em, but it's, like, *woman power.*

WELCH: I think it's diabolical. I think it's lunatics, really. The SCUM thing I read about in *Time* or *Newsweek*, about the "Society for Cutting Up Men"—women triumph and supreme over all, and let's get rid o' men as a species altogether. Well, it's just sick, isn't it?

> So rather than play some kind of a sucker rap, as it were, and have myself cut up on the floor and have just my bare ass in to sell the movie, I just don't do it.
>
> —Raquel Welch

SMITH: That's the extreme. More about women joining together, like where they demonstrated against the Miss America competition…

WELCH: Oh, lovely, that sounds fun. Why did they demonstrate?

SMITH: It's valuing women for the wrong reasons.

WELCH: Well, I think that women should be decorative. Don't you?

SMITH: That's *exactly* what they're against.

WELCH: I don't think that they're right. It doesn't necessarily negate other aspects of being a woman, but I do think that women should be decorative—however they go about it. That's a moot point whether the Miss America contest means anything. Those things are all so peculiar anyway, aren't they? I was in some beauty contests. They're really strange.

SMITH: Why?

WELCH: Because the best-looking girl never wins. It's the most peculiar thing. Because someone thinks she's wholesome or something…with that kind of a *right* upbringing. A symbol of Americana. They're not really out there being judged by the masses and the people are saying,

"Oh, make her Queen of the May because she's so lovely. She has hair like spun glass and these beautiful eyes and terrific figure, like a Venus." That has nothing to do with it. They decide they're gonna make a beauty pageant because it's probably gonna be the high point of some convention, and then they're gonna send that lady round to promote a buncha things—it's a big commercial deal, isn't it? It's got nothing to do with *beauty*. But I do think these women are a bit sick if they don't like beauty in a woman.

SMITH: It's not that they don't like beauty. It's that they don't want that emphasized.

WELCH: I think that's wrong; people should emphasize it. If they got their way, they'd be doing womanhood a great blow....That's awfully complicated, isn't it? But women have always been exploited. That's part of it, isn't it, being a woman?

SMITH: Is it?

WELCH: As far as I've been alive, women have always been more or less the symbol of sexuality rather than the male. We don't see the naked male body, do we, as the symbol of sex? We see the naked female body. I think that's a rather nice simile, women and sex.

SMITH: But do you see women as a suppressed class?

WELCH: No, I don't....There are some areas where more understanding is probably yet to come. Of course, I don't travel in the midwestern part of this United States, or in the kind of groups of people where we're restricted. I travel with a bunch of loonies.

SMITH: But even in your circles, what a woman says—is it considered as important as what a man says?

WELCH: That is true to a certain degree: "Well, you're just a girl," "Oh, women, they're all alike." "Actresses..." and that sort of thing. I don't particularly like it, but there are ways to get around it.

SMITH: Don't see it all as part of the same thing? If a woman's treated like a decorative object, then why should we listen to her?

WELCH: A good percentage of men like to believe they're more important. They like to feel that primacy of being a male, of being able to direct another person. And woman has always been an easy ploy for a man to direct. "You wear *this* dress; you wear *that* hair; be this way with these people." But I think there're quite a lotta men today who are very willing to accept women as human beings.

SMITH: What kind of men are you generally attracted to?

WELCH: I must confess, I'm not attracted to people who just laugh at me and say, "Oh, yes, but don't worry your pretty little head about that." It's

RAQUEL WELCH

very infuriating but you can get around it. It's not *easy* and they may not like you when you're finished, but you'll get it. It's professional women, women who have careers and go out in the world and just upset the universe—just libertines, all of us.

SMITH: It sounds like you want it both ways: you wanna be a decorative object but important at the same time.

WELCH: Yes, I do. I don't think one negates the other.

SMITH: But that sounds like an incredible *game*.

WELCH: Why? Well, now you're talking about egos. I mean the male, female ego, the eternal battle for truth, justice, and…

SMITH: You're making it sound like it's that.

WELCH: Oh. I didn't know I was.

SMITH: Because you'll use whatever you can.

WELCH: I probably would, yeah. I don't know about all ladies. Maybe not *whatever*, but I'd try a few things up-front. I mean, if I'm thinking something and have an idea, I'm not just gonna drop the idea because someone says, "You're just a sweet, lovely little lady but you really can't expect us to listen to your thoughts." Well, I'm not going to just stand back and take *that*. I'll fight a little for it. But I realize this is not necessarily a popular stand. There have been quite a number of people that have made it all too clear to me that they prefer a very, oh, how can you say, vapid female who really doesn't do more than just this *Miss Sunshine* number….It's like a symbolism of the old-fashioned American little cutie-pie who's really just supposed to get married and have children and live happily ever after and not question anything. We're just not in that situation; that's not the climate of the times.

Raquel Welch master #1 FT. EMERALD

Stones 10/20/69 EMERALD

Mick Jagger
October 1969

Mick Jagger arrived in Los Angeles from London three days ago, with tonsillitis. This week the Rolling Stones are at Elektra studios finishing work on the band's eleventh album, Let It Bleed, *recording, among other things, Merry Clayton's famous background vocals on "Gimme Shelter." Next week the Stones will be rehearsing in Stephen Stills's basement for a monthlong American tour, the group's first in almost four years, which will end on December 6 with the notorious free concert at Altamont Speedway.*

SMITH: Why the tour after such a long time?

[Background talking]

JAGGER: Ronnie, shut up! I think you'd be better off, unless you want a lotta background noise, to close the door. I didn't think about it. But after we said we were gonna do it, I figured the reason was…that to be the complete rock 'n' roll band, you've gotta write good songs 'n' you've gotta make good records and you've gotta perform well. I figured we weren't spendin' enough time on the performing. We spend too much time on the writin' and the recording, so we thought we'd do a tour to even it out.

SMITH: Do you get as much of a charge out of performing as recording?

JAGGER: It's so different, because one is a charge, as you say. I don't think you can call recordin'…I don't get a charge out of it, a flash…Goin' onstage, you get this big sort of "whew," because it's all gone very quickly. It's only, like, an hour or somethin'. But recordin' can be like that. So six days a week and ten hours in the studio each day. It's, like, a grind. It *can* be a flash, occasionally…but it's a long, patient thing.

SMITH: How do you decide which song to release as a single?

JAGGER: We would sort of agree on it. Sometimes people have ideas on hit singles. We have disagreements, you know. Because the record company, you dig, wants to release everythin' as a single. They'd have one every month, right? Anything. They don't really care. But I quite *enjoy* singles, 'cause it's a game of, like, "Can you make a hit single?" I don't like to release just anythin', I like to release things that're really gonna be nice in the game, that will, I suppose, *win* the game—and be nice at the same time.

Because it's a weird thing: in America, the singles market's not as important. But in Europe that's still, like, the big thing. Albums don't mean a lot. They never get played on radio. There's not FM stations; we don't have anythin' like that. So the only rock 'n' roll on the radio's singles, throughout the whole of the world, 'part from America. So that's a serving thought for you, gentleman. Your stereo radio—you're lucky, man. You really are.

SMITH: There's not much rock, then, on the radio in England?

JAGGER: *No.* I don't mean—England's a big place, but Germany's a big place, and all the countries are big places: fifty million people in each one. A lot of kids, but they don't *hear* the rock 'n' roll music on the radio, because there's no commercial radio. There's only radio stations run by—how'd you like your radio station run by Nixon? Would you like that? And there's only *one*, but it divides itself into three, so that there's one for people that's a pop station, there's one for, like, the old people, and there's one for the other, right? But it's all run by the same people. How would you dig that in America? You wouldn't like that. We don't like it.

> It's no different if you have money or if you don't have money. There's always problems with it.
>
> —Mick Jagger

SMITH: I heard an advance, that acetate of the new album, and "Honky Tonk Women" is done all different.

JAGGER: The country one, yeah. Do you like the country one? It's the way we originally wrote it. I can't remember whether we recorded that before the other one or not. Keith might be able to remember it. But we wrote it like that. And then we said, "Oh, no, let's do it another way." "This is all very well," we said, "but we can do it, like, rock 'n' roll too, and it'd still be good." So we did it rock 'n' roll. 'Cause that's the *other* one, which I like because we put this fiddle on it. We got this cat from Oklahoma; he's really good. It *almost* sounds, if you play at a distance, very sort of Cajun. It's really good.

SMITH: On these kinds of tours—thirteen cities, or something, in eighteen days—it's really very fast. Do you all get tired and tense?

JAGGER: We get really happy. We have a really good time. But you don't get tense, not on thirteen cities. No, it's easy.

SMITH: Do you all get along okay?

JAGGER: We really get on all right. Don't people always get along? I don't understand—I couldn't see [how] it could be a group 'n' not get along. Otherwise, you're not in the right group. I mean, I know them all so well.

We think the others sometimes are silly or—but it doesn't *hang us up*. We don't worry about Charlie's silly "can't remember where he is"—I mean, he needs to know what he's doin' or what day it is, but I appreciate it.

SMITH: You did that huge Hyde Park thing. How big was that?

JAGGER: I don't know how many. You couldn't count them.

SMITH: I heard it was a quarter of a million people.

JAGGER: It was more, I think, than that. It might've been half a million people, between a quarter and a half a million people. It was a lot, all the same.

SMITH: And it was free.

JAGGER: Yeah, free. You couldn't get that many people in to pay, I don't think. But why? There's, like, that many people wantin' to go—it was great. I didn't know there was that many in England.

SMITH: What's it like performing in front of something that big?

JAGGER: Well, you can't really see them. I just treat it, like, I don't really communicate with them pretty much. I just can't, with that many people. You want to try, fine. So I just thought, well, I'll just see if I can *get it on* up here a bit, 'cause if I get it on up here, they might get it. Because I couldn't reach to that one....I couldn't *see* them. They just become... You know what *five thousand* people is like, well, it's pretty hard tryin' to get across to *them*. Unless you're Jesus or somethin', then you can get it together, but I certainly can't.

SMITH: Are you pretty happy with where you're at?

JAGGER: I guess everything's goin' like it should do. I mean, I have to keep my toes on everything...

SMITH: How about money?

JAGGER: Well, that's all right. I mean, you just *live*; you just go. But then you have to sorta *get into* it. That's the only time when you say, "So I need so and so thousand," whatever, $100,000, $200,000, something. Then you have to think and you say, "Oh, where am I gonna get it?" You have to go pull strings 'n' get it.

SMITH: The Beatles seem to be in so much trouble with their money scene—

JAGGER: But they publicize everything they do. They always have—that's their big hang-up. They always, like, *tell* everyone. "I'm in love." "No, well, now I'm not." "I'm taking this," "No, I'm not." They always gotta tell everyone. That's the thing—they like tellin' and everyone likes to *know* what they're doin': "Beatles haven't put away any money; they're just like us." I mean, everyone has problems with money. The Beatles aren't any exception. How's *your* bread scene? You're like me and you get bills, right?

SMITH: I think it blows everybody's mind to imagine making all of that money…then to hear that you also have *trouble* with it—

JAGGER: *Of course* you do, because it's no different if you have money or if you don't have money. There's always problems with it.

SMITH: There've been some complaints that the price of the tickets is very high.

JAGGER: Yeah. I heard that people thought that it was really high. I don't know what….I've always been a, basically, a rock 'n' roll singer. You know, most rock 'n' roll singers don't worry about things like that, quite honestly. I like to sort of think it's nothin' to do with me. Because nobody ever asks any rock 'n' roll singer *before* that the price; you know, they never said…I have no idea how much tickets cost in America when I came before. How much were they then?

SMITH: I don't know, but now some of the cities they're up to eight and ten dollars a ticket.

JAGGER: No, they're not. 'Cause when I heard that I asked, you see. I didn't know how much they were.

SMITH: In New York they're $8.

JAGGER: Yeah. That's the very expensive ones. But I don't know if that's a lot of money. They tell me that they *all* cost that, that everyone's tour cost, like, $7.50 or $8 or whatever it is. I don't know. That's what they say they *cost*. I mean, we come much cheaper than…People offered us a lot more money than we're *getting*. They offered us three or four times what we're getting for the same work. And I figured that really would be expensive, because they were givin' us a lotta money, up-front—*astronomical* amount of money….No, I figure it's pretty fair. How much would you pay to see Ike and Tina Turner, Terry Reid, and B.B. King, anyway? That's pretty good, man. That's not a bad show—I'd go and see it. Okay. So but that's what concerts *cost*. That's what they cost; that's what it is. There's a lotta people that can't see it. When *I* was a kid I had to go 'n' see Buddy Holly from the back row—big deal. That's how America is.

SMITH: A lot of your music seems to have American roots, blues roots…

JAGGER: Yeah, it's all a mixture, though, because we've grown up with English folk music as well, in a way. We don't only like *black* folk music. We like white folk music too, you know—English 'n' American. Irish.

SMITH: What kind of music do you listen to?

JAGGER: Folk music. I don't mean *folk music*, folk music. I mean as apart from *pop*. *Abbey Road*'s pop music, right? Area Code 615 is folk music. There're a lotta differences between that and *Abbey Road*. Do you see what

I mean? Because it's like—because *Abbey Road* is derivative. Derivative. The Rolling Stones, derivative. Derivative. But I mean, we try and be less. It's, like, goin' one generation and recording. Because the closer you are to your own folk music, the less derivative. I think one step derivative is essential. But if you go more, when you go about three steps derivative, I start to lose contact with the music. Understand what I mean?

SMITH: Do you read much?

JAGGER: Not while I'm on tour. Can't be a rock 'n' roll singer 'n' read books. It doesn't go together.

SMITH: But when you're off tour, do you read? What kind of stuff do you read?

JAGGER: It's terrible tellin' people what books you read. I read *Airport* on the plane. I did. Everyone reads *Airport* on the planes. You get it off the lady sittin' next to you. [In an elderly voice] "Have you read this one?" I did it on the way from Bangkok. I was comin' from a holiday in Indonesia; I stopped over in Bangkok to have a bath. You have baths with those chicks, right? It's really weird. First of all, you go in there, and you think, "Well, what's this, anyway?" So the chick comes up to you and she says, "I'm the madam of the bathhouse." She's like, "I want a hundred whatever they are." It's, like, two dollars. And you say, "What happens now?" So she turns you round and there's a big glass. You've been to recordin' studios. You know the big glass as you look into the studio? Like that. And the other side of this glass is a room with steps on it, with carpet. There's all these chicks in there, all in uniforms—like, twenty-five chicks with long, long hair, and they're all quite pretty. They've all got these shorts on with zips and little blouses and they look all sorta the same. It's like *Alphaville*. And they all got numbers and you just ask which number you want. You pick the number and she gives you a bath. And she massages you. It's really weird.... You can go to places where they're a bit more traditional, but this is, like, the modern ones. They're really weird—because the weirdest thing is when you have to select 'em and it's *this glass*. Can you imagine? It's really weird to actually do it. I don't know if it sounds peculiar to you or normal, but it's really weird.

I don't understand—I couldn't see [how] it could be a group 'n' not get along. Otherwise, you're not in the right group.
—Mick Jagger

SMITH: Do you see the Stones as going on and on indefinitely?

JAGGER: Forever. No, I don't know, man.

Sandi Morse
November 1969

On September 17, the school newspaper at Drake University published an article asking if Paul McCartney was dead, citing clues supposedly hidden in the Beatles' cover art and music as proof. By October the rumor picked up steam, and a DJ at Detroit's WKNR-FM spent over an hour discussing it on the air; from there, it snowballed. The story became so big that Life *magazine featured McCartney himself, posing with his family, on their November 7 cover under the heading, "Paul is still with us." The magazine hit newsstands this week. Sandi Morse is the national director of the Official Beatles Fan Club.*

...

SMITH: Have you had a lot of phone calls today about this?

MORSE: Oh, you're not saying enough. We've had phone calls for three days straight. Every one of our lines has been tied up. We're completely exhausted and we keep saying the same thing over and over again, "Paul is alive and well. He's just great." And there's nothing more we can say about it. From every country, from disc jockeys and radio stations, from newspapers, from colleges, from high schools, from fans...They just keep calling, "Is Paul dead? Is Paul dead?" and I keep saying, "No, no, no." I don't know how to *handle* it anymore....Nobody seems to want to take no for an answer.

SMITH: Why doesn't he step forward and make a statement?

MORSE: He *has* made a statement through Apple and feels that if he personally made a statement, they'd only say it was his double standing in anyway. They can go to England and see Paul himself: all they have to do is stand outside EMI studio on Abbey Road and they'd see him.

SMITH: But they'd say that it's just a double again. This is what I find so ridiculous. How does somebody prove who they are?

MORSE: The entire Apple office on Savile Row is so jammed that people cannot get in and out. I just spoke to Peter Brown a few minutes ago. Paul is so disgusted with the whole thing. He says, "I'm here. What do they want from me? I'd be the last one to know if I was dead anyway."

Jim Morrison
November 1969

The Doors are in the middle of recording their fifth album, Morrison
Hotel. *They've seen a lot of troubles this year, as Jim Morrison's drinking
and drug use nearly tore the group apart. This past March, he stopped in
the middle of their Miami show, burst into a drunken onstage tirade, and
wound up being charged with indecent exposure. The court case against
him has been looming, and in three days he'll fly back to Miami and be
sentenced to six months of hard labor. However, Morrison won't serve the
sentence—he will die of an overdose in July, 1971 while living in Paris.*

...

SMITH: Do you enjoy performing more than recording?

MORRISON: I guess so; I do. It's more fun with a lotta people around.
Recording studios tend to get a little dry and monotonous. Yeah, the real
fun is in performing.

SMITH: How do you decide what you're gonna do?

MORRISON: We have a repertoire of thirty or forty tunes. In the dressing
room before we go on, we usually plan the first three or four songs and
then we just play it by ear. So we don't really know what we're gonna do
when we go out there.

SMITH: How about in the recording studio, how do you work out what
you're gonna do?

MORRISON: Usually we rehearse a couple weeks, till we have a considerable
amount of material, and then we go in and do it. Well, on this new album,
it's really strange—it went really quick. We went in and got, like, a song
a day, which is kinda unusual. It was funny—the first album we did in
about ten days. Then each succeeding album took longer and longer till
the last one took about nine months to do. This one, we went in and we
got a song a day—it was amazing—partly because we went back to the
original instrumentation: just the four of us and a bass player.

SMITH: Why'd you decide to go that way?

MORRISON: I don't know. I think that phrase is the most horrible phrase in
the English language: "I don't know." It's terribly embarrassing.

SMITH: I generally read put-downs of the Doors now. Why?

MORRISON: I think we're the band you love to hate. It's been that way from the beginning—we're universally despised. I kind of *relish* the whole situation.

SMITH: Does it bother you?

MORRISON: Yeah, it does. I wish they wouldn't do it, but freedom of the press and all that.

SMITH: You say it with a nasty glint.

MORRISON: I think maybe it will change. It's a question of longevity. It's that old thing like a first novel, they usually give the cat a break and everybody pats him on the back. Then the second one, they really chop him up. And then if he does a few more and shows staying power, they say, "Welcome back to the fold, the human family embraces you," and I think it'd be the same way with us. We just have to hold out for a little while and everyone one day will real-ize, "Wow, they're just like old friends. They've been around for years now and they're part of our national psyche. I guess we'll just accept them." But now we're kind of in an in-between.

> I've noticed that when people are joking, they're usually dead serious. And when they're dead serious, it's usually pretty funny.
>
> —Jim Morrison

SMITH: Some of the criticism has been about the music. It seemed more revolutionary at the beginning and then it got sweeter, more Top 40. Were you aware of that happening?

MORRISON: I don't agree with that. I just think the music keeps getting bet-ter and better; it gets more subtle and more sophisticated, musically and lyrically. Besides, if you keep saying the same old thing over and over, it's bound to get boring, right? Who wants to hear revolution twenty-four hours a day?

SMITH: About money—have the Doors become wealthy enough?

MORRISON: Oh, yes, I can go into any restaurant in town and order anything I want, and I don't have to go to fifty-cent movies anymore, either.

SMITH: No, really, if you stopped now—have you made enough to stop?

MORRISON: Let me think…No. I'm just so greedy, the more I can get, the better. My ambition is to have a whole bunch of gold bullion. Big gold bars, I'd like to have big chunks of gold, just to have around the house….

SMITH: A lotta the groups I talk to say they have trouble holding onto money.

MORRISON: Well, that's their fault. They're probably spendthrifts. It's like giving whiskey to an Indian.

THE SMITH TAPES

SMITH: So you don't wanna talk about money.

MORRISON: Sure, what do you wanna know, man?

SMITH: Have you held onto your money?

MORRISON: Let's put it this way: I think with our economic system and tax structure and all that, I don't think it's possible, ever, to just retire and never work. Because the economy keeps increasing—if you drop outta the economy, then it just passes you up. In a couple years you're left high and dry. I don't think it's possible to retire in a capitalistic society. But I enjoy talking about money, Howard.

SMITH: Obviously.

MORRISON: Well, what do you want to know? I'll get my accountant down here and show you my bank statement.

SMITH: I interviewed Mick Jagger the other day and he said it's almost impossible: "You work and you work, and where's the money?"

MORRISON: I think I dig money because I've always said this: "Money does beat soul every time." Not only that, it's a form of communication. And besides that, if you run into some good luck and get some money, then you should just keep pouring it back into creative ventures. Just as soon as you get it—don't go out and buy a buncha diamond rings, but pour it back into creative ventures that are creating new things, and you can't ever go wrong.

SMITH: This is a strange kinda interview.

MORRISON: Do you have any more stimulating questions to ask me?

SMITH: Watching you perform onstage, I got a similar kinda feeling like I'm having now. It's sort of a disdain for the audience, and I'm feeling it directed at me now also. What do you feel—the questions aren't worthy enough?

MORRISON: Hey, listen, man, this has been probably one of the most exciting interviews *I've* ever participated in. You're getting the benefit of my grand Irish wit, all over the place. And you call it *disdain*—well, you wanna arm wrestle? What do you want, man? Go ahead, ask me something else and I won't be disdainful. I'm sorry if I was disdainful.

SMITH: Do all of you still get along?

MORRISON: It's like being married or being a member of a family: there's always…strife. People who live together fight a lot. But I've noticed we went through a period it was really getting strained, and the last few months everything has really smoothed out. I think when you're creating well, when the music is going well, everybody's happy. It's only when your creativity kinda dies off a little bit, then everybody starts feeling the strain. But the relations are very good these days.

SMITH: Do you see the Doors going on for a long time?

MORRISON: I have no idea, really. I reasonably project at least another seven or eight years, but beyond that I don't know.

SMITH: That whole thing in Miami, is that still pending?

MORRISON: Mm-hmm. It's still up in the air right now, but there will probably be a big trial. I might even buy a suit to make a good impression on the judge and the jury. I'll get a suit and take a lot of tranquilizers and just try and have a good time. Maybe I'll keep a diary of the whole thing and publish it in *Esquire*, my impressions of my hanging.

SMITH: Is there still a warrant out?

MORRISON: Yeah. Hey, man, you're putting me on a bummer. It's a rainy day in L.A. and you're talkin' about all this horrible nonsense. Let's talk about something... *light*.

SMITH: I find it pretty hard to get a straight answer. What did you think I was gonna ask you?

MORRISON: It's a funny thing—I've noticed that when people are joking, they're usually dead serious. And when they're dead serious, it's usually pretty funny. Actually, I think anything you say means exactly what you say and its opposite....Are you hungry?

SMITH: Why do you ask?

MORRISON: Well, maybe we can order out for some sandwiches, Chicken Delight or something. It's lunchtime. Did you have breakfast this morning?

SMITH: Yeah.

MORRISON: What'd you have?

SMITH: Chocolate cake and tea.

MORRISON: Is that all you had?

SMITH: That's all I wanted.

MORRISON: You should eat more, Howard.

SMITH: You put on a lotta weight; are you eating a lot?

MORRISON: Well, that's something that really bothers me. What's wrong with being *fat*?

SMITH: I didn't say there was anything wrong with it—

MORRISON: Why is it so onerous to be fat? I don't see anything wrong with fat. I remember when I used to weigh 185 pounds. I was goin' to college and I had this food ticket at the cafeteria, and the cafeteria food is mainly all based in starch. It's cheap food, right? So if I missed my meal, I just figured I was getting screwed, right? So I'd get up at six thirty every morning just to make breakfast: eggs, grits, sausages, toast, and milk. Then I'd go do a few classes and I'd make it in there for lunch: mashed

THE SMITH TAPES

potatoes; every now and then they'd put a little piece of meat in something. I'd go to a few more classes and then I'd go to dinner and it's more mashed potatoes. So about three months later I was 185 pounds. And you know what? I felt so great. I felt like a tank. I felt like a large mammal, a big beast. When I moved through the corridors or across the lawn, I'd just feel like I could knock anybody outta my way. I was *solid*, man. It's terrible to be thin and wispy, because you could get knocked over by a strong wind. Fat is beautiful.

SMITH: Back at the beginning with the Doors, you seemed to be model of the year—couldn't pick up a magazine without those sultry pictures.

MORRISON: Sulky too. Sordid. Well, I was in vogue.

SMITH: What did that mean to you at the time?

MORRISON: I don't know, I musta been *outta my mind*. Can you imagine *doing* that? *Posing* for a *picture*. And really looking in the camera and really...posing? It's insane. If I had the whole thing to do over again, I wouldn't do it.

SMITH: What'd you think though, at the time?

MORRISON: I *thought* I knew what I was doing. And the horrible thing about a photograph is, once it's done, you can't destroy it. It's there forever. So can you imagine, when I'm eighty years old and I have to look at myself posing for these pictures? But, you know, it's too late.

Man, I'm finally starting to wake up, Howard—let's get into some heavy stuff now.

SMITH: How did the Doors come about? Was it still when you were in college?

MORRISON: No, it was after I got out of college. I finished up in the film school, because I wanted to make movies, although you know how difficult it is to break into the movie game. So I just kind of just wandered around. I was living down at the beach in abject poverty, and just for no reason at all, I started writing some songs. They just kinda popped into my head. I ran into Ray, who was at the film school also, and he'd been working in bands since he grew up in Chicago. So I showed him some of the songs and said, "Hey, let's get a band together." So we did.

SMITH: How did it come about that you were the singer?

MORRISON: I suppose because the person that writes the songs oughta sing 'em—he's the one that must feel it more than anybody else. So since I was writing most of the songs, I just gradually became the singer.

SMITH: Seems since the Miami episode a lotta places don't want a Doors concert.

MORRISON: It's like a political football, you know. They let us sign up for a concert, and then about two days before we show up, the mayor or sheriff or whoever wants to get his name in the paper will try and cancel the show and get everybody all outraged. People like parents that wouldn't even know who we were, all of the sudden they hear that Sheriff Peabody says they shouldn't be allowed to perform, so…It's just a political football.

SMITH: But why the Doors?

MORRISON: I told you: we're the band you love to hate.

SMITH: Do you, at times, wish that were different?

MORRISON: I know—I could write an American folk song, something that would appeal to everyone. And everyone would say, "Gee, what a great guy." I'd put a lot of American eagles in it and sagebrush, timber, boulders, rivers, mountains, prairies….

SMITH: Do you see yourself as self-destructive?

MORRISON: Well, not in my more sober moments, I don't. But I think everyone has that urge for self-destruction; it's like your first piece of ass.

SMITH: I don't see that.

MORRISON: Don't you remember? You hear everything about it—everyone's talkin' about it all the time. So you kinda have this itch to try it and see what all the talk's about, right? I think everyone possesses that to a slight degree.

Joe Cocker
November 1969

Joe Cocker spent the summer of '69 playing music festivals across the United States, topping it off with his breakthrough performance at Woodstock. He and his longtime backers, the Grease Band, are in New York City for two nights at the Fillmore East, but in a few weeks, back in England, the band will break up because of tensions with their manager, Dee Anthony. Cocker won't stay away long, though, and will return stateside in February with Leon Russell's thirty-piece band for his legendary Mad Dogs and Englishmen tour.

SMITH: Before you started singing professionally, what is it that you used to do?

COCKER: I was a gas fitter.

SMITH: What's a gas fitter?

COCKER: It's like a plumber, only fittin' gas appliances. You know what I mean?

SMITH: And all the time you were rehearsing to become a singer?

COCKER: Well, singin' at nights and workin' in the daytime. Every night we used to go out and sing in these pubs and a few little dances.

SMITH: You didn't make enough money at it so you had to work as a gas fitter?

COCKER: Well, I mean, comin' from the background I come up with, everybody expected me to get a job, my folks did, and I didn't know what the hell I wanted to do. And this gas-fitting thing came along when I was only sixteen. Took this apprenticeship up and followed it through. But the singing bit was always the strong thing in my head.

SMITH: As you started to make it then, as a singer, how'd you handle all the money coming in?

COCKER: "All the money coming in?" You see, this is pretty hard for you to come in and say that. "All the money comin' in." If you could believe just how much money you can move livin' on the road and workin'. I haven't got that much money at all, out of what we've earned up to date. Everything we have, we just sort of plow back in: that's my sort of philosophy. Not

　　　　　　　　　　　　　　　　　　　　　　　　　　　JOE COCKER

sayin' there's anythin' wrong with acquirin' money, but up till now we've had to plow everythin' in. If you want good things, like we've got a road manager whose imagination is beyond belief. He can think of all sorts [of ways] to shift a couple of grand for you every week in new equipment and things. And the record contract and the royalty I got off it originally wasn't that powerful, so, you know, I'm not wealthy or anything.

SMITH: But you're doing all right?

COCKER: Yeah, we're doing all right, but you're doing all right—

SMITH: Well, I know I haven't been able to handle *my* money; maybe that's why I ask. I mean, did your head go through a lotta changes with the idea that you really don't have to worry about your next meal?

COCKER: You do worry about things like that. I remember I went through this thing where you sort of see through what money is and how crap it is, but then again, it's still there, man—you're still faced up to the fact that you're earning it. And if you save it up, it's just a matter o' when you got it, you got to think of something to do with it. That's all.

SMITH: So you've thought of what to do with it?

COCKER: No, I've not got enough to think of... If I had a million dollars, then I'd think of somethin' heavy to do with it. But I don't call havin' a few thousand havin' much money, because you can shift that in ten minutes if you drive some project through with it....Last tour we were here so long—we were here four months—and we didn't make any money all. We just broke even.

SMITH: One group, I forget who it is now, told me they went out on a thirty-day tour and took in $300,000 as their cut and they really lived it up. They came back, their manager totaled everything up, and it came to something like $298,000 that they'd spent.

COCKER: Usually ends up where they say, "You owe me $1,000 but we'll get it back at next tour." These managers, I think it's just a big standard hype they got on all the artists, making all the figures total to exactly what you've earned. They keep saying to me that we'll make money at the end of this tour, but I'll believe it when I see it.

SMITH: How about the band; do you get along with each other on tour?

COCKER: I think our band gets on very well, in fact. We never have any squabbles, because everyone is pretty earthy in our band. Do you know what I mean? And if someone starts flyin' off, you just tell him to come down a bit. When you're on a tour, you put yourself in a frame of mind that you're on the tour, and if you can get in that frame of mind, everything's all right.

SMITH: Because the Who told me that they used to have fistfights. The first two years they used to beat each other up and take sides.

COCKER: Well, Keith Moon told me that they hated each other so much that in the end they had to love each other. Case of either stabbin' each other or saying bye. So they choose that direction.

SMITH: You were much bigger in England before here, right?

COCKER: Not what I call big. We had one hit record...and we did a few shows.

SMITH: I meant when you came here, you had to almost start an earlier point than you were at in England.

COCKER: It was like starting at the beginnin' again, yeah.

SMITH: What was that like?

COCKER: I'd always wanted to come to America. I always felt I wanted to get through in America. And it was a great challenge. It's like starting somethin' from the ground that you've got to work at.

SMITH: Was it as hard here as there?

COCKER: You can't tell how to put it in perspective. All you do is you *work*. If you work hard and every so often you can just keep gettin' reflections of things comin' back, for the work you've put into it....If your album's sellin', you feel you're makin' some sort of progress. It's a big country to cover when you're totally unknown.

SMITH: Do you find it the same playing in front of a British audience as an American one?

COCKER: No, it's different. Some people say all audiences are the same. I agree you should be able to get through to any audience, but there is a difference between English audiences and American audiences.

SMITH: What is it?

COCKER: Well, when I used to go out on stage to a lot of English audiences...I didn't know what the reaction was, but I didn't feel welcome when I walked out. But some American audiences, you can feel relaxed as soon as you walk out. But English audiences go, [in an old lady's voice] "Oh, look at *him*." You get a lotta that goin' off in England.

We were here four months—and we didn't make any money at all. We just broke even.

—Joe Cocker

They view freaks differently than they do here, because Americans love freaks, don't they?...Americans just love for somebody to come out on stage doin' somethin' not seen before. If it's in rock, they'll pick up on it, whereas in England they sort of shoot back for a bit and think about it.

SMITH: What picture did you have of this country before you came here?

COCKER: I mean, it's what you got off the movies I used to watch as a kid.

SMITH: What'd you imagine, cowboys?

COCKER: No, I mean I always knew America down to hamburgers and big cars. You come off as very flash....The first time we came here, New York used to depress me beyond belief. I just used to wanna sit in me hotel room. Just didn't like it at all. But now that we're gettin' to feel the place out, I enjoy it wherever we go in America.

SMITH: What is it that depressed you?

COCKER: It was the vibrations came on so strong, of New York to me....I mean, it's really moving about. Sirens going off eternally all through the night, all these bells clanging, and people lyin' in gutters....I just hadn't seen it before. We took a walk down Forty-Second Street one night, Chris Stainton and I, and saw some really desperate cases. How the Americans will let their fellow people get in some bad states of health. Like in England nobody'd let anybody die. You wouldn't ask him to show his money before you take him in hospital or anything like that....We were in L.A. one day goin' to cinema and there's a guy in the street and he was in really bad condition...and everybody was runnin' away from him. And he was really in *bad shape.* Bruce, our drummer, sort of sat him down on pavement, told him to take it easy and we got them to ring for an ambulance. And this ambulance came and these ambulance guys were just—I couldn't believe their attitude to it. Sorta sayin', "Well, have ya got any money, man?" And he is goin', "Aahh, ahh," slaverin' his guts up on the pavement. Just wouldn't see things like that in England.

> **Americans love freaks, don't they?...For somebody to come out on stage doin' somethin' not seen before.**
>
> —Joe Cocker

SMITH: Which part of this country do you like the best?

COCKER: I can't say I like any particular place the best. I like goin' to Los Angeles and I like goin' to San Francisco and I like comin' here, because they're all such big cities and there's always something cookin' in the music field—that I can go around and meet people who're interested in it and try to do somethin' about changin' everythin'. More or less, it's not so much the place—it's the people.

SMITH: A lot of people when they hear your records and if they don't know anything about you, they think that you're a Negro. Do you run into that a lot?

Joe Cocker, promotional photo, 1971

COCKER: A Negro?

SMITH: Or black.

COCKER: Of course people said that, you know, with the phrasin' and everythin', and the voice. I don't mind if people say it sounds like a Negro. Actually, it is nice when I've spoken to some black people to think that they can take it, comin' from a white artist, hearin' somebody sing it. There are one or two that come, "Get out of it."

SMITH: Did you plan it to sound like a black person singing?

COCKER: I suppose I did, really. It was sort of what I wanted. There was a stage when black music seemed so honest. Like, if you were on the lookout for the truth in things, the black music seemed so honest and the white music didn't. I don't know; you never get a chance to sit back and actually think *why* you're doin' anything. *Why* you're trying to sing like a Negro or whether you *are* actually trying to sing like a Negro. I don't dwell on that.

SMITH: Do you see changing your style at all?

COCKER: What do you mean, changing me voice? Doin' a Dylan? I don't know, because somethin' might happen tomorrow to make me decide that, but not today.

Dick Gregory
November 1969

Dick Gregory's 1963 autobiography, Nigger, *made it known to America that he was not solely a comedian, but his write-in candidacy on the Peace & Freedom ticket in the 1968 presidential election was still a surprise. He published his political platform as a book,* Write Me In!, *and has spent the last year as a social comentator, activist, and satirist, giving lectures on college campuses across the country. In two days, at Carnegie Hall, he'll give one of very few comedy performances this year, supporting his latest, and ninth, LP,* The Light Side: The Dark Side.

SMITH: You travel a lot now. What's the main reason?

GREGORY: I do about 310 college lectures in a ten-month period, so in order to crowd 'em all in sometimes I do as many as three or four lectures in one day.

SMITH: Large audiences?

GREGORY: Always a heavy response...If the school restricts you to the student body, and the school is small, then we fill the room...I just came out of the University of South Carolina, and the same lecture I'd give at Harvard or Columbia or University of Chicago, I give it *identical* there and you'll get the same response at all three schools. No doubt...That's how connected the young folks are today and it's very groovy.

SMITH: At this point, do you see more of what you're doing as "lecture"?

GREGORY: It's all lectures, yeah.

SMITH: Still heavy on humor?

GREGORY: I'm just a funny guy. But that's not my intention, to go there and do a concert. It's to go and inform. If somebody hired me for a concert, the most they could get is an hour. For a lecture, I've been known to talk as much as eight hours without having a break. I love lectures. You can tell young folks what is goin' on and what they role is.

SMITH: What are the key things that you say?

GREGORY: The young kids in America today are probably the most morally dedicated, committed group of young people that's ever lived, in the history of this country. And they dealin' with one of the sickest nations on the face of this earth—and their job is to give America their sanity back.

SMITH: How do you tell 'em to do that?

GREGORY: First, they have to inform theyself to the frauds that go on in the system. The most important things that I tell them: One, don't go to school like we did, to learn how to make a livin'. Go to school to learn how's to live. And two, work like hell to beat the capitalist behind the United States Constitution. So for the first time, we put emphasis on *human* rights instead of property rights.

SMITH: What are the key things that you would like to see changed immediately?

GREGORY: Well, if we can talk about long-range and short-range programs—we ran a system *too* bad to talk about cleanin' up all at once. We probably got to deal with the Indian problem. And one o' the most important things we have to deal with is *survival* right now. You see, we sit down with a master program to get the Indian off the reservation and give him land back. That's not important right now—*survival*. If we sit down and talk about the minority groups that's really in trouble: the Indian, the Puerto Rican, and the Mexican—right now, those are your three worse-off groups. The fact that the highest form of tuberculosis, among any minority group on the face of this earth, happens up on the Indian reservation; the highest suicide rate happens on the Indian reservation....If anybody really wanted to change the system, the first thing they should do is go and read from *The Rich and the Super-Rich*, just first ten pages. It would shock many people. This is not in there, but two hundred million people live in America and less than five thousand people make $50,000 a year or better after taxes. That's very scary, man. We have so many important things that we have to do at the *same time*: redo the whole tax structure; to go in and make the basic social changes. I'm talkin' about feeding people, talkin' about programs.

But if you had to pull it down to the *number one* problem, I would say a redistribution of people in America; 98 percent of the American people live on 2 percent of the land—that's a problem in itself. Eighty percent of all Americans live within a six-hundred-mile radius of Cleveland, Ohio. Now in a free society, I can't make you leave New York 'cause it's crowded. Hell, you can't make me leave Chicago. But we have to do just the opposite of what made people run to New York and Chicago and all the urban centers. The rural area did not serve the basic need for modern man...And so consequently the government is gonna have to go back and redo the rural areas, to go in and build industrial complexes, and tell large industries, "If you come down, you can have that buildin'

for free." But we got to guarantee these people work for twenty years. And you got a mother, father, with seven kids—if they can be guaranteed twenty years work, they gets their kids through school, a new house, rent reasonable, new medical facilities, *then* we start redistributin' the people in this country. And we're not gonna solve *no* problem of crime, the problems of health, the problems of education—give me the best educational institution in the world and let me put ten thousand people more in it than should be in it, and I'll show you a bad system; give me an area where the people are overcrowded and you gonna have high crime rates. So until we can find some way, *that is the number one problem.*

SMITH: There's a lot of splitting-off—"which is a *white problem?*" and "which is a *black problem?*" Do you see all of these things being worked out by both blacks and whites together?

GREGORY: In some instances, black and white together, and in some instances, not. There's a lotta white kids that's sayin' they have to tear up the whole system. I can't legitimately say they're wrong, because they've *had* the United States Constitution all their life—we haven't. So we leave our hopes in the United States Constitution. If we can make the Constitution work right, we feel it would solve the problem. Now it might *not*, but until black folks *get* that Constitution, we can't use it and say, "It don't function right."

You got the young white kid that's been free all his life, so the things that's important to him is not important to many black folks. The things that would be important to black folks would not be important to the Indian, because the Indian is still fightin' to survive; we won our survival fight. So consequently, thanks to the young white kid—he's changed our civil rights movement into a human rights movement. For the first time, the conscience of this country's been shaken. With your white kid that's never seen a Mexican before…that's out in front of the supermarkets sayin', "Don't buy California grapes"—that's very important. And I think it's the biggest movement goin'.

> **Everybody's talkin' about all the problems that ever existed in this country, except that poor white hillbilly.**
>
> —Dick Gregory

What happened in the black ghetto this summer was a tremendous example of black folks doin' their thing. The reason there were no major riots this past summer is because the black militants have opened up the offices. They talkin' about *feeding* folks—like the Black Panthers. They runnin' herd down there. For the first time a black person can *call* somebody.

Somewhere this white kid who's done a beautiful job in human rights, except one area: he's forgot about his poor, white hillbilly brother, and somebody's gonna have to reach out and get him. That's the *only* man in this country that's forgotten about right now. Everybody's talkin' about all the problems that ever existed in this country, except that poor white hillbilly. You know, *we* cannot go in that hillbilly community and talk about helpin' or liberatin' him 'cause he's still bent up on that hate weed. But because he's bent up on that hate weed and because he's got that racism planted in his head, don't mean he shouldn't eat a full meal and don't mean his kids shouldn't get the type of education so they can move on and go to college.

SMITH: Why has the poor hillbilly been a forgotten man?

GREGORY: He's *always* been the nigger; he just didn't know it. He didn't have anythin' to fight for, 'cause he could always look at me and call me the *nigger*. But he can't do that anymore. He looks at television and used to look at Liz Taylor and Richard Burton and identify with white folks—he can't identify with Liz no more 'cause that black arm of Sidney Poitier is in between Liz and Richard Burton. He turns on the news and hears about black folks in Boston stealing two million dollars from the poverty program...He hears this and all at once he finds out he's the only cat, man, that ain't actin' like white folks. So he realizes he's the only nigger...As much resentment as white folks have held for black folks, they still let my mama work for 'em. And she could steal the steaks and bring home some good shoes. But that white hillbilly, he better not be caught within a ten-mile radius of no rich white folks' house. So he's never had anything. He's never had a pair of shoes that was decent. Many of 'em never had a five-dollar bill in their life. And somewhere down the line he's gonna begin to rumble, because he finds out he don't have all of those little nigger things that he could, you know, forget who he was. So it's very important now that we reach back. Are we talkin' about feedin' people in America who we feel are our pets or who *deserve* to be *fed*? Or are we talkin' about feedin' *hungry* people in America?

SMITH: You're making me uncomfortable about something: it's this use of the word *nigger*. I don't know whether you do that in a calculated way to make white people uncomfortable—few years ago the word *black* was pretty much in the same classification. What's happening to the language? Does all of this mean anything?

GREGORY: No. Probably the most used word in America is the word *nigger*. I don't think you just throw it in, just to be throwin' it in. I think black

folks use the word more in one day than white folks could use in a lifetime, so the fact that we use it that much means we couldn't be doin' it to make white folks uncomfortable, 'cause we use it when ain't no white folks around.

SMITH: Do you see the word *nigger* becoming used as *black*?

GREGORY: No…Only thing we doin' now is [being] honest enough to use it in front of you.

SMITH: Like in doing an introduction to this interview, if I said…"One of the most well-known niggers of America."

GREGORY: You'd get a good whoopin', because that's a right you don't have. White folks done lost their right to use it. They had a right one time when you could use it and I woulda answered to it. But it's like, Liz Taylor could never sit here and put down a ugly broad, but Phyllis Diller can. The dues you pay decide certain things that you can do. The word *nigger* today is becoming less derogatory to black folks. Only time we used to hear it, publicly, was when white folks was usin' it. Now we talkin' about, "Let's bring this sick word up and let's air it out," and it takes a lot of sting out of it. A lotta white folks didn't know we used it—only time they thought it was used was when they was usin' it. It was a missile. He could still do it today, call up a black cat in L.A., he be in New York. Black cat picks up the phone, he says, "You nigger!" The black cat goes *stone crazy*. Now when that word stops offending, then white folk gonna have to use a whole lotta energy to make black folks as mad. That was one of the greatest fringe benefits this system had—they could use that word and black folks would go into a thing. That don't happen no more. It's gettin' to the point now that anybody gets offended by it, anybody answer to it, nigger is a nigger.

But the word we talkin' about today, *black*, is what the young black folks is talkin' about. The thing has shifted. *Black* used to be bad because everythin' the white folks didn't like, we didn't like. But now the word *Negro* upsets a whole lotsa people because we wanna know: What *is* a Negro? Where did it come from? We left Africa *Africans*. Why do we got to be Negros and colored folks? The Jew leaves Israel and come to America, he stays a Jew. The Italian leaves Italy and come here, he stays an Italian. The Irishman leaves Ireland, he stays an Irishman. So we say, "Don't play no more games with us." We don't mean to put white folks in no *imposition*, but we look around and see they don't play games with themselves, so I don't want no cat callin' me colored nothin'. You wanna play some games? Call yourself *clear folks*. A white man can answer

equally to bein' clear as I could to bein' colored. It's change. We talkin' about *human dignity*. We talkin' about relating with ourselves. We talkin' about droppin' all the hang ups that we had. Everything the white man liked, we liked…I don't want no *white dolls* in my house 'cause white folks ain't got *black dolls* in their house. Don't send me no birthday cards with no white folks' picture on it. I don't want my kids goin' to no school reading about Jane, in the third [grade] reader, about some simple white broad up on a hill feeding some dog. That do not relate with the *ghetto*. Keep it out there in Scarsdale in them good white schools, but give us some book that's relevant to us. This is *all* black folks is talkin' about— black studies. Give me somethin' that relevantly makes sense to *me*. Any old fool knows a man without a basic knowledge of himself is like a tree with no roots.

A white boy's got a *right* to be a racist. Individual racism ain't never bothered me—*institutionalized* racism is what's chokin' us to death. If all the white folks in America left today, and left nothin' here but black folks, Mexicans, Puerto Ricans, and Indians, if we still had to take these old white racist trick tests to get into these institutions, we *still* couldn't get in….The white cat ain't my problem! It's the racist system and the racist institution. This is what we talkin' about.The guy that goes to the doctor to be examined and finds out he got cancer is the guy that have a chance

> **Black folks use the word more in one day than white folks could use it in a lifetime.**
>
> —Dick Gregory

on bein' saved. The guy that feels the pain but he's scared to go, and don't know what it is, is the guy that's in trouble. All of these things, I think we should start talkin' about it…once we get it out in the open, we might have a chance of solvin' the problem.

SMITH: You ran for president in the last election—a lotta people took it as a joke. Was it?

GREGORY: It wasn't for *me*. It wasn't for the million-and-a-half people that voted for me. Matter of fact, I was the only presidential candidate in the race—the rest of 'em was runnin' for sheriff. I was the most morally honest, ethical, dedicated man in the race, in a system that's so degenerate and so sick, as long as you commit no degenerate act, the system can't relate with that….I coulda got *nationwide coverage* had I got as sick and degenerate as the politicians. Had I said, "If I get elected I'm gonna send all white folks back to Europe." They woulda *loved* that…"If I get elected there will be no more white police." Now as silly and as stupid

and as impossible as that was, I woulda been gettin' nationwide coverage, and they'da been runnin' me next to [George] Wallace. But I ran a honest, ethical, statesman, human campaign. And the groovy thing is, the decent people that heard it, *heard* it. I put out a book on my platform—first time in the history of America a presidential candidate ever sold his platform into a book. And a lotta things I talked about in the book, now I see a lotta other people talkin' about. So if for no other reason than the fact that a book was published—I'm talkin' about how to solve a lotta the social ills that exist in the country today—I think we won a tremendous plus.

SMITH: Do you see yourself running for any office other than president?

GREGORY: After you run for president, it's very difficult to step down. See, I had another thing goin' for me—I turned on my television about a minute after six on election night when the polls closed, and I got that first ghetto precinct that came in. I was leading Humphrey and Nixon. So at that split second, I felt like I was the president.

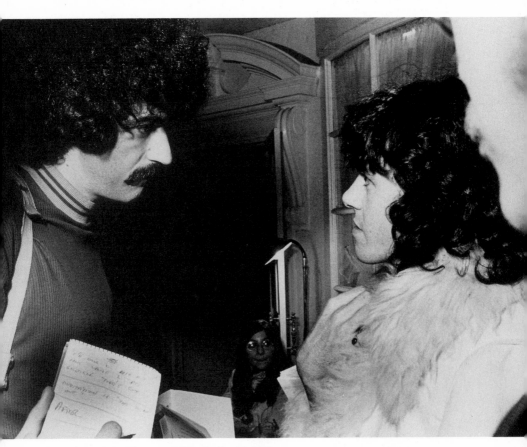

Howard Smith and Donovan, N.Y.C., October 14, 1969

Jerry Wexler
November 1969

Jerry Wexler, known for coining the term rhythm and blues, *runs Atlantic Records with partners Ahmet and Nesuhi Ertegun. He's always been close with his artists, and has personally signed and/or produced some of the biggest, including Ray Charles, Aretha Franklin, Led Zeppelin, and Bob Dylan. Wexler is currently number one on the list of producers with the most hits on the Hot 100. Next month,* Billboard *magazine will feature an article of his, titled "What It Is—Is Swamp Music—Is What It Is."*

...

[*On the phone from Los Angeles.*]

SMITH: What was the most interesting thing, musically, for Atlantic Records in '69?

WEXLER: Oh boy. The year covered so many facets....Let me tell you what the most interesting thing for me personally is in the general scope of music. I think that there's a definite trend back toward what I call "swamp music" that has turned a lot of people—

SMITH: Swamp music?

WEXLER: Yes. As a matter of fact, I've written a piece for *Billboard*—Paul Ackerman asked me to write on any subject, and I wrote this because I feel that there's the emergence of what you might call "American root music." It's country-funk, white rhythm and blues. There's a lotta ways to describe it. But I can illustrate it by the emergence of people like Creedence Clearwater, Delaney & Bonnie, Tony Joe White, Dr. John. You know, it's a very special kind of music. It doesn't depend, for example, upon a lot of high-powered, souped-up electronic work. It doesn't depend upon extreme equalization, echo, feedback, but rather it's basically southern R & B music with a country aspect to it.

SMITH: You think that's where it's going to now? Or that's what's already begun to happen?

WEXLER: I think it's an emergent trend that's right in front of us. This all has to do with the Memphis / Muscle Shoals ambiance. Right? This is an interlocking network of southern musicians—they all know each other. Some of them are studio men; some are group men. Take Duane Allman,

for example, who comes from central Florida originally. He's very much into this thing. It's southern, country-born musicians who've gone for the blues.

SMITH: Atlantic's always been very strong on soul music, and I've heard that that isn't selling as well. Is that true?

WEXLER: Absolutely true.

SMITH: What was the biggest year for that, '68?

WEXLER: We've always been very, very heavy in soul music: the relationship with Stax and Volt, you know, the Memphis thing with Rick Hall that brought us a lot of great product with Joe Tex....

SMITH: Which was your biggest year?

WEXLER: Well, I would say '68 probably was the high point in actual volume. I can go back to '55....

SMITH: Was '69 a big drop-off...?

WEXLER: Enormous.

SMITH: What was your biggest album at Atlantic in '69?

WEXLER: I guess it would have to be *In-A-Gadda-Da-Vida*.

SMITH: It came out in '68 though, right?

WEXLER: It just reached two million copies, you know.

SMITH: You mean it sold for Atlantic more in '69 than any other album?

WEXLER: Two million units. I'm at a disadvantage here. I'm in California; I don't have my data with me. But I would have to say...Let's see, what were all of the big albums?

SMITH: Blind Faith.

WEXLER: Oh, well, I would say that they sold more, yes.

SMITH: How about a single? Which one was your biggest in '69?

The Led Zeppelin record has just passed a million copies and that is in, what, five weeks!

—Jerry Wexler

WEXLER: I'm sure it was one of Aretha Franklin's—because she had all the million sellers. What else did very well? Oh, the Rascals had a good year in '69. Of course, Iron Butterfly...oh! Led Zeppelin. It's still '69, isn't it?

SMITH: Yeah.

WEXLER: Well, the Led Zeppelin record has just passed a million copies and that is in, what, five weeks!

SMITH: Wow!

WEXLER: It was a gold record before it was issued, but it's over a million units now. That probably was our leading record seller of the year.

SMITH: So you had "iron and lead"; it was a good year.

WEXLER: And, of course, it was very exciting for us that we were able to acquire Delaney & Bonnie's contract. As you know, they're working with Eric Clapton. They'll be recording together and touring together, and Eric will be producing their album. And Delaney is producing an Eric Clapton album right now. Howard, you're quantifying this thing: which one sold the most, which was the biggest. I'd rather think in terms of what were the more relevant emergent groups and trends. Crosby, Stills, Nash & Young was a tremendous thing for us this year, as well as the Zeppelin and the continuation of the Iron Butterfly. Oh my God, so many happy things happened this year. Another thing is our arrangement with Kenny Gamble and Leon Huff to produce for us. They made a beautiful album with Dusty and the first record is out, the single, and it's a big hit: "A Brand New Me." And they've got a lotta tape.

Audiotape brand 7" recording tape box

John Lennon and Yoko Ono
December 1969

John Lennon and Yoko Ono have been busy. In the last two weeks they've released a live album; played a benefit concert in London with George Harrison, Eric Clapton, and Delaney & Bonnie; and been filmed for two British documentaries. Two days ago they rented billboards in twelve cities around the world that read, "WAR IS OVER! If you want it—Happy Christmas from John & Yoko." They're now in Toronto where, earlier today, they held a press conference to promote their planned Toronto Peace Festival. Ono asked Smith to meet them in Toronto and help convince Lennon that New Yorkers would love to have him living in their city. Four months from now the Beatles will break up.

...

SMITH: What'd you think of the press conference today?

LENNON: It was very good. They were all tense when we came in—so were we—and it was relaxed by the end of it...The press in Canada are pretty straight with us.

SMITH: And not elsewhere?

LENNON: See, in London we have the worst time. They've always treated Beatles like private property. They think they have—well, they do, because we came from there—they have this parent-child relationship with us. The press is generally doing that bit about, "We're not being preached to by some middle-aged, past-his-best Beatle; no entertainer should open his mouth" kinda bit. That's the attitude they usually take in London. So all our best work is done abroad....The only way to get the British interested is to leave and do it somewhere else.

SMITH: Is that how they treat other entertainers in England also?

LENNON: Oh, sure, yeah. They sort of have a little snob thing about America—the way they treat their entertainers: "You ain't in America now, boy." They did that to the Stones when they got back.

ONO: It's the classic case of your hometown treats you differently, indifferently.

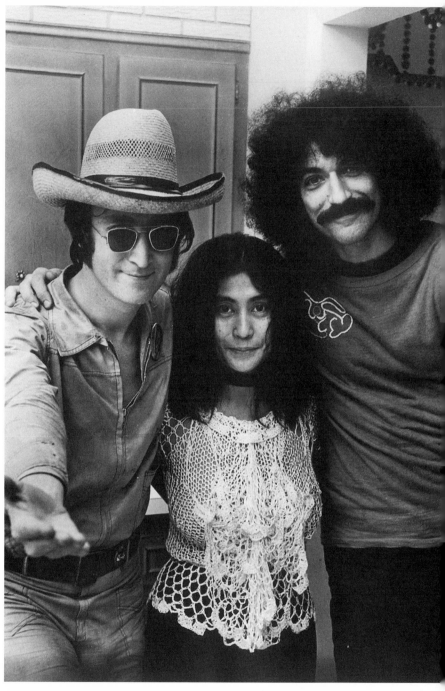

John Lennon, Yoko Ono, and Howard Smith at Allen Klein's party for Lennon's 31st birthday, Syracuse, NY, October 9, 1971

JOHN LENNON AND YOKO ONO

SMITH: Do you feel these things you've been doing for peace really will have an effect?

LENNON: It's like asking Coca-Cola, do you think these stupid little ads have effect? I was in the Himalayas and they have Coca-Cola; they didn't have anything else.

SMITH: But with Coca-Cola, it's something that people seem to feel they need.

LENNON: Who needed soap before they sold it to us? We didn't have soap. We didn't have Coke. Who needs Coca-Cola? We had water. Who needs any soft drink? Who needs most of the stuff we've got in our houses? Who needs it? But now once you get 'em hooked on it...I think we can get people hooked on peace.

ONO: Now it's a part of culture.

SMITH: There are times I think that it's just part of our own upbringings that we think there are solutions to a lotta problems, and I'm not so sure myself that there is—

LENNON: Yeah, I've gone through that too.

SMITH: —ever gonna be peace.

LENNON: Of course, I go through that—but the alternative is to do something or not to do something, and to do something is better than not to do something.

ONO: If we can make it happen, that's the thing.

LENNON: We have that choice, what little choice we have, of doin' or not doin'. And we're plum for doin' when we've got the energy and we're not too paranoid—we *do*. When we're in the other mood, we hide. And then we come out again and *do*.

SMITH: Maybe I'm more cynical, but selling peace as a commodity?

LENNON: Well, why not? Howard, don't you see that they sell war all the time...that John Wayne has been sellin' war since I was a kid....So all I'm tryin' to do is get as much space, film, 'n' song about *peace*, that's all. Just to give it a chance...Every night on telly they sell war, every other film—they sell war and violence. All I'm tryin' to do is equal the balance a bit.

SMITH: Why did you decide on billboards this time?

LENNON: It was a poster event—Yoko's idea originally. We tried one poster event in New York; it never worked. One person went round with a poster on his back. It was to do something for Christmas. We did have some vast plan but we just didn't have the energy. Maybe we'll do it next time.

All our best work is done abroad....The only way to get the British interested is to leave and do it somewhere else.

—John Lennon

SMITH: But putting up a billboard like that, I was wondering whether the average person on the street would understand what you meant.

LENNON: It's as simple as—we can only do what we do, and that's the way we think, and that's the simplest thing we've done....The songs are man-in-the-street ideas. They get through but we can't just sit on the records—I can't keep writing "Give Peace a Chance" all the time. I'll have to think of another slogan or something, you know what I mean? They only come now and then. So we've got to do *everything*: posters isn't our only answer, we're trying to do TV, film, acorns...

ONO: You know about the acorns.

LENNON: Anything. Whatever idea we have, if we can put it out, we put it out. If it's the guy in the street or the guy in the office or the president, maybe some of them will *get it*. That's all we can do is keep sending out the message in different form, in different language; it's the same message all the time.... We only could try it. We don't know how people will be affected by it.

ONO: Pessimism is not gonna take you anywhere—we have to do *something*. We're waiting until we die or whatever. While you're waiting around, what are you gonna do, just cry and be bored? Or are you gonna make something out of it?

SMITH: Will there be more Beatles records coming out soon?

LENNON: There's a Beatles album coming out in January, which we finished a few months back—that's the next thing—and a Beatle film.

SMITH: Which album?

LENNON: *Get Back*. It was the one that was scheduled for before *Abbey Road* but now it's after it, to tie it up with the film, which's a documentary of us suffering while making the thing.

SMITH: Why suffering?

LENNON: We were goin' through hell. We often do.

SMITH: How? I don't understand....

LENNON: It's torture. It's torture every time we produce anything. Any artist, poet, whatever you call yourselves, listenin' know what it's like. Well, the Beatles haven't got any magic that you haven't got. We suffer like hell every time we make anythin'.

ONO: They're flesh and blood....

LENNON: And we've got each other to contend with. Imagine working with the Beatles, man. It's a tough scene.

SMITH: Whose songs will be on the album?

LENNON: The *Get Back* one?...It's a strange album; we never finished it. We started off with this intention of doin' a TV show or somethin', and

Dear How are you?

 you were supposed to have your "Attica State" and/or "the Luck of the Irish", did you? well anyway here's a consolation scoop!

 Happy Xmas

 John + Yoko.

P.S. listen the snow is falling!

Letter from John Lennon and Yoko Ono, January 1972

it went on and on and on and we didn't really wanna do it and Paul was hustlin' for us to do it and we didn't really wanna do it and we never did it and we never finished the album. So we never quite finished the songs: we put it out like that. And there's bits of us mumblin' and chattin' and singin' old rockers and all sorts of messin' about.

ONO: It has a very nice improvised quality about it.

LENNON: It's the Beatles with their suits off.

SMITH: How do you decide whose songs get on, now that George seems to be writing?

LENNON: We hustle for it. I mean, in the old days, Paul and I won. That's the problem. I don't know, personally, whether there'll ever be any more Beatle product with the four of us on again. That's a decision we make every time, but it gets harder. In the old days Paul and I'd write most of the songs, because George wasn't prolific. We encouraged him to an *extent*; subconsciously, we would've just made sure we got the LP for ourselves. So now he is prolific: now there's three of us all trying to squash ourselves onto that fourteen tracks. And then there's the bit about…you prefer your own songs.

> **And we've got each other to contend with. Imagine working with the Beatles, man. It's a tough scene.**
>
> —John Lennon

ONO: Every one of them has thirty songs, then what do you do.

LENNON: Do we make a double album every time? That's six months out of your life just to get an album out. That's why I broke out with the Plastic Ono bit—make my own stuff on the side. I can't *wait* to get two tunes on an album, and the same goes for the others.

SMITH: Why does it take so long to record?

LENNON: We used to do 'em quicker. But now we just like certain sound, so it takes a bit of time. If you want what you want, you have to take time over it.

SMITH: Do you know what you want when you go in? Or literally work it all out in the recording studio.

LENNON: Usually work it out in the studio…We have 'em usually written in quite a finished state, but to get the *sound* that you have imagined is the hard thing. I usually say things like, "'Heartbreak Hotel' this is." And just do it that way—I have some other song in mind to say, "That's what I'm going for." We always used to do that in the old days, tryin' to tell the EMI engineers in 1960, "We wanna sound like 'Be-Bop-A-Lula.'" "What's *that*?"

SMITH: Do you get into arguments among you while recording?

LENNON: It's not so much arguments, but there's just tension. It's tension every time the red light goes on, for a kickoff. And gettin' four of you to groove at the same time is difficult with *any* band. You get two going, and somebody else drops out halfway through and gets paranoid and screws it. We're always goin' for *perfection* and because you never achieve it, that's why it takes so long.

SMITH: You said you don't know if there'll ever be any more Beatle product—

LENNON: Well, there'll be plenty of Beatle product—but whether we ever get together and do it again, I don't know.

SMITH: There are always rumors that go around all the time that you're breaking up.

LENNON: Yeah.

SMITH: Is that true?

LENNON: Well, we've had Ringo leave once. George has left once for a couple of days.

SMITH: Is that the longest?

LENNON: Usually.

We're waiting until we die or whatever. While you're waiting around, what are you gonna do, just cry and be bored? Or are you gonna make something out of it?

—Yoko Ono

ONO: I'm sure every group goes through things like that, but because they're in such a limelight, everything they do—like he just shaved off his beard and that was big news....

LENNON: It gets blown up. George had an argument with Paul, and in the papers it was that me and George had a fistfight. So it gets blown out to ridiculous things like the Paul rumor.

SMITH: Have any of you ever had fistfights with each other?

LENNON: Not ever. I think I once threw a plate of food over George in Hamburg...

SMITH: Would there be any chance that the Beatles will tour again?

LENNON: I'd say it's a ninety-to-one chance they won't. It doesn't sound very inviting to me, *touring*. Tourin' was a drag.

SMITH: Why?

LENNON: It was just complete madness from mornin' till night, with not one moment's peace. And livin' with each other in a room for four years on tour...Of course, there were great moments, and whenever we talk about it, it's all *laughs*. But when you get down to the physical reality, it

John Lennon, Yoko Ono, Miles Davis, and others attend Allen Klein's party for Lennon's 31st birthday, Syracuse, NY, October 9, 1971

was all *pain*. Because there was nothin' in the music. We weren't gettin' any feedback. We'd just go on and we weren't improvin'. We were just churnin' out the same old...Half the time we'd just mime on the mic, because your voice had gone and the kids would just be howlin'. You'd get kicked, beaten up, hustled, pushed....

SMITH: But that might not happen *now*...

LENNON: I'll give you ninety dollars against one, or whatever the odds are, that if we came on the road again—maybe the first time it'd be like that just again. Because the *myth* still exists. I can judge it by the reaction to one lone Beatle and his Japanese bride wanderin' round. You multiply that four times, and the hype and the pressure that'd be out and the publicity that would go with it. You saw what happened with the Stones. They hadn't done it for four years in the States—it was like Stone mania again. So, if the Stones can do it the Beatles certainly would do it. And the way the Beatles did it—

SMITH: How long has it been now?

LENNON: Four years or five. I'm not against performing, but performing as a Beatle is like—there's such a myth and an aura about it that they expect Jesus, God, and Buddha to come onstage. It's like the Isle of Wight Dylan concert: he was beautiful, the whole atmosphere was beautiful, but the way it was written about, it was a big *disappointment* because they were expecting God to come on and lay it on them—the press, especially. And for the Beatles to come on, we'd have to come on and do a miracle.

SMITH: You don't think that it's just a lotta people out there wanna see you perform live?

LENNON: Yeah, but it's anticlimax, the buildup of the myth. The myth is bigger than the actual four human guitarists—three guitarists and a drummer. The *myth* is bigger than the *reality*. So I'm inclined to leave 'em with the *myth*. If the Beatles would split open the group a bit and have Yoko, Billy Preston, Bob Dylan, Eric Clapton, Elvis Presley in the group,

JOHN LENNON AND YOKO ONO

I might be interested. But as the Fab Four, I'm not personally interested in goin' out like that.

SMITH: Are any of the Beatles?

LENNON: A few months back it was *George* that didn't wanna work. I tried—there was a point where I was tryin' to get him on the road again. I thought, "It'd be good. Come on, let's go." I ended up out here on me own, rockin' with Yoko. And now, course, George is on tour with Bonnie and Delaney and Eric Clapton. He's out there now playin' and he performed with me the other night for the UNICEF thing. In fact, it was great: we had the whole Bonnie and Delaney band and the whole Plastic Ono Band, seventeen people playin'. It was fantastic. We did two numbers, "Cold Turkey" and "Don't Worry Kyoko," and they lasted one and a half hours. I'd like to come and play *that* in the States, but I don't wanna go on as the myth.

SMITH: I'd heard that Ringo…was the main one that wanted the Beatles to dissolve.

LENNON: No, no. There's no *main one* that wants the Beatles dissolved. There's no decisions like that being made. We're just four guys with different points of view, who change every now and then, and decide they wanna do somethin', decide they *don't* wanna do something. We're just like any one of you, but we're in the public eye, so all these myths grow up and all these stories, but we just change our minds every now and then.

SMITH: But they're pretty spectacular changes, I mean, goin' from the whole drug thing to the Maharishi thing and now the peace thing.

LENNON: But I mean, lotsa people been through those trips. *Everybody* went through acid. Everyone who's anyone went through the acid trip. Millions of people've been through the yoga-meditation trip. I'm now on the *macrobiotic* trip. Everybody's goin' through it *all the time*; it just so happens we do it in public. But us two, John and Yoko, have made use of goin' through our changes in public and make it into an event.

Like [Jean] Genet and them, writin' plays about a strange couple and makin' it into "theater," quotes, or "art," quotes. Instead of doin' that, we're livin' it. We're doin' it *now*, not puttin' it down on paper and gettin' someone to perform it later. This is twentieth-century theater, art, music, whatever you call it. We're livin' it.

SMITH: In spite of your dedication to a pacifist ideal, the world does seem to be goin' the other direction…the Arab-Israeli war, the thing in Greece and Vietnam—

LENNON: Is it any different from it was twenty years ago or a hundred years ago? It's not *going* anywhere. It's static, *violencewise.*

SMITH: Which goes to my thinking, maybe there won't be peace ever.

LENNON: Listen, do you believe this last decade, the sixties, produced negative things? I believe this decade produced positive things: the whole youth movement, the Woodstock—

SMITH: What has the youth movement *produced?* I'm aware of the youth movement more as a *marketing* concept, it seems.

LENNON: No. What about Woodstock, man?

SMITH: What has Woodstock produced after Woodstock?

LENNON: Not *after* Woodstock, Woodstock *itself*: the thing, the power and the positive message that came over to all the kids in Britain, all the kids round the world. The fact that so many people were in one place on earth...and weren't there to kill.

ONO: They weren't soldiers.

LENNON: The fact that that happened is worth *everythin'*! That is so positive and fantastic that—

SMITH: But I'm sayin', what did that *change?*

LENNON: It's never happened before! That's the first time it's ever happened. So if before it, would you have been sayin', "It would never happen; you couldn't have two hundred thousand people..."?

SMITH: Four months later, in San Francisco, we have almost the same amount of people and with *violence* at the Stones San Francisco.

LENNON: Because there's always—

ONO: There's always cancer somewhere.

LENNON: The *yin-yang* bit. It's probably the negative. But the Stones thing wasn't set up in the same spirit...as the Woodstock thing. It was a completely different scene. The Stones' whole image, their whole idea, the thing they put over, wasn't Woodstock. They have a different way of thinkin', a different vibe, and that thing happened because of that.

ONO: But what you're saying is, it's like saying, "All right then, no babies are born in the world because so many people are dying." We *have* to just go on producing positive....And what you're saying is: "You might be doing that but look at these people; they're dying." But all right, some people are dying but then at the same time, you can't deny all the babies born.

SMITH: With the Panthers...The police on one side say it's the Panthers that cause it because they arm themselves; the Panthers say they've just been murdered. I mean, twenty-eight Panther leaders in the last two years are dead.

JOHN LENNON AND YOKO ONO

ONO: Can we say that the sixties was just a start and we're still in the primitive age—

SMITH: How would pacifism work in the case of the Panthers?

LENNON: I have no idea, because I don't know the ins 'n' outs....I just know that whatever the *monster* is, as Dick Gregory puts it to me, the monster is insane and getting careless. And when it's *careless*, that means it's out of control, and that's our only hope....All I've got is hope...I believe in magic. I believe in evil, but I don't believe in good 'n' evil, and I think that's what it is. And we have to fight it on all levels, as well as in the street. Of course, if people put more questions to me about it, I can't answer. When I believe in magic, what can I say? I'm an idiot. But that's what I believe in: power and vibration, and that's what's going on.

SMITH: In the States...couples and marriage seem to be virtually on the way out. You seem very, very close. What's your secret?

LENNON: It's called *love*. We've had previous marriages and they're the ones you're talking about. Whether you're getting married or not is up to yourself. But love is *our* secret, and there's nothing that splits that up. I mean, you've gotta work on it—it is a precious gift. And it's a plant and you've gotta look after it and water it. You can't just sit on your backside and think, "Oh, well, we're in love so that's all right." But that's the secret. It's all true, folks: all you need is love.

SMITH: But what is it that—

LENNON: I don't know how you get it; it just *comes*. I can't give you the formula for meeting the person you're gonna love. But it's around. And it happens. It happened to me at twenty-nine and Yoko at [mumbles]—

ONO: Whatever.

LENNON: But it's a long wait. I thought it was an abstract thing, you know—when I was singin' about "all you need is love," I was talkin' about something I hadn't experienced. I'd experienced love for people in gusts and love for things and trees, but I hadn't experienced what I was singin' about. It's like anything: you sing about it first or write about it first, and find out what you were talkin' about *after*. So that's why we say, "Think positive." Even if you con yourself into it and it happens later, like all these novel writers in the nineteenth century always wrote their lives out before it happened. And if you write out a bad scene for yourself, I think you get it. And wondering about them books I wrote in 1964, they're pretty screwed up and I'll have to wipe them out before *that* happens. I can see me in a wheelchair—

SMITH: Why do you think other couples seem to be havin' such trouble getting along?

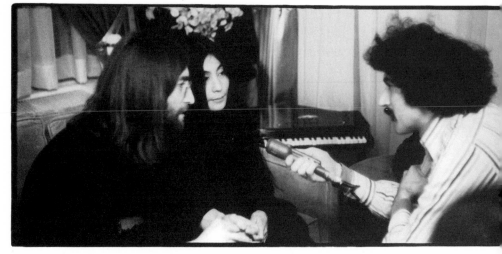

Howard Smith interviews John Lennon and Yoko Ono at Ronnie Hawkin's ranch outside of Toronto, Canada, December 17, 1969

John Lennon, Yoko Ono, Jerry Rubin, and others at Allen Klein's party for Lennon's 31st birthday, Syracuse, NY, October 9, 1971

LENNON: I don't know. It's just that they're sayin' it now. In the old days they pretended that it was all goin' all right. Now they're saying, "Christ, man, this is nowhere; drop out; get rid of her" or whatever—that's all I see. They're just ownin' up now that it doesn't work in just choosing the right guy with a nice job and she's a nice family and all that. It's not marriage or love that's not working; it's just that people are ownin' up.

ONO: I never thought that it would happen in this late stage of my life. I was startin' to give up hope, becoming very cynical. But it happened and it's very, very good. And the thing is, I think most people, aside of not having the luck [of "it] just happened"—I think, because the whole society is geared toward that thinking that it's almost silly to be in love and stay together, it's not very fashionable, is it? It's that bit too.

When I was singin' about "all you need is love," I was talkin' about something I hadn't experienced.

—John Lennon

LENNON: Yeah, and as soon as they get together, the whole place is set up so as the guy has to work in Vancouver and his wife lives in Los Angeles, and everybody accepts that right away. Sure, we could never possibly work together, because women can't get a job and men all have to work together. So the whole place is geared to splittin' you up as soon as you get together.

ONO: Even us. Don't you think that, almost subconsciously, people tried to just split us up in a way? It's very strange, very subtle things. They don't even notice it probably.

SMITH: How do you mean?

ONO: Well, the simple form is…say if somebody quit drinking and all the people who still drink are sort of nervous. So they say, "Why don't you drink just one. It's okay." And subconsciously they want this guy to not stop drinking. Because everybody else is sort of unhappy or whatever, it's "Come on now; you're not serious."

LENNON: "Come on, John, you're a musician…." It's just subtle and it's not evil intent. It's just the way people do it with the drinks when you give up smoking: "Come on, have a cigarette; have another bar of chocolate."

SMITH: Marriage itself, as an official ceremony, seems to have somewhat gone out of style. How come you decided to go through with a regular marriage?

LENNON: Because we turned out be romantics. We went through the whole intellectual bit about marriage and it's a bit of paper that some guy gives

you. And that's all true. But when he gave it to us, it was very *emotional*…
It's completely against what I thought intellectually, "Once, never again
if I get out of *this*, man. What a joke it all is." The next minute I'm stan-
din' there and she's cryin' and it's like we're soft *kids*. So we're romantic
and it *made* a difference.

smith: Do you ever listen to your own songs when you're just around the
house?

lennon: Sure. But normally when we've just done it or six months after to
see what you meant. In the old days we used to make an album and listen
to it and then forget about it. Then make another one and I'd play 'em
both, one after another, to see where it was going. But we got so many—I
tried sittin' there, like, with the Beatle's double album and everything
right back to *Please Please Me*—I just couldn't sit through it all. To see
what happened, listenin' to it one after another, I couldn't make it. Not
'cause I wasn't enjoyin' it, but there's just not enough time.

smith: Something like *Sgt. Pepper*, did you listen to it six months later and
go, "Why'd we do *that*?"

lennon: No. I used to think that more in the early days, all embarrassed
about the early stuff we did. But I got over that. I don't regret anythin'
we've done. I just have preferences for tracks, but I don't regret *any*
record we ever made. It was just us then and it's valid…That was where
we were then. I think everybody's in that state, every record or book, art,
or anythin' is a reflection of where the person's at the moment he con-
ceives it and puts it into action.

smith: Let's say you do find yourselves, all four of you, back in a record-
ing studio three months from now: what do you see?

lennon: I can't imagine at *all*. I don't think of it in terms of Beatles
music. It's only Beatles music when it comes out under the name *Beatles*.
There's no limit to where anybody's music can go. I think Beatles stood
still a bit too long after *Pepper* and they've gotta freak out a bit more.
That's where I'd push 'em.

smith: Do you think that's the general feeling?

lennon: You see, because we're all different, we all have different con-
cepts of how far you go. I say, "Go as far as you can." I can't quote for
the others but we don't all think the same. That's why we make individual
music. See, on the Beatles double album, "Revolution Number 9" is the
track I'm interested in. I had to impose that on them, really. I'd like to just
be able to go there, that way—I still like off beats.

Howard Smith

Howard Smith is our link with the rapidly changing social and music phenomena. His interviews and observations help provide the involvement our audience seeks from a radio station.

A native New Yorker, Howard is also the assistant publisher of The Village Voice, the most widely circulated 'alternative newspaper' in the country. His association with the Voice has put him in contact (and often friendship) with political, social and entertainment industry leaders. Because of this, Howard has been able to bring our audience exclusive interviews with a wide array of guests: from Dick Gregory and Norman Mailer to John Lennon, Jimi Hendrix and Peter Fonda.

Howard interviews his guests at length . . . often two hours or more, and then excerpts the best parts for on-air presentation in capsule form. Howard is totally mobile, travelling across the United States and into other countries to track down good interviews and provide interesting observations and comment. He was with Mick Jagger and the Rolling Stones during their last American tour, beginning in California and winding up in New York. To get one of the most in-depth interviews ever done with John Lennon and Yoko Ono, Howard flew to Toronto and spent one whole evening talking with them in a friend's private town house.

Howard's capsule features are heard throughout the day. His articulate, no-nonsense approach to interviewing and reporting often uncovers news long before it reaches other media. This has been a key factor in attracting an alert, interested audience that is excited about change . . . whether it be in society or in an advertiser's product.

1970

Artie Kornfeld
February 1970

Artie Kornfeld was the vice president of rock music at Capitol Records when he and his friend Michael Lang (coproducer of the 1968 Miami Pop Festival) came up with the idea for Woodstock. They found business partners John Roberts and Joel Rosenman to put up the money, and, in a matter of months, pulled it off. Things did not go smoothly, however, and since the festival, that partnership has fallen apart. Kornfeld and Lang recently signed away all ownership rights, and debt obligations, to their own festival.

SMITH: Artie, here it is almost six months after Woodstock. What does it feel like that far away from the event itself?

KORNFELD: Well, what's happened is Woodstock has become to me, I guess, what it has become to everybody who was there, and I look at it the same way: you almost feel detached. I don't feel any more a part of it than anybody else who was there or who was a part of what happened there. And it sometimes really blows your mind to just hear all the things going down about it now, and how people are getting into it and trying to study it and trying to see what happened. I guess anybody who was there saw what happened. It's just sorta like being removed and yet feeling very good. And every time a film clip comes on and there's something written about it, I guess you read it or you see it and you sort of feel, you get that sort of, like, tears come to your eyes. I imagine that anybody who was there has the same feeling.

SMITH: In hindsight, what would you have done differently?

KORNFELD: I think that we, being Michael and myself, would have done what we did the way we did. I don't think we would have done anything differently. I think that Michael's staff and the people that worked for us and with us were all excellent and dedicated and all did a fantastic job.

SMITH: No, I mean would you still have done it as a free show?

KORNFELD: Well, I wouldn't have had the same partners; that's the first thing we would have done differently.

SMITH: But they gave you the money.

KORNFELD: Yes, but the thing that people don't realize is that there were two or three groups of people that had come up with it. The reason that we went in with those partners is that we felt that their function would be strictly financing and not attempting to get into any of the business that they didn't really know about, and they never intended to in the beginning. I guess just the excitement of it swept them into it. It is just, like, I'm sure Joe Namath wouldn't step on the court with the New York Knicks and think he could do a good job, you know? And everybody being the same, it's just a matter of doing what you personally can do and knowing what you can do and what you can't do. I think that, yes, if it could be done all over again, and the point to be made is that many, many times Michael was over here and we went through the riff of it being a free festival, a nonprofit festival, and I think the proof will be if we do another festival.

SMITH: But in hindsight, what I meant is, if you could do it over having known what already has taken place, how would you, at the same exact festival, have kept it from being a free festival?

KORNFELD: No, I wouldn't have done it. I woulda made it not a free festival but a nonprofit festival right up front.

SMITH: How would you have collected money, though?

KORNFELD: Oh, we would have collected money—

SMITH: How?

KORNFELD: Well, it would have been the same. To carry out the festival that went down takes X amount of, as a business community says, dollars.

ARTIE KORNFELD

Okay? For people to have music on stage, and for talent to perform, you have to come right up front and say, "This is nonprofit and you have to do it for just your expenses, and we're gonna get together and have a big party, and it's gonna be all of our party and we're all gonna enjoy it—"

SMITH: But how would you have collected whatever the money is you would've needed from…?

KORNFELD: All in advance.

SMITH: All in advance? And it would have been no gates or anything.

KORNFELD: No, no gates. I don't think that you can build fences strong enough to keep out the spirit of the people.

SMITH: Why would anybody send the money in advance if there was gonna be nothing…?

KORNFELD: Because there are logistics that can be considered, now that the experience of doing something like this has already happened. You know that's done and now we can benefit, and on the next trip we'll make the advance setup; people will know it's nonprofit. There'll be no gates but perhaps there's a better way of collecting tickets. Maybe cars won't even get to the area unless tickets are collected at the cars before they even get near the site. That's one possibility. If it's nonprofit and it's for the community by the community, then I don't really feel that people will be tryin' to, I mean, tryin' to *take* yourself. It's sort of weird to hurt yourself, and if it was nonprofit up front, then there's no reason for it. Then if people can't afford it, they can always find a gig at the festival.

SMITH: Okay, now you and Mike split off from John?

KORNFELD: Right, we split from the business people, the money people.

SMITH: What are your plans now that you have split off?

KORNFELD: We have two simultaneously happening things. One thing is that Michael is so into the community and into the culture that we'd been tryin' to think of ways to get people involved, to get people interested, to keep that spirit happenin'. We're also trying to survive and keep alive. I've been producing records for seven years and I'm gonna continue producing records for our record company.

SMITH: Which is called what?

KORNFELD: We have no name yet, but it won't be called Woodstock Records.

SMITH: It won't be?

KORNFELD: No.

SMITH: Are you planning another event next year?

KORNFELD: We're really tryin' hard to pull one off, yeah. And if it happens, and I'm a believer and I think it can happen, I think that it can even be a

different experience. I can't say it can be a better or bigger or a worser or whatever it is, but I think it can be another beneficial, really fantastic life experience.

SMITH: Where are you planning it?

KORNFELD: We're planning it, we are checking out numerous sites right now...

SMITH: What I mean is, East Coast? West Coast?

KORNFELD: Well, yes. East Coast, West Coast, and anywhere else we can get enough people together to have a big party. And if there were twenty places where a big party could be had, and if there are twenty groups of financiers that can be gotten together to put up the money, then we would definitely, you know, do it. I mean, even on a nonprofit basis.

SMITH: You mean you'd run them all simultaneously?

KORNFELD: Well, possibly. There's many possibilities and...

SMITH: Have other money people stepped forward with money for this?

KORNFELD: The point is there always are *money people*, but we're very hesitant, for obvious reasons, to get involved with money people. So what we've been doing for the last three or four months is we've been totally self-sufficient, and we haven't sold or given up anything to anybody. We've taken people in with us where there was no money involved and we've had people become associated with us on a participation level. But we're past the point of just going to people for money, because there's too

I don't feel any more a part of it than anybody else who was there.

—Artie Kornfeld

many hassles that can happen. Only because people come from different lifestyles and different backgrounds, and people have different values. And, like, at least we know each other and we know what our values are. We know the faith and the trust that we have in each other, and why even involve anybody else if you don't have to, on that kind of level? But there's plenty of room in the family for anybody who wants to be in the family, but they don't have to buy in.

SMITH: What other things are you working on? Any other projects?

KORNFELD: Well, yes, we are writing a movie. We created an idea and we're working on a script and a treatment right now. I really can't get into who it's with, but we've already discussed it with a producer and we're about to form a coproduction company to shoot this movie. And I think the movie will have the lifestyle of all the communities of the rock culture and of the drug culture, whether it be Coconut Grove or Sausalito or

Woodstock. It's gonna be about all of that, only it's going to be from a different approach—attempting to communicate exactly what's happening in a truthful light, the negatives and the positives.

SMITH: What else are you into?

KORNFELD: Well, I'm into a weird trip. I've been thinkin' it out quite a bit and digging what people like Abbie Hoffman and Jerry Rubin and those people are saying, and digging what the other people are saying, and just deciding that my personal involvement—I would really dig to get involved with some new political type of structure. Like, possibly a coalition party or something. And I have a campaign in mind to really get people from within the rock community to get out to...Believe it or not, man, I'm really into voting. I haven't voted in eight years but I've been thinking about it. And I think if we all get together and do constructive things, like get *us* to register and get *us* to be active in the city government, like, if we have the vote, then we can get our ideas across and that's the way I prefer to do it.

> **Joe Namath wouldn't step on the court with the New York Knicks and think he could do a good job, you know?**
>
> —Artie Kornfeld

SMITH: I've heard around that you and Mike have been flying all over in a private Learjet, all over the country? Is that true?

KORNFELD: No, I mean, we'd like to!

SMITH: What about chauffeur-driven limousines?

KORNFELD: Chauffeur-driven limousines when there's a great many appointments to make and it would be impossible to get around any other way. Or when you're too stoned to wanna drive. And, you know, you don't always have to pay for those things. Usually they bill ya.

All-access pass from the Woodstock Music & Art Fair

THE SMITH TAPES

Jerry Garcia
February 1970

The Grateful Dead have been on a roll since the success of their latest album, 1969's Live/Dead, *on FM radio, which has finally given them a broad, national fanbase. In the midst of a hectic month crisscrossing the country, the band is at the Fillmore East for four nights, sharing a bill with the Allman Brothers Band. In a few weeks manager Lenny Hart, drummer Mickey Hart's father, will steal all of the Dead's money—$155,000—and disappear.*

SMITH: That whole Altamont Stones concert…Seems like a lotta people are trying to dump on the Grateful Dead for that.

GARCIA: Oh, I don't think so, man. I mean, if that's happening, I'm not aware of it.

SMITH: They're sayin' the Grateful Dead are responsible for the Hells Angels being hired.

GARCIA: Well, in a sense we are, man. We're responsible in that we're the ones that started playin' for free….Like, starting to play *free* eventually leads to Altamont, if you go about it a certain way. Or if there are errors involved. But Altamont is, like, the other side of the Woodstock coin. It's another way for that whole thing to happen, and it's unfortunate but true. I mean, it really happened just like they told you it did. And so there's a fact there somewhere, a great big lesson for us all, every Head, every revolutionary, everybody who's considering what social changes are about and considering the way the world is gonna be. There's something to be learned from all that.

SMITH: Which is what?

GARCIA: Well, I don't know. Everybody has to look at it and find out. The results aren't in. I'm still learning. I'm still finding things out. I'm still talkin' to people….It was some kinda heavy thing, and nothin' heavy goes down without it being some kinda lesson or some kind of instruction, and it's a big price to pay.

SMITH: The main thing that's been pinned on the Dead is the hiring of the Hells Angels.

GARCIA: No, no, man. Nobody hires the Hells Angels for anything. The Hells Angels aren't *for hire*...See, there's nothin' like the Hells Angels on the East Coast....It has to do with the whole social structure of the West Coast. It's much freer than it is out here; it's not so organized. It's not a question of hiring or not hiring; it's a question of who is it that's gonna say to the Hells Angels, "Go away"? Nobody's gonna say that to the Hell's Angels, man.

SMITH: At Woodstock, at one point, a lotta Hells Angels showed up—

GARCIA: Not California Hells Angels.

SMITH: No—and somebody did go talk to them and they went away.

GARCIA: Well, they're not California Hells Angels, man. And also, Woodstock wasn't the Rolling Stones. See, those are a couple o' big things to make it different. For one thing, the Rolling Stones are one of the world's two most famous groups. And famous doesn't mean good; famous means lotsa people know about it. When you take that thing and put it in the headlines and say, "Rolling Stones gonna play free some- where around San Francisco," it means that *everybody* who listens to AM radio and who's heard o' the Rolling Stones, which is nearly everybody, is gonna go to that thing. Woodstock was Heads, largely. There weren't any Top 40 commercial huge groups there, in that sense...All the bands that played at Woodstock, their audience were mostly Heads. But the Rolling Stones, man, their audience is everybody. So when you have *free* a commodity that everybody knows about, everybody goes.

And the Hells Angels and the Rolling Stones, they're talkin' about the same thing, "Street Fighting Man." They're gonna go see them no matter where they are. When they played at Oakland, the first fifteen rows were nothin' but Hells Angels....Not only that, but there's a rela- tionship that goes on between the Heads' scene and the Hells Angels in San Francisco. It's like we know each other, because we kinda been out- laws for the past five years. We've all been on the other side. The people that went to see the Stones, they're mostly just people. So they don't know who the hell the Hells Angels are, man. They don't know that if you stand around in the middle of a buncha Hells Angels, eventually you might get hit.

SMITH: Can you see another rock festival happenin' through in that area for a long time?

GARCIA: If somebody still needs to go through rock festivals, they're gonna keep happenin', but it's not particularly what I wanna do.

SMITH: You've played a lotta them?

GARCIA: We played at the first one, the Monterey Pop Festival, and all the major ones pretty much. And it's really an old form already. It's an institution that should be happening. There should be some kind of huge festival goin' on with that kind of more-people-than-the-ecology-can-stand density happenin' twenty-four hours a day all year long somewhere so that everybody who feels that that's where it is can go there and do it and

What's to save for? I mean, who said there was gonna be a tomorrow?

—Jerry Garcia

split when they feel like it. It'd be like a perpetual trip. I can see a need for that, because everybody's talkin' about million people festivals....

SMITH: Do you like playing at festivals?

GARCIA: When they're outta hand it's more scary than it is enjoyable. You don't really have any sense of communication when you're lookin' out on a sort of anonymous sea of just...people. The sound is never very good when it's huge. You can't really be heard well. It's just not what I'm interested in doing. I don't think that kind of thing gets high on the level of, like, where music is. It gets high on a different level: on the people level, the energy, and social dynamics level.

SMITH: A lotta people who're into your kinda music feel that it works best when it's free and when you can dance.

GARCIA: I would add outdoors, sunshine, and a few other things if you want it to be *really* best. But also not a huge crowd. If you're talkin' about *my* best, I like to be able to relate to everybody, as much as I possibly can. When you get a huge crowd, you can't do it. You can't cover it. You can't tell what's goin' on. It's weird. It's freaky for me.

SMITH: Is there a difference in the audience when somebody's paid or they're in for free?

GARCIA: Well, there's free and *free*. The kinda free that I like is the kinda free where everybody's there to get high, not to go to a rock 'n' roll show. Every kinda scene that I've ever been into that was expressly set up for people to get high—that is, on any level you choose to experience that, whatever it means to you, like dope or spiritually or whatever it is that gets you high. If that's the orientation rather than free, it's a better thing, it's a bosser thing, regardless of whether there's an exchange of money or not.... That stuff doesn't really matter, unless you've got it in your head that it does.

SMITH: Do you rehearse a lot?

GARCIA: We rehearse a lot.

SMITH: What's "a lot"?

GARCIA: When we have uninterrupted periods of time, that is to say weeks, we go in every day to the rehearsal studio we have and put in about six, seven hours a day. And I practice with my instrument about three hours a day no matter what, just me and my chops. And then there's the thing of playin' together with the people that you're playin' with, so you're into each other's time sense, able to anticipate the movements. It's mostly a matter of keepin' the communications open, musically. And if we lay off for a week, we just play badly.

SMITH: Lotta groups talk about the terrific pressures of getting along with each other. Is that true of the Dead also?

GARCIA: No, we've already been through all that shit. We've been together for five years and most of us were friends before that. You get so everybody knows what everybody else is into so intimately, man, and that we've all been having more or less identical input, and we're in a unique position to be this high-energy trip, week in and week out all these years. It's put our heads in a very specific place. So we relate to each other better than to anybody else, in fact, because there's kinda, like, a group consciousness. There's each of us as individuals and then there's a group consciousness, which is us all. And that's our baby. We're only doing somethin' that's kinda like an experiment we got into some years ago. "Wow, wouldn't it be weird to play music together? Sure, why not." And then *bam*, we started doin' it, and it's a huge experiment and it doesn't really matter whether we make it or not. There's nothing to gain or lose. You see what I mean? It's not a game situation. We've agreed to do this trip and so that's all that has to happen.

SMITH: How about money? There's always this rumor the Dead have never made any money and they're always broke.

GARCIA: Oh, we've made lotsa money, but we got a whole big scene that we support, as well as all that equipment.

SMITH: How big a scene?

GARCIA: At the outside gettin' up to about fifty, sixty people probably.

SMITH: Consisting of *who*?

Music here should be the way it is in India. It should be holy.

—Jerry Garcia

GARCIA: Everybody, man, all our friends.

SMITH: You support all of that with the money you make?

GARCIA: Indirectly. We don't give everybody a certain amount o' dollars every week, but everybody eats; everybody has places to stay....What else is there to do with money?

SMITH: You guys haven't managed to save much, I guess.

GARCIA: What's to save for? I mean, who said there was gonna be a tomorrow? Remember, this is all an experiment, man. We started out with nothing, and nothing to lose, therefore. So everything's been gain since that point. It's like below ground zero, where they take everything away from you and leave you standin' naked, you still have your mind, man, and you're still you—whatever *that* is. There's nothin' to lose. That's what this all is; it's some weird adventure. And we get to play as much as we want, and not only that but they give us bread so that it can all be loose, for a good long time.

SMITH: What happens to the money, literally? I'm curious—

GARCIA: What happens to *your* money, man?

SMITH: I'm personally in control of it. But when it's a group and a big thing like that, what do you do?

GARCIA: Well, we got a guy that does money; that's his thing. It's Mickey's father. And in this last year we finally got outta debt, like, up to where we're kinda movin' along pretty evenly.... Who wants to bother with it, man? You can't eat it and can't get high from it.

SMITH: Did you always feel that way about money even before you guys started making it?

GARCIA: Oh, sure. Listen, we were all on the street for years. We were dealin'. We were musicians. We were goin' around from one dumpy... The whole San Francisco scene is a whole buncha people who've known each other for almost ten years now. Been playing in weird places, been unsuccessful for most o' those years, right? Starving, stayin' at each other's houses, dealing back and forth, gettin' high, all that. It's been goin' on for a *long time*, man, and all of a sudden in the past four or five years, here's this whole big trip goin' down. And it's just, somebody must be taking it really seriously somewhere but, you know, it's all so patently crazy.

SMITH: I've noticed that the audiences at Dead concerts are not a really typical rock audience. They tend to be a little older, for one thing.... Why is that?

GARCIA: Well, we're grown-ups, man; we play grown-up music. Whatever that is, that's just what we do. And so our audience is like other versions of us. It's the same people. There isn't any difference. Our audience is really groovy. It's really super. It's brilliant. It's sharp. It's smart. And it's groovy to have a smart audience that knows when you're gettin' on and when you're not. It keeps you on your toes and it gives you that impetus

to travel in a sort of upward arc, musically speaking. So if we had a stupid audience, we'd be able to get by playin' bad sets for a long time.

SMITH: How about in different parts of the country? Does it vary?

GARCIA: It's the same all over, man. The Grateful Dead audience is the Grateful Dead audience, everywhere in the country. No matter where you go, it all kinda looks about the same and does about the same things, gets high about the same.... The people that know about us are the people that know about dope, generally. That's the world that we're in, and so our audience is mostly Heads.

SMITH: The drug scene has changed quite a lot in the last five years, hasn't it?

GARCIA: It's everywhere now. That's what's different. Everybody gets high now.

SMITH: Do the Dead get as high as they used to?

GARCIA: How do you mean?

SMITH: As often?

GARCIA: Oh, sure, yeah.

SMITH: Generally perform high?

GARCIA: Sure, man, that's what playing is about. That's what performing is about for us. That's what music *is*; that's what music should do. It should be high. You should get high and any way you have to get high—Weir is on a whole special diet to get high. Pigpen's got his way of getting' high. It's not *my* way; it's *his* way. We've all got our own ways of gettin' high and we do what we do to get high, because that's what we're doin', is getting high. See, music should be that sort of thing. Music here should be the way it is in India. It should be holy. It shouldn't be business, and here it's business. And because music is business here, it's mostly awful. It's just plain bad; it's shitty, because it's designed to make money, not designed to do what music is supposed to do.

SMITH: And the West Coast is about the same?

GARCIA: It's a stoned place there. It's a way of life there that's been goin' on for a long time. It's working. The revolution's over on the West Coast.

SMITH: It's over?

GARCIA: Yeah, it's all working. It's *after* the revolution. This is postrevolutionary times.

SMITH: And yet you have an Altamont—

GARCIA: Man, that's a whole other problem.

SMITH: Charles Manson—

GARCIA: Those are *after* the revolution trips.

SMITH: *After* the revolution?

GARCIA: Sure, because those guys are us too. All that stuff is *us*. We only deal with it when it becomes manifest, when we suddenly realize it's there. It becomes a reality and then we have to deal with it. So Altamont comes up. Okay, maybe now we have a year before we decide to set up a situation in which that kinda thing can occur again. You know what I mean? It's like there's a responsibility involved in all o' these things, man, and when you turn somebody on, if you don't turn 'em on right, eventually they kill somebody. If you look at it in the most extreme, direct, sort of, from *this* event to *that* event.

SMITH: So that's sorta what Altamont was? A lotta people who weren't turned on right?

GARCIA: It was a mistake. Right, and to the wrong things. Altamont—the drugs there were mostly reds and juice, and those things aren't conducive to getting high, really. They're conducive to shutting things off. And shutting things off is the problem that the world is experiencing right now. See, Altamont was a microcosm of the world, which is us *all*, man. And it's one little scene, one little bit of virus, which is *really* the minority. Maybe two hundred people were hasslin' out of those three hundred thousand, but *everybody* in that whole crowd by the end of the day knew that there was violence goin' on, and it was the deepest, most basic psychic fear going through the whole crowd.

If there's any little part o' the truth that I can help uncover, that's what I'm supposed to do.
—Jerry Garcia

That's something really heavy and, like, that model is the model that this world is operatin' on right now, man. There's little bits and pieces of things goin' on here and there, and it's bringin' us all down a certain amount, and the only way it's gonna be dealt with is by each of us individually realizing what part they took in the murder, or what part they have to do with the war. It's, like, "When did *I* do that?" That's the only way those things are gonna work out, is by seein' that.

SMITH: Somehow I feel that you're being maybe too forgiving.

GARCIA: What's to forgive? There isn't any blame.

SMITH: There's no blame?

GARCIA: No. You can't operate with blame, because who're you gonna blame? You have to blame everybody....

SMITH: The guy who's visible on film that did the stabbing.

GARCIA: On the film he looks like a hero, man. Here's this guy runnin' toward the stage with a big fuckin' gun, and here comes this brave Hells

Angel outta the crowd and drops him. That's a heroic act, man. At any other time in history, that's a heroic act. That's a samurai trip.

SMITH: How come that guy is being depicted in the underground press as being *not* a hero?

GARCIA: Because most of the people in the underground press are lame and that's why they're in the underground press. Let's face it, the underground thing is like a hype too. There isn't any *us* and *them*. There isn't any underground and overground. We're all human beings, we're all on this planet together, and *all* the problems are *all* of ours. Not, "Some are mine and some are theirs." If there's a war goin' on, I'm as responsible as anybody is. If somebody's murdered, I'm responsible for that too. The question is, how can you have freedom and still work it out? See, Hells Angels have happened because of *freedom*. And they're a manifestation of what freedom is, in essence, and so at some point or another, somebody has to say, "There can be no Hells Angels," and who's gonna say that, man?

SMITH: Okay... Very good interview.

GARCIA: Well, I ain't interested in sellin' records. None o' the shit, man.

SMITH: Okay, I'll say that on the air: "Don't buy the Grateful Dead's records."

GARCIA: If there's any little part o' the truth that I can help uncover, that's what I'm supposed to do. Not sell records. Sellin' records is just bullshit. Take it or leave it, man.

> **Sellin' records is just bullshit.**
> —Jerry Garcia

Pete Bennett
March 1970

Pete Bennett, who started out as "just a kid from Yonkers," began promoting records with the Shirelles' 1960 single "Will You Love Me Tomorrow." Since then he's pushed over one hundred singles to the top of the charts and worked with the Supremes, Elvis, Frank Sinatra, Bob Dylan, the Rolling Stones, and the Beatles, to name just a few. He was the director of promotion for Apple Records but now works for ABKCO Music & Records. In 1972 Billboard *magazine will name him Record Promoter of the Year.*

SMITH: One of the things I've wondered: You're doing promotion for the Beatles' records, the Stones' records, Donovan's records too. Do they need promoting? Wouldn't they become hits anyway?

BENNETT: No, that's not the story. Everybody does need promotion, from the top to the bottom. Because hundreds of records are released every week—the station cannot play three hundred records on the radio...the station can play at most about fifty to sixty records. Certain stations play only thirty-five records. Doesn't mean the station's gonna play Donovan because he just came out wit' a new release and drop the other thirty hits on the station.

SMITH: It really wouldn't happen?

BENNETT: No, because the station has a meeting once a week, and sometimes they don't like the song Donovan puts out, sometimes they don't like the Beatles song they put out—maybe it's a lyric that's bothering 'em—so there always has to be a spokesman for these groups.

SMITH: So how do you do it?

BENNETT: You go around, and you talk about the group, and just be a pest. Go out to the station and just push your group. And you have to be ahead o' the next promoter.

SMITH: Do you know most of the people who program music at every major station?

BENNETT: Every major station throughout the country—I could say international, around the world.

SMITH: Which would include how many stations? Like, a hundred?

BENNETT: Oh, more than that. Personally, I know about three hundred.

SMITH: Do you visit them in person or is it done by mail, by the phone?

BENNETT: Majority of time it's done by the phone, but I make it my business to visit them in person whenever I'm out of town. And I do a lotta traveling through the year and I go coast to coast.

SMITH: You arrive into town and you call up the station manager?

BENNETT: Sometimes I deal with station managers, sometimes I deal with program directors, record librarians, I deal with disc jockeys; I talk to everybody. I also talk to the porter who's moppin' the floor, because to me everybody's important, no matter how big you are....To me, everybody's a human being.

SMITH: Then what do you do? How does it happen?

BENNETT: It's not an easy thing. I say record promotion's the most important thing in the record industry. It's the most important thing to an artist. People don't know—they hear a record on the radio and they go in the store and they buy it, but there's a lot of work behind the artist. [The] artist realizes himself how important promotion is, because today anybody could record a record. For instance, you could go out and record a record yourself. How much could it cost? $100? $1,000? But the problem is getting it on the radio. Before you get it on the radio, of course, you gotta put it on a label, but today anybody could open a label. If the record is not played on the radio, the listening audience won't listen to the record.

SMITH: Now when you have a record that people really want...how do you decide which station and which city where you break it?

BENNETT: Now breakin' a record and knowin' what stations I really want to play it—see, you could have about twenty major stations, and outta the twenty major stations could wind up bein' two thousand stations. Because each disc jockey of a Top 40 station, or top PD or station manager, has *friends* all over. What they usually do is they get 'em into the studio, they make cartridges, they make another forty, and everybody wants to be friends, and they start mailing them out—so already we exploded the whole country.

SMITH: Which are the cities that if a record becomes a hit, it'll become a national hit?

BENNETT: I still base it in New York. I know a lotta people say, "It's gotta make it outta town." Yes. Because the reason why they say it's gotta make it outta town is because they can't do it in New York. So if you

can't do it in New York—all right! You'll try to break outta Chicago, you'll try to break outta L.A., Detroit, Baltimore.

SMITH: We've talked before about AM versus FM. You still seem firmly locked on AM.

BENNETT: Well, yes. Because I say for chart action for an artist, I still say that AM can break the artist. I'm startin' to listen to FM, since you told me, and I get some excellent reports of breakin' albums—but not on singles.

SMITH: Just on albums?

BENNETT: Yes, and not only that: gettin' into this FM situation…I noticed that the storekeepers like it very much and it has boost the retail sales right up. Because in retail level, there's been a lotta sales in records comin' from all different kinds of artists—artists I never *heard* of are sellin'. So there's gotta be certain stations playin' 'em.

SMITH: In the last couple years, there are people who never had a hit single who are on top of the album charts.

BENNETT: Correct. It started groups like the Cream and Blood, Sweat & Tears—

SMITH: They were big sellers first as albums, then singles.

BENNETT: Big sellers first, before the AM stations capture these artists. Like Jimi Hendrix, I never heard of him until he busted out on AM.

SMITH: So you're gonna be paying more attention to FM?

BENNETT: Sure, why not? That's where it's at. You hipped me up to that.

SMITH: Can you make a bad record a hit?

BENNETT: That's what you call "a million dollar question." I did make a lotta bad records a hit; to my personal opinion they were bad, but as far as the listening audience, they were great. So I cannot decide what a record is—in other words: I gave up a long time ago, because I made a lotta number one records, and to my personal opinion I don't know how they became number one. But I had them in my hand—I always gotta like it, to the artist—and I figure, let me go out there and push anyhow. So the listening audience wanted the record up there, and they made it number one.

> **[The] artist realizes himself how important promotion is, because today anybody could record a record.**
>
> —Pete Bennett

SMITH: Being the man that promotes the Beatles and the Stones, and Donovan, you literally have acetates of their records that you go around with—that's a pretty powerful position to be in.

BENNETT: Well, your power is yourself. I understand that not everybody in the business could carry a Donovan or Beatles or a Rollin' Stone record

advance copy. But you have to be a top man yourself to have your brain work, to know what you're doing wit' it. You cannot just send a mailman or an errand boy to go up to stations with it or to know how to operate the record and to break it nationally.

SMITH: In radio it's considered a big thrill to say, "And here it is, the first time anywhere...."

BENNETT: Yes, in fact, I'm the one who really started that throughout the country.

SMITH: I didn't know that.

BENNETT: And the first artist I started with was Nat King Cole. [*Those Lazy-Hazy-Crazy*] *Days of Summer* was the first exclusive of the United States.

SMITH: You mean up to that point it was generally sent to all the stations at the same time?

BENNETT: Up to that point, every record company was releasin' records everyday, normally. I'm the one that started that trend.

SMITH: How long ago was that?

BENNETT: About five years ago, I guess. Then we started with the Rolling Stones, Herman's Hermits. Then, I see that every other record company [and] promoter followed the leader.

SMITH: But that's still important.

BENNETT: It's still important to radio. To me, it's an old fag.

SMITH: It's so important that I'm sitting here drooling over this acetate that you brought along with you.

BENNETT: That's an acetate of the new Beatles single, "Let it Be."

> **This is the first time, on any radio station, throughout the world, that it's played, on Howard Smith's show.**
>
> —Pete Bennett

SMITH: Is this just the copy of what has been done as the bootleg?

BENNETT: No, no. This is the real copy—[the] bootleg was just a rough over. This is the real one that's edited down, and this is the one that all the stations around the country and...every retail buyer or wholesale buyer is goin' to have in their stores.

SMITH: So this is it.

BENNETT: This is the one that the Beatles want out.

SMITH: And I can say this is the first time on *any* radio station—

BENNETT: This is the first time, on any radio station, throughout the world, that it's played, on Howard Smith's show.

James Taylor
March 1970

After breaking both hands in a motorcycle accident last summer, James Taylor recuperated to record his second album, Sweet Baby James, *right before Christmas. It's just been released and will mark the turning point of his career. The record will go triple platinum, reach number three on the charts, and be nominated for a Grammy Award for Album of the Year.*

..

SMITH: Yours was one of the first records put out by Apple other than the Beatles'.

TAYLOR: I was the first artist signed by them, but Jackie Lomax, Mary Hopkin, and the Beatles—I think the Iveys also had a single out before mine finally got out. But it was one of the first albums out on Apple.

SMITH: Now *Sweet Baby James* is your new album and that's on Warner's?

TAYLOR: Yeah.

SMITH: Why did you switch? Most people would be dying to get on the Apple label.

TAYLOR: I was too in the beginning. Apple started off being a very principled company. It was to be an artists' company dedicated not to making money and not to the commercial side of the industry so much as being, like, a mouthpiece for the artist. It was to be a company that was key toward what the artist had in mind and toward making good music. In the beginning that was very attractive, and it was successful in the beginning too, but the management of it was helter-skelter for a while. They never really set up in the States, so to be working in the States and on Apple, you were really on Capitol. But you couldn't get a straight answer from Capitol, because they had to get back to Apple first. So when Allen Klein came in, the whole changeover took place in the Apple administrative structure or whatever was goin' on. Peter and I just decided to leave for an American label, since we were gonna be living and working in the United States.

SMITH: Peter's your producer?

TAYLOR: Peter's my producer and my manager.

SMITH: He was head of Apple Records, wasn't he?

TAYLOR: Yeah, in a sense, but a lotta people left when Klein came in. Klein saved the Beatles a lot of money—I think a lotta bread was being drained off through Apple, because they weren't running it so much like a company as it was a project. Sometimes I got the feeling it was an expensive toy, and I got angry at it sometimes too. I went over there last summer in June and tried to get some recording done, but everything was so disorganized, we couldn't do anything. So I busted both my hands later on that summer in a motorcycle accident and we took advantage of the time when I was just submerged, sort of, to change around.

SMITH: What else about Apple? You sort of knew that scene inside—

TAYLOR: Apple went from being the kind of recording company that the artist really wanted…I was attracted by, you know, the Beatles running a recording company. At least the people at the top are sympathetic toward making music and the artist and writing….

SMITH: John Lennon told me they were literally broke and most people didn't take them seriously. They thought it's a bottomless pit. But it wasn't.

TAYLOR: Well, Klein served a purpose in trimming the company up and just rounding it out some and plugging the leaks or whatever. Klein, himself, isn't too savory a character, I don't think.

SMITH: I like him because he's very up-front. He doesn't make out to be anything than what he is: a tough businessman.

TAYLOR: We didn't only *leave* Apple; we also *went* to Warner Bros. It's a fine label. They've been treating me real good and I like the people up there. It's run really well and efficiently too. It was a choice between Capitol and Warner Bros., and Capitol just isn't my kinda label. I mean, I don't really get too involved with the labels, because I'm really interested in making music and what goes on in the studio and writing and performing. I like to keep outta the way of the administrative side of it and the commercial side of it, 'cause as far as I'm concerned, that's mutually exclusive with making the music. I'm glad someone else handles it. But Warner Bros. seems to sign people who they like and then just get behind 'em, whereas Capitol signs everyone, and someone who shows a little bit of corporate promise they'll jump behind, and I didn't particularly like that. There were days when I'd go up to Capitol and no one would even know what Apple *was* up there, in the Capitol Tower in Hollywood, much less James Taylor.

SMITH: How did the signing actually come about? Was it through the Beatles themselves?

TAYLOR: I had met Peter Asher before in New York. I used to be with a group called the Flying Machine, no connection at all with the present

Flying Machine. But I quit that group and decided just to travel around some and hopefully to sing. I got the idea into my head of making an album when I got to England, and I made some demo tapes and started peddling them around, and finally remembered Peter and took them over to him, and he took them over to McCartney, who liked them, and that was it. We decided to do an album.

SMITH: Did you have further dealings with the Beatles themselves?

TAYLOR: Yeah.

SMITH: Could you see their split-up coming?

TAYLOR: Well, there was talk of it, of differences of opinion between, say, Lennon and McCartney. I just sorta got a general feeling about how... It seems to me to be impossible to be the Beatles, to continue being the Beatles for any period of time. They've been so blown up out of proportion and I think it's probably hard to live that way: having always to answer to a public image of you that you have no control over. I couldn't say that I saw their split-up coming but it's no surprise to me. It's unfortunate, because I don't think anything that the Beatles separately do...Ringo's got an album and John has the Plastic Ono Band and Paul has *McCartney* out and George has got a whole buncha things goin' on and is working on his own album, I've been told, but I don't think anything they do separately is gonna be as good as the Beatles. Great band.

SMITH: Do you write all the time?

TAYLOR: No, I'm not very prolific. There's nothing regular about it. I usually have a coupla unfinished tunes in my head and they'll fall together slowly. I suppose I write about a song a month is what it works out to. Which works out to a neat, clean album a year.

SMITH: Music first? Words first?

TAYLOR: Hopefully together. You get a central idea that's music and words first and you just work off of that.

SMITH: Performing live, does that give you a bigger charge than recording in a studio?

TAYLOR: I feel I'm getting better at it or more used to it, and I really like performing live. The danger in performing live too much is that after a while you start to go off your material, and you can't be really enthusiastic about singing the same songs over and over again. And it keeps me pretty busy—sometimes too busy to get any other writing done. But that's probably an excuse. But I really like playing for an audience and large ones too. I enjoy it.

SMITH: Did you do any of the big festivals?

TAYLOR: I did Newport last year, but by the time I got on it'd been raining all afternoon, there weren't a whole lotta people left. I guess twelve thousand is the largest audience I've played for.

SMITH: You like that, huh?

> **If you verbalize about it, you lose it. Because songs don't verbalize about it, they just come in and if you're lucky, they just sorta touch on it.**
>
> —James Taylor

TAYLOR: If the sound is good and if I'm in good shape, I really do, yeah. It makes me feel very good, 'cause I think the people who come and listen to it enjoy it.

SMITH: Some people say that performing in front of a really large audience, they lose contact.

TAYLOR: You do.

SMITH: There's a certain point, about two or three thousand…over that it's hard to feel the feedback.

TAYLOR: I doubt I ever play to the people that I'm actually thinking of and playing to in an audience, no matter how large—it's probably not more than two hundred…It's not that I'm not aware of a couple more thousand, but yeah, you're right. You can't keep that many people in your head, impossible.

SMITH: Now that money must be beginning to flow in, is it changin' your head?

TAYLOR: Uh, yeah. I think if you make more money than you need to make—in other words, that represents real things to you, like pay the rent, build a house, buy some land, keep your car going, keep food coming into your body, and keep heat in your house—if you make more money than represents those real things, then it's a dead weight. And then you're just making money abstractly, for money's sake, and that's a disease in this country, isn't it?

SMITH: Have you gotten to that point? Have you caught the disease?

TAYLOR: I think I'm about to start making more money than I need to make. So you can have it all.

SMITH: What are you gonna do?

TAYLOR: I have no idea. I hope I'll work less. Or work *for* less or work more selectively, not work so much for the money but for the gig. I don't know yet, really. It completely flusters me, because the tendency is "Make it now, kid, because it's not gonna last."

SMITH: Not with you, though. You don't believe that, do you?

TAYLOR: No, I don't. I think I'll always be able to make a living. I hope to

THE SMITH TAPES

write, just to publish and write. I have my own company and that's what I'm countin' on, sort of. I don't wanna rock 'n' roll through another five years or for more than that—it's just too much.

SMITH: But there are other pressures when you get to this point, right?

TAYLOR: Well, an agent wants me to make a lotta money. An agent wants me to play as often and for as much bread as I can, because that's 10 percent there. My manager, Peter, hasn't got that in his head. But there probably is a difference of opinion or difference of viewpoint. Because Peter, as my manager, his job is to make me as big as he can, I guess, to make as much noise as he can with me. And you've gotta be…The more noise you make, the less that's in your control—what people are thinking of you, what you represent to other people, and what's actually happening with what you put out. And that's half of it, you know. Generating it is one thing, but putting it across, packaging it and selling it, that's a very frightening thing. I mean, that's what happened to the Beatles, I think, is they ceased to be four people at all: they're not four people, they're maybe four billion people's concept of them, and I think that really rips you apart.

SMITH: *Do* you wanna be as big as agents and managers wanna make you? Does that sound attractive to be a teen idol?

TAYLOR: Well, it does in a sense; I can't deny it. I wouldn't say a teen idol….

SMITH: Where you walk outta this building and people say, "Hey, there's James Taylor!"

TAYLOR: There's something in me that really wants to do that; I think there's something in everyone that wants to do that—to have that kind of recognition and success. It's just a subconscious animal drive, to be on top o' the heap, or to be powerful or something. But it scares me too.

SMITH: You seem by nature incredibly modest.

TAYLOR: I'm not terribly modest. Well, I don't know—[in a southern drawl] shucks, folks, it's just ole poor boy Jim from down on the farm.

SMITH: But that's what you sound like. It's hard for me to imagine you even admitting to wanting to be famous.

TAYLOR: Yeah, well, I would like to be, I think—I wanna be successful. And to a certain extent that means being famous in this line of business. I guess I wanna make really good music. And I guess I wanna do positive things to people with it. And I wanna generate something solid inside o' people….I wanna remind them of something that's there all along but that's very good or something—I'm not sure. If you verbalize about it,

you lose it. Because songs don't verbalize about it, they just come in and if you're lucky, they just sorta touch on it. And if they don't touch on it, people can't make up their minds about a song. It either hits them an' connects with them or else it just misses them.

SMITH: The times that we're living in now, everything is getting harder and tougher and scary, and yet your music is fairly gentle. Do you see your music becoming more of a reflection of the times? Or are you just doin' what you can do?

TAYLOR: I'm doing what I can do, what I know how to do, and that's write a certain kinda song. My songs don't encompass everything in general; they just touch on certain things. A song comes out of a mood that I get into, and I write that mood down into a song and into music and try to put it across and try to make that mood in someone else or something like it. So they're no reflection of the times, but I think they're something real. I think if the songs weren't real, they probably wouldn't meet with any kind of response at all. People don't *dislike* music; they just either like it or they don't even see it. That's what I mean about songs—it's very seldom you hear a group, unless it's the MC5 or the Three Stooges [*sic*] or whatever, that you listen to and get angry at the music or say, "I disagree with the music." Either you listen to it or else you say, "Can you turn that down?"

SMITH: When are you gonna be doing your next record?

TAYLOR: As soon as I've got it written. I've got a few new things I'm workin' on now, but I'm a long way from…The way it's going now, if I keep writing this slowly, it won't be until next winter. And Warner Bros. says that it'd be good to put another one out soon, just in terms of momentum and keeping things going and putting more *product*, they call it, out on the market, but I'm not gonna make another one until it's a good one. I don't wanna make a worse album than I've made before.

SMITH: And you can't write under pressure; it has to just come?

TAYLOR: I haven't been very lucky writing under pressure. I can't come out with something. I really admire Goffin and King and Lennon/McCartney, Bacharach and David and other real professional, you know, music-business writers who can sit down and really come out with stuff. They put a certain amount o' work in and they come out with the songs, sooner or later. But I still think that the best songs just happen.

Jack Valenti
March 1970

Jack Valenti left his position as special assistant to President Lyndon B. Johnson in 1968 to head the Hollywood studios' private lobbying group, the Motion Picture Association of America (MPAA). Last year he and the MPAA introduced a rating system as a guide for parents to gauge a film's "mature" content, and it's proven to be controversial. Valenti will weather the storm and lead the MPAA for thirty-six more years.

SMITH: What is MPAA?

VALENTI: The Motion Picture Association of America. It's an assembly of the nine largest motion picture producer/distributors in the world, who have gathered together to make certain that the American motion picture can move freely around the world, can move freely in this country, can maintain freedom of the screen— and allow its members to operate in a free enterprise market and withstand foreign pressures of censorship and taxation abroad.

SMITH: But the thing it seems to be known for is its rating system.

VALENTI: I suppose that's true. It really is a minor part of what the association does, but I suppose that's what attracts people's attention. It's a voluntary self-regulation.

We have inaugurated this film rating system for two reasons. We want to make sure that the creative man is free to express himself. Second, to make sure that freedom is sensible freedom, because if it isn't, the government will step in. We believe it is wrong for the government to move into this area.

SMITH: Would the organization have done this if it didn't appear that the government was going to move in and do it?

VALENTI: When you have great social change and new kinds of films, you have a chasm that appears between an older generation and a newer generation impatient for experimentation and innovation. So they collide, and fury and fire and smoke takes place. That's happening now.

As a result, people who find some of the films today rather unlikeable asked the government to step in and stop what they think is an erosion of

the moral base of this country. Who is to say what is an erosion? Who is to say what is right and who is to say what is wrong? Therefore, Motion Picture Association thought it would be wise if we could give information about films to parents and to young people, and then let them decide what they wanted to see. Second, that we would take certain films that we thought probably went beyond the boundary lines of, let's say, the judgment values of young people, and we said on an R picture, unless your parents are with you, we don't think you ought to see this picture. And on X pictures, we say under a certain age—sixteen, seventeen—you can't see it at all. Now obviously, that calls for some critical comment. Yet we believe what we're doing is right.

> **I think in the long-range best interest of the creative man in the motion picture arena, this is the greatest thing that's ever been done for him.**
>
> —Jack Valenti

SMITH: How can you draw an arbitrary age like that?

VALENTI: Well, you can't. Actually, only the parent knows which of his children is mature. No one can tell me which of my children is ready to listen to something or to make a judgment, except myself and my wife. I recognize that, and yet if you're going to have a national system, you can't have forty-seven different age limits in a community. Have to have one. We pick twenty-one to vote. In some states, sixteen to get a driver's license, eighteen to be drafted, and all of these are arbitrary limits which people have imposed. You just draw a line somewhere. We drew one at sixteen and now we have raised it to seventeen.

SMITH: Why was it raised?

VALENTI: We wanted to strengthen the system. Show people that we're not strictly economically gain minded but that we do mean business. That we're willing to turn people away in order to give the creative man the freedom to make the kinda picture that he wants.

SMITH: I don't understand. They sound opposite. Before, you said "sensible freedom." What do you mean by that? By setting up a standard of who's allowed to see it, that takes away a creative person's freedom, because he might not be able to get the proper financing with a lower rating...

VALENTI: Well, now you're beginning to put economics and creativity together.

SMITH: In the movie business, they're very closely connected.

VALENTI: Money is not the sole test of whether a movie oughta be made. But you cannot mingle freedom of the creative man and the right of an investor to invest in his movie. They're two different things entirely.

A creative man can make any picture he wants. But under our system, he can label his picture X and make any kind of picture he wants, because we make no demands on him to cut a single millimeter of film. Now if he wants a larger audience for economic reasons, then he himself is compromising.

SMITH: No, he has to because you've set up this system that he has to compromise *to*.

VALENTI: No, he can make his movie and put an X on it and he doesn't have to cut anything out unless he wants to.

SMITH: But you end up in situations where people are in the editing room and they're thinking, should I leave that in? Shouldn't I leave that in? Your system places some kind of prior restraint. It's a self-censorship thing. That's what it is.

VALENTI: No, I beg your pardon. We do not censor. We do not ban.

SMITH: But your system does affect what will happen to his film when it's finished.

VALENTI: Well, perhaps. But consider the alternative.

SMITH: Which is what?

VALENTI: Government intervention.

SMITH: I find it very curious. I get the feeling...that the movie industry really wouldn't care about what age who saw what. It's only because of the threat of the government coming in—

VALENTI: Well, I can't speak for the movie industry, but I can speak for myself. I think it's not right that a child should be allowed, willy-nilly, to go into a theater to see anything. I resent that.

SMITH: But the basic motivation for the rating system...was because the government was going to move in and do it.

VALENTI: I didn't say that. I said there were two reasons. We wanted to ensure the freedom of the creative man. And the second was I wanted to keep the government *out* of our business. And I think there's a third reason, which is an obligation to the community in which you live to be fair and just and honest with them. And so if you provide them with information about a film, I think you are being accurate and honest. And that's what we try to do.

SMITH: Some of the criticism aimed at the rating system has been that you can show a couple, fully clothed, splitting each other's head open with an axe, and that will do all right in the rating system. But if that couple is in a tender love scene, nude, they get an X rating. It seems like the rating system is preoccupied with only sex.

VALENTI: Well, you've made a general statement. Is there a specific film you have in mind?

SMITH: Do you take into account violence when you're giving the rating or just the degree of nudity?

VALENTI: Violence is very much a part of our ratings.

SMITH: Then could you tell me a movie that has gotten an X rating because of the violence, not the nudity?

VALENTI: We've rated 566 films and I don't rate personally—that's done by a group in California. I know one film, *The Wild Bunch*, which was a very violent movie and it wound up with the rating right below an X, which is an R rating. I'm not privy to what went on in the rating of that picture. Are you aware of any specific movie yourself?

SMITH: No, but isn't it generally accepted in the movie business that violence is all right and sex isn't?

VALENTI: You must be reading the movie magazines on Mars....I'm not aware of a single leader in this industry that's ever said what you intimated. Do you know of one?

SMITH: OK, then tell me what actually happens when a movie comes up for a rating. Who sees it? Who decides? What considerations? I've heard that bargaining goes on. "You have five nude breasts. That's not good, so take out one."

VALENTI: That's not true.

SMITH: So what happens?

VALENTI: A movie is presented to the Code and Rating Administration on the West Coast or the East Coast. There's a total of eight people who are involved. They range from a child psychologist to a former writer for one of the news magazines....They see this film, at least two of them. If there's any problems in the film at all that would cause a controversy as far as a rating is concerned, then all eight see the film. They discuss it and as a result of their discussions, they give a rating.

SMITH: Based on what? Do they have a list of rules, guidelines, what?

VALENTI: Yes, they have a list. You're not rating for adults, you must remember. These are for children. We're rating for parents to give them guidelines...The elements that you look for are theme and treatment. You can take any subject and present it on the screen; it's the way that you do it. Language. The use of violence, gratuitously and brutally. The use of sex, gratuitously and needlessly and in a coarse and garish way. Then they make judgments. There are no fixed, inflexible rules, because each film must be viewed as an entity. And you take a picture like *The*

Pawnbroker when Sidney Lumet bares the breast of the young girl, a poignant, sad, desperately pathetic scene. On the other hand, you take a sex movie out of Denmark or Sweden and baring of the breasts on the screen can be titillating and coarse.

SMITH: But you were talking about an artist's freedom. Now *you're* going to decide what was in the artist's mind when he made it.

VALENTI: No, we don't do that at all....All that they can judge on is what appears on the screen. We don't tell a man to cut the scene out or to leave it in. We merely say that this film will be rated in such and such a fashion so that parents will understand what's in the film. If you won't accept the rating, you can appeal it. But in all cases, he's under no compulsions of any kind to make any cuts of any kind.

SMITH: That's too easy to just say that. There are newspapers in this country that are refusing to take ads for X-rated movies. This radio station will not run a commercial for an X-rated movie, whether they've seen it or not.

VALENTI: I think that's wrong.

SMITH: But that's the repercussions of what you're doing.

VALENTI: I'm telling you honestly what the system intends to do. Anytime that you deal with culture values or anything that has to do with creative work, you're going to have a lotta criticism, a lotta disagreement. I'm quite prepared to accept criticism where half the people in this country think that this is wrong. I believe it's right. I think in the long-range best interest of the creative man in the motion picture arena, this is the greatest thing that's ever been done for him.

SMITH: Why is there so much turmoil about it?

VALENTI: There's no turmoil in the industry. After all, five people can put out a press release and make you think that the whole world's coming down. I could start a demonstration in this studio today and demand your resignation. There could be a great voice being heard. But it wouldn't represent the majority opinion of your listeners. I know of no turmoil, no great avalanche of criticism. Our survey, taken in October and September of last year, showed that 58 percent of all the moviegoers in this country thought the rating system was very useful to them. It rose to 70, 75 percent among people from eighteen to twenty-five.

SMITH: How about under eighteen?

VALENTI: The farther down you go, the higher became the awareness and delight with the rating system.

SMITH: You mean under eighteen, the people who the rating system specifically affects, they like the fact that they are not allowed to see X-rated movies?

VALENTI: No, they like the fact that we gave them information about movies.

SMITH: Was that how it was worded?

VALENTI: It said do you find the movie rating system very useful, useful, not useful, or fair, fairly useful in helping you decide movies for children to see?

SMITH: And that was the same question put to people under eighteen?

VALENTI: Mm-hmm.

SMITH: And the age just said "children"? So somebody sixteen answering that question could think you meant seven-year-olds.

VALENTI: I don't have the precise question in front of me. I can't answer that question. I don't know...I've spent a good deal of time with young people, because they comprise the vast majority of the audience of the motion picture. And whenever I'm able to speak at length to point out what the alternatives are, what it is that we're trying to do, I find a great majority, having weighed the alternatives, are quite willing to go with the motion picture industry's way of doing this. If you talk to a good number of film directors, writers, most of them don't like rating systems of any kind. But given a choice, what we're doing makes more sense, is more in their long-range best interest.

> **Something that is, from a literary and motion picture creative standpoint, excellent and meritorious lives in the same arena with something that's sheer garbage.**
>
> —Jack Valenti

SMITH: But that's still talking within the framework of a compromise. What did we have before the rating system?

VALENTI: You had an onrush of legislation by state, local, and federal governments, who respond to constituents, who protest against what they think is a film that goes beyond what they consider to be normal standards of conduct. This is normal in the society. There are some people who believe one way and some who believe another. But since our rating system has come in—I won't claim entire credit for it, personally or for the industry—there has not been a single bill passed by state legislature which impinges on the freedom of the creative man or supplants a law in place of our rating system.

SMITH: There have been seizures of all kinds of movies.

VALENTI: But see, they're seizing them under already existing statutes.

SMITH: Does the MPAA join in any of those lawsuits to try to keep legislation from being passed?

VALENTI: Of course. We'll fight censorship laws all over this country. We're fighting it right now, censorship, legal classification, unlawful seizures of films.

SMITH: How about newspapers and radio stations not taking X-rated commercials?

VALENTI: I have personally written to dozens of newspapers and been on the phone to some other publishers telling them that it's wrong to ban all X films. Because X doesn't mean obscene. X means unsuitable for viewing by children. A great many things are unsuitable which have nothing to do with obscenity or pornography. I think *Midnight Cowboy* happens to be one of the great literary achievements of the visual image in the last ten years. It's an X film. I would not consider it to be put in the same class as a Danish skin flick. But they're both rated X. That's probably one of the flaws in the system. We've been unable to rectify it, which means that something that is, from a literary and motion picture creative standpoint, excellent and meritorious lives in the same arena with something that's sheer garbage. That's a fault. We haven't been able to correct it.

SMITH: Is it legal for a movie producer to self-regulate his, to just put an X on it?

VALENTI: Yes. According to our system, if you don't submit your picture, then you must self-apply the severest rating, which is X.

Natalie Wood and Robert Wagner present Sarah Kernochan and Howard Smith with the 45th Academy Award for Best Documentary Feature, L.A., March 27, 1973

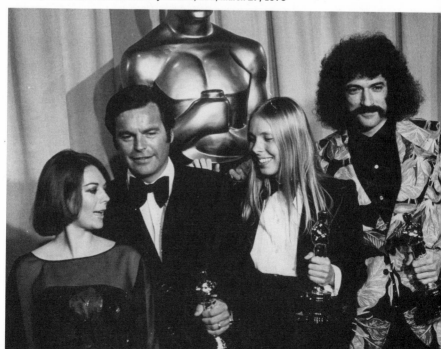

Dick Cavett
March 1970

About a year ago, The Dick Cavett Show *moved into ABC's late-night slot to go up against* The Tonight Show Starring Johnny Carson. *Cavett is known for pushing the limits of the television networks' conservative programming, inviting guests from across political and social spectrums to engage in discussion, often with opposing viewpoints. This week's show will include a discussion of women's liberation between two of the movement's leaders, Sally Kempton and Susan Brownmiller, and Playboy Enterprises founder Hugh Hefner.*

SMITH: Doing a show like you do every night of the week, I mean five nights a week...

CAVETT: It seems like every day.

SMITH: Is it a real grind?

CAVETT: Yes, it is. I used to be a tall redheaded man and what you see left is me. Yeah, it is rough. There's something good about the kind of fatigue you get as the week goes by, though. I find that I do a better show on Thursday and Friday, when I'm a little tired. On Monday, when I'm somewhat rested, I don't do as well. I don't know why. I mean, it may not show on the air but I don't enjoy it as much—I think it must show some. I don't want to discourage people from watching on Monday, because occasionally I do a really good show on Monday. But there's something about being a little tired in your work that helps, if it's just enough. You shouldn't be, you know, lying there, but...

SMITH: I keep reading that you're the one host of the talk show game that really prepares and reads everything. Is that all true?

CAVETT: It's partly true. I read some things and I prepare some. This summer when I had the three-night-a-week show, I think I overprepared....I used to find out that I would...read somebody's book and their *New Yorker* profile and six clippings on them and their bio if they have a bio—then I would get out there and I'd realize I've only got eleven minutes with this person and I can't think where to begin because I know too much. It's really not such a hot idea to read everything about the person

before they come on. It's better to know five or six things. Unless, of course, it's somebody you know nothing about and you're going to discuss for twenty minutes the subject you know nothing about. Then it's good to prepare.

SMITH: Do you work from notes? It's hard to tell whether you're reading from anything.

CAVETT: I'll usually go out there with some notes but I like to even get away from that. But if somebody comes on and they want to mention six things specifically, it's better for me to have those down and then I can either get to them or leave them out and go to something else. I have a theory right now that I would do a better show if I *didn't* have any notes. Something comes into your voice if you're asking a question that you really thought of at that moment and asking one that you…

SMITH: You seem more interested if it hasn't been written down.

CAVETT: Yeah, I think they can see and hear that. So lately I try to use as few notes as possible.

SMITH: Sometimes while watching your show it's, like, a discussion is very hot, very excitable…and then it's over. Does it continue after the show?

CAVETT: Sometimes it does. Sometimes a sort of curtain drops and everyone just shakes hands and you suddenly get this feeling of "Gee, I guess we were faking it because we aren't continuing the subject." I can't really think of times where it's gone on very long after the show. That's a good question.

SMITH: I mean, there's no setup for it. Everybody doesn't end up in the same room after the show, or do they?

CAVETT: No, because they start coming and covering the set up with plastic covers so the furniture will last longer, and clearing the stage, and people's friends swarm up from the wings, and there's really no way of continuing to talk. It's a bad feeling at the end of the show when you realize you'd just gotten into something that's really rolling, and it seems to have taken two-thirds of the show to get to it and now you don't have time to go on with it. A couple of times, I've taped an extra segment and used

> **Then I would get out there and I'd realize I've only got eleven minutes with this person and I can't think where to begin because I know too much.**
>
> —Dick Cavett

it. I still have, as we are sitting here now, a segment from the Jerry Rubin show that we did with the audience afterwards because they were just steaming to ask questions and they only got a few in on the air. Maybe I can use that, you know, still use that segment. It's a good one. There's a

very old man in it who stands up and says, "Who elected you to anything, Mr. Rubin?" And it's like a cameo bit in a Sidney Lumet movie. He goes on and on like that. It's kind of nice, just artistically.

SMITH: Do you have that carefully planned out? I watched the night that you had the Black Panther show; I call it that. I found it really exciting and I kept thinking, "*Oh!* The next commercial, it's gonna be all over," but it wasn't. Did you plan it that way?

CAVETT: Yeah. You try to guess how long something's worth and then try to make a kind of arbitrary schedule up, because the commercials have to be separated by certain distances. On a thing like that, I just leave time for it. And if it's interesting, you just got to keep going, because it's not that easy to get something interesting. 'Cause I don't like to stop something good. I've done that a couple times and hated myself when I watch it. Also, you don't realize when you're sitting there whether it's as interesting as it may be at home. When you get home and see "Gee, this was good" and I cut it off, you hate yourself.

It's kind of fun to express your opinion, but opinion is cheap. I'm really more interested in what I don't know.

—Dick Cavett

SMITH: You seem to have more *politically* oriented guests, more controversial ones than any of the other talk shows. But then it's hard to tell where you stand.

CAVETT: I don't know....I'm a little confused as to what my role is at a moment like that, really. I, in one sense, don't really think it's that interesting where I stand. I'm really interested; in that sense, I think I'm like a reporter. On the other hand, if something makes me annoyed or really pisses me off, I can't help reacting to it. Although at times I don't, because I think maybe I'm doing it for theatrical reasons. So I have a lot of confusion going on about that.

SMITH: Again, I'm thinking of the Panther show, where I kept feeling that you almost...

CAVETT: I don't know where I stand on that. That was probably an honest performance on my part, because I certainly think that there's reason to believe the Panthers have been "gotten," in the dramatic sense of the word. There is an attempt to wipe them out. And on the other hand, I don't like a lot of the things they do, but on still another hand, I can see why they do them and what the effect that they want is....

SMITH: I don't know, maybe that is the role, that the audience at home perhaps shouldn't know where you stand.

CAVETT: I haven't really figured it out. I think personally, I have a kind of desire to not be categorized. And if somebody says, "You're an intellectual," I deny it. I can prove that I'm not that, so that's easy. But whatever it is, I don't really like them to get a fix on me, for some reason. I sort of like to be not categorized, because once you are, then there's nowhere to go. There's a little of that operating there. But in general, it's kind of fun to express your opinion, but opinion is cheap.

I'm really more interested in what I don't know. It's possible to see a number of sides to an issue at the same time and not really know which one I believe in, at that moment. I'm not a kind of reflective person. I haven't sat around and made up my mind on a lot of subjects. So if you don't seem to know where I stand, I may not either. It isn't that I'm hiding it. Sometimes I decide in the middle of an interview what I think of someone. I liked Timothy Leary, personally, when I interviewed him but at the end of the interview I said, "I really think you're full of crap." They left that in. If I had told certain public figures they were full of crap, they wouldn't have left it in. But I guess whoever was in charge that day thought that that sentiment would be palatable to most people, because it was Leary—which is sort of unfortunate. You should be able to tell people indiscriminately that they're full of crap, as they are.

SMITH: Have you ever felt that the show has gotten out of control at all, you know, like, right in the middle of it while you're talking with a guest?

CAVETT: Not completely, no. I've had a sense of *here's where it might*. I don't remember now where that was, but there are times when you feel you have to take hold of the arms of the chair and say, "I'm gonna remain in control of this show." It's kind of exciting, though. I *like* that feeling. So it's...something you don't often see on TV. I like that. I'm not out to provoke people, though, really. I hate that kind of artificially contrived controversy that you get a lot of times on television, where you *jab* the person into a reaction. But if you can have one happen without prodding it too much, it's good.

Michael Benson
Spring 1970

Michael Benson is a student at Wesleyan University, a leader of Indians Against Exploitation (IAE), and the president of the Organization of Native American Students. In August 1968 he and a group of other young Navajos attended the Gallup Inter-Tribal Indian Ceremonial—a tourist "festival" of Indian culture run by the white Navajo Inn bar owner and mayor of Gallup, New Mexico, Emmett Garcia—and handed out pamphlets that began with the words, "When our grandfathers carried guns, they were free and they were people." After being kicked off the grounds and denied reentry, Benson and pro bono law firm DNA People's Legal Services filed suit. Gallup, which borders the Navajo Nation, will continue to be the nexus of Indian-white tensions until they come to a head in a 1973 shootout, where IAE central committee member Larry Casuse will take the mayor hostage and be killed by police. Militant American Indian Movement members will arrive from Wounded Knee, South Dakota, but Benson, along with student, tribal, and community leaders, will hold them in check throughout negotiations with the town to stage a peaceful protest march in Casuse's memory.

..

SMITH: What tribe are you from?

BENSON: I'm Navajo. The Navajo reservation in Shiprock, New Mexico, is my home.

SMITH: But you were away at boarding school most of the time?

BENSON: I went to public school on the reservation for a few years and I also attended our Bureau of Indian Affairs boarding school.

SMITH: What are the Bureau of Indian Affairs schools like?

BENSON: They're really not that good. They do things like make all the Indian students go to church on Sundays. And we weren't allowed to speak Navajo at the school. They beat the kids, handcuff 'em to beds, and that sort of thing.

SMITH: These were things that went on when you were there?

BENSON: That went on, but these still go on. These are the type of schools which they designed many years ago because Indian students, many of

them live way out in the sticks and they can't get to a public school, so they set up the boarding school and you go into it when you're six years old or something. And there's another bad thing about them: they take the little tiny little kids away and they turn 'em against their parents.

SMITH: How? What do you mean?

BENSON: Because they speak Navajo at home, and if they're told at school "speak English," pretty soon they're gonna think, "My parents, I guess, aren't good enough." Then the same way with the religion—everything's put down that's Navajo.

SMITH: Why do parents send the kids to those schools? Is it compulsory?

BENSON: There's nothing else for them. They live *way out* in the sticks and it's the only choice they have. I guess they could easily keep them out of school too, as a protest of the whole thing, but then we don't. Indians—I guess many of them, all they can do is submit. Over the years, this is the way they've become.

SMITH: Are the schools run by an Indian administration?

BENSON: In most of the boarding schools there isn't, no. Most of the teachers are white and then the superintendents are almost always white; principals are usually white.

SMITH: What's behind their putting down the Navajo ways?

BENSON: You'll have to ask them; I don't know. There's a definite hostility there against Navajos. Really, from our side of the thing too, I guess the Indians could easily rise up and take over their schools, and devise a new type of school which would be good for them, which would not put down their way of life. But then, all the people do nowadays is they just submit and they hardly even ever complain, and they're scared of Anglos. This is the main problem, right there.

SMITH: Even among most of the young Indians?

BENSON: Now the young Indians are sorta rising up. You can tell it by the incident in Alcatraz, the way they took the island, and also there's demonstrations all over. Not all over, but there's a few demonstrations. So the young are sorta beginning to rise up, but then this still doesn't make that much of a difference for the people that live, say, deep in the Navajo reservation. The ones that are really put down by the whole—by the Americans, I guess.

SMITH: Can this change?

BENSON: I think it can, but the first thing that has to happen is the Indians have to stop submitting to all this: they have to just get mad. I guess they forgot how to get mad since they put down their guns. Now they have

MICHAEL BENSON

to get mad when they should, instead of just always submitting. I know many of the Navajos, they complain about traders on the reservation. These are the white people that sell most of the supplies that the Navajos need. While they terrorize the people, they make them sign their checks over to them, and they molest the people and assault them. They complain about this in their hogans but they won't go to the authorities or anything. They are afraid of them.

SMITH: You mean this goes on today?

BENSON: Yeah. I was involved in a program last summer and this is what we did: There was a group of Navajo students. We went into their reservation and we observed; we talked to people. We have specific incidents to show this type of thing still goin' on. Most of us, before we went away to school, we lived with our grandparents and our parents on the reservation and we knew: right from the beginning, when you're small, it's always the Anglo down at the trading post that decides how much food you're gonna have this month. He sorta rules over the thing.

SMITH: Why don't you just throw him off the reservation?

BENSON: I keep telling you, there's a problem with the Indians. All along this has been goin' on, so they just sorta given up, many of them.

SMITH: But legally you could, right?

BENSON: You could.

SMITH: It's your own laws on the reservation.

BENSON: Legally. Physically, they could just burn his store down. But that's not the way the Indians are anymore, I guess. On the Navajo reservation the situation is so that people get these welfare checks every month. And so most of their bills is paid every month and here the trader still charges them 20 percent for a cash loan. Then also, the Navajos are noted very much for pawning their turquoise jewelry, and the interest rates for these are very high too. In one place it was 120 percent; the people are scared of him. There's cases where people have refused to sign their welfare checks—they wanted to take it to one of the off-reservation towns where they could get cheaper prices—and the trader pulled out a gun and made them sign it. One woman told us about an incident where the trader grabbed her and just tore off her blouse; this is the treatment that the Navajos get from their traders.

SMITH: There's only one trader per reservation?

I guess they forgot how to get mad since they put down their guns.

—Michael Benson

BENSON: No, on the Navajo reservation there's over a hundred, and they all seem to cooperate. There's a store right here, seven miles down there's another, then about eight miles down there's another and there didn't seem to be any competition. You compare the prices and they're all the same.

SMITH: How do these people get the right to be a trader on the reservation? Do the Indian tribal councils have to approve them? Or the Bureau of Indian Affairs?

BENSON: It's both. The tribal council has the right to license the traders on the Navajo reservation. The leaders that we have—somehow they don't have any sense, they could easily....The Navajo tribal government has millions of dollars from oil, gas, and uranium, and what they could do is buy up all those stores and run them themselves. This would solve the problem of the Anglo trader having too much power in the community, and then the tribe could afford to lower the prices. Somehow, they don't even think about this. It's been suggested, but they won't move on it.

SMITH: Why?

BENSON: I wonder.

SMITH: It just seems like the power is there, why not just *do* it?

BENSON: It's sort of like a blanket thrown over on many of the Indians. They're so used to being down that they just submit to everything. This is the first thing that has to be changed, before any real change comes about.

SMITH: What is the key thing on the reservation, that has to be changed before anything else?

BENSON: It's this business of how the people are just *afraid*. They have a very low opinion of themselves. I notice when many of the Indians, when they talk to white people they lower their voices. Even my own relatives they say to me, "We're no good—maybe since you speak English pretty well you can change these things—but us, we can't, we're just no good." That sorta thing. Then they're afraid of the Anglos....It's both sides. The white people continue this—if the trader continues to look down on the Navajos then the Navajo is gonna continue to stay down. So it's both things working there. I don't know what we can do to get the white people to change *his* mind, so what the young Indians have to do is to work through their own people, to get them to be *angry*. They have many reasons.

SMITH: It's that simple? Just to learn how to be angry again?

BENSON: Well, I don't know if you could say it's that simple, but that could do a whole lot, if they just learn how to complain again, really. I

MICHAEL BENSON

remember one of my uncles telling me that he had some problem, and I tell him, "Why don't you go down to the legal aid service and see if they can do something for you?" He says, "No, I don't speak English, what can I do?" I said, "Why don't just you go down there yelling in Navajo, and if they don't understand you, then let them get an interpreter." I think this sort of thing has to come about.

The goals of the Indian people are more sovereignty for their tribal governments and to keep their way of life; they wanna go on speaking their language and they want to be free. They really *aren't* free right now. All these types of things they want to change—that they should kick out the traders, the poverty, the schools, and the status of the tribal governments.

SMITH: Is the poverty really as bad as we've heard on the reservations?

BENSON: Yes it is. People starve.

SMITH: Starve to death?

BENSON: Yes, and many of 'em walk around with malnutrition.

SMITH: I don't know what it is—maybe it's that I expected somebody who represents one of the Red Power movements to be more angry, or something.

BENSON: Probably.

SMITH: You don't seem very angry.

BENSON: What do I have to be angry about at this moment? I notice that people always say that. Not what you expect, you expected—

SMITH: I don't know what I expected.

BENSON: One of these people, like the black militants, who thinks that everybody is against him.

SMITH: Maybe that *is* what's necessary, because you keep coming back to the thing of submission.

BENSON: Yeah.

SMITH: I think one of the biggest functions the black militants serve for their community is raving and ranting so irrationally a great amount of the time. It focused such attention on the idea that you *can* get angry and get away with it.

BENSON: I think it's necessary but I don't know. I consider myself pretty militant and I'm considered pretty militant by other Indians....I can name you one person that's like that, his name is Lehman Brightman. Many of the Indian people, I don't think, like the way he works—even though like you said he's the type that thinks everything is against him.

SMITH: Is it basically like an anti-Indian way of doing things to rant and rave in that way?

BENSON: It might be, yeah... But then certain things have the same effect, and, to give an example, last summer a really small group of us Navajo students went to this thing called the Gallup Inter-Tribal Indian Ceremonial. It's an international event; I guess many people know about it. It's been held for, I don't know, near fifty years now. It's become so famous now, Gallup calls itself the Indian capital of the world. This is a town where you see the white policeman beat up the Indians. And then there's an Indian Center there but the [white] merchants don't even donate anything to the center at all... yet [they] call it the Indian capital of the world.

So what we decided to do was— while it was being held last August— to pass out pamphlets... They kicked us off because they said it was private property. They did this twice. So we brought a court suit against this saying it violated our, I think they call it, "constitutional rights." This received widespread news coverage. Well, really not very many Indians would stand up to any Anglos like that, and when I went home over the Christmas vacation, many Navajos I didn't even know would come up to me and say, "Yes—now the Anglos are getting scared," and they're saying "keep it up." So I think a demonstration or passing out pamphlets for a specific reason, for a specific goal, has the same type of effect as, say, Stokely Carmichael just yelling about how the FBI's against him and all this.

> **They're so used to being down that they just submit to everything.**
> —Michael Benson

SMITH: What can a white person do if they wanna help the Indian?

BENSON: What I usually say is to write to your congressman. We'll tell you what to write about, and then you give us your money. And that's all.

SMITH: You smiled when you said "and give us your money."

BENSON: Yeah, pay us back. Many Indians, when you ask them, "Why do you think the Indians have been like this all along, sort of been asleep, and they don't even question, they don't complain, nothing? Why do you think this is?" then many of them will say they think the Indian people have been waiting for something, just waiting. I think that maybe this is it, this movement among Indians, this activist movement. People are willing to stand up to people like traders, the state government, and all this. I think this is what the Indian people have been waiting for. If you talk to some *real* old man way out in the middle of nowhere on the Navajo reservation and you tell him what's going on he'll say, "Yes, that's good. It's about time that happened."

MICHAEL BENSON

Gary A. Soucie
April 1970

Last year, six miles off the coast of Santa Barbara, a Union Oil rig suffered a blowout and poured two hundred thousand gallons of crude into the sea. This sparked grassroots clean-up efforts and large-scale media coverage, and was, arguably, the catalyst for the new environmental movement. The president of Union Oil's response? "I am amazed at the publicity for the loss of a few birds." Among the organizations founded in the disaster's wake was Friends of the Earth, one of many groups behind the first Earth Day, which took place a week ago. Gary A. Soucie is its executive director.

SMITH: I was at the rallies. And what I wanna know is, what, if anything, was accomplished?

SOUCIE: I'm not sure. I'm not trying to dodge the question—I mean it depends on how I feel. If I'm having a cynical day, I can say, "Man, it didn't add up to anything." If I'm feeling optimistic, I can say, "Well, what it did was really kinda smoke everybody out"—you know, all the people you never saw before—"and now, hopefully, they're doing something." But I'm not really sure of what Earth Day accomplished. It *may* in fact have been a mistake, because now everybody who went out and paraded around Earth Day feels that he's done his bit.

SMITH: Yeah, I hate to say that's what I thought in advance. I thought it was too "carnival atmosphere" and that everyone would feel like, "Oh, I was there; I helped clean up America because I went and listened to some speeches."

SOUCIE: Yeah, "I'm not using Baggies and nonreturnable bottles so that's my contribution."

SMITH: There's something that bothers me about the whole ecology fight: there doesn't seem to be any visible opposition. People can just constantly say, "I'm for clean air. I'm for clean water. I don't want to litter the country." And everybody agrees with them. Everybody—every newspaper, every magazine, every large corporation—was *behind* Earth Day.

SOUCIE: That's right. Nothing significant has changed yet, to use the old word, in the *conservation battles*. You still are fighting the timber

companies, mining companies, automobile manufacturers, oil companies—you know, the same old guys....And they're still fighting you in the same way, except now they don't say some of the things they used to. And then there's this too: this problem of politicians playing it superficially as well, because they're not sure they *have* to do it any other way. Because to do it any other way *but* superficially incurs political risk. Because you can't tell how much this new environmental interest is going to help you in your political career, but you know damn well what's going to happen if you start fighting Shell Oil: you're gonna get in some serious trouble. So you have things going on like Senator Kennedy, for example. We met last week with two people from Massachusetts to talk about the

But I'm not really sure of what Earth Day accomplished. It *may* in fact have been a mistake.
—Gary A. Soucie

SST [supersonic transport], and he said he's very much on our side. I know he is. I had a correspondence with him. But as of the moment, he's not planning to help lead the fight against the SST in the Senate, because it's not a big enough issue for him.

SMITH: One reason I have trouble in my own head about actively joining the ecology movement is that the people in government who *can* make a difference are dragging their feet or just don't care. So what effect does one single person have in the fight against pollution? For instance, what could a student do to be really effective?

SOUCIE: It *is* possible to pick out two or three things that you care strongly about and do something in each one of those fields. Now, what to do varies from field to field. And just like in the field of the environment, it really depends on whether you're terribly concerned about, say, endangered species of wildlife, where you do one kind of thing, or whether you're concerned about the internal combustion engine, where you can do something else.

SMITH: Let's take the internal combustion engine. What can somebody do?
SOUCIE: Okay, it depends who this somebody is.
SMITH: A college student, very wrapped up in his studies and getting through school wanting to get their degree.
SOUCIE: One thing he can do, for example, is, himself, make sure that the car he drives has got an efficient, small engine. I drive one of the world's great cars, but it's got a tiny engine. Every time I drive it, I'm cognizant of how many cubic inches of air I'm polluting. And I use unleaded gasoline. And then I try not to drive the car unnecessarily.

SMITH: But what if you don't have a car? What can one person really do?

SOUCIE: All right. First inform yourself so that every time you bump into somebody who you don't ordinarily talk to and the subject comes up, discuss it intelligently. He may not have read our side of the argument. You may in fact begin to erode this guy's confidence or his smugness or, in some cases, his feeling of despair....

Because the people who say, "Oh yeah, I'm on your side," don't show up for the vote. It's inconvenient.

—Gary A. Soucie

SMITH: You mean that by enough people doing that, the gasoline companies will begin to feel the pinch?

SOUCIE: We don't know, but the real change is gonna come when government threatens to take it out by legislative fiat, like telling oil companies to get the lead out.

SMITH: So that college student we're talking about, how can they help the government reach that point sooner? So far what you've described just sounds like moving pieces of sand from one beach over to a cleaner beach. It's endless.

SOUCIE: Yeah, in a way it is. It's an endless process; we will never *clean up* the environment. It'll never happen.

SMITH: Can it accelerate things to clean it up faster? It just sounds so slow, and we live in a very accelerated world.

SOUCIE: Well, I'm a great believer in political insistence, and this is the thing that's lacking from the whole environmental movement. In other words, when you really get down to the nitty-gritty, will you insist that your elected representatives in state's legislature and Congress do the right thing—will you really *insist*? Everybody says they will, but in fact nobody is doing it yet. And that's why we're losing votes, every day, in the state houses around the country and in the Congress. Because the people who say, "Oh yeah, I'm on your side," don't show up for the vote. It's inconvenient.

George Harrison
May 1970

Two weeks ago Paul McCartney announced the official breakup of the Beatles. George Harrison is in New York City to see the new Apple offices and pick up his tourist visa—eighteen months in the making due to a drug possession charge in the UK—before he goes back to England to begin recording his debut solo album, All Things Must Pass. *The record will top the Billboard charts and its single, "My Sweet Lord," will as well, making Harrison, surprisingly, the first Beatle to hold both number one spots simultaneously.*

SMITH: Are you going to be doing any recording while you're in town?

HARRISON: No. Well, I can't work that sort of work; I'd need a different visa. Anyway, there's not enough time to record. But I am gonna be recording in about three weeks. Gonna start an album of my own, as Ringo and Paul...This is gonna be the George album. I start that [in] three to four weeks' time and I hope to do it with Phil Spector.

SMITH: Have you written the material?

HARRISON: Yeah. I've had songs for a long time and lots of new songs. I've got about enough songs for three or four albums actually, but if I do one, that'll be good enough for me.

SMITH: I didn't know you were that prolific as a writer, because there's so few of your songs on Beatles albums.

HARRISON: Well, I wrote some songs—in fact, some songs I feel are quite nice, which I'll use on this album—about four years ago. But it was more difficult for me then to get in there, to do it. It was the way the Beatles took off with Paul and John's songs, and it made it very difficult for me to get in. Also, I suppose at that time I didn't have as much confidence when it came down to pushing my own material as I have now....I did write one song on about the second album. And I left it; I didn't write anymore. That was just an exercise to see if I could write. About two years later I recorded a couple more songs, I think *Rubber Soul*, and then I've had one or two songs on each album. There are four songs of mine on the double *White Album*. But now the output of songs

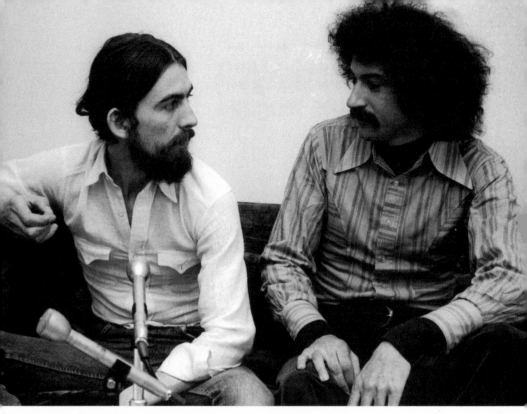

George Harrison and Howard Smith at Pete Bennett's office, N.Y.C., May 1, 1970

is too much to be able to just sit around waiting to put two songs on an album—I've got to get 'em out.

SMITH: How was it decided how many songs you would have on a Beatles album?

HARRISON: It's always been whoever would be the heaviest would get the most songs done. Consequently, I couldn't be bothered pushing like that much. Even on *Abbey Road*, for instance, we'd recorded about eight tracks before I got round to doin' one o' mine. Because you say, "I've got a song," and then Paul, "Well, I've got a song as well and mine goes like this, 'Dit a lit a lit a li,'" and away you go. It was just difficult to get in there and I wasn't going to push and shout. But it was just over the last year or so we worked something out which was still a joke, really: three songs for me, three songs for Paul, three songs for John, and two for Ringo.

SMITH: Why did Ringo only get two?

HARRISON: Well, because that's fair, isn't it? That's what you call being fair. No, but even Ringo is writing more songs. We just cut a Ringo song called "It Don't Come Easy." But Paul and John and myself have just got so many songs....This is a good way: if we do our own albums, we don't

have to compromise. Because in a way, Paul wants to do songs his way, he doesn't want to do his songs my way, and I don't wanna do my songs their way. I'm sure that after we've all completed an album or even two albums each, then that novelty will've worn off.

SMITH: You think the Beatles will get together again then?

HARRISON: Well, I couldn't tell if they do or not. I'll certainly try my best to do something with them again. I mean, it's only a matter of accepting that that situation is a compromise. In a way, it's a compromise and it's a sacrifice, because we all have to sacrifice a little in order to gain something really big. And there is a big gain by recording together—musically and financially and also spiritually and for the rest of the world...It's the least we could do to sacrifice three months of the year just to do an album or two. I think it's very selfish if the Beatles don't record together.

SMITH: But everything looks so gloomy right now.

HARRISON: It's no more gloomy than it's been for the last ten years. It really isn't any worse. It's just that over the last year, what with John and stuff and lately with Paul, everything that they've thought or said has come out to the public; it's being printed; it's been for everyone to read and to comment about or to join in on.

SMITH: But the feelings had been there all along?

HARRISON: In different ways. We're just like anyone else: familiarity breeds contempt, they do say. We've had slight problems, but it's only been recently, because we didn't work together for such a long time, and the Yoko and John situation, and then Paul and Linda. But it's not as bad as it seems.

SMITH: There seems such animosity between Paul and...It sounds like he's saying it's all over.

HARRISON: But it's more of a personal thing that's down to the management situation with Apple. Because Paul, really it was his idea to do Apple....Then it got really chaotic and we had to do something about it. When we started doing something about it, obviously Paul didn't have as much say in the matter...because he wanted Lee Eastman, his in-laws, to run it and we didn't. That's the only reason; that's only a personal problem that he'll have to get over, because the reality is that he's outvoted and we're a partnership. We've got these companies which we all own 25 percent of each, and if there's a decision to be made, then like in any other business or group, you have a vote. And he's outvoted three to one and if he doesn't like it, it's really the pity. Because

> **I think it's very selfish if the Beatles don't record together.**
> —George Harrison

we're tryin' to do what's best for the Beatles as a group or best for Apple as a company. We're not tryin' to do what's best for Paul and his in-laws.

SMITH: You think that's what the key fight is over?

HARRISON: Because it's on such a personal level that it is a big problem, really. You imagine that situation if you were married and you wanted your in-laws to handle certain things. It's a difficult one to overcome, because you can think of the subtleties. He's really living with it like that, you see. When I go home at night, I'm not living there with Allen Klein. Whereas in a way, Paul is living with the Eastmans. So it's not really between Paul and us. It's between Paul's advisors, who are the Eastmans, and our business advisor, which is Allen Klein. But it's all right.

> **We'd earned a lot of money but we didn't actually have the money that we'd earned.**
> —George Harrison

SMITH: I'm not as optimistic.

HARRISON: It's all right. All things pass away, as they say.

SMITH: I detected some animosity between Yoko and Linda; is that part of what it's about?

HARRISON: I don't think about it. I refuse to be a part of any hassles like that. Hare Krishna, Hare Krishna, Krishna, Krishna, Hare, Hare, and it'll all be okay. Just give 'em time, because they *do* really love each other. I mean, we all do. We've been so close and through so much together that to talk about it like this, we'll never get any nearer to it. But the main thing is, like in anybody's life, we have slight problems and it's just that our problems are always blown up and shown to everybody. But it's not really a problem; it's only a problem if you think about it.

SMITH: You don't think there's any great anger between Paul and John?

HARRISON: No. I think there may be what you'd term a little bitchiness, but that's all it is. Just being bitchy to each other, childish. But I get on well with Ringo and John and I try my best to get on well with Paul. It's just a matter of time, for everybody to work out their own problems, and once they've done that, I'm sure we'll get back round the cycle again. But if not, it's still all right. Whatever happens, it's gonna be okay. In fact, it's never looked better from my point of view. The companies are in great shape—Apple Films, Apple Records, my song company....We got back a lotta money that a lotta people had that was ours, a lotta percents that different people had....

SMITH: Did Klein do all that for you? Were you really broke or were all of you just crying poor?

HARRISON: We weren't broke. We'd earned a lot of money but we didn't actually have the money that we'd earned. It was floating around.... Right back, that's really the history since 1962; the way everything was structured, none of us knew anything about it. We'd just spend money when we wanted to spend money, but we didn't know where we were spending it from or if we paid taxes on it. We were really in bad shape as far as that was concerned, because none of us could really be bothered. We just felt as though we were rich, because really we were rich by what we sold and what we did. But it was so run together, the business side of it....But now it's very together and we know exactly where everything is and there's daily reports on where it is and what it is and how much it is.

SMITH: What do you wanna do with all your money? I just saw one of the daily reports and you've got a lotta money.

HARRISON: I just want to live as comfortably as I can or as I need, which is really very comfortable, I can tell you. Money is to be used. I try and help different things that I believe in. But I don't believe in just givin' my money away....I'd rather keep my money and make it into more money until I've got so much money and then give it all away. But that's not for a few years. I'd much rather buy something with the money, like buy a house and fill it full o' people doing something good and then give that away, rather than just give people dollars.

SMITH: On the new album that you mentioned, are you gonna be playing all the instruments?

HARRISON: No. I'd much rather play with other people, because united we stand, divided we fall. Musically, it can sound much more together if you have a bass player, drummer, and a few friends, a little help from your friends.... But I really want to use as much instrumentation as I think the songs need. It'll be a production album, as opposed to down home on me Nagra.

SMITH: I guess you've heard Paul's album. What did you think?

HARRISON: I thought "That Would be Something" and "Maybe I'm Amazed" are great and everything else I think is fair. It's quite good but a little disappointing. But I don't know—maybe I shouldn't be disappointed. It's best not to expect anything and then everything is bonus....

SMITH: I wonder whether that can work again with you guys. I find it very hard to imagine you all staying in a studio again for the months that it takes to produce a record. How are you gonna just work it all out?

HARRISON: Well, it's really quite easy. We've done it for years....All we have to do is accept that we're all individuals and have as much potential as the other. Having accepted that, it says, "Scan not a friend with

microscopic glass, you know his faults, then let his foibles pass." That's written on my house.

If we were all perfected beings, we wouldn't be here in the physical world. The fact that we're all here in these bodies means that we're not perfected. So having accepted we're not perfected, we can allow for each other's inadequacies or failings with a little compassion. I'm certainly ready to be able to try and work things out with whoever I'm with. But if whoever I'm with is full of hassles, then I'm not gonna be with him, am I? I'm gonna go with somebody else. I mean, that's really how things happened for me when I got tired of being with the Beatles. Because musically, it was like being in a bag—they wouldn't let me out the bag. Which was mainly Paul at that time, the conflict musically for me was Paul. And yet I could play with any other band or musician and have a reasonably good time.

I can be Lennon/McCartney too, but I'd rather be Harrison.
—George Harrison

SMITH: What was the conflict with Paul? I don't understand.

HARRISON: Well…Paul and I went to school together, you know? I got the feeling that, you know, everybody changes and sometimes people don't want other people to change, or even if you do change, they won't accept that you've changed and they keep in their mind some other image of you. Gandhi said, "Create and preserve the image of your choice."

SMITH: What was his image of you?

HARRISON: I got the impression he still acted like he was the groovy Lennon/McCartney. There was a point in my life where I realized anybody can be Lennon/McCartney. Because being part of Lennon/McCartney, really, I could appreciate how good they actually are and at the same time see the infatuation the public had or the praise that was put on them. I could see everybody as a Lennon/McCartney if that's what you wanna be. I don't know if I'm explaining…. The point is that they're nobody special. There's not many special people around. And if Lennon and McCartney are special, then Harrison and Starkey are special too. That's really what I'm saying is that I can be Lennon/McCartney too, but I'd rather be Harrison.

SMITH: Are you doing things other than recording now?

HARRISON: Just composing and recording and trying to get myself straight. The only purpose for being alive is to get yourself straight. Each soul is potentially divine; the goal is to manifest that divinity. And liberation, that's really what I wanna do—is liberate meself from this chaos and of

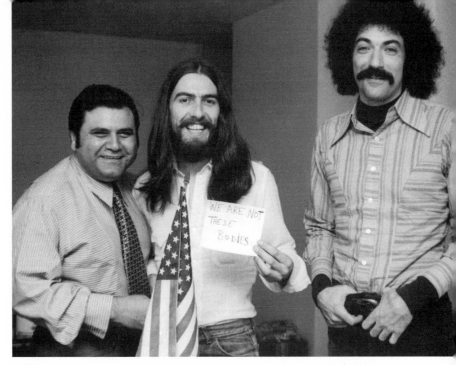

Pete Bennett, George Harrison, and Howard Smith at Bennett's office, N.Y.C., May 1, 1970

this body. I wanna be God-conscious. That's really my only ambition, and incidental is everything else....

This is where I really disagreed with John, because I want peace too. But I don't think you get peace by goin' around shouting, "Give peace a chance, man!" For a forest to be green, each tree must be green. You don't get peace by talking about peace. You don't get any sort of peace until you really stop talking and be more on the road to peace.

SMITH: It seems much slower, less direct. I think what Lennon's trying to do is find a quicker way of getting peace.

HARRISON: But it's like trying to take a pill, isn't it? It's like acid: people took acid in order to have some higher state of consciousness, but it doesn't work. To get God-conscious, you have to stop taking pills and stop all that scene. You're not gonna get God-conscious just in half an hour. It takes lifetimes. It takes a million years of healthy life to spiritually evolve like that. It gets boring all those incarnations and stuff. I can understand John wantin' to get it in five minutes, because I'd like it like that too. I wish you could take a pill and it'd just make you disappear, but that's not the way.

GEORGE HARRISON

Floyd Red Crow Westerman
Summer 1970

Floyd Red Crow Westerman, born on the Sisseton-Wahpeton Sioux res-ervation in South Dakota, was taken from his family at the age of seven and placed in government-run Indian schools, where expression of his language and culture was forbidden. After college he played one-man gigs singing in bars around Denver, and was contemplating law school when Perception Records gave him the opportunity to collaborate with American Indian poet Vine Deloria Jr. and record his first album, Custer Died for Your Sins. *While here in New York, he'll record his next album,* Indian Country, *live at Town Hall.*

...

SMITH: How do the Indians feel about people like Jane Fonda, Dick Gregory, non-Indians, taking up the Indian cause, holding fasts for them and getting arrested?

WESTERMAN: I think there are two feelings about it. One is, if they're gen-uine, it's a good thing. But regardless of if we want some white figure to come in, if we like it or not, it brings the Indian problem out there before the media and pinpoints the issue about the Indian problem more than it does Jane Fonda. Whatever Jane Fonda does in it, her sincerity is some-thing I don't even question.

SMITH: Do Indians feel that perhaps you're selling out because you now have a record that's selling pretty well, owned by white people; it's not an Indian record company?

WESTERMAN: Whatever is being said on these albums is what everybody's more concerned with. I'm just a vehicle to get these indictments out, to get out what has been suppressed for 140 years.

SMITH: Are you afraid at all that you're being co-opted, that you're being *used* as a commercial thing? Like, Indian clothes are so popular—all the buckskin things. Are you being used?

WESTERMAN: A certain amount of that is a lot of bewilderment on the part of the white kids. They're trying to figure out what the hell we're all about

and trying to get into that kind of a cult way of life. As far as my personal feeling about what's happening with the record, the fact that I'm going to become a shiny piece of mahogany in the eyes of the people who I'm in contract with is one feeling. My feeling is getting the message out. And hell, I'll just drop out of the damn thing once I feel I've done what I felt I should've done. I'm not in it for the money thing; I don't even consider that, because much of the money I get will be going to the Indian effort anyway.

SMITH: I hope that you become even more popular so you can get the message out, but what happens if you start having $5,000 or $6,000 a week coming in or per concert? What if you become as famous as Johnny Cash or Doug Kershaw? At that point maybe you won't wanna drop out—

WESTERMAN: Well, there's one thing. I know there's a little kid in the Indian boarding school somewhere who would kinda like to see something like this. I'd be thinking and more concerned about him. I think it would give him a different attitude on what the Indian should feel about himself once he sees that this is happening. And a lot of this has gotta happen in the Indian community....And once they begin to digest that in the boarding schools, maybe a different sense of what education is all about, or what it's worth, will come out in the Indian identity.

Personally, even though I did get through a college degree, I don't feel I have to read another book or write another word to function anymore. I could play my guitar in some little bar back in Colorado or South Dakota or Minnesota. But it's just a fact that these things on the album are basic indictments. And an Indian has a superior right to bring this kind of thing up, because it's been 140 years since the establishment of the reservation.

I'm just a vehicle to get these indictments out, to get out what has been suppressed for 140 years.

—Floyd Red Crow Westerman

SMITH: Do you know Jeannette Henry? She started a publishing company in San Francisco. It's the first wholly owned Indian publishing company in this country.

WESTERMAN: That's good.

SMITH: Their first book is a book taking apart textbooks, saying where they depict Indians all wrong.

WESTERMAN: Books and movies...they're *still* doing that. *A Man Called Horse*, look at that.

SMITH: I didn't see that.

WESTERMAN: Pretty vicious treatment, really. We got up and protested the movie right in a preview of it and we said, "We're not blood-and-guts people." And they said, "Well, that's what sells." They have the gall to want us to preview a movie, we tell them it's wrong, and they say, "That's what sells." It's as if they only did it as a token thing for you to come and preview the damn thing.

SMITH: What about the draft, as young Indians are becoming more militant and antiestablishment.

WESTERMAN: Most Indians don't evade the draft, but they usually become AWOL after their disillusionment in what they even went in for.

SMITH: What do they go in for?

WESTERMAN: The Indian thing, and the respect of the family, and the warriorship thing kind of supersede any other kinda reasoning until he gets in there and finds in the ranks it's all screwed up. And begins to put it together, this reservation scene, and he being in the *military*...Other Indian kids are talking to him sayin' "What are you in a war for? What are you in uniform for—when actually your people are back on a reservation still gettin' *taken*?" He starts to mull it over and he goes AWOL. We got a lotta Indian kids who're getting a bad deal in military jails. And the new law that says a person can refuse to go into service because of his real feelings? We're trying to incorporate that as...the very basic way an Indian lives and believes.

SMITH: As a way of getting out of the draft.

WESTERMAN: Yeah. We're gonna try to utilize that now to get them out. But at this present point...the bulk of 'em are not able to articulate that reasoning of why they don't feel they should be in the service, as American Indians.

Michael Costello
June 1970

At the end of the month, Special Agent Michael Costello will be asked to give expert testimony to the Ninety-first Congress's Select Committee on Crime at its Crime in America: Heroin Importation, Distribution, Packaging and Paraphernalia hearings. He's a standout in the bureau and has been awarded two medals for superior performance. Costello will go on to become deputy director of the Bureau of Narcotics and Dangerous Drugs. He's also a licensed pharmacist.

SMITH: The Bureau of Narcotics and Dangerous Drugs. Is that a new name?

COSTELLO: Only since 1968. Under the reorganization plan of President Johnson, the Bureau of Narcotics, formerly in the Treasury Department, and the Bureau of Drug Abuse Control, which was under Health, Education, and Welfare, were both merged and subsequently transferred into the Justice Department.

SMITH: Do you go into frequent changes of appearance? You don't look like you could do any undercover work on the New York drug scene. I mean, pardon me, but you look kinda square.

COSTELLO: We have agents who would tend to specialize in undercover investigations because of their physical appearance. It's not necessary, however, because we're not dealing in a particular area where the personal representations of one individual are the criteria for making a case. We deal strictly in selective enforcement. We choose the target of investigation and we go to work. It's not a case where we'd go down in the Village and ferret out one individual with long hair and concentrate on buying one or two marijuana cigarettes.

SMITH: Then how come so many people are arrested for one or two cigarettes?

COSTELLO: We feel that local problems are best dealt with at the local level. New York City is an atypical situation, because this is actually the melting pot of drug use of all types. We have approximately 50 percent of the nation's addicts right here. New York City, for that reason, is one of the focal points for the drugs entering the country, and there are certain

individuals in New York who will import these drugs and send them out to other portions o' the United States.

SMITH: Did you used to do undercover work yourself?

COSTELLO: I can count up only about two dozen times when I had the opportunity to work undercover....

SMITH: Have you been involved in enforcing the marijuana laws?

COSTELLO: We may be called upon to assist on a large marijuana case, where the drugs may be coming in from Mexico and funneled across the United States, caravan style, the ultimate destination being the city o' New York. However, I've never made arrests for the possession or sale of marijuana. It was always either heroin or barbiturate drugs, amphetamine drugs in some instances, but never marijuana.

SMITH: I read a figure, it's something like forty thousand people in jail, right now, in the United States for marijuana.

COSTELLO: Well, this would be the purview of the local, municipal, or state authorities. We cannot be responsible for the laws that exist; we must enforce. However, we cannot dictate the type of enforcement that they do. The enforcement that they do is extremely necessary, because someone must get down to where it's at and enforce the laws to the people that either use or sell on the local level.

SMITH: I've heard that agents get into situations often where they have to use drugs; otherwise, they would blow their cover. Is that true?

COSTELLO: No, for one simple reason. What would you think sitting on a jury at a subsequent trial of an individual who had sold to an undercover agent, and the agent is on the stand and the defense attorney asks him, "Have you ever used drugs?" If the answer is "Yes," as a juror, what would you think? So our agents are cautioned. They are told that they must never, never use drugs.

SMITH: Come on. You've been working on a case and everybody is sitting around smoking, and the common thing is for the buyer to taste....I can't imagine you're not smoking a few joints.

COSTELLO: If you're sitting around with a bunch of individuals and they're all lighting up and you're trying to buy, then shame on you. No one is going to require an agent to smoke a reefer if he is negotiating for the transfer of two or three hundred kilos of marijuana. Now that's a little ridiculous.

SMITH: You mean no agents from your division make a pot bust for less?

COSTELLO: Any cases involving just mere possession of marijuana would be automatically referred to the local authorities.

SMITH: Are there busts in your division for as little as a pound?

THE SMITH TAPES

COSTELLO: No, sir. Absolutely not. We are empowered to expend government funds for the purchase of evidence, but we are not gonna spend whatever the going price is in New York City, which is now about three and a quarter for a kilo of grass. Nobody is gonna approve $325 for an agent to procure these official funds and then go out and buy that kilo. We're not interested in this particular type of enforcement right now, because of the limited manpower available.

SMITH: What is the smallest amount that you can get approval of funds for?

COSTELLO: If we're interested in making a case on a particular group or individual, if this individual happens to be selling heroin in quantities of twenty-five dollars or fifty dollars, then I dare say that we would take a chance and go ahead and buy in the hopes that we could get into the organization and find out where the drugs are coming from, who is involved....

SMITH: But you wouldn't be buying from him to bust him?

COSTELLO: That's right.

SMITH: Would you eventually pick him up in the final arrest?

COSTELLO: Yes, because once an individual breaks the law, we cannot disregard that breaking of the law. This is solely within the purview of the judicial system.

SMITH: I actually know people who were let go if they had a really good story. I heard a joke once that if you kick a narc in the heart, you break your toe. Now that can't be *completely* true.

COSTELLO: No, that's not within the purview of the agent to turn an individual loose, no matter *what* his story is....But God help the narcotic agent that would take somebody into custody, bring him up into the office and listen to his story and find out that he's a victim of circumstances.

SMITH: I meant before you got to the office.

COSTELLO: You can't let him go. You can always call the United States attorney and ask for a delay in arraignment—that's a possibility. But to take the purview of the judicial system and carry it out on your own level is catastrophic.

SMITH: Last week I interviewed John Dominick, who wrote *The Drug Bust*. He said a lot of federal narcotic agents are afraid of arresting girls.... Afraid that they'll be brought up on moral charges and that it can be very injurious to their career if, on the witness stand, the girl claims that the agent did something to her. So it isn't that girls smoke less or shoot less, it's that agents prefer to keep away from 'em. Is that true?

COSTELLO: It's true that situations can arise which may seem to be nonbeneficial to the agent. However, there are not that many women involved

MICHAEL COSTELLO

directly in the sale of drugs. Occasionally a female enters the scene as an international courier, the girlfriend of the individual who is selling. But as far as negotiating directly with females, this does not occur often, because there are just not that many independent female dealers.

SMITH: But is it true that's a fear?

COSTELLO: No, we have an internal inspection service, which is quite good. These people will get to the bottom of almost anything. They'll dig until they do. Allegations have been made against me in the past and they will be made in the future. They will be made against other agents but we do survive.

SMITH: What type were made against you?

COSTELLO: Particular situations involving improper conduct, say, by a defendant stating that I made overtures and things exactly along the line you're alluding to. But of course, with all of the facts being exposed at the subsequent trial, it is within the discretion of the judge as to whether or not this should be allowed in the evidence. I'm sure that if there was *any* suspicion of this evidence, it would be considered tainted under the fruit of the poisonous tree doctrine all the way down the line, and the judge would never let it in.

SMITH: Wait, *fruit of the poisonous tree* doctrine?

COSTELLO: Yeah. If evidence is uncovered, and any part in the chain of that evidence or any information that you have obtained before that evidence is secured by you, if the defense counsel can show that it's tainted in any way, everything that follows that will be suppressed and not allowed in. But BNDD has an excellent conviction record. When we go to trial, we will convict over 90 percent of the cases. It's a matter of integrity. You look for the agent who has a large amount of integrity. Every now and then a bad apple comes along. This is human nature. You roll in dirt and you are liable to get dirty.

SMITH: I kinda believe that people become what they do. Is it true that agents become similar to sellers and dealers?

> **We have approximately 50 percent of the nation's addicts right here.**
> —Michael Costello

COSTELLO: No, because this is a role that is played by the agent with some expertise. I must add, it is not his constant role. The time will come when the investigation will be terminated and the arrests will be made. The agent will then assume his normal enforcement activities, which may not necessarily be going back and working undercover.

SMITH: How can you work so long around that kind of scene and never be curious about sniffing a little cocaine, which you certainly know is not addictive from a few little sniffs.

COSTELLO: For the investigator, a certain amount of respect is engendered for all drugs. You'll have to remember that it's not just merely ferreting out those that are selling and taking them into custody. More often than not, we will come across people arrested by other agencies who we desire to interview. Sometimes these people are highly addicted to drugs…and the agent sees the toll of the drug. We have opportunities to work closely with people in rehabilitation, to take a good hard look at their type of approach to the treatment of narcotic addicts and acidheads and potheads. The agent can see firsthand the type of ruin sometimes dictated by the constant use o' drugs.

SMITH: Do you subscribe to the theory that one sniff of cocaine and you're hooked? One drag on a joint and you're hooked?

COSTELLO: No, of course not. We have to be realistic.

SMITH: Aren't you curious what it's like to be high?

COSTELLO: No, I'm not, because…I don't subscribe to the theory that there is a need to escape from reality or even to alter it or even to experiment. If I desire a good time, there are many ways to do it.

SMITH: Do you drink?

COSTELLO: Moderately, I do.

SMITH: Well, how about smoking moderately?

COSTELLO: This is the old cliché arguing alcohol and marijuana, which you cannot do.

SMITH: No, I'm not even going to argue that with you. But one glass of wine and it alters my mind an awful lot.

COSTELLO: If I've taken, say, a glass of wine with dinner or one drink at a cocktail party, that's it. That's what we call moderate. More or less the effects are predictable. I know that if I take a drink that it's nice. It doesn't do anything *for* me. I don't feel that it does anything against me. But I wouldn't have the same predictability with marijuana. It's a matter of what you're after.

SMITH: Have you ever been close to smoking a joint?

COSTELLO: Never. I have an innate respect even for aspirin. With what I have seen, and the dredges of humanity with whom we all have come in contact at one time or another, I have a great respect even for a drug such as aspirin. Of course, prescription drugs I have the greatest respect for. But the contraband items such as heroin or LSD or marijuana, I have nothing but the most disgust for them.

MICHAEL COSTELLO

Pete Townshend

June 1970

Pete Townshend is the guitarist and songwriter for the Who. Last night they kicked off a thirty-day tour with two performances of their rock opera album, Tommy, *at the Metropolitan Opera House in New York City. They're in America to support their latest album,* Live at Leeds, *which was released last month. Since their last visit to the States they've reached new levels of stardom, and instead of playing colleges and rock clubs, the band will fill stadiums and arenas.*

..

TOWNSHEND: A funny thing happened quite recently, since we last spoke. One of our last appearances in England, we played at a university and there were Hells Angels there...And they'd already commandeered the dance hall. We'd given up playing *Tommy* and were just playing rock 'n' roll songs for 'em, and they tried to get on the stage and we wouldn't let 'em on the stage. They pinched a mic stand, and it ended up with me at the front o' the stage, normal uncool self, goin', "You come up here," and them saying, "You come down here," and so on. One of 'em did try 'n' get up and I kicked him off, and he went and picked up what is called a Newcastle Brown bottle, which is, like, a great big quart bottle made out of very thick glass, and he threw it up in the air and it happened, by incredibly cunning trajectory planning, to land right on my head, where-upon blood gushed out like nobody's business all over my white boiler-suit. Everybody in the place screamed and ran, including all the rugby players who were supposed to be protectin' us.

I came to in an incredible rage and broke my guitar over someone's collarbone. I'd, like, seen blood on me face and thought I must get revenge. Just saw this incredible Hells Angel standing at the front of the stage goin', "Could I ask you a question?" he was saying at the time, in all this affray. He had a ring in his nose and long hair and a great big hairy chest, and I've got the guitar side arm and I smashed it. I literally smashed it to pieces against his collarbone and he just didn't even wink, didn't even twitter. Unfortunately, our wonderful road manager, Robert Pridden, leapt out in the audience to retrieve the guitar and he ended

up gettin' bottled as well. So we both, phenomenally, went off to the hospital.

I mean me, driving me Mercedes 600…Quite an amazin' scene. I was laughin' all the way to the hospital, thinking, "Here I am, in a £10,000 motorcar, blood pourin' outta me head, chauffeuring meself to the hospital…." It's just an amazing ritual. It's the part of being a rock star that I like the most, in actual fact. It makes me feel like a rock star, when most of the time I don't feel like a rock star. But it's, like, very strange because it all seemed so terribly dangerous at the time, and when reviewed…. When I got to the hospital to collect eight stitches, I was well drunk so I didn't feel a thing by the time they got all the needles in. There was kind

> **I came to in an incredible rage and broke my guitar over someone's collarbone.**
>
> —Pete Townshend

of a queue of young kids, all been beaten up by these guys. It's really kinda crummy. But then, I hate to say this to a country which is so anti-war, but people like that should be out on the battlefield. There are people that are born with this kind of thing in 'em. They *have* to fight, and if you don't give 'em a place to fight…I'm afraid that people are just like this. Some of 'em are naturally very sweet 'n' nice 'n' peaceful. Some of 'em are very horrible 'n' aggressive and there's got to be a place…I mean, our stage is our battlefield. I still spill over a little bit outside the stage. If we don't play enough, my aggression starts to come out on things around the house.

SMITH: But sometimes war does bring more war.

TOWNSHEND: Yeah, I shouldn't really bring it up in a country where the situation is so delicate. But perhaps I'm old-fashioned enough to say that when I see some real violence, a dose of conscription might do that cat good. Because he's not lucky enough to be in a position where he can take it out on a $150 guitar like I do.

SMITH: Last time we talked you mentioned how much you had hated Woodstock.

TOWNSHEND: Yeah. Woodstock's cooled off a little bit in my head now. At the time I was pretty vehement about it, particularly because we were gettin' caned a lot—not just about the Abbie Hoffman incident, as it were, but because a lotta people were picking up on the crap which Abbie Hoffman was puttin' out about us gettin' our money before the show, which is absolutely normal procedure anyway. It was in the contract, and we were leavin' the next day, and we're committed to pay withholdin' tax

to the American government before we leave the country so we had to have it. It's as simple as that.

SMITH: Did you see the movie? I believe they left the Abbie Hoffman incident out.

TOWNSHEND: They wouldn'ta done, because I remember the producer of the film jumpin' up 'n' down 'n' screamin' after I'd hit the guy, saying, "Why didn't one of you get it?!" So if it'd been in, I suppose it would've been recorded for posterity. Thank Christ it wasn't, because it wasn't a particularly pleasant incident. And I don't suppose it woulda been very nice to watch close up. But I never hurt him. He was very badly freaked out on acid, I understand, so it was incredibly melodramatic. All I did was gently nudge him with it. But apparently, he seemed to kinda collapse in a ball and run off screamin'. I mean, it has put us off big festivals, actually. It's quite amazing.... We were one of the few English bands on it, and consequently being English we didn't feel it was quite such a big, historic moment. It wasn't so historic for us. I mean, in a country which's got such a huge population, it doesn't *seem* so astounding to me that when you put together some of the best rock music that there is in the land, and the best publicity that I've ever seen for any show on earth, that you get half a million kids. I don't think that that's quite so astounding. It's just that America does. I don't know why.

> **Here I am, in a £10,000 motorcar, blood pourin' outta me head, chauffeuring meself to the hospital...**
> —Pete Townshend

SMITH: With the times being so chaotic—war everywhere and everything seems to be getting worse—do you find yourself drawn to become more political in your songs?

TOWNSHEND: I usually find the exact opposite. I kinda get very disgusted at just general down-the-line thinking. In other words, people get an idea in their head about something, make a decision, and then rigidly stick to that decision for, say, six months or a year. And throughout that year their thinking stays very clear about some political issue like Vietnam or dope or demonstrations or anything, you know, the Beatles maybe. Then at the end o' that year will shift their head to somethin' which is perhaps the exact opposite. It's one o' the things I feel about most kids these days: somethin' that you mustn't deny yourself is the right to change your mind.

This is a very difficult country to really say what you think because there's very set patterns of *mental behavior*, as it were. People believe that, for example, people that look straight should think straight 'n' people

that look freaky should think freaky, and never the twain shall meet. And both parties think that so vehemently that quite honestly, I don't think they ever will meet. Maybe the point is they just don't really wanna meet. I think that's perhaps what prevents me becomin' too political.

I don't think rock's got anythin' to do with it, you see. *Rock*'s got to do with *rock*. And I think that the Who in some cases don't even fit into rock because they're kinda settin' up a set of limitations which are very, very narrow for themselves. It's as though we're walkin' down a funnel, you know, and the constriction is gettin' narrower 'n' narrower, until in the end we're gonna kinda be squeezed out the end like shit. It seems like it would be very, very difficult to really say anythin' that had any effect, because what everyone says is kind of bottled as meaning somethin' anyway. In other words, whatever you say has applied to it what people think you're about anyway, so you might as well just write a song 'n' people will find in it what they wanna find.

Rapidly, I'm one o' the people that probably talked more about their work than anyone I know, actually. Things like about *Tommy*. I talked about it in *Rolling Stone*, thirteen pages before we'd even wrote the thing, and afterwards I must've rapped about it with somethin' like four hundred interviewers, become the most interviewed person in the world, I think. And in some cases it's bad that I might've spoiled a lotta people's enjoyment. I mean, on the other end of the extreme is someone like Dylan who just says nothin' to anyone about anythin'. I don't know who said this, somebody famous said it, but "Trust the art, not the artist."

I mean, what I say changes from day to day, so how can you trust me to say the right thing at the right time? If, for example, I say somethin' about *Tommy* or about a song I've written, about it being politically or spiritually this or about Meher Baba or about my family life or whatever, that it might just spoil somethin' which it's got goin' for it. I know a lot of enjoyment of music that I've known has been spoiled by gettin' to know the people that wrote it. It can really sometimes, you know, knock the feet from under the music.

Abbie Hoffman
June 1970

Abbie Hoffman is an author, an activist, and a cofounder of the revolutionary Youth International Party (the Yippies). Four months ago, he was sentenced to five years in prison for his involvement in organizing and leading the demonstrations surrounding the 1968 Democratic National Convention in Chicago. He's due to begin serving his sentence this fall.

SMITH: What are the three books that you have to do in this month and why do they have to all be done this month?

HOFFMAN: Well, June is vacation month; that's when you write. I mean... school's out and there's a summer lull.... When you're in the midst of a trial, or organizing demonstrations and things, you can't take time out to write a book. So I'll do it in June.

SMITH: What are the books?

HOFFMAN: One's about the trial. It's called *Offense of America* and [it's] mostly my testimony, edited, and thoughts about the trial. The other one is called *Steal This Book*; it's [about] how to live free and conduct guerilla warfare in America.

SMITH: You mean literally how? With weapons and bombs and the whole thing?

HOFFMAN: Yeah, what different kinds of weapons to use, how to build an underground. I've done a lotta research about how, in the Second World War, undergrounds were built: how the French built their underground, how the Algerians built theirs. I mean methods of communication. There is an active underground in this country—

SMITH: In those countries there was an occupying force.

HOFFMAN: Well, we have that.... There's a very real war goin' on in America—and a violent war. The Yippies are part of that struggle. It's a little different than when we went to Chicago two years ago: I'm now a convicted felon, five years in prison; in September, I have to cop a plea for at least nine months—

SMITH: Really? Why?

HOFFMAN: It's all sorta *Catch-22*, the law. I think it's because I beat up three policemen while I was handcuffed with leg irons on me, which is a neat trick.

THE SMITH TAPES

SMITH: You mean you're gonna plead guilty?

HOFFMAN: Well, the police department in New York would consider it a fine badge to put me away, so…it's a question of doin' five years or doin' a certain amount of months. I mean, the risks and the penalties for living the revolutionary life in America have gone up. The first book I wrote was *Revolution for the Hell of It*. That was the book that was used to send me to prison in the trial in Chicago. I'd be sitting on the witness stand and the prosecutor would be waving this book in the air and quoting long passages from it; it was a book that was used to show my intention. It was the first time in judicial history of the United States that a book has been used against a defendant in a criminal case, except for a few obscenity trials.

> **The revolution is personal, and the deaths are personal, and the stakes are high.**
> —Abbie Hoffman

I think it's a different empire in which we find ourselves in 1970 than we did during the 1960s. Brothers and sisters of mine are being killed, and it's not just in body counts, "four dead in Kent," "six dead in Augusta," "two dead in Jackson State": they're people like Terry [Robbins] and Diana [Oughton] and Fred [Hampton]; people that I've joked with, argued with, and turned on with, and it's personal. The revolution is personal, and the deaths are personal, and the stakes are high.

SMITH: You sound a lot different than you did before Chicago.

HOFFMAN: Well, things have changed.

SMITH: I remember we had an argument where I said that it was gonna be fairly heavy, that the Chicago police were notorious for not being exactly liberal.

HOFFMAN: Yeah.

SMITH: You kept saying, "No, it's gonna be a ball, a festival of life. It's just gonna be camping out in the parks and great fun." It seemed very hard, at the time, for you to be serious *at all*. Now, it seems the other way around. Did the trial have that effect on you?

HOFFMAN: No. We're caught in a kind of semantic battle. Lenin said that the revolution is a festival of the oppressed; I always related to that in the same sense. The word *life* symbolizes the struggle against the death culture. *Fun*—it doesn't mean the kind of fun that we're conditioned to understand…the fun that the Yippies represent, it means struggling for our authentic existence against capitalism and imperialism and racism…

SMITH: I've heard you say all of this before. It just sounds very pat; you don't seem as spontaneous as you used to.

HOFFMAN: Well, the trial was a…I said in my closing statement that I came in as "Abbie in Wonderland" and I left as "Abbie in 1984." Because I had just been given five years in a courtroom that was bizarre under a system of justice, which resembled *Catch-22* at its ultimate, under a law which Strom Thurmond dreamed up to combat the nightmares that haunt him. I had to sit and listen to tape recordings of television shows, of news broadcasts, brought in and used as evidence against me…So I went through some changes, and if it isn't spontaneous, it's because spontaneous remarks have gotten me five, ten years in prison. So maybe I ain't so spontaneous.

SMITH: Okay, but what about this book…about how to conduct guerilla warfare?

HOFFMAN: It's called *Steal This Book.*

SMITH: It sounds like it's gonna be used against you. Are you just writing your own incarceration orders?

HOFFMAN: Well, I hope not. I think the first duty of a revolutionary is not to get caught. And I think it's survival, and I think maybe we will survive. But maybe we won't, I don't know. The future's undecided. The book is needed, and therefore we'll do it. It's possible that the book will be suppressed. Every one of my books—*Woodstock Nation*, the FBI approached the union in Philadelphia that was engaged in the binding. They refused to bind the book; it had to be shipped to another bindery. *Revolution for the Hell of It* had the same problems.

We have a tape recording of the whole trial, and we were gonna issue records through a record company in California. They bought the tape from the court reporter. The FBI, through the Internal Revenue Service, made it clear to that record company that their tax reports were gonna be gone over quite thoroughly, for the past six years, and maybe this wasn't so good an idea putting out this tape, and they buckled under. There've been a number of those experiences. Jerry Rubin's book *DO IT!*—Simon & Schuster will never do another book like that. Even though our books are popular, the publishers have to think about other things. And the government, through President Agnew and his forces, are moving to clamp down on censorship in this country.

> There is a semblance of democracy while, at the same time, beneath it exists a police state.
> —Abbie Hoffman

SMITH: How about you with your publishers?

HOFFMAN: Lenin once said that "when capitalism hangs itself, it'll be the bourgeoisie that sell the rope." In *Woodstock Nation* I called Random

House "a bunch of pigs," right in the book. They didn't particularly care for that. On the back it said, "Steal this book," and while I was in jail, [in] the second and third printing, it got exorcised from the back o' the book. I thought it was the best line in American literature, and they just snipped it because booksellers were blamin' me for all the theft goin' on in all the bookstores in America.

SMITH: Why do you go through regular publishers?

HOFFMAN: Because they have the rope! They have the methods of distribution and the methods of reaching large numbers of people.

SMITH: But don't you just reinforce that by dealing with them?

HOFFMAN: Yes, well, those are the contradictions. I mean…even if you do a book free, like [*Fuck*] *the System* that we did—we printed fifteen thousand copies and the best we could do was stand around St. Mark's Place and hand them out, you see? And even then, I think we were only able to distribute six or seven thousand. That book is in the back of *Revolution for the Hell of It*, which has sold 175,000 copies….Random House is there. Simon & Schuster is there. Why not use 'em until you can't use 'em anymore?

American fascism is different than Greek fascism; in Greek fascism, you couldn't publish a book even through Random House. America has a system called *repressive tolerance*, which Herbert Marcuse correctly describes, which is that you allow certain kinds of safety valves. You allow demonstrations in the streets at certain moments, not always, but at certain times. You allow a semblance of free speech, meanwhile underneath you're sending people to prison for five and ten years for writing books, and you're cutting off freedom of speech and assembly as they did to us in August 1968 in Chicago…So there is a semblance of democracy while, at the same time, beneath it exists a police state. That's what I think was demonstrated in the streets of Chicago: that in order to have that convention, they had to bring in tanks and helicopters and arm bayonets and have thirty thousand troops, even though there were like five thousand of us, up in a park. And we only asked for the right to be in a park, which was ten miles away. But the image, because of television, is that there were lots of young people running around disrupting the convention. In point of fact: we never got within seven miles of the convention.

SMITH: This nine months in jail—you're certain you're going to jail?

HOFFMAN: Well, it's a question of bargaining, and yeah, I'm certain that in the fall and in the winter of this year, I'll be in jail…I think now I get arrested about once every ten days in this country, but they don't follow

through. I was arrested, for example, three weeks ago in upstate New York. I spoke at Colgate—and speaking at universities is getting to be more and more difficult. I think there are now eight states in which I personally am banned, legally banned, from the whole state, even though it's illegal under the U.S. constitution....I'm banned in Oklahoma; I'm banned in Alabama; we *were* banned in New Hampshire, but we—Jerry and I and Dave Dellinger—went and violated the injunction, went and spoke, and the attorney general and the president backed down. Three weeks ago I spoke [at] Colgate, and the *jocks*, as they're affectionately called, ringed the building, [to] prevent me from goin' in. There were about three thousand people inside. I was with Paul Kantner and Grace Slick from the [Jefferson] Airplane, and we just did a little theater thing, pulled out knives and said, "Let us through." There was a scuffle, and I end up stabbing myself in my behind; they let us through, though. We get right up on the stage. My behind was bleedin' so I had to pull my pants down, right, to get at the wound. I have this handkerchief that's made out of a flag, so that's what I had to wipe with. So I was charged with brandishing a concealed weapon with intent to do bodily harm, lewd and indecent exposure, obscenity, [and] desecration and defiling of the flag, but local attorneys who work with the movement were fortunate enough to convince the DA that it just wouldn't be expeditious at this moment to try me…

Two days later I spoke at Alfred, New York, and goin' from there to Geneseo, I was ambushed: they had a roadblock set up; the police were lookin' for me; they found the car; they pulled me out; they threw me against the side o' the car; they slapped me; they said, "You give that same speech again, we're gonna kill you." Just like that [snaps fingers]. That's the reality that I now see movin' around in America. So sure, I have different feelings than I had two years ago.

SMITH: How do you feel about going to jail, though?

HOFFMAN: I don't like it one bit. I mean, I've been in jail. Jail is meant to break the human spirit. It's meant to make people somethin' other than human beings, and I don't like it at all. I'm not a model prisoner. I was in jail just for two weeks in Chicago in Cook County Jail: I spit at three guards. I was in solitary confinement after two days. I was handcuffed and dragged down four flights of stairs and tied in a chair while they shaved my head, which is a total Nazi act. I didn't eat the whole time— not 'cause I'm a martyr and I was on some hunger strike; I mean, the food is just totally inedible. It's not a good place to be.

So I'm not looking forward to goin' to jail. But, 'course, when you are in jail you're there as a revolutionary, not as a criminal. So you have a different sense of why you're in jail. You're not in jail because you got caught with a loaf of bread runnin' out a store or somethin'. You're in jail because you're a threat to the established order in America. It gives you a kind of strength.

SMITH: How do you think the other prisoners react to you?

HOFFMAN: The prisoners were totally with us. The first time we got in jail—the seven of us—we had to be put in separate cells. And then that was too complicated, because already we were making too many friends. They thought, "Well, there's gonna be a riot right here in the prison within a few hours." And there probably would've been, because we symbolize something to the prisoners. You know, they had all seen the trial on television; there was tremendous talk about the trial in prison. And they would come up and slap us on the back, say, "We shoulda told our punk judge off." "We shoulda stood up [to] fight." "We were railroaded in here." So we had a special position among the prisoners. After about a half hour of this, we were all gathered up and put in isolation. There was a demonstration: eight thousand people came to Cook County Jail on Conspiracy Day, and all the prisoners in the jail were yellin', "Boom, boom, tear the walls down." In TDA, which was the day after the verdict when something like a half million people took to the streets in this country, one o' the things that was most gratifying to us was the fact that there was a riot over the trial in the San Jose penitentiary. Two hundred prisoners said that they, too, had been on trial in Chicago.

> **I think there are now eight states in which I personally am banned, legally banned, from the whole state.**
>
> —Abbie Hoffman

You see, we believe that's why we're out. We believe that we're out because there was a militant movement that took to the streets and decided to put the real conspiracy in America on trial. And without those people in the streets, we'd still be in jail.... I think that's why Tim Leary's in jail right now, and probably will be for a long time, because he and the people around him did not build a mass movement, but instead hoped to influence people in power to say, "Tim's a good guy. Let him out." But that has long gone. There was not one liberal senator during the trial that came out and opposed the trial—not McGovern or McCarthy or Ted Kennedy.... And it was, in fact, a liberal trial. It was not like the Bobby Seale trial in New Haven, which is more the trial of the revolution; our

trial in Chicago was about free speech, the right to assemble. Liberals remember what happened in the streets of Chicago and could identify with us in some way. But they didn't mount an effective campaign against the trial. It was up to us.

SMITH: Why didn't they?

HOFFMAN: Well, I think they're runnin' scared. They have a view that we push the country into fascism; we embarrass liberals and therefore they'd just as soon write us off and forget us as they've written off the Black Panther Party. [A] perfect example was what happened last week here in New York, down at Pace College near City Hall. Pace College was the center of the citywide strike. I mean, our communication network was there on the fourth floor; the right wing knew it was there. The right wing, well, they're hard hats. That's what they're called, I guess; we just call 'em "brown shirts." I mean, they mounted a military attack on that strike communication center, complete with meat hooks and chains and blackjacks and lead pipes. They attacked the school. There were men with business suits with bullhorns leading platoons of these hard hats into the school. They sent seventy kids to the hospital with gashes and severe concussions and things like that. There are loads and loads of pictures of it and there's been not one arrest…the police just stood around in their buses, smiled, [and] watched the whole thing…

> They said, "You give that same speech again, we're gonna kill you."
>
> —Abbie Hoffman

SMITH: On this "pushing the country towards fascism," do you feel that that's accurate?

HOFFMAN: I think it's already there. I think when people think of fascism, they think it's gotta look like a 1942 movie of Nazi Germany, with storm troopers marching the streets. And it's not gonna look that way because we're in 1970, or 1984.

SMITH: You don't think the kinds of things you do does push the right wing further right?

HOFFMAN: No. I think fascism comes when liberals sell out their conscience. Our trial is a capsule of how it comes. Our trial…who are the enemies as we see it? Are they the judge, a seventy-four-year-old insane monarch? Are they the prosecutors that are there carrying out the government's wishes? We would say they're not the chief villains; the chief villains are four women who sat on the jury. One in particular: Mrs. [Jean] Fritz, who thought we were innocent of all charges—thought we were right, agreed with the Walker Report—

THE SMITH TAPES

SMITH: How do you know that?

HOFFMAN: There have been a number of reports of what went on in the jury room that've been published. Some of the jurors have told stories to the newspapers, made their views known. Mrs. Fritz, her daughter—while the trial was on, her daughter was goin' around giving speeches about what was goin' on in the jury room. There was so much government tampering with the jury that—well, it was Chicago. People keep forgetting that, even though they understand what *Chicago* means.

There were four people that, to this very day, think that we are innocent of all the charges. But what they did was they sold out their conscience. As you know, we're not guilty of conspiracy; we're cleared o' that. Five of us were found guilty of a substantive charge: "crossing state lines with the intention to incite riot." The evidence against us is a total of thirteen speeches, six of which were press conferences—that's the total amount of evidence [by] which we, five of us, have been given twenty-five years in prison. But it was a compromise verdict...because the four liberals said, "Well, that law is unconstitutional, and a higher court will decide that the law's unconstitutional and free them. We can't have a hung jury because...the government has spent so much money— five and a half months—we have to come up with some verdict." So they came in on the day and their heads were down low, and they were crying while the verdict was read, these four women. Nonetheless, they sent us off to prison.

Maybe *we* understood the implications more than they did, because when you go into prison in America as a political prisoner, your chances of getting out, even in those five years, are very, very slim—because what they do is they keep adding charges on. Like John Sinclair, right, he got nine years in prison. And look, there'll be a chance they might be able to free him in a year, on legal technicalities. So what they did was, after he was in for six months, they charge him with conspiracy—another charge. Huey Newton, the same thing'll probably happen to him. Huey Newton got two to fifteen years in prison.... The lawyer said, "He'll be out in two years. It's all worked out." But it's been much longer than two years now, I think, that he's been in. Everybody now thinks that he'll probably be in for the rest of his life—because you just don't go around in America releasing people who are political prisoners, because they have a unique kind of power after they've been in prison. [The] same will happen to Bobby Seale: Bobby Seale will be in prison for the rest of his life. Even before the trial starts in New Haven, everybody knows this.

It doesn't matter, the evidence. That's ridiculous. The evidence in our trial in Chicago—one of the jurors said right off, the first thing they did when they got into the room was ask "what was the evidence in the trial?" Nobody knew! So she said what they did was they immediately began voting their prejudices. I mean, jurors said, "Do you want your daughter to marry someone like that? Do you want America to belong in the hands of these people?...Look how rude they are to the judge—they *gotta* be guilty." I mean, the thinking goes like that. It's nowhere near a jury of your peers.

SMITH: With everything looking that grim, do you think you're gonna end up in jail for the rest of your life?

HOFFMAN: Yeah, jail, or probably shot. I mean, it sorta looks that way. Yeah. I don't have a rosy view. I mean, three of our friends are on the Ten Most Wanted list of the FBI. I think that, within six months, more than half the people on the Ten Most Wanted list will be *political* fugitives...I mean, they did their acts because they're against the war in Southeast Asia, because they're against racism in America, because they don't think people oughta go to jail for smokin' pot, and they're acting on those beliefs... They aren't acting as criminals but as revolutionaries.

Postcard from Abbie Hoffman, 1988

 THE SMITH TAPES

Dr. John
July 1970

Malcolm "Mac" John Creaux Rebennack (aka Dr. John) just arrived back in the States. After playing festivals in Paris, Rotterdam, and Bath, England, he landed in London to record his concept album, The Sun, Moon & Herbs. *Lacking most of his usual lineup, he put the word out through horn player Ray Draper, and when he arrived at Trident Studios, the place was packed. Eric Clapton, Mick Jagger, and a dozen of the best musicians and backup singers around were ready to play, along with thirty African drummers. Dr. John's manager, Charlie Green, took the tapes to L.A., and Dr. John came to New York City to play the Pop Festival on Randall's Island a few nights ago; tomorrow, he'll close a four-night run at Ungano's, a tiny club on the Upper West Side. Unfortunately, Green will soon screw him over, refusing to give the London tapes to Atlantic, and those Dr. John eventually gets from him will turn out to be incomplete, partially overdubbed, and edited. He'll fire Green and salvage what he can with Tom Dowd at Atlantic's studio in Miami.*

SMITH: What did you used to do before you were Dr. John the Night Tripper?

DR. JOHN: I used to be a studio musician. I used to have a band in New Orleans—just played music. This was from 1957 to about 1962 or '63.

SMITH: What was your band called back then?

DR. JOHN: Well, it was accordin' to who we were workin' with. For a while we were Frankie Ford & the Thunderbirds, then we were Jimmy Clanton 'n' the Rockets....Whoever the guy that was frontin' the band, I would just keep the band together to back up whoever had a record that was gettin' the gigs.

SMITH: But you didn't front it yourself in those days?

DR. JOHN: I used to front it too. Like, if we couldn't get nobody with a record so we could get no decent gigs, I'd take a gig somewhere with me and whatever I put together. I might call it "Spider Boy and the Spiderwebs" or somethin'. It was just, like, we'd throw somethin' together and we got

us a band, 'cause all the cats down there all know the music; if you knew Ray Charles's music, you'd get a gig. One band was Mac Rebennack and the Hurricanes…the Dominos, the Spades—we had so many names, man….We used to mainly play out in Jefferson Parish. It was mostly just rowdy houses, just bars with a band in them, and mostly playin' for the "hipty-dipty" set, or whatever you call it. They wasn't no kinda class gigs or nothin', but we used to work any kind of gigs. You gotta survive—whatever it was, that's what we used to do.

SMITH: When did you leave New Orleans?

DR. JOHN: I used to go out on the road with different little package shows, but then I split 'n' went to L.A. around '63 or '64. Harold Battiste and Charlie Green and J. W. Alexander conned me into goin' to L.A., tellin' me, "Man if you come out here you'll make a million dollars playin' in recording studios," and all. I was perfectly content in New Orleans, starvin', and I go to L.A. 'n' starve, and I was ready to split, but they got me hooked up makin' these Sonny and Cheryl [*sic*] records. So I got hung out, started bein' a studio musician in L.A. Then I got into all this mess with all these *psychedelical* records and all that junk. But it was a different understanding I got out there.

SMITH: You made it all right as a studio musician there?

DR. JOHN: Yeah—like right now, if I wanted to hang this up, I could go back and do that. But I can't psych out. Like, the way they do records now, you cut the same song over eight thousand times and all that stupid stuff. To me, what a record session is and what these record producers think is a record session is a far cry from each another right now. I'm kinda glad to get away from doin' the record dates. It's got too phony.

SMITH: How do you do *your* dates then?

DR. JOHN: I just go in and cut. We rehearse a song and tell a man to turn on all the knobs and record everything.

SMITH: But all at one time, you mean? You don't do any overdubbing?

DR. JOHN: We did that, but whenever we do it, it comes out like a mess, 'cause something is false with all of that overdubbin'. You put horns on a record after you put the rhythm section. Them horns, they may play it correctly with the notes and all but they're not gonna get the same spirit as if they was there with the rhythm section. Same thing with verses and anything else—they never get the right feeling again. We did this whole album with a whole bunch of overdubbin', this thing we cut, *Babylon*, and it just sounded like garbage to me when I heard it back. It took something out of it from tryin' to do it too right or somethin', instead of just lettin' it flow, you know?

SMITH: When you were a studio musician in L.A., what other records did you play on?

DR. JOHN: I used to play on everybody's dates, man, whoever. If I start layin' down names, I wouldn't know where to start 'cause it's, say, anybody from Brook Benton to Jackie DeShannon...Whoever they are, it'd just be a record date 'n' half the time the artists won't be there. It's just, like, the studio band is there and it's a big track, and you don't even know who's goin' on—all you know is what label it's for. How can they make a record for a singer and the singer ain't there? Even if the guy has a hell-fired arrangement read-out, it should be for to back up the *singer*. If you don't even hear the words to what's goin' on, you're just makin' a track, and it just cuts out a lotta the *feelin'* of somethin'. Them little things that you put into a song to compliment a singer, and there ain't no singer there...somethin' I was glad to get away from, is all I can say.

That's why I feel fortunate bein' with Atlantic Records, 'cause the cats have got that—to me it's an old-time understandin' o' music. It's just gonna be how it is. That's why I don't dig too many o' these record companies, 'cause I done worked for a lotta 'em and felt them *vibes*. Some of 'em, all they'd be interested in is products; they don't care if you put out a record with just a hole in the middle and nothin' on the grooves, as long as you got a record there. But I'll be in, tryin' to get somethin' on them grooves to feel it's worthwhile. I had a gig for a while workin' for a record company—these cats, all they wanted was *products*, and they didn't care *what* they sounded like. That's all a record *is*, is the *sound*; if the record don't sound good, I don't even wanna be no part of it. That's why I fell out with all that studio stuff. Man, like, these cats have no interest in what the music is goin' down like. All they're interested in is, "Hurry up 'n' make a record." Got a formula for making records like a factory: you pack all these sardines in a can, you got a thing you can sell. Well, they pack all these musicians in a studio 'n' then they bring in the singer, and then they got a thing, they can sell it. As far as if it's anythin' good, original, or anythin' pure or true about it—[that] ain't got nothin' to do with it. It's just that *sickness*. That's what I call "the cycle of the record" sickness.

SMITH: Where'd the name Dr. John the Night Tripper come from?

DR. JOHN: Before that I was Professor Bizarre. Cats used to call me things like "Bishop" or "Governor" or somethin', but they started callin' me "Doctor" for a while, so I just hung it on myself for keeps.

SMITH: How did you get into this Dr. John phase?

DR. JOHN: It was somethin' I'd been tryin' to do for a while, but any time I'd go give somebody the idea, they'd think I was crazy or somethin'. I went from one record company to another record company and I'd keep tellin' 'em how I wanna do this album and it won't cost a whole lotta bread or nothin', all I need is some studio time. I explained to 'em what I wanted to do and they'd say, "Sure, come back 'n' talk to us next week." And that went on for about two years. Finally I went and seen Harold Battiste and he says, "Come on, I'll work you a deal through Sonny and Cher. We'll use some of they studio time and won't tell nobody what we're doin', but we'll just go and do this album. If Atlantic Records is cool and digs it, well, we'll have the record did." So we just snuck in and did the thing. Then they had the record for about a year 'n' didn't know exactly what to call it—they didn't know to, say, push it like if it'd be a rock 'n' roll record or a folk record, all those different kinda labels they put on records. They finally stuck it out though, and that's what I was tryin' to get across anyways so it finally worked out in the end. But the time that elapsed between when what I was *tryin'* to get across was fresh 'n' all the time that was wasted in between, I was into somethin' else by the time the record came out, you know what I mean?

SMITH: But it still was pretty fresh for everybody else.

DR. JOHN: But it's really nothin' fresh 'n' new though. I mean, it's really old stuff. I feel like *all* music has been played before, it's nothin' new. But it's just in a different flavor 'n' different seasoning's in it. I think the first thing what we cut was groovy. At that time, the band I had, the cats was really hittin', man…but everybody blew they minds somewhere along the line. Right after we had cut that record we went 'n' cut another record. That was the end of the band; everybody got too Californiarized or somethin'.

SMITH: What do you mean?

DR. JOHN: You get a whole buncha guys from a place like New Orleans, this kinda cut-off place—it's not as crazy and wide open as San Francisco or Los Angeles or New York—and all these cats come out there 'n' they start playin' and hearin' all these bands with the loud guitars and all this loud stuff. It just blew all of 'em's minds. Some of 'em wanted to go back to New Orleans, some of 'em stayed in Los Angeles—studio cats—but the *band* fell apart. Everybody just went into different bags. I started throwin' together different groups and tryin' to find somethin' that would groove me and would groove the people on the gig. Slowly I got some-thin' back together again now. It's nice.

SMITH: How did you get to this sound?

DR. JOHN: On the side we was just jammin'. I guess we liked to play. We used to think we was jazz musicians or somethin', but I'd play with all different kinda bands. I used to play with a Dixieland band, a Latin band, all these different kinda bands, and, I guess, all them influences.

SMITH: How about all the voodoo? Were you always into that? Or are you just using it musically?

DR. JOHN: Well, I grew up around it. When I was a little kid I used to get on the horrors behind all that—and my peep used to tell me, "Don't go down to the Ninth Ward. You know they got a temple down there, and those people do some crazy things." But people start tellin' me that—it drew my interest all the more to go down there 'n' see what they was tellin' me not to go see. So I used to go hang around, listen outside the temple, and dig the music. The vibes I was gettin' was *anything but* bad. These people was singin' some beautiful charts 'n' everything was really nice. All the cats around there kinda took me in—they'd see there's a little guitar player hangin' around the set—I used to have a guitar 'n' try to sit in, 'cause I was tryin' to learn how to play music. These cats kinda took me under their wing and would teach me how to play the changes for songs 'n' stuff like that. It was like a school edumacation that I couldn't have caught nowhere else. I try to paint that picture in the music, those things that I was catchin' around there.

> **They wasn't no kinda class gigs or nothin', but…you gotta survive.**
>
> —Dr. John

SMITH: When you were playing in New Orleans in those days were the bands segregated? Could you have a mixed band, black and white, play in front of a—

DR. JOHN: We used to go out on the road with these package shows, and they'd be stone-mixed package shows. We used to work outta either New Orleans or Jackson, Mississippi. And the *shows* was integrated, but we hit certain parishes in different places—like, we made gigs where I had this killer, James Booker, playin' piano with us, and I seen one night they made him play behind a curtain 'cause he was black. It's pretty weird, but it figures for that area.

But things was more cooler before them words got into the picture *to me*. I can't speak for all peoples, but when them words "segregation" and "integration" got into the picture, that was used as like a force to seem to complicate things more when it started. We had the first integrated jazz

club [in America], in New Orleans. It was the Blue Note, and the place was open like two weeks 'n' then it was busted. That was right after all these things was supposed to be *changed*, but it looked like it got worse, 'cause before that, at least, everybody could *jam* together.

SMITH: When I was down there, the bands had to be either black or white. But if they didn't call it a band and were just jamming on the stage, then everybody seemed not to be uptight.

DR. JOHN: Right. You see, that was in the French Quarters—if you got out of the French Quarters more and [went] in almost any direction into the different wards in New Orleans, things was more open than that. Like, this place in Shrewsbury and places where it's always been—just bands is how they are, 'cause that's the way they always was. But it wasn't no thing that was smiled upon—it was definitely frowned upon by authorities. It was supposed to be the wrong thing to do. Like, I'd walk in, sit in with a band one night and damn near got the *whole band* fired. "What's this white boy doin' on the stand? Get him outta here!" And the man could proceed to firin' the whole band, just 'cause I was goin' to sit in. It would shake me 'cause I'd forget that you could do somethin' at this joint, but you can't at that joint. 'Cause most of them club owners, if they was in that bag where they was so prejudiced that they wouldn't let nothin' like that go down. Well, that's just the way they was. But there was a lotta people that was more open-minded than that.

> **I had this killer, James Booker, playin' piano with us, and I seen one night they made him play behind a curtain 'cause he was black.**
>
> —Dr. John

SMITH: Everybody writes differently. Do you do the words first, the music first?

DR. JOHN: I might take a idea of somethin'—like, if I got a line 'n' I start messin' around with it 'n' start teachin' the girls a line to sing, then I'll start puttin' somethin' in between there for *me* to say that's gonna fit in with what they sayin'. And by the time it all starts flowin' together, their spirit'll lift me up into puttin' more words to fit on 'n' keep it goin'. And my spirit will give *them* somethin' else and by the time it's all together, it's a record.

SMITH: You mean, right in the studio? You don't sit down in advance and write it out?

DR. JOHN: Well, I don't put it on paper, I mean I have it writ out in my head.

SMITH: But you don't write on paper.

DR. JOHN: No, it's not too hip 'cause, you see, I don't like to put no music on paper. I believe if a guy come in and has to look at a card sheet for a song, he'll depend on that card sheet and play it by eye, rather than by ear. Even if you have all the part writ out, there's gonna be that lack of spontaneous feelin' that'd be there if they playin' from *ear*. When you play by ear, it's more natural to play from *feelin'* than if you play by eye it gets stiff.

SMITH: But as a writer, aren't you afraid you're gonna forget certain things?

DR. JOHN: If it's somethin' worth keepin', it'll stay in my brain; if it ain't, well, it's gonna be lost anyhow. This just went down on this last day we was cuttin'. We was goin' in there to cut a song about someone burnin' candles on me. So I started playin' the tune, and the way it was feelin', it put my head in another place and it wound up being a song called "Zu Zu Mamou." But it's just the way the overall effect of it, the spirit lifted me in that direction instead o' where I had plotted it out to go. We was playin' one groove for a while 'n' all I could think of was, "When the battle is over, who'll wear the crown?" I kept fightin' the natural feelin'. I wound up doin' "When the battle is over, who'll wear the crown?" but instead o' doin' it the way that we rewrit the tune to make a rock 'n' roll song, did it to where we used to do it in church—with the church words 'n' all—and let Joni [Jonz], one o' my girls, sing it instead o' tryin' to make it into somethin' else. But that's lettin' the music pull a flow to flow *me* into another satchel. I tried to fight it for a while but you can't fight it. It don't work, 'cause if it's natural, it's meant to be that way.

But I don't do songs the same way twice *any*how, so it don't matter, the difference, anyways. Some o' them things *belong*, in that people expect to hear you play a song like you recorded, I guess. But I just don't operate in that kinda satchel. I try to just flow while I'm goin'. That "sit down and try to write somethin' on the paper"—and then what I'ma do? Memorize it 'n' go up there like a robot and plug me in 'n' I'll rattle it off? If that's what happenin', might as well just plug a record in and get a dummy up there 'n' wind it up and let *it* do the show, and I'll stay home.

SMITH: Anything else you wanna say?

DR. JOHN: Heaven on earth—bring about some united state of mind with a little together *in us*. 'Cause that's my word for today: it's not togeth-er*ness*, it's together *in us*. If I could promote that feelin', I think we'd achieve a little heaven on earth.

MARJOE

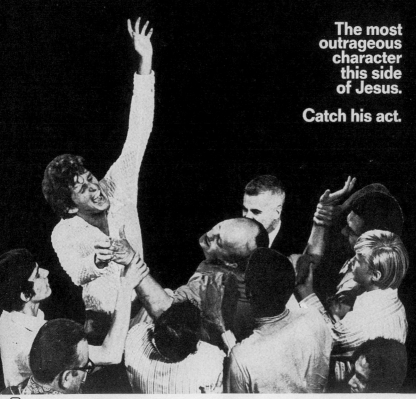

**The most
outrageous
character
this side
of Jesus.**

Catch his act.

Marjoe film poster, Cannes Film Festival, 1972

Jim Fouratt
Fall 1970

Jim Fouratt has been very politically active since he moved to New York City from Rhode Island, joining in with the Yippies and the antiwar movement. Impassioned by the Stonewall riots last summer, he's come out of the closet and become a powerful voice within the Gay Liberation Front, a nonhierarchical radical group he founded in New York City. He's been known to disrupt and co-opt the meetings of other, less radical gay organizations, so much so that unfounded rumors will circulate that he's paid by the FBI to derail the gay rights movement.

SMITH: I've known you for a long time. What is it exactly that you're involved with now in the gay movement?

FOURATT: I've been working with the Gay Liberation Front, which is a radical aspect of the so-called gay movement. We're trying to break down the stereotypes of what it is to be a homosexual, to free that image. We say "gay liberation" also to free gay people from whatever *gay* means, because *gay* is certainly not a positive term, I think.

SMITH: There are so many groups that address themselves to the homosexual now. The Gay Activists Alliance, the Mattachine Society, just to name two. What is it about the GLF that's different?

FOURATT: The chief difference is, the two organizations you mentioned both relate predominately to men. The general impression that people have of homosexuals in this culture is that it's a man. But homosexuals and lesbians—there are women there too. The GLF is homosexual men and lesbians working together to make change. Also, both the GAA and the Mattachine Society, examples of two groups that are doing a lot of good work, believe in legal reform and working within the system. The people in the GLF think that there has to be a fundamental change in the society and it isn't just by changing laws. Many of us have come through the civil rights experience, where just getting a Supreme Court law changed didn't mean anything. You have to change people and you have to change society. I think *all* the work that's being done by all the groups is very important, and there should be motion on all fronts. Just

that my own personal feelings, and the feelings of the people I work with, are that you don't change things by just making laws. And just by getting a sympathetic politician is not the way that you change society or change people's attitudes.

SMITH: You change it by being radical?

FOURATT: To be radical means to believe in a fundamental change. I do think that in terms of the whole sexual orientation of this country, there has to be a radical change. It's gonna affect from education to socialization to all the processes that people go through growing up in this country. It also is going to affect productivity of the country and the kind of economic system that we live under. I think it's all tied into a sexual definition.

SMITH: What are some of the actions or things that the GLF has been involved in so far?

FOURATT: The GLF came out of the so-called Stonewall riots. It was the first time that homosexuals had stood up for their rights, which they considered equal to everyone else. It came out of that kind of militant action, which was...I mean, you were there. It was a spontaneous thing; it was not directed. It was not peaceful. And it seems in this country, the only way that change ever comes about, unfortunately, is when people stop using peaceful recourse. That's one of the things that the gay people are discovering.

When *Time* magazine put out their homosexual issue....They had one of these articles that was very nice, very sort of liberal attitude that homosexuals are not sick people; they're part of society and we shouldn't jail them....In the last two paragraphs, after you got through all the sort of liberal attitude, it said, well, this is really a disease that we have to cure, because it's going to undermine the youth of America if we let it get out of hand. And the GLF took an action against *Time* dictating morality, telling people what they can do with their bodies.

SMITH: What did you do?

FOURATT: We started picketing. We tried to get inside. We worked with people we knew within *Time*—see, there are gay people everywhere. The person sitting next to you is probably gay. We think that everyone is gay and it's just...

SMITH: How do you mean?

FOURATT: I don't think the baby that's born makes the distinctions in terms of affections between male and female. It's only the conditioning, the socialization that goes on, that says one thing is right and one thing is

wrong. So you repress whatever side that you're repressing. If the person expresses his homosexuality, then he has very definite stereotyped roles that he has to play. I don't identify with those roles. The people that I know don't identify with those roles. Yet, this is what we're told homosexuals are supposed to be.

SMITH: In the black movement, *black* is fairly current as an acceptable word. It used to be that *Negro* was all right; now that's considered patronizing. In the gay movement, I'm at a loss almost to know what the proper word is: queen, fairy, fag, homo.... Will there be a point where homosexual people say *fag* is good?

FOURATT: I hope not. Because particularly the word *fag* is used to put down. I've never heard it used with affection or in any kind of positive way. When I walk down the street, because of my long hair, a truck driver will go by and say, "Hey, faggot." The fact that I am a homosexual he doesn't know, but because the way I look or the way I am threatens his masculinity or his sexuality, he wants to put me down. And the easiest way to put me down is to call me "faggot" or "fag." So I don't want to use the word.

SMITH: There was a time when the word *black* was definitely a pejorative term.

FOURATT: I think it's important that homosexual people do not take basi-

> **It was the first time that homosexuals had stood up for their rights.**
>
> —Jim Fouratt

cally straight terms. These are words that straight people have made up to define us. I think that an oppressed person—and homosexuals are oppressed people because they have to internalize most of their feelings, to live double lives; they can't be totally open and free and vulnerable... In very much the way black people tell us, "We don't want to be called 'Negro'; we want to be called black. And if we want to call each other 'nigger' or 'Negro,' we'll do it. But don't *you*, white people, tell *us* what we want to be called." I think that the same way, the homosexual says, "Don't use the word *faggot*." You shouldn't. You should listen to what the homosexual will say.

SMITH: Okay, I'm asking you then. What is—

FOURATT: For once, I don't have a term. I think eventually we won't have to use any terms. They'll just be people.

SMITH: But in the interim period?

FOURATT: In the interim we're using the word *gay*, which we're trying to redefine. Today we're trying to give examples to other gay people that they can be happy or they can be proud of their homosexuality. We use

the word *gay*, but it's only a transitional term until there comes a time when we won't have to use those kinda terms or some other term comes along. But *we* will define that term. It won't come from outside.

SMITH: I knew you some years ago during the hippie thing, but I was under the impression in those days, maybe wrongly, that you were hiding the fact that you were gay.

FOURATT: To the social pressures that one doesn't talk about being a homosexual, particularly if one is relating to heterosexuals. At the time I was living with another hippie man, who I think you knew, yet it was never spoken about; it was avoided. I can remember it was something that my consciousness couldn't deal with, because everyone expected me to be heterosexual. The whole hippie thing was very heterosexual. Beyond all the beads and love and peace, it really got down to a very man-woman relationship, and there wasn't a place for homosexuals. There was one homosexual, Allen Ginsberg. He was allowed to be a homosexual....He was the exception.

SMITH: We never discussed it at the time, but you seemed to be going through a pretense that you weren't.

FOURATT: But no one ever talked about it and I couldn't bring myself to talk about it. When I talk about oppression...The homosexual internalizes these things and leads separate lives. So I could very well lead this public life, which was almost asexual, but when it came to my private life, I just sort of put it into one place. I think I was just responding to the demands of the society and to the conditioning I'd been brought up in. It's only in recent years, when my consciousness has been raised, when I began to realize to be effective and to be complete is to be as open about whatever I'm doing or whoever I am with any given moment—which is not easy, because there's a lot of prejudice. Long-haired people or hip people or movement people are just as sexist with just as many antihomosexual feelings as the so-called people on the other side. That's one of the things that the GLF is trying to deal with—to confront the sexism that exists among hip people or young people today. I don't think gay liberation would've come about so quickly if it hadn't been for women's liberation, which began to tear down the old roles. And not that gay liberation is on the tails of women's liberation, or is connected with it in any way, but it attacks or confronts male chauvinism. The whole issue of what it is to be a man. I feel no less a man because I'm homosexual, although society tells me that I *am* less a man, that I'm supposed to be some weak, ineffectual, effeminate, sort of womanly kind of creature. I don't feel that way. I'm trying to define for myself what it is to be Jim.

SMITH: I've begun to get a feeling—this might be completely off on my part—that people active in the gay liberation movement feel that straight heterosexual...that there's something wrong with that.

FOURATT: Any person who comes to gay people and says, "Oh, right on to you people. Let's help you. I'm a heterosexual," I really don't want to work with. I don't make any demands on a person's sexuality but I don't want to have to be told constantly, "I'm straight and I really understand you." We don't want working out of guilt. Say, "All right," put on a gay liberation button, or say, "I'm a homosexual." What's the difference if you know you're not? So that you begin to understand...

I think that it's very hard to be close to anyone in this society and that if people can develop some kind of communication and it becomes physical, well, that's a beautiful thing. That should not be inhibited by some sort of "this is right" or "this is wrong." People should not be made to feel guilty. I mean, the stage of the movement now, we're dealing with the self-image, right? It's similar to the black thing, because most homosexuals don't like themselves, because society said you're not good; you're terrible people. So we have to begin to *like* ourselves....

But all men must really begin to relate to each other and to redefine their relationships. They have that choice. I mean, frankly, do you feel free to have a homosexual experience now?

SMITH: I don't know what you mean by *free*. No, I'm not a...I don't find a natural affinity...

FOURATT: Even the question...

SMITH: Men are not allowed to show tenderness towards each other; that's definitely true.

FOURATT: That's a feminine quality, and where does that come from? Or if you see a woman walking aggressively or speaks up, suddenly she's a dyke.

SMITH: What are the priorities for the GLF?

FOURATT: The absolute right to be open, be a homosexual and to display affection towards another man without that being used against them in any way...I'll tell you where the movement is going that I'm involved in: towards collectivism, towards defining what it is to be a homosexual. The tendency in the movement goes toward nonleadership, nonspokesman; I'm just talking to you about what I feel, not representing other people. Although I think there is a consensus about many of the things that I've said.

SMITH: You're describing goals. I'm talking about immediate priorities, like in the women's liberation movement that women should be paid the same amount of money as men are for the same work.

FOURATT: See, the more establishment-oriented Mattachine or Gay Activists Alliance would talk about equal rights, equal pay, law reform. Well, that's all fine; change the laws. I don't think it's gonna make that much difference in my life, but still it's a good thing to educate people how meaningless that kind of process is. It certainly should be supported. Laws should be changed. People should be paid equally. But see, homosexuals generally are not discriminated against in pay unless they're *known* as a homosexual. The whole thing is that people cannot *reveal* themselves as homosexuals....I consider every gay person that's become an alcoholic or committed suicide to have been murdered, in a sense, or to have been martyred by their society because they weren't in control. They had no control over their own lives....I turn on Carol Burnett and she's got some queen camp humor and they're all making fun of it, and it's very sad to see a homosexual man up there making fun of himself that way, for the benefit of straight people to laugh at him so "Maybe they won't hate me so much." I'm not condemning the person doing it—I understand why— but that kind of conditioning has to be removed.

SMITH: How about the way police react to the homosexual community? Is that one of the priorities of the movement?

FOURATT: Yes, it is. The exploitation of homosexuals...You're given turf where there are bars, in every major city, someplace homosexuals go over *there*. Here in New York, a certain part of the Village where homosexuals are *allowed* to congregate....I can remember getting arrested at demonstrations and always being called a faggot. And the worst, if they do find out you're a homosexual, then somehow they have to prove that *they're* not. Huey Newton recently came out with a letter to the Panthers about gay liberation and women's liberation in which he talked to his own fears about gay people and particularly gay men, that says it was a problem and he really had to begin to deal with it....All straight men apparently have this fear that the worst thing that could happen to them is they could be a homosexual, and so when they see a homosexual, and particularly a homosexual who's not acting out the stereotyped roles, then it's a terrible threat.

Howard Sheffey
September 1970

In 1960 the National Council of Police Societies (NCOPS) grew out of the New York Police Department's Guardians Association to form a national federation of black police officers' organizations, aiming to fight discrimination and bring more black people onto the force. Sergeant Howard Sheffey is both the chairman elect of NCOPS and the president of the Guardians. He is also the sergeant of the Preventive Enforcement Patrol Squad, a police unit formed last year composed of fifteen black and five Puerto Rican officers, who patrol Manhattan from Fifty-Ninth Street up, river to river. This winter, as Mayor Lindsay's specially appointed Knapp Commission investigates the New York Times' *sweeping allegations of police corruption, Sergeant Sheffey will be maligned within the department as a "racist instigator" for bringing two white officers in front of the police review board on charges of police brutality.*

⋯⋯⋯⋯⋯⋯⋯⋯⋯⋯⋯⋯⋯⋯⋯⋯⋯⋯⋯⋯⋯⋯⋯⋯⋯⋯⋯⋯

SMITH: How long have you been a New York City cop?

SHEFFEY: October will be fourteen years.

SMITH: In the whole country, do you know what percentage of the police are black?

SHEFFEY: It's under 5 percent. In New York City we are up now to about 8½ percent, but that's just recently. Three years ago it was 4½ percent.

SMITH: I don't understand why a black would wanna be a cop. I've seen, when the black cop has to make the arrest, blacks in the crowds yelling, "Uncle Tom!" It seems very thankless. It seems almost impossible to turn around the white police establishment.

SHEFFEY: Well, you can't really equivocate that. The only answer I can give you is that the people that are most vocal in the street, they don't really care what goes on in the neighborhood. The people that care, you never see. The only time you see them is in the morning when they're on their way to work. They're running to the subway or you see them in the evening when they stop off from work in the grocery store on their way home. The people that really care.

I've experienced quite often this business with "Tom," and I'm prepared to accept this. You have to grow another veneer of skin. You are the public's whipping boy. A person will have a peeve with the city administration—he takes it out on the first cop he sees.

SMITH: Is the force as anti-black as it's been played up to be?

SHEFFEY: I wouldn't say that any department is anti-black as a policy. You can't say something like that.

SMITH: No, I mean in your experience—

SHEFFEY: We have more anti-black whites on the police force than we need. We don't need any. We have people that don't leave their partiality at home. It's not supposed to matter what location he's working in or who he's giving the service to—he's supposed to perform the same way.

Now I ask you: How can you get a police department that has a Park Avenue where the policing is done one way, and you have Lenox Avenue where the policing is done another way? And in some cases, it may be the same policeman working both posts.

You ask me about anti-blackness in the police department. There's a lot of it. For instance, you can tell by the neighborhoods, by looking at the crime statistics. There were crimes committed in some areas of the city that the policeman will take the youth home to his parents. That's the same crime committed in Harlem and that kid has maybe a half a percent chance of going home—when a lotta times, you could go either way.

SMITH: What are you saying? When it's a black kid, he's gonna be arrested?

SHEFFEY: Yes. And I'm gonna tell you, in my early years in the police department, I was guilty of the same thing. I mean, you lose your perspective sometime.

There's quite a few ways a policeman can go out and do a job. You can go out and enforce the law exactly according to the book and make everybody miserable. It's not necessary. Or you can go out and, as our Supreme Court justices are finally saying, "temper justice with mercy." That doesn't mean that the policeman goes out in the street and holds court....There are so many ways that he can be helpful if he just would go one step further. Small things, but it only takes one little bit of motion, one little bit extra. For instance, the motto of the NYPD is "Courtesy at your service." But I'll bet you half the department doesn't know.

Here in New York City they have an experimental squad working in Manhattan North and it's an all-black squad. We feel we have more rapport with the people from the neighborhood. We understand the local mores, so to speak, the habits of the people. It's not just a fellow, comes

in from outside, fifty or sixty miles from the city to work eight hours—he's not gonna be too concerned about what goes on in the community.... He doesn't have a concern with the political structure, because what does he care? He doesn't even vote here. You have a man that lives in that community, he has his own personal stake in what goes on there. For instance, if his wife and children have to walk the same streets he patrols, he'll patrol a little more diligently. He won't want situations that you have to be armed in order to walk certain streets. He wouldn't want situations where you have to have one neighbor watch your apartment while you go to the movie.

I was told last week of a standing order in the school board that you can't flunk a kid over one time. Now if he doesn't learn in the sixth grade one year or the second year, what purpose are you going to serve by promoting him to the seventh? Now he comes out, got a big diploma, and what can he do? He pushes garments around the rack for the rest of his life, or he goes into crime. It's very easy to sell dope on the streets now. You ride the streets, you'll see more Eldorados and the Continentals....I've seen the only custom-model Cadillacs in my life, in Harlem. You have men driving those, the average age is about twenty-two, with no high school education. Now where does a man get a car like that?

We have more anti-black whites on the police force than we need. We don't need any.
—Howard Sheffey

We like to show our youth that there's something else besides a life of crime. When I was young, the only person in the black neighborhoods you could point to with success was the pimp, the number runner, the dope pusher, or the fellow that ran the after-hours joint. There were a few doctors and professional persons around, but the only time you saw them, you read in the *Amsterdam News* that they were having a big hoity-toity downtown in white America. They didn't do too much in Harlem. They were sort of outta contact with regular people.

So we want our people to grow up in the mainstream of life. You can't get it in and out of jail. You hear talk by the sociologist about recidivism. But it really gets to you when you find yourself arresting the same person for the third and fourth time. It gets to a point where it's a battle of wits. You know you're after him and he knows you're after him. But he can't go anyplace, because he's only got this one block. When he goes into another block, he's in somebody else's turf so he can't work there. So now what do you do with a situation like this? He's not gonna change

his way of life. What else can he do? He's got a habit that needs fifty to a hundred dollars a day to support. How else can he support his habit, except by selling drugs to someone else? If he's an enterprising fellow, he'll get somebody to work for him. And he'll come up in the world, so to speak, until something goes wrong and then we read about him in the paper. We find him somewhere, a bullet in his head.

SMITH: Why was it necessary in 1949 to start the Guardians? There're police societies open to both blacks and whites, right?

SHEFFEY: To my knowledge, with approximately four hundred 'n' some delegates in the Patrolmen's Benevolent Association, there are two blacks.

SMITH: Why's that?

SHEFFEY: It's an elective office. Not that blacks don't run for office—they just never get elected. The way the organization runs is that you have no voice in the organization....The Guardians is what they call a fraternal organization. By the same token, the Irish policemen have the Emerald Society and the Italian have the Columbian Society. Our charter dates to 1949 but the Guardians were a fact long before. My predecessors met in each other's basements. They met in the back of bars. It was a form of lobbying to figure there's strength in numbers.

> **The motto of the NYPD is "Courtesy at your service." But I'll bet you half the department doesn't know.**
> —Howard Sheffey

I can recall when there were certain precincts that you would never see a black officer. He just never got assigned there. I remember being assigned to a radio car as a fill-in man, and the man I was supposed to ride with went to the desk and told the lieutenant he didn't wanna ride that particular day. There's a lot of that still goin' on. We formed the organization because of inequity in assignments predominately. We were never at a loss for assignments as plainclothesman, so-called undercover agents, because let's face it, the white man can't undercover anything in Harlem. Now when it comes to having a seat in the radio car—which is a preferred assignment—I can recall times when you might see one black in a whole precinct assigned to a radio car. There were certain posts that a black would never work unless it was the St. Patrick's Day Parade and the black was the only one in the precinct.

And when you have...blacks on the force and none of them are capable of being a superior officer, a lotta times people will say, "Oh, I didn't know." But nobody's gonna tell me that they don't know they don't have any black superior officers.

SMITH: How widespread is everything that's wrong in black-white relationships in police departments? Is there that much police brutality toward the blacks all over the country?

SHEFFEY: Yes. There are certain pockets where it's a fact that you just run into. It's gotten to the point now where black people expect police brutality.

SMITH: Do you think it's possible to eliminate?

SHEFFEY: No, because you're always going to have a certain caliber man that will go into the police department knowing he's gonna have opportunities to exercise his desires. It has nothing to do with racial business. I would say that more whites, simply because there's more whites in the department....But I'd say we're always gonna have a certain degree of brutality, because any job that restricts the human flow is a job that's gonna attract a kind of sadistic person.

SMITH: With the Panther killing in Chicago, the Jackson State killings, and maybe even Kent State, can that ever be changed? Where people feel that the police just set it up and wanted to kill people?

SHEFFEY: I question the necessity to fire into groups like that. I question to use inexperienced National Guardsmen with fully loaded firearms in a situation that may or may not turn into a violent thing....It doesn't mean that the police officer that really feels he or another person is in danger of serious physical harm can't use his firearm, but it puts a degree of responsibility on his use of the firearm in that he should be responsible for his action. An officer can accidentally shoot someone. So be it. But to wantonly fire into a group and not know who you're gonna hit...This situation in Chicago, it's appearing now that the policemen were the only ones doing the shooting. In the long run, they may come out with an indictment. But what good will it do when the people that read about it won't be able to relate it to what happened two or three years prior?

I question our police tactics, particularly since I never see policemen storming the Ku Klux Klan's caverns. I don't see them storming John Birch Society headquarters. I question the trend of the Justice Department with some of the bills they're putting through Congress. They have this No-Knock Warrant Narcotics Bill. Now suppose you get a policeman that has an ulterior motive to want to come into your premises. It's very easy to substantiate the basis for a search warrant. All we have to do is show the judge that there is probable cause that what you're looking for will be there. Now when you have the authority to kick down doors without giving warning simply on the basis that the evidence you're looking for

HOWARD SHEFFEY

may be destroyed if you use the regular procedures to get in, then you leave the citizenry open for some pretty tough abuse.

I recall hearing a program on the radio dealing with student groups and strong police actions. I thought they were talking about our current problems. I thought it was someone running for political office; it was just prior to the primaries this year. At the very end the commentator said, "This was a statement by Adolf Hitler, 1933, Munich." It's the same thing that's going on right now.

There's a lotta talk about law and order. But I wonder what these people talking about law and order would feel if they got involved in one of these situations that they had no control over, and find themselves on the receiving end of some of this indiscriminate use of force.

I question our police tactics, particularly since I never see policemen storming the Ku Klux Klan's caverns.

—Howard Sheffey

SMITH: How does the phrase *law and order* sound to a black cop?

SHEFFEY: It sounds to me like "keep the niggers in place."

SMITH: The drug problem, does your organization have any position on that?

SHEFFEY: To do everything we can to rid the neighborhood of narcotics. Now that's a very ambiguous statement that says nothing.

SMITH: Through more police action?

SHEFFEY: Police action and we try to encourage them to use the rehabilitation centers. I personally don't see how a police agency can in itself correct a narcotics problem, because, in the first place, an addict knows that he is outside the law in his usage and in his means to acquire the narcotics, whether he's a burglar, thief, fence, pusher. He's not gonna come to a policeman for help. The individual policeman can't do too much toward correcting the drug problem. However, he can stop drugs from being dealt right out on the street. He can question things that are out of whack on his post.

I recall in 1948 the streets of Harlem were full of junkies. But at that time we didn't have a national narcotics problem. We only began to have a national narcotics problem three, maybe four years ago when young white America started to use narcotics in great amounts. When you had children of influential people being arrested for using, now all of a sudden there's a furor: "We got a national narcotics problem!" In 1956 I was told in the police academy that they estimated 40 percent of the national population of narcotics addicts was located in New York City, but nobody

was overly concerned about it.... When you find little children now, eight and ten years old, nodding in the street, it's the time to do something. Somebody had better do something.

SMITH: In talking with you, I have the feeling that there's almost no hope.

SHEFFEY: For what?

SMITH: The police ever changing. Seems so hopeless. How do you get to work every day? How do you keep being a policeman?

SHEFFEY: That's a good point—I do it intentionally. You see, throughout my life I've had people mislead me by not informing me.... The first thing you have to do to solve any problem is to admit you have a problem, right? Then you secure all the facts that you can get, find out what things in there contribute to the problem, and try to eliminate them as well as you can.

For me to sit here and tell you that all is well wouldn't serve any purpose. I have to tell you the truth: Now I don't use the terms *prejudice* and *brutality* in a "all hope is gone" attitude. I see a lotta hope. I can see changes in the street, but there aren't enough and they aren't coming fast enough. I see young policemen tryin' to do the job and an old-timer [saying], "What are you trying to do—be a hero? Get a lotta medals, make detective?" Now these young fellows have to be *encouraged* to do the job.

SMITH: You're doing it again. It's sounding hopeless.

SHEFFEY: I may. But I want people to be aware of what the situation is so they can correct it. Like I say to anybody, if you see a policeman out in the street and he is not doing his job or he is doing his job in a wrong manner, report him. Make him perform to the standards that he's being paid to do. If not, can him. Get rid of him.

SMITH: That's easy to say—

SHEFFEY: But do you advocate just giving up? No. Giving up is not the answer....It's gotten that way through public apathy. I mean, you only have these insurmountable giants grow up because someone lets it happen.

SMITH: Is it possible to get rid of that?

SHEFFEY: Yes.

SMITH: I'm not so convinced.

SHEFFEY: Well, I am. And if I weren't convinced, I would've left a long time ago. If we're just gonna abandon our cities and our country to people like that, you may as well give up.

I laugh about being called Tom now, because I remember when I was the young radical of the Guardians. There were times when the president

HOWARD SHEFFEY

threatened to have a sergeant at arms put me out of a meeting. Now there are young fellows coming along, call me Tom. So it's rather ludicrous to me, but the fact that people want to just give up—that bothers me. You can't give up. What do you do then?

It takes two elements to make up a crime. You've got to have the desire to do it and the ability to think you're going to get away with it. By the policeman being there in uniform, he takes away your thought that you have an ability to get away. You can't change a man's desires. So you've got to have policemen. Just by being there, he prevents a lot of crime. The police force itself has a fault in that they reward policemen by promotion most of the time by their arrest record. The best policemen in the world is a man that has no crime on his post. How's he going to get an arrest record? There's one fellow who works in Harlem. They call him double-breasted Willie. "Here come double-breasted Willie." Everything stops when he works that post. Now why is it just one individual policeman that has this? Why can't every policeman that works that post do that?

I remember in the academy, an instructor said, "A policeman can be described in one of two ways. A guy can look at you and say, 'That's a policeman.' Or a guy can say, 'That's a policeman?'" You're either one category or the other.

Emerald brand audiotape box

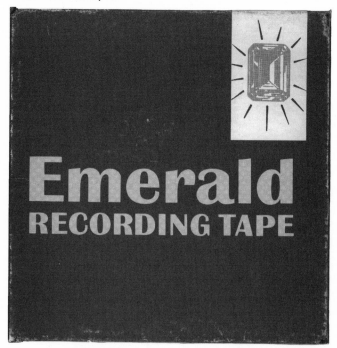

Janis Joplin
September 1970

Janis Joplin and her newly formed Full Tilt Boogie Band have been getting great reviews since they started touring in May, and right now they're in Los Angeles recording their first album. Despite the success of and her love for the band, Joplin's emotional life is in turmoil and, unbeknownst to many around her, she's relapsed and using heroin again. The album they're recording, Pearl, *will spend nine weeks at number one, but Joplin won't live to see it. Four days from today she'll be found dead of an overdose in her motel room.*

..

[On the phone from Los Angeles]

SMITH: I hear you're making a new record.

JOPLIN: Yeah, I've been working on it for a month or so now. It's really goin' good. I like my producer—he's really working out very well with me.

SMITH: Who's producing it?

JOPLIN: Paul Rothchild.

SMITH: You haven't worked with him before?

JOPLIN: No, I haven't. I knew him for a long time though, and it's just workin' out real good. He's really good in the studio 'n' helpin' us out a lot.

SMITH: How much of the album's done already?

JOPLIN: It depends on which tunes we take. You know? We've got enough now for the record, but we're still puttin' down some more tunes.

SMITH: What'll you do for what's leftover, wait for the next album?

JOPLIN: Well, if it's good enough to use, we might save it; if not, we'll just, you know, chuck it. We're just gonna put down all we can, then take a pick o' the best, you know?

SMITH: Can you talk about it? What kind of songs are you doing?

JOPLIN: Well, I don't know. Critics are more ready to categorize things than artists are, I think. You know? It's more of a country-blues feel than an R & B feel that I was tryin' to get in the last record. But it's still got some R & B in it. I don't know—it depends a lot upon the instrumentation of the band. And now I have *no* horns and a predominant keyboard sound. So it has a different sound to it than the old material.

SMITH: Are they new songs or old songs?

JOPLIN: Some are old. Some are new. Some are written for me. Some I got off records. Some people brought into the studio for me. I wrote one.

SMITH: Why are you recording out in California?

JOPLIN: Paul likes the studios here. And also I live here—you know, not in Los Angeles, but I live in California. I like it a lot better than the East Coast.

SMITH: It's been pretty miserable here, a lotta pollution.

JOPLIN: I guess I just like the people's attitudes better out here: they seem to be a little friendlier, a little less jaded, a little less anxious to be critical, out here, and more willing to just accept you and float with it. Out there they seem to be tryin' to pick each other apart.

SMITH: We were supposed to do an interview; do you remember? A long time ago—

JOPLIN: Oh, yeah.

SMITH: And the day that we're supposed to do it, some article putting you down in *Rolling Stone* had just come out. And you got very upset about that. Are you still that upset when you *are* put down in any articles?

JOPLIN: You know, I should be able to get past that, but it's just like…Most people, I think especially girls…you know how chicks are—say a chick says, "Does this look good on me?" You know? You're not supposed to say, "Well, uh, I don't like purple" or "I don't; it's too long" or somethin'. You know, you're supposed to say, "Yes! Looks good." I mean, girls want to be reassured, you know, which is not to say that all people don't but I think women especially, and I get…I mean, even though I know that those are just assholes that don't know what they're talkin' about, and I should just continue with my music and let them either come into the show and listen, or go home and beat off—I don't care what they do— you know, I should be able to do that but in my—in my *insides* it really hurts when somebody doesn't like me. You know? It's silly.

SMITH: Yeah, I remember that time you were *very* upset.

JOPLIN: Yeah, well, that was a pretty heavy time. For me and our…You know, with the Big Brother it was really important whether people were gonna accept me or *not*.

SMITH: One of the things I've been hearing around a little, this whole women's lib movement that's become so militant and strong now—a lotta women have been saying that the whole field of rock music is nothing more than just a big male-chauvinist rip-off. When I say, "Yeah, but what about Janis Joplin? *She* made it," they say, "Oh, her." And it's not a

comment on your music, but it seems to bother a lotta women's lib people that you're kind of so up-front sexually.

JOPLIN: I mean, that's their problem—not mine.

SMITH: Have you heard anything like that at all?

JOPLIN: No. I mean, I haven't ever tried to talk to anybody in women's lib. I haven't been attacked by anyone yet—how can they attack me? I'm representing everythin' they said they *want*. You know what I mean? Well, I have an opinion about this. It's sorta like—you are what you settle for. Do you know what I mean? You are *only* as much as you settle for. And you know, if they settle for being somebody's dishwasher, that's their own fucking problem. You know, if you don't settle for that and you keep fightin', you'll end up anything you wanna be. How can they attack me? I'm just doin' what I *want* to and what *feels* right and not settlin' for bullshit and it works; how can they be mad at that?

> **If they settle for being somebody's dishwasher, that's their own fucking problem.**
> —Janis Joplin

SMITH: One girl I know said, "Well, how come she doesn't have any women in any of her groups?"

JOPLIN: You show me a good drummer and I'll hire one. Show me a good chick. Besides, I don't want a chick on the road with me.

SMITH: You don't?

JOPLIN: I've got enough competition, man. No, I like to be around *men*. What do I wanna see myself worryin' for?

SMITH: Do you like still travelin' around and playin'? Or do you prefer studio work?

JOPLIN: I like working as opposed to...Well, you know, it depends. It's just different trips. Studio work is different than roadwork. You get a little tired of bein' on the road if you do it too long, but if your tours are planned cleverly, where you aren't out, you know, fifty weeks outta the year, I like working in front of an audience. Does all that shit I said about chicks sound bad?

SMITH: No, you said what you wanted to say. Don't be silly. I don't think you should worry about it. The whole thing with women's lib is, people should just say what they wanna say and then maybe a whole lotta the air'll get cleared that way. You know?

JOPLIN: Well see, 'cause, like, I read these papers like *Youth* or the *L.A. Free Press*....There's so much shit goin' on that really I have no *contact* with. Like, it's very strange, once you get into this music thing, your whole

life pretty much starts to revolve around promoters and musicians—and musicians and the record company people—and musicians and musicians and musicians and guitar players and truck drivers and ushers and promoters and musicians. You know what I mean? Like, you can pretty much find yourself locked away into a pretty, what's the word, *exclusive* crowd of people. Not exclusive in the sense that nobody else can *join*, just that the people that are in it are in it because of one specific field of endeavor. So I'm not really out on the street running into all these people with all these different trips. Like, if somebody can't understand what I'm talkin' about in terms of promotion, ticket sales, five-chord turnarounds, and, you know, three-dB echo on the bass guitar, we don't have much to talk about. You know what I mean? That's the way my life has evolved. I think in terms of Holiday Inns, good audience rapport, and a good bass sound, right? So I don't meet many people in women's lib. The people I know already have somethin' to do with their lives.

SMITH: There's something I'm curious about. I've heard this around. You always hear it about singers who put out with their voice—

JOPLIN: I'm not losing my voice; it's in better shape than it ever has been.

SMITH: *Ah.* That's what I wanted to ask. Because there are times I've watched you perform live and I don't know how you do it.

JOPLIN: It's stronger than ever, as long as I don't have to work *too much*. You know? If I only have to work three nights a week, I can last forever.

SMITH: OK, good luck. Maybe when you're in New York, we'll get together—

JOPLIN: Call Myra [Friedman] and tell her what I said and see if I said something wrong; maybe she won't wanna use it.

SMITH: Don't worry about it, really.

JOPLIN: Well, I don't want to *offend* people. It's just that, like, you know, I have a certain set of circumstances that I live under. Like all this repressive upbringing and things? I have that *too*—I mean, you don't think I had a repressive upbringing in Port Arthur, Texas? It's just that it drove me crazy and I kept fightin' against it. I don't think you can talk anybody into fighting against it if they don't have it in themselves to *need* more.... Just plain *need* more, then that's that. If they *do* need more, they'll get more; they'll *demand* more. You know what I mean?

SMITH: I know what you mean.

JOPLIN: But hey, would you do that, talk to her in case I said anything wrong?

Eric Clapton
October 1970

Eric Clapton and his new band, Derek and the Dominos, are beginning a U.S. tour in support of their debut album, Layla and Other Assorted Love Songs. *A limousine is waiting downstairs, and immediately after this interview Clapton will race over to play at the Fillmore East. The show will be recorded and released as their landmark album,* In Concert, *but will be their last—come next May the band will break up.*

SMITH: I made a little list of all the groups that you've been playing with. It's one hell of a list: Rhode Island Red and the Roosters, the Yardbirds, John Mayall—

CLAPTON: You left one out already. There was one after the Roosters—Casey Jones and the Engineers.

SMITH: The Yardbirds, John Mayall, Cream, Blind Faith, Delaney & Bonnie, Derek and the Dominos. How come so many groups? That's probably more than any person's played in.

CLAPTON: No, I'm sure there are some people that have played in lots more groups....That's just a widely publicized thing—it's kind of like my gimmick that's been attached to me.

SMITH: How come groups break up? What happens, in your own case?

CLAPTON: Dissatisfaction, the desire to move on. That's probably the whole thing: dissatisfaction with what the group that you're with is doing or dissatisfaction with your own contribution to what the group is doing. The group dissolves. It's a natural thing.

SMITH: You feel that it's natural, a good thing?

CLAPTON: Well, all things must come to pass, sooner or later. It depends on how powerful and how productive the group is. With a group like Cream, it was very spontaneous but not necessarily very productive. So it didn't last very long. With a group like the Stones or Beatles, which are very productive and they are very successful, they'll last longer. But sooner or later, they'll fold or become something else.

SMITH: How about with Derek and the Dominos now? Do you see that lasting a long time?

CLAPTON: Absolutely, yeah.

SMITH: You didn't form it with the idea of it just being a quick group and on to something else?

CLAPTON: I think I probably did, actually—it was all accidental. Bobby came to England, Bobby Whitlock, and I was doing nothing but I wanted to do something. And I was offered a concert, a benefit; I wouldn't make any money but it was just a chance to play somewhere. Bobby and I thought, "Why don't we do that? We'll need the rhythm section." So we got Jim and Carl over as soon as they'd finished with Joe Cocker. We rehearsed for two days and did that one concert. Then after that, there was no guarantee. We still haven't signed a thing. No one in this group has signed one contract.

SMITH: That's a little unusual.

CLAPTON: In fact, I'd shy away from the idea, because the only times I've ever signed anything on a piece of paper, it's always meant that pretty soon after doing it, I'd get disillusioned. I mean, so far, the fact that we haven't signed anything has been part of the reason why we stuck together. It would have to be a pretty strong reason for this group to break up. Because, you see, most of the times before, it was me that left. But this time I can't leave, you see, because I'm at the forefront of the group. I'm responsible, in a way. This is the first time I had a responsible part in any groups I've been in. So? I've gotta live up to it. I mean, if I chicken out this time, I chicken out, I cop out to myself too.

SMITH: Why not call the group by your name? Everybody knows that Derek and the Dominos are Eric Clapton.

CLAPTON: Well then, what's the difference? I guess it's just more fun to have a name. It's nice to have a nickname. If I gave you a nickname right now, you'd be pleased with it, because it would be a sign of affection. Someone gave our band a nickname right away and so we've stuck with it.

SMITH: I'd heard that it was part of your alleged shyness, that you didn't want people to come and see you just based on a past reputation.

CLAPTON: Well, yeah, that's part of it. I wanted the audiences to accept the fact that it was four musicians rather than me being backed up by other guys. Although a lot of the time it does come out like that, because I sing a lot of the lead—in fact, too much of the time. But I still really nourish the idea of the thing being a group instead of one guy with a rhythm section.

SMITH: There're stories about how you never wanted to sing. Is that true?

CLAPTON: I've always wanted to sing. I've always sung, but only sung in my head or with my guitar. But the voice is the natural instrument. You

don't have to have a case or an amplifier to sing. You can take that instrument anywhere.

SMITH: What kept you from singing so long?

CLAPTON: It's *hard* to sing. It's not easy. It's something you have to learn to do. It takes years and years to be able to sing and please yourself.

SMITH: Are you pleasing yourself now?

CLAPTON: No.

SMITH: I thought it was pretty good.

CLAPTON: Thank you very much. I think it's a lot better. It gets better every day. But with me it's so fine and gradual, the difference between my singing one day and the next, that it's hardly noticeable. But I'm sure it will get better as long as I keep at it.

SMITH: Are you sorry now that you didn't start earlier?

CLAPTON: Goddamn, yeah. Cause if I'd started when I was ten years old… But, you see, I came from the wrong environment. There weren't people singing around where I came from. If I'd been born in the South where people just sing all the time—Mississippi, somewhere like that—I'd have stood a better chance. But farm laborers in England in the country don't sing while they work. They grumble.

SMITH: How did it finally happen, then?

CLAPTON: It was Delaney. I really think Delaney is like a saint. And he has a lot of weaknesses—he drinks a lot; he's really a Southern rabble-rouser, a hillbilly.…But he was the first one that told me straight out. The first thing he said to me, more or less, when I met him last year was that "God has given you a talent and if you don't use it, it will recede. He'll take it away from you." Because he knew instinctively that I had wanted to sing. I had the desire to sing and maybe had the capability to sing. But it needed someone else to tell me to do it. I needed a kick up the ass, really. And Delaney was the first one to encourage me to do it. Most of the other people I've been with have been too hung up with their own thing to have time to tell me what to do or to encourage me. But Delaney had his thing so together that he had the power to be able to give as well, to encourage.

> **If I chicken out this time, I chicken out, I cop out to myself too.**
> —Eric Clapton

SMITH: Did it kind of scare you? Was there, like, a first night, almost?

CLAPTON: Yeah, there was. Doing that first album scared me, because we spent a week doing the tracks and then we had to put the voices on.

ERIC CLAPTON

And I refused to let anyone in the studio but me and Delaney, and it was even hard singing with Delaney there, because he's so good. It was really, really frightening. I still don't like to listen to that album, because it brings back memories of how scary it was.

Sometimes now when I'm on stage—even halfway through the act, even if we're doing well and the audience likes it—and I've got a song to do which I know requires a few kind of vocal gymnastics or something that I'm not really quite capable of doing yet, I get panicky. And I try not to let it show, because people can sense it very quickly.

SMITH: But you actually feel that fright, even on stage?

CLAPTON: Of course, yeah.

SMITH: How about with your playing?

CLAPTON: It never did; it does now. Because I've separated out my talent that I've been given into two things. Before, it was just channeled into guitar playing. So I had that covered. I really thought for a long time that I was all right. That I could just pick up the guitar and play anytime and it would be all right. But now that I've got two things to think about, singing and playing, I often find that when I stop singing and start to play, I don't like the sound of it or I get worried about the notes I'm playing.

SMITH: I see a guitar next to you, an acoustic guitar. Do you always have one and you just play a lot?

CLAPTON: All the time. I play all the time and I sing as much as I can. But singing in a hotel room is totally different from singing on stage. You've got to sing out, because sometimes you might not be able to hear yourself back too clearly, because the band is playing loud. So you've got to sing through it. You've got to have power in your voice. But as far as guitar playing is concerned, I just do that all the time. I don't think I practice, do exercises or anything like that.

> **I think money corrupts, so I get rid of it as quick as I can.**
> —Eric Clapton

SMITH: Do you feel pushed every night to better what you did the last show?

CLAPTON: Yeah, of course.

SMITH: In an enjoyable way?

CLAPTON: It's a challenge, really. My responsibility is to the other guys in the band. I feel responsible to them…to try and make an improvement every night, because the audience may not know the difference but the band knows. But it's sometimes a strain. Sometimes it's very, very hard. And when you've been on the road for two or three months, you need a rest. You do need to stop and regenerate your batteries.

SMITH: But you're not considering giving it all up?

CLAPTON: I don't think I could. I really don't think I could, unless something came along to take its place.

SMITH: Because I thought there was actually that idea that you were going to just stop.

CLAPTON: I don't think I could ever stop playing. I think…I could vanish at any time. I could just stop making appearances. I think that's quite easy. Financially, if I was secure enough to be able to not have to go on the road—which I'm not at the moment; I need to go out to make money to exist—then as long as I had someone around me to play with, I could probably just stay at home all the time.

SMITH: How could you not be financially secure after all those enormous hits?

CLAPTON: Because I've spent all the bread I've made. I've always lived outside my income, man. Ever since…if I had five tuppence, two cents, I'd spend three.

SMITH: Do any rock musicians live within their income? Because when I talked with Mick Jagger, he said the same thing. When I talked to John Lennon, I said, "Really? If not for Allen Klein, you guys would be broke now?" And he said, "Absolutely broke."

CLAPTON: It's absolutely true. You spend all your money. You see, most musicians don't actually like the money they make. It makes them feel guilty, because there's so much poverty in the world and people starving who could, with five dollars, live one more day. And here you are, making a lot of money, which you waste and squander. But…I don't think you can save the world with money. I don't think money will change anything. I think money corrupts, so I get rid of it as quick as I can. As quick as I make it, I get rid of it. I mean, I don't, at this time, have a penny in this room.

ERIC CLAPTON

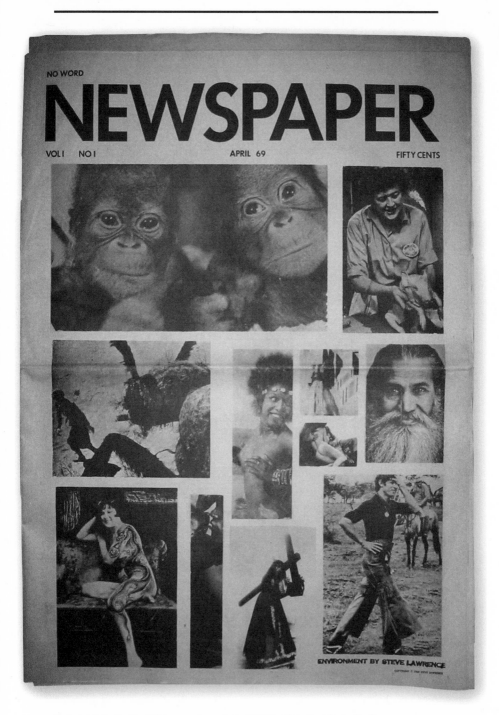

Various artists, *No Word Newspaper* 1, no. 1, April 1969. Printed by Affinity, Reality, Communication, Inc., New York.

Steve Winwood
November 1970

Steve Winwood's rock band Traffic broke up a year ago. He then—along with Eric Clapton, Ginger Baker, and Ric Grech—formed the short-lived supergroup Blind Faith, but they only lasted one album. Following that split, Winwood quickly reunited Traffic, and the band has already recorded a new album, John Barleycorn Must Die. *They're in New York City to promote it, playing two nights at the Fillmore East.*

..

[The questions from the original interview reel were edited out by Smith in 1970; only Winwood's answers remain.]

I think that the values of what's good and what's bad have changed such a lot. Because now it isn't a matter of what is actually a good group or a bad group; I think it's a matter of a group that does what they do and they do it with every conviction. They do it with complete confidence. And they do it with the full strength of believing what they do. That is a good group; I don't care what it sounds like. What they do, you just could not put down—well, I couldn't put it down. Because it would come through with the strength that they would have in believin' in what they do.

The story of the Creamers [Cream] were, way back in the old blues days, they were individually so very, very capable on their instruments. They really are three brilliant musicians of bass, guitar, and drums, you know? And put together, they started a whole different scene.... There was never a group that were so intensely hot musically, that really gave everything they had. They're like giants, in a way. If you don't mind me saying so, it's almost typical of what's happening in America, you see. When it comes down to it, any artist or anybody—a group, a single artist or anything—today I believe it's reached this position of you do what you have to do, the best way you know how, and that's all you can do. If you've gotta try and market what you do, market your talent and wrap it all up into cellophane and put it out especially to please people, I believe that is old-fashioned. It's way, way behind. What's happening now in certain places, I mean, the public has become very aware of what is good or what is honest and what is something that is really good, which is really sayin' something.

I think that when that was brought to the surface and almost commercialized, that wasn't just any product that would be like packaging some sort of detergent. It was something about life. You see what I mean? So that most definitely leaves some aftereffect on the people that got involved with it. Because it made them think. Because the love philosophy, I think, is something which is already in everybody that's on the face of the earth. So it wasn't just like bringing out some new craze. It was almost unveiling something, to a lot more people, and I think which has definitely had a big effect. I don't think everything could slip back into the way it was before, after having this love thing being brought out like it was, because I definitely think it must have changed a lot of people in the way they thought.

Being in a group, you've got all the time in the world to think about that sorta question, and you must, at some time, ask yourself, "What do I mean to those people? Or the things that I say, what do they mean? Do they have any meaning or value?" I think to myself, "They could have a good meaning, they could have a bad meaning, or they can have an indifferent meaning." So obviously, you do see yourself sometimes as, in a way, trying to add a little bit of good to the world you live in, because you are a person. You do live in the same world as everybody else, as does the politician, the bank clerk, the factory worker....You are a person like they are, and you have your own views, and what you say can be listened to by them. So what you want to say is either something to make money or something to maybe make *them* feel happy in *their* life. Maybe you get a kick out of entertaining them but you do have to think about those things. But just don't get too involved till you see yourself as some sort of god.

> **But just don't get too involved till you see yourself as some sort of god.**
>
> —Steve Winwood

It's *changes* that count. You've got to change all the time. Once you've done one thing, you've gotta get on to the next thing. You've got to feel self-improvement, that you're getting somewhere, that what you do means something. And when you do a record, an LP, and it's appreciated by ten people or ten thousand people, that is when you get the happy times and you feel good and you feel it's all worth it anyway. You know? It's great to do what you do and be accepted; it's simply down to that. If you're just a very happy, light sort of person and you make people feel the way you feel, that's great. Or if you're a very heavy person and you make people feel heavy, because that is a reality of the feeling, then that's good also.

Harry Richardson
December 1970

For the past two years, the Do It Now Foundation of Los Angeles has had a series of public service announcements playing on radio stations across the country. They feature Frank Zappa, Grace Slick, Steven Stills, and other musicians telling kids to stay away from amphetamines, with the slogan "Put it down. Do it now." Harry Richardson is the foundation's codirector.

SMITH: What is the Do It Now Foundation?

RICHARDSON: Essentially, we do drug education: prevention, rather than rehabilitation.

SMITH: You mean *anti*drug education?

RICHARDSON: Right. Yeah, hard drugs: smack, downers, speed, sniffing things like petroleum products—that kind of thing.

SMITH: You keep away from soft things, which are...?

RICHARDSON: The areas that are controversies—marijuana, psychedelics—those are things that the facts aren't in one way or the other. We try 'n' stay away from 'em because in order to get across any kind of a message that has any meaning at all, we can't come out with a really hard antipot stand with nothing to go on.

SMITH: So the drugs that you're against are the ones that just about everybody, no matter how hip you are, are against?

RICHARDSON: Yeah. Everybody except people who have somehow, I don't know, through the media or whatever, gotten the impression that *all* drugs must be personally experimented with before they can be determined by the user whether they're valid or invalid. And our stand is that there are thousands of people who have had extensive hard drug experience, and people should be able to benefit from their knowledge—people that they can trust, you know, people that don't sell out, people that are not part of the establishment.

SMITH: Is the Do It Now Foundation a building somewhere? Is it ten people? A thousand people?

RICHARDSON: It's about a dozen full-time people, and maybe fifty friends

who come in and lay things on us from time to time, or do this or do that, or give us a name and help us in some way. But it's about twelve people. We've been around about three years. We've managed to get nonprofit status from the state and the federal government, which is unusual for a bunch of freaks. We get into schools sometimes; if the superintendent of the schools is cognizant of what's happening, he'll let us in and talk to the kids. But mainly our thing is media—you know, radio, television, records, newspapers. And not pushing *our* trip, because we don't *have* a particular trip. What we do is pass on the condensation of years of experience by the underground, the rock musicians. We try and get as much exposure through the media as possible—and when I say *media*, I mean media that the kids and people who are into dope will listen to—and we just expose people's opinions who have been through it or know the scene thoroughly, who have not sold out to General Motors or AT&T or the government or whatever. You know, people like [Timothy] Leary and Donovan and [Jimi] Hendrix and the Beatles and the [Jefferson] Airplane and [Allen] Ginsberg and—

Most of the time the friend is half-stoned and the other one is overdosing.

—Harry Richardson

SMITH: These are all people who you've had do stuff for you?

RICHARDSON: Yeah. And it wasn't hard; all we had to do was ask 'em, and they said, "Far out, it's about time somebody asked me." Because they've been takin' a lotta hard raps—bad-mouthing from people about [how] "the music business is responsible for the drug-crazed population of radical"—

SMITH: The stuff they do is in the form of commercials, right?

RICHARDSON: No, they do different things for us. They give us written statements that we put in literature, like a newspaper; we've got a newspaper we put out and we put some of the things in there—

SMITH: But I mean, do you pretty much leave it up to the performer what he wants to do?

RICHARDSON: Yeah. We never put any copy in front of him and say, "Read this." We say, "What do you think about this?" And he raps, and we put it either on tape or on paper, or on a record if it's music.

SMITH: How did you get involved with Do It Now?

RICHARDSON: I was pretty wiped out, about two years ago. I went around looking for someplace that I could get some help, you know? I tried the standard things, I went to the city things and I went to the county things and to the state things, and nobody—

SMITH: What were you strung out on?

RICHARDSON: I was never really strung out; I was wiped out. I had used a little bit of everything—whatever I could get my hands on—but I was never, like, addicted or strung out. Primarily speed, and a lot of acid, and a little bit of this and that, whatever I could get ahold of. But I went looking for help and there wasn't any place I could get it—this was two years ago and there was nothing happening—and then I stumbled across the Do It Now Foundation. It was the only place in town—number one—where I could get some good, solid help in the way of advice, and letting me know where I was at and there was a way to get out of it; and also, it was a place where they would let me work, where they would let me pass on what I had learned, 'cause I'd learned a great deal. You know, when you get your mind totally wiped out and you start to put it back together, you learn a lot. I wanted to pass on some of those things, and I didn't have to have a PhD to work there. So I've been there about two years.

SMITH: You have a drug hotline people can call, right? In Los Angeles? What kind of phone calls do you get?

RICHARDSON: We get the calls that, generally, the rest of them can't handle. There's a lotta hotlines in L.A.; a lot of them have a philosophy of giving an emotional aspirin, and that's it. You call up and you say, "Wow, I'm really tormented," you know, and going through this or that or the other thing—not necessarily with drugs, but any particular scene. And they say, "Yeah, that's really a bad scene, and I really feel that you're getting the bad end of the stick, and why don't you call again sometime and we'll rap." Just a nice person on the other end of the phone—somebody who cares. But as far as constructive action, nothing's done. It's like an emotional aspirin: the person feels better, but the thing that made him hurt in the first place is still there. We're, like, action oriented. We go—number one, which nobody else does that I know of—we go out to the point of crisis. If somebody's bum tripping or overdosing or freaking out, we'll go there and we'll do something; whatever needs to be done. We'll either take 'em to a hospital, a hospital we know is cool, or we can give them some vitamins that we've found that bring people down off a bum acid trip, for instance—it won't bring 'em down, it'll smooth out the trip so they can handle it—and just be there with several years of knowledge of what to do in various situations. We try and get them in contact with people who can help 'em.

SMITH: Are most of the calls that you get about bad acid trips?

RICHARDSON: No, we've had an increasing number of—a mind-blowing number of barbiturate overdoses lately. It's really freaking us, because we concentrated on speed for a long time, and speed is still a heavy thing, but I can't picture how or why so many people are getting hung up on downers now. Speed is, like, a long-term debilitating thing: you can't overdose from it, you can't get addicted to it, but it kind of eats your body away a little bit at a time over a long period of time. But, like, downers—[snaps fingers] like that and you're out of it, you can overdose and die. You *will* get addicted if you use them regularly; the stuff that's being sold on the street is garbage.

SMITH: What's the kind of call that you'd get from somebody who is—

RICHARDSON: An overdose, for instance.

SMITH: But they're still able to call?

RICHARDSON: They're able to call, or else a friend is able to call. Most of the time the friend is half-stoned and the other one is overdosing, and the one that's half-stoned doesn't know what to do. So we tell him, "Empty his pockets and take one of whatever he was taking down, and give it to the doctor so the doctor'll know what he was taking. Try and get some idea how many he was taking." We'll give them instructions on how to get there; if they can't get there we'll go out and pick him up and take him there.

We get people who are strung out on reds and wanna kick, because they know it's a one-way trip, you know, it's a vicious closed circle. They wanna kick, and they can't because you can't just stop using reds. I mean, if nothing else happens in this interview, I want to get this out, you know, in the open: you cannot just *stop* if you're strung out on reds. If you do, quit all at once, cold turkey, you run a very high risk of going into convulsions, grand mal seizures, and suffering a central-nervous system collapse. And people die trying to kick, which is unique; you don't die trying to kick smack, or trying to get off a speed habit. But reds—if you try and do what you think is the right thing, you're runnin' a risk, you've got to either taper off gradually—

SMITH: What's the medical name for reds?

RICHARDSON: Seconal is a trade name; Secobarbital is the pharmaceutical name.

SMITH: So what do you tell somebody in that situation?

RICHARDSON: We've had a problem, because there's no place that'll handle 'em. Barbiturate withdrawal takes a *minimum* of a week; a minimum of a week and sometimes even more, depending on how heavy their habit is. They have to take them and bring 'em down slowly, reduce it one or two

THE SMITH TAPES

caps a day. They even do this in the federal institutions: if somebody is in a federal institution like Lexington or Fort Worth for smack, they'll just say, "Kick, baby"; they'll put you in a room and they'll say, "Kick." But a barbiturate addict—they will have to put him in a hospital; it requires a hospital scene, requires twenty-four-hour observation. So it's very expensive, it's very time consuming....

SMITH: So what do you do?

RICHARDSON: We take them to a place that we know in Los Angeles, where the people are cool; but it's only one place. We're screaming for more places but we can't get them, mainly because the danger of the bust. You know, there's laws against using drugs or being addicted to them even if you wanna kick.

If nothing else happens in this interview, I want to get this out, you know, in the open: you cannot just stop if you're strung out on reds.

—Harry Richardson

SMITH: Do you try to get people who are trying to withdraw from a certain drug to abstain from all drugs...hard or soft?

RICHARDSON: If they're going through what we call a "wipeout"—a psychiatrist would call it an "artificially induced state of schizophrenia," "simple schizophrenia," maybe. If they're wiped out, they *need* a period of time of complete abstinence in order to get their head back together. Because dope has a thing about it where it fragments the subconscious reflexes, and a lotta people consider this to be a good thing. They say, "I'm turned on, I'm deconditioned. I don't respond in the way I did before to the nonsense around me," and they consider this being turned on, 'n' they dig it, and they say, "Fine, I'm gonna live this life, and I like this state of mind." Another person can exhibit the same symptoms of wipeout and say, "I am going insane"; that's *his* label, as opposed to being "turned on," and he feels emotional distress because of it. If he's feeling this emotional distress and he wants a way out, step one is to stay clean for a period of anywhere from thirty days to ninety days.

SMITH: And you mean of everything?

RICHARDSON: Everything.

SMITH: Even if the main thing he's been abusing are downs, you would suggest not even turning on while he's...?

RICHARDSON: Well, he's got to detoxify, which means a gradual withdrawal, but after that he's got to stay clean in order to get his head back together.

SMITH: If there's an ever increasing number of people really messed up on the hard drug scene, are there times when you, or the Do It Now

Foundation, feel completely overwhelmed? Like it's just too much to handle?

RICHARDSON: Sometimes I feel like that, but I know, don't ask me how because I can't justify it, but I know that the drug scene, in its entirety, is a cycle. And the end of the cycle will happen when enough people across the country, in each town and each school, have either died or drastically overdosed, or seriously messed up their minds and their bodies and their lives, and the people around them have a walking, talking, breathing example of what's gonna happen to them. And also, these people are pretty good crusaders themselves, like, individual people going around spreading the word. So I think, eventually, the whole drug scene will be a self-limiting thing; our goal is to make that limiting as rapid as possible so that as many people as possible don't die or mess themselves up. Also, there's an underlying thing that's very important, and that is that there are things that need to be fixed in this country. I mean, things are falling apart, man. It's just, like, a bad scene—and it's not only here, it's all over the world. And if you're strung out on downers, you're strung out on speed, you can't do anything about it. You can't fix it. You can't even start, you can't even figure out what the hell's going on. You've got to be fairly clear in your mind, in order to get it together enough to even function to do something about it.

THE SMITH TAPES

Dustin Hoffman
December 1970

Out of left field, Dustin Hoffman has become a star of the New Hollywood aesthetic with his leading roles in The Graduate *and last year's* Midnight Cowboy. *Just a few years ago he was a struggling off-Broadway actor who couldn't get a job, and now he's a two-time Oscar nominee. He'll be nominated twice more before the decade's out and will finally win Best Actor in 1980.*

SMITH: I'm curious what you think about entertainers getting involved in politics.

HOFFMAN: Well, in one aspect, when I see entertainers on TV talking about causes, sometimes I think that they use the cause as an outlet for their own anger or almost an opportunism. I'm always suspect of entertainers asserting political views in media. Though I think it's important and I think one should, I'm immediately suspect of it. I think entertainers, and I include myself, are like politicians. They're extremely aware of the audience and of *their own* audience.

For instance, there's not that big a difference between [them and] someone like [Spiro] Agnew, who knows exactly what he's doing, who he's polarizing, and is doing it because he feels the people that he's losing certainly do not outnumber the people that he's gaining. An entertainer that speaks their political views on television knows exactly what they're doing. The youth is supposed to be the big audience for films, and everyone knows that the youth today is rather left. So if an entertainer comes out and speaks for left causes, he knows he's playing to that audience.

SMITH: Do you think they're doing it to gain more fans?

HOFFMAN: Not to gain more fans, but they figure those *are* their fans. Sometimes it's a sincere thing, I guess, but it depends on the person. As far as I'm concerned, I've supported certain political things I've found myself caught up in.

SMITH: Out in the open or just behind the scenes?

HOFFMAN: Out in the open. Right after *The Graduate* came out I was living on Eleventh Street and I got a form in the mail saying that McCarthy

needed help for New Hampshire. So I call up on the phone, and I think it was a double thing with myself—you start to feel your own power. I wonder how many entertainers, or let's say actors, are like myself: we're very selfish people in the sense that we're into our art. And for ten years I did nothing but try to get acting jobs. I just didn't know what was going on; I wasn't even interested. I was only interested in reading plays and books and improving myself to become a better actor. That literally took up all my time.

Then suddenly, I do a film like *The Graduate* and I realize, or I think, I have a certain power. And the kids are behind McCarthy. Well, the kids saw *The Graduate*. Now I like McCarthy. So there's a double thing. In one sense, it's a sincere thing to promote someone who I believed in, and at the same time it's a way to kind of test your own power, test your own popularity. I just think that it's important to know and be aware of that. Many times when I see actors promoting political causes or speaking out on issues on television, they sometimes are not as honest with themselves as they could be. I find myself suspect. It's an easy way to put a halo on your head to say, "There's terrible injustice done to the blacks; there's terrible injustice done to the Indians."

> I think entertainers, and I include myself, are like politicians. They're extremely aware of the audience and of their *own* audience.
>
> —Dustin Hoffman

SMITH: When you're asked about politics, it's not because of your political nature...but because you're famous. Does that bother you?

HOFFMAN: Yeah. I used to sit in front of the TV like everyone else before I was *famous* and I would see actors come on panel shows, and I knew some of them before they had made it. Then they had made it and suddenly being an authority on everything, not just politics but philosophy, humanism. There was just nothing that they didn't know anything about.

And *I* kind of have a feeling that actors are rather limited in what they know. Because there's too few actors that get work and the only way to get work is to really put in the hours. The bottom could drop and they wouldn't know it. Actors aren't really that much different.

SMITH: But all of a sudden you're a political commodity because you have the power for people to listen.

HOFFMAN: There's a desire for all of us to speak out and want to be an authority. We all wanna be intellectuals. We wanna think of ourselves as being more than we are....To be Marcuse or to be a great mind. So

suddenly, you're on Johnny Carson or Merv Griffin and you're asked questions…and rather than just saying, "Gee, I don't know that much about it," you don't—you start going, and there's a little signal in your head that says, "Go in the direction where your audience is." At the same time, I think it's wrong to keep your mouth shut. I just think it's important to question yourself, to have as much honesty as you can with yourself.

The youth today are in a tremendous position. For the first time in years and years, it's the youth that we are intimidated by. Used to be the elders—had to gain the respect of the father or whatever. Because it is the youth who have, in a sense, opened up a lot of things. So there's a tendency to jump on that bandwagon. Hollywood doesn't care what kind of movies they make as long as they make money. So they'll favor radicals if it's fashion, and if it's not, they'll favor Ku Klux Klan if that happens to be a large enough audience. And it doesn't just exist in film; it exists, then, in the people who make those films. They push toward that market without even knowing it.

I see over and over again people on TV saying, "If we would just listen to the youth." I don't know if the youth is that much different when they go to Fillmore today than when they went to see Frank Sinatra in the forties. I was down at the Fillmore; they may smoke or drop stuff or look differently, but finally the kind of outlet they're getting or enjoyment or things that are being fed to them by that stage aren't much different than Sinatra or Presley.

smith: You're supposed to have a lotta power in terms of the actor/director struggle. Is that true?

hoffman: In a funny way, it's true sometimes. Before I got into *The Graduate*, I was off-Broadway and I used to fight an awful lot and I just refused to do the scene in a way that I didn't think it should be done…. And if I didn't get my way, I got fired and I got fired a lot.

Then in *The Graduate*, I disagreed with Mike Nichols on a few occasions and suddenly realized that I couldn't, because to disagree with him on certain scenes would be to disagree with him on the entire thing…. That whole film is his film. Every character, including myself, played the characters as he saw them.

smith: You're just saying you would have done it a different way if it was your film?

hoffman: Probably wouldn't've made any money, either. The same is true in *Midnight Cowboy*. There were just a couple things I wanted to do, I felt, that would've somewhat altered the character but it would've greatly

altered the audience's response to the character....I wanted to be bold with it, in the sense that I wanted to be in a kind of Daumier area. To call it caricature kinda cheapens it, because Daumier stuff is so much better than caricature. Yet it's bold. It isn't documentary, it's heightened.

I feel that I failed in the sense that it's all right to do that but then you have to drill it next to your skin, and I felt that many times I didn't adhere the character to my skin....So I created this character then sometimes stayed outside, and, through whatever technique I have or talent, just kinda let the character go. I guess it's a hard medium for me and that was only, like, the second picture I did. And I have not yet conquered the medium.

I once sat for a friend of mine who sculpted me. I used to come in every day and once the face started to take form, it would look like me each day, yet it was different. One day he'd have the eyes in and the next day he'd take the eyes out. Another day I'd be smiling. Another day I'd be nothing and then a frown. I'd say, "How do you know when you're done? Because each time I come in, it still looks like me but you shift the emphasis of the total look." He says, "When I just can't do any more. I don't know when; I'll just be done one day." And he was just done one day. I would like to be able to *act* like that.

So when I saw (I guess it's true when I've seen anything that I've done) *Midnight Cowboy*—boy, would I like to go back and do it again. I'd carve it down some more. I'd take away some of the boldness. Just take it down a little; I'd bring it closer...I would've just tried to sync it in more with myself. Sometimes you see a performance where there's a moment of it. They rereleased *Streetcar* and I saw Brando, and it's an example where I think it's just *one*. He couldn't do anything wrong. All through the movie I just watched him and no one else, and he was just never off. He was completely adhered to the character that he was doing....It's a marriage. I'm always going for that and I've never hit it. I've hit moments of it.

There was a moment in *Cowboy*—it's funny because an audience, it's true that they *do* know the difference even without knowing they know the difference. On the streets when kids come up and say "Ratso" to me, like they do, they all pick out the same scene where I was crossing the street with Jon Voight and the cab almost hit us and I hit the cab and said, "I'm walking here!" It's one of my favorite moments. The interesting thing is that it was not in the script. It was a hidden camera and we had radio mics on us and a cab really almost hit us. I didn't plan it and I

just did it. It was a very true moment. That, I think, is what acting is all about. You create a character for yourself but then it's *you*; you then go through that character. And it's you that should be reacting to everything. Actors many times say, "Well, he wouldn't do that." They speak of their character in the third person. It always worries me because they remove themselves. I wouldn't do that. You create your framework but then it's *you*. It's *you* who's getting angry. It's not the character that's acting like a bastard, it's you. If the character's weak, it's *you* that has to be weak. You have to find your own real weakness. Many times that's a painful experience, so what you do is you stand outside and let the character take the blame.

SMITH: What was the turning point for you getting work? Was it that the times changed to suit your type?

HOFFMAN: In a funny way, I guess that's true....*The Graduate* came along and I was very frightened about it and ambivalent about it because I read the book and I was *wrong* for it, and that maybe what you were saying that times turned right, because had anybody else been directing it, I would've *never* gotten that part. That part wasn't a short, squat Jew like myself. Benjamin Braddock in the book was a track star and head of the debating team. Tall, slender, Waspish, all-American looking...I found out Nichols wanted to test me, and I remember talking to him on the phone between shows of *Eh?* I said, "I'm wrong for this part." I said, "I identify with the humor of it and I like the part, but I'm wrong for it." He says, "What do you mean?" I says, "'Cause I'm Jewish. This character is clearly American Aryan." He laughed and he said, "But he's Jewish underneath; he's Jewish inside."

Clearly what Nichols did was to not only go against the type, but turn it all around and to make the antihero the hero. I, myself, was the kid in school that was on the periphery of things...never could get into clubs and honor societies, and at the dances I was always standing. I made friends with a couple of Mexicans and a couple of black guys and joined the outer circle and we played jazz badly but, you know, hung around together. You still hang around at lunchtime watching all of these beautiful people get together. It's interesting because he cast the *periphery* to play the part that was the kinda people I used to watch. It was a shrewd move, because today, of course....And that was kind of the beginning of it. And if you

> **For the first time in years and years, it's the youth that we are intimidated by.**
> —Dustin Hoffman

DUSTIN HOFFMAN

look at the change in three years, it's fantastic…today the periphery kids are the *stars*. And the beautiful people are the peripheral people.

SMITH: Now it's almost if you're out, you're in. For me, the big turning point was moving into New York.

HOFFMAN: I always wanted to come to New York…my whole life I wanted to just live in New York.

SMITH: You are terribly New York.

HOFFMAN: I've always been told that. When I started college, Santa Monica City College… People would always come up to me and say, "You're from New York." I'd say, "No, I've never been to New York."

When I finally came here, I didn't have any money. I had all my high-school clothing. I was here in the middle of August. It was humid and I didn't know what humidity was. I got off the plane and got into the bus and went to the terminal on Thirty-Third Street, walked out on the street sweating, saw a bum urinating right in the middle of the street, and I said, "I'm home." I'll never forget that image. I coulda cried, I was so happy. I don't know why. I finally had met myself, I guess.

SMITH: I want to ask you about the bombing that took place next to your house. That famous Eleventh Street Weatherman bomb factory.

HOFFMAN: It's hard to realize how everything is relative….The abnormal became the norm.

SMITH: Been a lot of bombings.

HOFFMAN: And now if there is an explosion outside, you say, "That's a bomb," and you just go on eating your sandwich. When that bombing took place, everyone thought it was a boiler….It had a couple levels to it. No one knew it was a bomb yet. It happened at twelve noon and it was only about six o'clock that night that they realized it must be foul play. They found around sixty sticks of dynamite, and they figured out by the intensity of the explosion that eight to ten sticks went off. Now when those sticks went off, miraculously the building collapsed and smothered the other dynamite. Had the sixty sticks of dynamite gone off, the whole block would've gone. There were three or four hundred people watching this fire, as people do, all day long. At any time those sixty sticks could've gone off. They can't quite explain how they didn't.

Then people started to discover that I live there because I was running in and out to save things….People would recognize me and in the midst

> **That's the transit strike, the blackout, when Kennedy was killed, and this bombing.**
> —Dustin Hoffman

of the flames stop and tell me how much they liked my performance, or would find me kind of vulnerable and kick me when I was down. Because here I was, this movie star, and people relate to movie stars in interesting ways. Some people are threatened by the thing they haven't attained within themselves that they want very much. A lot of people want to be a movie star, though not literally, in the sense of whatever they identify with being a movie star: adulation, money, success. And people that are frustrated within themselves at not having these things sometimes are very threatened when they meet you on the street.

People then came around every day standing outside and looking. I don't really understand it. I think it kind of pacifies a certain thing in people. If a movie star can get hit like that, then everyone is vulnerable. Some people think that you're invulnerable when you're in the public eye, that you're godlike.... You kind of want to see that big person get hit, because then he's the same as you are. He's just as fallible. It can happen to anybody.

SMITH: These are perilous times.

HOFFMAN: We moved to a hotel for a week before we could get relocated. I suddenly realized what a devastating thing it is to be fired out of your place and all your belongings gone. The difference between it happening to people that don't have any money and it happening to someone who has money, who can move into a hotel, where the pressure isn't, "What am I going to do now financially?" Suddenly [I] really realized what that feels like when it happens with people who just literally have no place to go. I had some small identification with that kind of thing.

So anyways, we moved into a hotel and there was an English guy that was the manager, and I was telling him how no one talks to anyone in New York and I didn't know any of my neighbors and they didn't know me. And suddenly we were all next door in the church that was made into an emergency shelter and everyone was helping each other and talking to each other. Out of this tragedy, out of this devastation, suddenly in a strange way it's a beautiful time. Somehow, life is opened up between people. There's only been a few times where I have felt that commune feeling, I guess that a lot of the youth are in search for, since I've been in New York. That's the transit strike, the blackout, when Kennedy was killed, and this bombing.

Howard Smith and others in the WABC/WPLJ studios, N.Y.C., 1971

1971

Marjoe Gortner
January 1971

Once known as "the Miracle Child," Marjoe Gortner traveled the Amer-ican South, preaching at evangelical tent revivals from the age of four. Smith starts this interview by playing a recorded track of him, as a little boy, shouting over the chords of a church organ, "Sin aboun-deth ev-ry-whe-ruh! I can hear Je-zus. He ri-zez and says, 'The de-vil's goin' forth as a roa-rin' lion seeking yu-mins to dee-vo-wer.'"

..

SMITH: All right, that was [you] at the age of four, preserved from an old record, and you're now twenty-seven. I don't know where to start. Like, what? *What?*

GORTNER: Well, I took this off some 78s. These were taped in studios, but this is a sermon that I preached to large audiences as we traveled all over the country from the time I was four till fourteen. We traveled in continuous revival meetings all over the country, up and down the nation, in big audi-toriums. And this was just a sample of the type of sermons. As I listen to it now, I think the violence I heard on that is fantastic. *Sin;* the monster of sin is waiting for you now, and just coming down on people's heads so strong.

SMITH: You were four years old?

GORTNER: But I wasn't really responsible, you have to remember: it was memorized. You know, my mother wrote the numbers and then I memo-rized them, and then I would get out and give them this as a performance, like Shirley Temple would act in a film. My gestures were memorized—everything was memorized. But the saints, you know, they believed that it was from a celestial being and God was working through me perform-ing his wonders and all this. Then they'd give lots of dollars to see this because they would believe it was a miracle of God.

SMITH: That *you* were a miracle?

GORTNER: Yeah.

SMITH: You were called "the Miracle Child"—you were called a lot of things—"the World's Youngest Evangelist." You were featured in *Ripley's Believe It or Not*, in *Life* magazine, on newsreels. You were the youngest ordained minister of the gospel?

GORTNER: Yeah.

SMITH: Your mother and father were ministers also?

GORTNER: Listen, ministers go way back to—my great-grandfather was a minister; my grandfather was one of the founders of the Assemblies of God church and was a heavy number with them; and my father was an evangelist. My mother was an evangelist. In fact, my mother met my father coming to his church to hold a revival meeting. So they came out to California and started up a church after they were married; then I came along.

SMITH: What was that church called in California?

GORTNER: Church of the Old Time Faith. Typical Pentecostal, *hallelujah*-type church.

SMITH: And then they trained you, much as like an actor's trained?

GORTNER: Well, as a child, I sort of—I had this thing: I could memorize. I was sort of the hit of my age as far as brightness, and my mother picked up on this. My mother, she's a Scorpio chick, right? And she's really into this heavy training number. She started training me, I guess at about three and a half, for the wedding ceremony because my father concocted the idea that a child had never married a couple before; when you think of a minister, you don't think of a four-year-old baby. And so he concocted the idea of getting me ordained, because he was president of his church organization and he could legally have me ordained into that church, see? And then I married a couple, and naturally that made international publicity—

> **But I wasn't really responsible, you have to remember: it was memorized...I would get out and give them this as a performance, like Shirley Temple would act in a film.**
> —Marjoe Gortner

SMITH: Oh, that came before you went out—

GORTNER: Right. We went out on the strength after the publicity went around the nation about a child performing a wedding ceremony. That made me "the Miracle Child," right? Because...the people were all wondering who the child was. All you had to do is put an ad in the paper then, [that] "the Miracle Child" that performed the wedding was in town, and thousands of people would come out.

SMITH: And then you would get up and preach sermons to thousands of people, at the age of four.

GORTNER: Oh, yeah.

SMITH: Wow. How were you dressed?

GORTNER: Oh, that was part of it too. I wore these little Lord Fauntleroy suits—black velvet shorts and a white satin blouse, white drum-major boots with little tassels on them—and my mother would curl my hair and fluff it into little ringlets; it was really quite adorable. I was just in the Ripley's museum and they did a wax figurine of me at the one in St. Augustine…I walked in there, [and] on the second floor, there I am preserved in wax, in Ripley's Believe It or Not, and that kind of freaked me out a little bit.

> **They believed that it was from a celestial being and God was working through me performing his wonders.**
>
> —Marjoe Gortner

SMITH: What was going through your mind at four years old? What'd you think when you were standing up there in front of all these people?

GORTNER: I think of that an awful lot, as I look back. Of course it was memorized—my *movements* were memorized. But I remember I enjoyed working in front of people. I've got a heavy ego going for me. I enjoyed having people come up afterwards and say, "Oh, you're cute…I enjoyed you," and I tripped out behind that. But basically, I knew my mother was sitting back there and I'd better do right *or else*, because eight hours a day we would spend training. She would write the sermons and I'd have to memorize it, go through all the motions, the gestures. Like when I would preach, she'd even give signals. Like, I'd be out there preaching and if she was sitting behind me and saying, "Oh Jesus, oh Jesus." That meant "hurry up, do it faster, speed up." Because [as] a child, you tend to unwind or come down. And if I wasn't putting enough punch in it, like I was just talking, and I had to put these huge gestures, spread my arms, hold up my hands, you know, "The *devil's* coming after you." And if I was standing there just rapping, but not really doing the heavy gestures, she would say, "Oh God, *oh* God." That meant "put the gestures in kid, or else." And if I did it really good, they would be really nice. I would get a toy the next day if it was a big meeting. But if I didn't do so good, they came down very heavy on my head too. So that motivated me a lot. Kind of a fear trip, I guess, too. But still I enjoyed it; I have to admit that I enjoyed it. Especially at about seven, I can remember really clear, really tripping out that all those people are coming to see me. This, like, brings up another point, because at seven I was tripping out:"They're not coming to see my mother and daddy. They're coming to see me." But yet my mother and daddy were taking all the bread, and I wasn't getting any of it—

SMITH: At seven you began to realize that?

GORTNER: Yeah. I began to think, "How can I get this money," right? Because they're taking it all. My old man was super uptight with bread. My brother and I—as kids, we had these moneybags full of change and money and everything. We'd come back to the hotel and dump out all the money for the night's take on the table, right? And I'd come over and say, "Daddy, can I count the change?" He'd say, "Get away," because he didn't even want us to touch the change, he was so paranoid about the bread. So at seven years old I'm thinking, "Aha! My old man's ripping me off. That's mine." I started conniving ways. So I remember sometimes I would take twenty-dollar bills and stuff them down the pants of my little suit and steal 'em. But the only trouble was I couldn't spend the bread because I was with them. In fact, one time, I remember I had, I think it was four hundred dollars stashed away that I couldn't spend so I gave it away to people. Went out shopping and I just gave it away. But it gave me a release to do that, because at least it was my money and I was giving it away.

SMITH: This is incredible.

GORTNER: As I look back it's hard for me to believe it myself even. I'm glad I made it through all that, really.

SMITH: I don't know how you did because you seem fairly together. You don't at all seem like a reverend or a minister or—

GORTNER: I went through a very heavy number from like, fifteen till twenty-one. I was very bitter toward my parents because we traveled continually on the road from the time I was four to fourteen. In fact, we even carried private tutors on the road, you know, for education. And my father split from us when we were fourteen, leaving my mother and us on the road, right in the middle of a revival. Our tent is up, right, we had one of Ringling Bros.'s old circus tents, which is really beautiful; we're in the middle of this meeting—it was in High Point, North Carolina—and everything is rolling good. But the old man, he decides to split. He splits and takes all the bread that we've been making and left me with my other and that. So we continued for about a year and a half, and then I stopped. I had this super resentment, actually toward both of them. For Mother for making me do this and Father for ripping me off. But now, I'm sort of over that because I'm twenty-seven. And in fact at twenty-one, I was gonna start a lawsuit because the Jackie Coogan Law states that when you're a minor and you earn bread, you have to put so much away. Like, his parents ripped him off really bad and he won a lawsuit case. I don't know if you remember it or not, but there's a law called the Jackie Coogan

Law. So I had these attorneys that could have taken and tied up all my father's assets, because I was a minor earning the money and a certain percentage I was entitled to. Incidentally he never paid any income tax either. Because he had, like, a nonprofit religious organization, so the whole thing was a *real* rip-off.

SMITH: Wow, that was back in 1949 when you started? I want to ask you more about that wedding. I still can't get over that.

GORTNER: Yeah. Another thing is, I remember—at four years old, I can't remember everything, so I just have to remember highlights—the Associated Press paid a big sum of money to have exclusive coverage rights on it. But somehow news got out about the wedding and there was this whole band of, I don't know, groups of reporters wanting to take pictures of the little child who's gonna perform this ceremony. But they couldn't let anyone have pictures because AP had paid for exclusive coverage to sell to other media. And so my mother wraps me up in a cape, right? And she carries me out like a sack of potatoes. I can remember: I'm being carried over her shoulder, out to a waiting car, and the photographers are waiting, and she puts me on the floor of the car. I lay on the floor and I couldn't get up. I started to get up, you know. "Stay down. Stay down." Like, I'm the minister on the way to do the wedding, right? We get to the chapel; there's more reporters waiting, and so she takes me out again, keeps me wrapped in this sack. There were a few pictures that came out, by the way, of me in this sack.

> **So at seven years old I'm thinking, "Aha! My old man's ripping me off. That's mine."**
> —Marjoe Gortner

SMITH: That probably just added to the mystery of it.

GORTNER: Yeah, exactly. So then when I got in there, she took me and got me all fluffy and cleaned up, and out I came to do the ceremony. And the heaviest part was, because an Episcopalian recital is what I memorized, the hardest thing for me to do was to get the handwriting down. My mother had to practice with me for weeks to write my name, you know? And after many cracks on the hand with a ruler—

SMITH: Until you learned how to write your name?

GORTNER: Until I learned to write *Reverend Marjoe Gortner*. And I had to make a little cross on the bottom of the *J*.

THE SMITH TAPES

Sammie Dunn
April 1971

Sammie Dunn would be a professional racer, but the American Motorcycle Association (AMA) only allows women amateur status. Yamaha Motor Co.'s brought "Shapely Sammie" to New York City to race tomorrow in Madison Square Garden's first ever motorcycle event, the Yamaha Silver Cup, but AMA officials will renege at the last minute and make her ride a solo exhibition lap. However, things will soon change, and, following the lead of Kerry Kleid, Sammie Dunn and fellow racer Debbie Seldon will apply for and be granted professional competition licenses by the AMA at the end of the year, rescinding its long-standing discrimination.

...

SMITH: You're the first woman motorcycle racer that I've spoken with. I've met plenty of girls who ride bikes, but are there many women motorcycle drivers that race?

DUNN: Sure, there's a whole bunch of 'em. I don't think it's too common or well known here on the East Coast, but on the West Coast there's quite a few women getting into the sport.

SMITH: I've heard that you can't race against men.

DUNN: Oh, no, you can race against men, just not in professional races.

SMITH: You can't be an American Motorcycle Association professional motorcycle driver?

DUNN: No. Not a female.

SMITH: But why do they make a separation that you can't be a professional?

DUNN: I really don't know the reason why they make this law or rule or whatever you wanna call it. I guess it's just more or less to keep a little o' the sport strictly for men—which I can't blame them.

SMITH: You can't? You agree with that?

DUNN: No, yes. I think women are getting into sports nowadays and it's exciting for women and they're enjoying it, but I think there should always be one field that a woman can't bother a man. And I feel very strongly about this.

SMITH: Do you enjoy racing against men?

DUNN: Sure. It's not against *men*; I just enjoy competition.

SMITH: It doesn't bother you personally? I mean, there must have been some events that you really wanted to enter, but you just couldn't because you're a woman.

DUNN: No, the only problem I've ever had there is the indoor. And really I'd love to race it, but it's not gonna irritate me or get me mad or say anything against the rulings, because I just enjoy the racing. If I don't compete in it, I enjoy watching it. Because I know what the men feel like out there. I get just as much excitement out of it watching it as I do participating.

SMITH: In the nonprofessional events that you compete in against men, do you get any trouble from the men, like before the race?

DUNN: Oh, no. They've all been great to me. They're always trying to help me out, give me good pointers here and there, what I'm doing wrong and how I can better my riding. But I haven't had any problem with 'em at all.

SMITH: And do you do pretty well against them?

DUNN: Some of them I do.

SMITH: What size bike do you usually ride?

DUNN: A 500 cc.

SMITH: Wow, that's a big machine.

DUNN: This is why I had to compete with men, because of the size of my motorcycle.

SMITH: Are there races just for women?

DUNN: Sure, what we call Powder Puff races.

SMITH: [Groans]

DUNN: But in order to race in a Powder Puff event, you have to stay on a 100 cc motorcycle or under.

SMITH: Wow.

DUNN: And they actually compete in the same races and the same areas, but it's just they're in their own class. They're racing strictly against women.

SMITH: Does that bother you that it's called the "Powder Puff"?

DUNN: It's kind of a corny name, but, you know… It sounds like ladies' events and there's not another name that could really describe it any better, I guess.

SMITH: Well, they don't call the men's events "Jockstraps." Do you have any difficulty handling a 500 cc machine?

DUNN: No, you just learn you can use the weight to your advantage.

SMITH: What, you mean that you weigh less…

DUNN: No. The weight of the motorcycle. Everybody says, "How can you ride such a heavy motorcycle?" But it's not heavy. You just need to learn to use the weight to your advantage and know how to handle 'em.

SMITH: Has there ever been anything about your racing that involved your strength that would've saved you if you were stronger?

DUNN: I don't think it's so much your strength as it is, are you durable? Can you withstand a continuous amount of strength and riding? I really don't think you have to be a muscle-bound person to ride a motorcycle, but you do have to be coordinated and very durable, and you have to be able to last.

SMITH: Which I guess should have nothing to do with the sexes.

DUNN: Well, sure, men are a lot more durable than women.

SMITH: You think so?

DUNN: Most of them are.... You don't know nowadays, really. But as a rule, men are better at anything, I think, than women, if you get down to the actual fact.

SMITH: What kind of events do you do, basically?

DUNN: Usually desert endurance races. The last one I was in was the Mexican 1000, which is a one-thousand-mile enduro, nonstop other than for gas. You start at one point and finish up one thousand miles down the road. It's a lotta fun.

SMITH: Hill climb? Have you done any of that?

DUNN: Oh, yeah. In fact, I'm the only woman in the States that's ever climbed the Matterhorn on a motorcycle. Now this is not the one in Switzerland—we have a Matterhorn mountain at Saddleback Park out in Irvine, California, that they hold national hill climb events. And they're offering a certain amount of money for a woman to even attempt to climb it and if they did make it, they'd give me the trophy and name on this wooden plaque, which is at the top, plus this amount of money. So I went out there and did it.

SMITH: How much money was it?

DUNN: One hundred dollars. It's not much, but the money doesn't mean anything to me. It's just knowing my name's on the top of that mountain now for being the first and only woman to ever climb it.

This is why I had to compete with men, because of the size of my motorcycle.
—Sammie Dunn

SMITH: Do you see a chance of it ever happening where you might want to fight the AMA about letting you compete with the men?

DUNN: No, no.

SMITH: You don't see that.

DUNN: See, I like men too well. And, you know, you start hasslin' with men and they don't like you no more.

SMITH: Are you married?

DUNN: Divorced.

SMITH: How did your husband feel about you racing, or the men in your life who aren't into motorcycles?

DUNN: Oh, they seem fascinated by it. In fact, my husband is the one who taught me everything I know about bikes. He didn't really want me goin' into the competition field, because he was always afraid I might get hurt or run over. But he loved it; he used to race himself. It's not that we're divorced is why I'm going into the competition field now; I've always wanted to.

SMITH: Do you have kids too?

DUNN: I have two girls, eight and six, and they both ride.

SMITH: I'm just left a little speechless, actually, because the whole country is being swept up by the women's lib movement, you know? With women trying to crack *into* everything.

DUNN: It's ridiculous.

SMITH: Here you are further along racing against men, I guess, than most other women motorcycle drivers now, right?

DUNN: There's a lot out there competing now. But not so much in the bigger bikes where you have to race with the men, but there's a lotta women.

SMITH: And yet it doesn't seem to bother you that you're…

DUNN:: No. Because I'm in it for the sport, my own self-satisfaction, not to go out there and try to show the men that I can do better than them.

LeRoi Jones Reel 2 Of 2

LeRoi Jones Reel 1 of 2

Amiri Baraka
January 1971

In 1969 LeRoi Jones left his life as an influential New York City Beat poet and playwright. He changed his name to Imamu Amiri Baraka, moved back to his hometown of Newark, New Jersey, and became a central figure in the black community and black nationalist movement. Dubbed a kingmaker, Baraka was instrumental in Newark's election of its first black mayor, Ken Gibson, last summer. But a crisis is looming. The Newark Teachers Union strike will begin on Monday, shutting down the schools for eleven weeks and bringing the city to the brink of a race war.

SMITH: Hello, LeRoi.

BARAKA: How are you doin'?

SMITH: In your book here, it says Imamu Amiri Baraka. Should I call you LeRoi?

BARAKA: Well, Imamu is better, but call me what you feel comfortable with.

SMITH: Your book is called *In Our Terribleness*. It's a very strong book. In the dedication it says, "For all the advocates of Kawaida...." What is that?

BARAKA: It means tradition, of African people actually. It's a value system and a philosophy or ideology that we practice. It actually can be translated as a political ideology of black nationalism but also a spiritual ideology of traditional African thought.

SMITH: This is written by you and photographs by Fundi, who is Billy Abernathy. Most of the photos are of people.

BARAKA: What I've done is try to get it into various aspects of the black community and explain the kind of *feeling*. Feeling as feeling, feeling as political statement, feeling as cultural configuration...But actually telling what the people mean and what they *need* to mean. That probably sums it up.

SMITH: Mixed in with all of it is a very strong polemic. Did you mean this book to be directed at whites or blacks or both?

BARAKA: I wrote the book to black people like a conversation—a long, unending conversation, so to speak. It's a very directed energy. But it exists as an artifact. So it's approachable by anybody who approaches it.

But it does speak specifically from a black experience to black people. It's meant to be instructive. It's meant to be inspirational.

SMITH: Is that what most of your writing is now?

BARAKA: I guess technically it differs maybe in the mode, but generally either very instructive, precise, technically instructive in terms of strict political, or maybe inspirational instructive in terms of raising the level of consciousness.

SMITH: How do you feel poets and artists mix with Black Power, with revolution, with politics in general? Do you see your own role more as a mover and shaker politically or still primarily as an artist?

BARAKA: Well, let me explain it this way that...The greatest thing that you could ever create would be something real. Like a nation would be a greater creation than maybe some scratches on a board, just by the nature and impact of its total impact on people, see. So we see this spirit of the poetry actually being a kind of animating force in the creation of a lifestyle and a life, and a thing to house that life—to generate more life. We don't really see the differentiation. We think that this westernized schizophrenia kind of thing where "art is here and life is here," we don't see that as being useful. One thing this kind of separation creates is you have the people who are supposed to be controlling the actual life of the people being, by and large, *goons* who have no real feeling for beautiful things, when actually, the people who are supposed to control people's lives, who's supposed to have the most power should be the ones who have the most knowledge. That would seem to be the most *rational* way to set up governments, but we've strayed from that. Black people have *been* strayed from it because against their will, you know, enslaved. So what we're tryin' to do is bring that all back together: the unified understanding of what the world is, that it's all the same actually. There're just different aspects of it, different ways it shows itself.

> It's this thing about white people always tellin' themselves what they want to hear.
> —Amiri Baraka

SMITH: Is that gonna be possible in this world or in Newark? When there're basic bread 'n' butter issues at this stage, to meld art with life?

BARAKA: But it's all the same thing. To get bread actually is to broaden somebody's consciousness. It's the same thing. If you deal with a society where people have not even learned to feed each other, than you're dealing with some kind of strange barbaric place where people really don't know what art is in the first place. There can be no art, really, if people are

still tryin' to find out how to eat. So we see ourselves as trapped by some crude barbaric society and tryin' to evolve a higher way of living out of it. This will pass, like everything else passed. What survives, we hope and we're very confident, will be the raised consciousness of men. Men will survive past America, past racism, past colonialism.

SMITH: How is it going in Newark? I grew up in Newark and left, and you left. You've gone back.

BARAKA: It's changed. But it's gone through its bad stages and now we feel, with this political victory last year, that we're on the upswing. We're moving positively. We're still facing great odds, the same kind of racism, the same kind of barbaric, colonialistic, imperialistic. But we're still making strides, because now we have *some* power to do *some* things, to make some moves. Now the confrontations will be broader. A lot of black people will begin to understand exactly what's happening in America even more clearly. Our struggle, which is nationalistic struggle, we see as a struggle to gain political power, that is, control of the space that we live on and develop institutions that speak to our needs, legitimize our culture, legitimize our way of thinking about the world. We believe that before we can enter into this sort of international world, we have to actually enter into the national world. We have to control at least our *own* ideas: control our ability to form ideas which will benefit us.

SMITH: Now that there's a black mayor, does that mean that the blacks are in control of Newark?

BARAKA: This is the confrontation, the paradox of political power, which is actually a great move for people who tend to denigrate it or make small of it. It's usually because A: They have never thought, I'm talking about black people now, about how actually you maintain and use power, which is what politics is about, but have always been in the world of rhetoric—"Off the pig"—but meanwhile they with the pig. They're in the same structure that they seek to destroy—in terms of its lifestyle, its mores, its philosophy, its ideology. Hate it / love it, mirror images of it, but yet not moving to make an alternative to it. What we're tryin' to do is make an alternative to it. But we see the contradictions in America, that there is this racist, capitalist, imperialist structure and that we are faced with it and that the people who, say, control Prudential and Mutual Benefit and Engelhard and those companies are the ones who are crushing our lives, but now we do have the power to have a forum. You see what I mean? Now we can *face* these people down as a legitimate—and we say legitimate that's recognized by white people as having a right to

speak. When I speak on the sidewalk prior to the election's one thing, but now if it comes outta the city hall structure, it's quite another thing. It *means* some other thing. So it's legitimized what we're saying about America in a lot of ways.

SMITH: Those large companies that you mentioned…were basically backing Gibson, weren't they?

BARAKA: No. They were backing him about a second before the election was over.

SMITH: Were they actually opposing him up until that point?

BARAKA: Let's put it this way. If there are $2–3 billion made in retail each year in Newark, what they're interested in is that $2–3 billion. They wouldn't care if all their mothers died or if there was Martians running it or if there was chameleons running it—as long as they can get that $2–3 billion. Now we have to accept that premise. The Italians were not taking care of the business correctly. The black people were making too much noise, rebelling, runnin' in the street; we're burnin' the town down. So they say, "Wait a minute, now. Are these Negroes organized sufficiently so they can take power?" They say, "No, they won't be organized until 1974." That's when white people say we can take control in Newark. So we went to them and said, "Look, we're gettin' ready to win this election—we need some money. And you wanna give up the money to help us win the election." They say, "No, we gotta stay out of it." Meanwhile, they were tryin' to support a *clean* Italian, which means they got the state senator, gave their money to this man and he was really a jerk. First public statement he made, he put his foot in his mouth and went rapidly downhill from that. Then they put their money behind Caulfield, who's an Irishman who'd left the Addonizio regime.

SMITH: Caulfield came out for Gibson, didn't he?

BARAKA: After. He *ran* in the first election, and because there were two sell-out, imitation-liberal-type Negroes runnin' against Gibson the first time, there was a runoff. The second time Caulfield came around—he couldn't throw in with Addonizio after announcing Addonizio was a crook. So he finally endorsed Gibson, which meant a small segment of the white population actually did go with Gibson. But the white business community never came in until the *last few days* of the campaign. But by that time they were whipped anyway. Addonizio, after they had got that whippin' put on 'em the first time, beat themselves. They polarized the community. They became *more* racist. They had the police chief making statements: "Now it's black against white." They actually polarized the town,

which is exactly what we wanted anyway. Because they had convinced themselves that there weren't enough black votes. It's this thing about white people always tellin' themselves what they want to hear. At first they said, "There's not that many black people." Then they said, "There's not that many black registered voters." And finally when the votes was counted, it was too late. But the business community never supported Gibson....The majority of the money, all of the strategy, came out of the black community.

SMITH: You were talked about as the kingmaker, the strategist of the campaign. Were you the power? The Addonizio forces kept saying it was voting for you rather than for Gibson.

BARAKA: They thought that would scare the black community. Actually, they were tryin' to stampede the white community into voting a solid block vote for Addonizio, and scare the black community away, because they thought we were militants. But see, after 1967, when a lotta so-called moderate Negroes saw just what was happening, people getting shot down in the street...Nobody was

> The best thing that so-called white radical/white liberal can do is, first, do not interfere in the affairs of black people.
>
> —Amiri Baraka

askin' *what* their politics was, whether they loved white people or didn't, they were just *shootin'* 'em. They saw that those people were beasts. Addonizio was not only corrupt, but a madman and a racist. So nothing he said could *make* any sense.

SMITH: But were you the strategist behind Gibson's campaign?

BARAKA: We did contribute something to the overall strategy, but it was a community effort. There were a great many forces. The one thing that we did do was keep the pressure up, constantly, on the community to respond, pleas for the community to be conscious of itself, what it needed, and exposing the corruption and the racism in Addonizio's regime.

SMITH: I was curious how you felt about backing Gibson, basically a middle-class civil servant. Would you have preferred a more militant candidate, but this was the most expedient way to gain power in Newark?

BARAKA: Well, I woulda preferred backing Malcolm X, actually. I wish he was the mayor of Newark....Now, I'm not the totality of the black community. A lotta times so-called black activists, because they think they have found the truth, they are pushing that ideology and if people do not agree with them, the only thing they succeed in doin' is hostilizing by saying, "You're backward; you're not revolutionary." But *that* is not how

to gain power. The way to gain power is to move the whole community. That is what we as nationalists are involved in. *Organizing* the black community and *moving* it—raising the level of consciousness. Now, is becoming mayor of Newark actually revolutionary action? *Not* being the mayor is less revolutionary. So what we're dealing in is the evolutionary process. How do you actually raise the consciousness of the *whole community*? Not just some militants who are talking about "*Off* the pig" but cannot even keep a storefront open. But how do you reach the totality of the community, *all* of the community and raise *it*? Because we can't survive without the community. The minute I come out and say, "Off the pig," if I don't have the community behind me, *I* will get offed. Because all I will've done is raised my hand and signaled that I need to be killed.

SMITH: Where does this place you, then, with the Black Panthers?

BARAKA: My difference with the Panthers—and I knew Huey and Bobby when the Panthers started, Bobby Seale when he was a comedian in Oakland—is that I feel our job is to organize the black community, that our strength is the organized conscious community, and that black people will only survive and become self-determining with an ideology that speaks *to* their needs, that has been created out of their experience. I do not think you can impose some patched-up version of Marx and Lenin on twentieth-century black community. I think that's just another form of racism, another form of militant integrationism. Where we used to have old Bayard Rustin, who was a pacifist integrationist, now we got integrationists with guns. We don't see that as being useful and we don't see the community being interested in that particular lifestyle or that development. But we *also* feel that the Panthers and nationalists, *all* black groups need to sit down and come to some concept of a united front. That we will never survive without the united front.

> **That's because you have the leisure to decide our fate abstractly. We are slaves to your leisure.**
>
> —Amiri Baraka

SMITH: A theme in this book, "survive and defend." Is that almost the core of what you're saying?

BARAKA: Development and defense, right. We have to survive America. From its beginnings, as we were brought here to slave and die, we had to survive that. And we have to survive the concept of *the ghetto* and change these ghettos into black communities where people share values, which are beneficial to them and help them to live and develop. And we

must be able to defend the things that we *do* believe in, the concepts we develop, defend institutions we develop. We must understand that we *need* institutions as the only things that will maintain and develop our way of thinking about the world, our culture.

SMITH: Do you think that the sensibilities of the hippie/yippie culture, which primarily have come out of a white middle-class background, are going to make it easier to achieve these goals?

BARAKA: It's difficult to say *easier*....But where the so-called hippie/yippie keeps up the increment of difficulty on the white nation in general, it keeps them occupied a little bit so they don't have *as* much time to shoot *us*. We can see that. But Charles Reich and the "greening of America"... And people who come up with this new kind of hierarchy of putting a white youth culture, *again*, as the most profound, most savant, savior of mankind...

SMITH: Do you see the white youth alternative culture—I'm lumping it all together as if it all has one mind—as enemy or friend?

BARAKA: We believe in self-determination. Now if that's what young white people are interested in—self-determination for young white people, or developing a white culture that will understand the self-determination of all peoples—then we can dig that. The best thing that so-called white radical/white liberal can do is, first, do not interfere in the affairs of black people.

SMITH: No place for them at all?

BARAKA: Wait a minute, now. First of all, *interference* is, quote, "progressive labor." In Newark we're gettin' ready to have a teachers' strike. Saying, "Finally all men will benefit by being together" and that "the nationalists are reactionary." Now, for them to come in my community and call me reactionary just because they think they got the inside on where the world is goin', that's racist. For them to say that a nationalist is caused by white racism is the most racist statement they can make. If *they* represent the alternate culture, they need to be killed off with Nixon. But we say, first, do not *interfere* with the internal affairs. Do not *give us* an ideology. Do not try to *steer* us in the so-called path of righteousness. The second thing is to provide the technological, financial assistance— just like foreign aid. For instance, a white boy who knows all about tape recorders and television and movies and handling all of that equipment, absolutely we're interested in learning all that, any kind of technological—airplanes, thermodynamics, atomic energy, any kind of highly technical thing—because we've been kept outta that.

The last thing is to humanize your *own* community. If so-called hippie alternative culture wanna do something, they should deal with the *hard hats*. Do not try to raise the level of *our* consciousness; try to raise the level of the hard hats' consciousness. Go to the Anthony Imperiales and hip *them* to communalism. Black people have *been* humanists. We have suffered because of the lack of humanism in America, so we certainly understand the need for humanism. But we do not need missionaries comin' to us. Missionaries should go in the *white* community, because that's where the *inhumanity* is comin' from.

SMITH: Do you see any place in the black struggle, in the black revolution, for white people?

BARAKA: No. We see the struggle of white people being to raise the level of their own consciousness. We see our struggle to raise the level of our own consciousness. Now, if, perchance, one day we meet somewhere in a world that has been made safe for a new kind of lifestyle, then that's something else—where nations themselves can deal with each other like brothers.

SMITH: Is it moving fast enough for you in Newark at this point? Are you happy with Gibson so far?

BARAKA: I think we're moving very positively. We're facing a lot of challenges. Tomorrow is a school strike, and this basically white suburban union is going to try to jack the city up for some money that the city doesn't have, and is gonna try to close the schools and we're determined to keep the schools open. There's no money to run the city: the businesses will not *put up*; the legislature will not *put up*. The problems are huge. But we just now begin to get on the level where we can deal with them like men deal with problems, rather than having other people deal with them for us or in our names or despite us.

SMITH: Do you think the entire government of Newark should be black?

BARAKA: No, I believe in proportional representative government. We're almost 70 percent of the population; I believe that 70 percent of it should be. But at this point it's not nearly. You see, the whole city hall structure, those old civil servants—all white people. They're protesting now 'cause the mayor wants 'em to work thirty-five hours a week instead of thirty. They're walking around—"I'm mad." I hope they all quit and leave.

Same thing with the teachers: 80 percent of 'em are white in the school system. If they don't want to get into a new kind of consciousness, they should leave....Those people who represent that dead mind, that dying consciousness, black or white, are going to have to change up. They're either gonna have to get better or split. That's the confrontation. I think

the strike tomorrow is gonna be the first thrust of that. Either get here and teach the children, understand that you're in a racist institution and this institution must be changed, that you are a racist and that you have to change your whole curriculum, or leave.

SMITH: Do you see the only way of solving the ghetto situation is by a strong reaction—it can't be gradual?

BARAKA: The only way it can be solved is through political power for the people who are powerless. The cities which are inhabited by black people and Puerto Ricans, like our city Newark, is a mess, because the people who live in the city don't have the power to control it. We can just say, "It's a mess," or we can get mad and try to burn it down. But there is nothing we can do about it unless we have power to do it.

Smith: **The white man did not invent war and killing.**

Baraka: **No, but he has perfected it.**

SMITH: Just win as many of the offices as possible?

BARAKA: Absolutely. But that doesn't mean that we have to be the same beings that are in those offices now. An office is just an instrument. Different sounds can come out of instruments depending on the experience that's playing it.

SMITH: Unfortunately, there's the thing about power corrupting.

BARAKA: Well, power corrupts that which can be corrupted in the first place....The United States, in terms of governmental structures and relating to society's needs, is barbarian. It's the most violent, barbaric country in the world.

SMITH: Let's take Newark. If blacks were in political power, it would not be as barbarian?

BARAKA: Absolutely not, because our needs are humanistic at this point.

SMITH: And the very fear of the white is that it'd become more barbaric.

BARAKA: We're not the ones who have destroyed humanity. We have not dropped bombs on Hiroshima and made war on the colored peoples of the world—

SMITH: The white man did not invent war and killing.

BARAKA: No, but he has perfected it. The atomic bomb is one application of atomic theory. The development of it into a weapon is a peculiarly European invention. You've got to face that.

SMITH: All I'm saying is it's very possible that when the blacks take over in certain cities through politics, things will be better, but it's also very possible that it won't be.

BARAKA: I know. That's because you have the leisure to decide our fate abstractly. We are slaves to your leisure.

SMITH: You misunderstand me. I'm not saying because of that you shouldn't come to power....

BARAKA: But you are. You have the power to say that. By you making an abstract judgment about whether or not it'll be better for us to take power, you have taken a position where—

SMITH: No, no, no. I didn't say whether or not you should take power.

BARAKA: But yes, yes, yes.

SMITH: I'm saying you *have* taken control of Newark, let's say. It's gonna be great if you can solve Newark's problems. But to me it looks almost impossible.

BARAKA: But you have never seen Newark governed by black people and Puerto Ricans. You've only seen Newark governed by yourself.

SMITH: Right.

BARAKA: So don't judge us by your own failure.

Amiri Baraka, N.Y.C., early 1960s

Jane Fonda
March 1971

In the past year and a half, Jane Fonda has completely immersed herself in radical politics, becoming active within, and lending her celebrity to, both social and political movements. Her latest film, Klute, *starring fellow antiwar activist and actor Donald Sutherland, opens this June and will win her the year's Academy Award for Best Actress. But in July 1972, three months after receiving the Oscar, Fonda will take her infamous trip to North Vietnam, where a photograph, taken out of context, will brand her a traitor.*

••

SMITH: The last time we talked was a year ago, maybe?

FONDA: Year and a half ago.

SMITH: Between then and now, there seems to have been an enormous change in your outlook and interests. What was the turning point? Was there one key incident?

FONDA: No. What I didn't tell you at that time was my marriage was breaking up, partly because of things which I now see in a more political light. It had to do with the sense that I, as a woman, was being put in a situation where I was having to deny change in myself. I was oppressed. I don't mean oppressed by my husband, necessarily, but by the situation.

SMITH: But you were saying exactly the opposite at the time.

FONDA: Yeah, one does that. It's because I was terribly unclear about it. It was almost two years ago, now that I remember. Things were just beginning to change in my life andit looks like to people on the outside that I suddenly surfaced on the left. And that, in fact, isn't true.

I went through a process of change, which began on a personal level and then had ramifications politically. It had to do with things that I became aware of while living in Europe. We had early-on access to information, films on French television showing B-52 bombers dropping antipersonnel bombs on North Vietnamese villages that had just churches and schools and hospitals in them. I began to read information and talk to soldiers who were coming back from Vietnam, work with deserters in Paris—and for the first time began to understand, helped

by the incredible change in attitude towards America that was taking place over the years I lived there. When I went there, it was during the Kennedy administration and America was looked to with great hope as being a place that could, perhaps, become what it professes to be on paper. When I left, the *hatred* for what America stands for was terribly difficult to confront. And one of the reasons that I came back was because I realized that my place was here. That there were things that I felt I wanted to fight for, not just in a from-time-to-time, sporadic, isolated kind of way. I didn't know how. I wasn't clear as to what form that was gonna take. I was also *very close* to doing a drop-out metaphysical type of trip, because of the cynicism and sense of hopelessness and disillusionment about this country.

I guess what stopped me is that I went to India. And I went to India for the same reason that lots of people go to India, seeking some sort of metaphysical answer. I found abject poverty and total misery. I found white middle-class American hippies living in the midst of this poverty, spaced out on drugs, making the situation worse, and totally insensitive to the problems that the Indian people are facing. And when I would talk about this, these people would say, "You're just bringing your middle-class values here. *They* don't consider sleeping in the streets and starving the same way you do." And I realized how irresponsible that whole drop-out, put-blindfolds-on way of life is.

As long as they can make a buck on me, they're gonna hire me.
—Jane Fonda

The country had really changed in the six years that I was away. And many people had gone through political evolutions that I hadn't experienced. So when I came back I was confronted with a whole new situation, and, in a very short space of time, tried to understand why this had happened and made contact with certain kinds of people: American Indians, militant and nonmilitant, the Panthers, soldiers....

SMITH: Actually, how did that happen?

FONDA: It happened because I came back searching.

SMITH: Did you say to a friend, "I wanna meet some militant Indians" and they introduced you?

FONDA: I came, literally, from Calcutta to Beverly Hills, which is a shocker right there. When I stepped off the plane, I saw a copy of *Ramparts*, which had an Indian woman on the cover, on Alcatraz with a thing called Red Power, the sign behind her....And it was the first time I had ever heard about a militant Indian struggle. So I contacted the writer of the

article and I went to Alcatraz and I met the Indians and through them got contacts all the way across the country.

At the same time, one of the first things that I did was contact Masai Hewitt and Elaine Brown, leaders of the Panther Party in Los Angeles—with a great deal of fear, I have to add. People told me, "Your career will be ruined." "You'll be killed." And I found a group of intelligent, sober, dedicated revolutionaries who were dealing with root problems in the country.

SMITH: How were you accepted by the Panthers?

FONDA: A liberal to be *used.* A white liberal who could maybe help, just on a civil libertarian level, and in the beginning that's what my support was. How is a black person from a ghetto supposed to raise $200,000 bail, unless his friends go out and rob a bank? I mean, it's unconstitutional....I had lived in a kind of ivory tower, as most white upper-class people have, but particularly Hollywood people. And I had, as a liberal, been involved, but it was a *do-gooder* from an immune position.

SMITH: You feel you've moved from liberalism to radicalism?

FONDA: To understanding that it's *my* life I'm fighting for....All of these things that I had viewed as isolated issues, like racism, poverty, unemployment, the war in Vietnam, the Indian problem here, and the Chicano problem there, were *in fact* the same thing. That they were the same thing that was messing *me* over as a white American woman, that was making it difficult for practically anybody in this country to have any kind of self-determination, any kind of control over their lives, any kind of sense of fulfillment about what they're doing in their work or in their daily lives and that there are many forms of starvation. I began to understand, *particularly* working with Indians on reservations, that there is a systematic exploitation taking place. That endless series of broken promises, broken treaties, Indians being sold down the river and exploited, *always* in the interest of the wealthy white landowners and oil interests supported by the same politicians that people think are friends of the Indians, and that when push comes to shove, it's with the money that they side. I began to realize that it doesn't matter who you put in office, even if it's a *saint.*

SMITH: Saying that all of these things are caused by the same thing, what are you after now?

FONDA: I began to understand that as long as we have a system which is geared to production for the sake of production, whose center is not human values but profit, that these kinds of things will continue no matter *who* is in office. And along the way understanding, *truly* organically, how

that affects me—becoming aware of my own oppression as a woman. What we must do is change the economic structure of the system in this country. That's not going to immediately solve all the problems. It's not going to solve the problem of racism or sexism. But it will lay a groundwork....

SMITH: Can you imagine this all being done through peaceful means?

FONDA: *No*, I don't, quite honestly. I don't have any blueprint for how that kind of transition is going to take place. As the conditions in this country get worse and worse, and as that touches not only black people, but also white middle-class people and the working class, people are going to begin to rise up angry. And as that happens, repression is gonna come down more, no matter who is in office, and eventually the situation is gonna be intolerable. Now what the progressive people in this country have to do is to show people that *we* are truly concerned about the day-to-day, bread-and-butter needs of people. That what we're talking about is not a threat to them, but in fact is *salvation* for the country as a whole.

SMITH: How are you moving towards this kind of a goal in your own personal life? Other than going around from demonstration to demonstration? You come from money....How do you relate to that?

FONDA: I was brought up [to believe that] money is sacred; I was encumbered by possessions....That began to change....It didn't happen overnight. It's just that I began to become aware that these things are not important. And that one can't profess a certain politic here and then live another way there. And I found that my needs began to change, my lifestyle began to change, and I began to rid myself of these trappings....I don't need furniture anymore and I don't need clothes anymore, and I am much happier for it. The people that I know, the people that I love, the people that I work with—the way I live is just totally different.

I continue to make movies for two reasons. First of all, I earn a *lot* of money. And *as long* as I can continue to earn a lot of money, I will go into Hollywood and rip them off for as *much* money as I can get, and I give it to the areas that I think are the most crucial.

SMITH: Is that what you do with your funds at this point?

FONDA: That's what I do with all of it. I need hardly any money at all, actually....But I also want to continue to make movies because I think that, potentially, they're an incredible way of reaching people. Now you're not gonna make revolutionary movies in Hollywood. But you can make movies that, hopefully, lay ideas out on people....I think that it's also important that I continue working, because it's important for people to

see that one can take the kind of position that I've taken and continue working. As long as they can make a buck on me, they're gonna hire me.

SMITH: But isn't it somewhat hypocritical on your side, also?

FONDA: No.

SMITH: I mean, Hollywood is an incredibly sexist place. It's one of the most male chauvinist of all industries.

FONDA: And one has to deal with that. One can't write that off. I mean, a lot of white middle-class people who have skills and talents and access to funds, because of the whole guilt about coming from that kind of bag, totally reject it and become poorer than everybody else and give up all of the things that are so essential to the movement. I mean, one of the big problems in the movement is a need for surplus. We need money. Whether it's getting people out of jail or carrying on a massive spring campaign against repression and the war, we need huge sums of money. And I'm in a *unique* position of being a radical who has access to a huge amount of money.

I was on the verge of doing a purist kind of trip. Some people in Detroit where I was working in January on a war crimes investigation sat me down and said, "Look, it's counterproductive. Don't do what so many of our friends have done....If we are to change a capitalist system, we need capital. We need middle-class skills. We need lawyers, doctors. We need movies, propaganda. We can't allow [Spiro] Agnew to be the only person who has control over the media. The people who have access to television and to films must become political."

And I'm in a *unique* position of being a radical who has access to a huge amount of money.
—Jane Fonda

We have started an organization in Hollywood called the Entertainment Industry for Peace and Justice. It was a shot in the dark, because, as you know, what happened in the fifties totally destroyed the movement out there. People were scared to death. We had a big meeting, which we advertised in the trades. We invited everyone from every union: you know, technicians, construction workers, makeup, costume designers, actors and actresses, and so forth. *Thirteen* hundred people showed up, which is incredible....There are two troop shows ready to go out to the GI bases right now. Guerilla Theater is making TV commercials of famous people talking about war and repression. There's gonna be, on May 2, a mass Hollywood-sponsored rally down Hollywood Boulevard....

SMITH: What do you see as your main role in 1971, this year?

FONDA: I don't see it as being one particular thing. I'm a good money raiser. If NWRO calls on me to come to a rally, more people will show up....I can perform that function. I tour. I've talked at about sixty universities in the last five months. I do so fully knowledgeable that the majority of people who come, and between four thousand and ten thousand people come to my lectures, come because I'm a movie star. But they stay and they listen....I'm talking, on a much more human, generous, and loving level, about the war and what's happening there and what's happening in the GI movement and what violence really means in this country....I don't consider myself a leader. I don't think I'm a particularly good organizer, but I'm a *hard worker*. My *life* is committed. I'm not gonna drop out, because it's my life that I'm fighting for.

SMITH: But so many people who have gotten into movement politics of one brand or another reach a certain point of disillusionment. Are you prepared for anything like that?

FONDA: What I'm discovering is that most of these people who dropped out, who were involved and marched and demonstrated and dropped out, dropped out because they never understood the relationship between the starving children in South Carolina and the Indian movement and Biafra and the war and their own lives. It never was an organic part of them. It was always sort of out of a guilt thing, people doing good for other people. I'm saddened with the realization that we're dealing with a mass of people who are in the Stone Age, politically.

> **I'm not gonna drop out, because it's my life that I'm fighting for.**
> —Jane Fonda

I mean, we're just an *a*political country. Above and beyond that...people are isolated from each other and competitive and threatened by each other and have *no sense* of collective struggle.

SMITH: You're not talking about politics.

FONDA: It *is* political! *Everything* is political. The way a man makes love with a woman is political. The way...

SMITH: I meant the common usage of the word. You're talking about revolution. *Total* change.

FONDA: That's right—

SMITH: When most people say, "You're not political," they don't mean "You're not revolutionary." But that's what *you* mean.

FONDA: Yes...And until people understand...that it is their own lives they're fighting for, then they will get discouraged and drop out. I will not get discouraged and drop out. *No way! I will die*, if necessary. Truly.

THE SMITH TAPES

And the more I learn, the more angry I get, the more hatred I have for the system—I mean real, *burning* hatred.

SMITH: Are you sure this terrific energy isn't something similar to over-compensation for all the nonpolitical, nonrevolutionary years you had?

FONDA: No, I have always had this kind of energy. I have more energy than anyone I know and it just used to be directed in silly things, that's all.

SMITH: One friend of mine said, "She's just a radical dilettante, hopping from movement to movement, thing to thing."

FONDA: I understand why people think that. Whoever that person is obviously still thinks of things in terms of isolated causes to causes. I don't think that it's a question of going from cause to cause, that I support an Indian struggle, that I support the black struggle, that I support the antiwar movement, that I support the GI movement, that I'm involved in women's liberation. Because it's *all* the same thing.

SMITH: Are you afraid for your life now that you've become such a public image? Most of America, for a long time, originally had the image of you as Henry Fonda's pretty little girl. Then it was crazed, sexy Jane Fonda who married that foreigner, right? And now it's, "She's turned against America" from the conservative point of view. Are you at all afraid that shots are going to be taken at you?

FONDA: I get mail that makes me very sad. There's a lot of very ill people on the other side: the hatred, the rage, the lack of comprehension, the threats—the bombing threats constantly; most of them are hoaxes. The day may come when they're not. But I'm not a martyr. I don't wanna die. But I'm not about to stop what I'm doing because someone may take a potshot at me one day.

R. Buckminster Fuller
March 1971

R. Buckminster Fuller is an architect, neo-futurist, engineer, professor of poetry at Harvard, magazine editor, author, and consultant with the U.S. Foreign Economic Administration. Last month the animated program NBC Experiment in Television *aired the episode "Buckminster Fuller on Spaceship Earth," inspired by his book* Operating Manual for Spaceship Earth, *in which he stresses the finite amount of resources on our planet and the imminent need for humanity to work together and do more with less.*

SMITH: Mr. Fuller—

FULLER: You can call me Bucky.

SMITH: Bucky. Everybody I know is leaving the city. Everybody is fed up with it and just wants to get out. In your viewpoint, can cities work anymore? Is it a viable thing, a city?

FULLER: No. I think the old cities as designed, such as New York, are really completely obsolete, and so we really have to figure whatever adaptability there is—I don't know. But we have a very big condition, a fundamental condition around our planet.

Humanity was born helpless, and we're actually learning it could live on various kinds of vegetation, first hunting and so forth, but learned how to cultivate special species of vegetation and special animals, and up to yesterday, 99 percent of humanity was out on the land somewhere either fishing or farming. But man had to be near that production, because there was no refrigeration, no way of preserving the food. You had to be near where it was, so he got roots, because the only way he could regenerate was by this vegetation and the vegetation had to get its energy from the sun, and in order to be able to take in that sun energy, it had to have roots, so man went near where the vegetation had its roots. But then the whole thing has changed and we have other kinds of energy under control, which is waterpower and so forth, and man has suddenly been able to refrigerate. So foods that used to perish and never get to the mouths around the world some way could reach people far away, and tools and

other energy came in, made it easier to do much bigger farming, take care of many more people by power tools, so suddenly man wasn't needed on the land to produce. So he began to then migrate into the city where he hoped—because that city looked pretty big; it seemed to have an enormous amount of wealth—maybe there he'd survive. So we have an enormous amount of stranded population in cities.

SMITH: Stranded?

FULLER: They really are stranded, sure. They came in hoping there was some way to live, but everybody has the working assumption, which I don't agree with at all, that you have to earn your living, that you have to prove your right to live. For instance, when a child is born, you don't say, you better get back in the womb then, unless—can you tell me you're going to be a plumber? No, we don't. We say, you're a cute little kid. We're gonna look out for you awhile. Then we say, we'll look out for you a little longer, and we see that people who have education get on a little better so we even go to school now. So we look out for him until he goes through school. So gradually we began to look out for human beings a little longer, and we didn't know that mechanics and so forth would take care of people a little better and that we'd have a little more help, so we didn't know people were going to live longer. But just during my lifetime, life expectancy in America has exactly doubled. We have a lot of people, then, that go way beyond retirement age and they're still fairly healthy, so we look out for them too. We really have a sort of narrowing band of where you're supposed to prove your right to live by having some kind of a job—that being our way of playing the game. Personally, I don't think it makes very much sense, because the machine can do the job better, and so what we want is for you to use your mind and use your brain and use your thoughts and so forth, to really find out what evolution is trying to do and how do we master principles and take care of a lot of people. So there's no reason why we shouldn't take care of people, not just when they're little babies, all the way through. There's nothing wrong about this.

In the old tough days of heartache, there seemed to be man so ignorant, seemed to be so little so very few could really have any success. People thought the tough concept: you gotta earn the right to live; otherwise, you're supposed to die. And I don't think that working assumption's right. We're still working on that basis. Some people have come into the city hoping they could get a job or some way they're gonna be able to live. We have the enormous numbers of people in a city that *itself*

is obsolete. Because there wasn't a city to start off with. People began [as] traders coming this way. Man had a ship and this was a good harbor. Somebody else was coming in over mountain trails that happened to lead this way, so something began as a good place to change goods because resources were very unevenly distributed…So we had then the merchants bringing things together.

Then along came—if we go back to the old gangster business saying, I see you got a lot of pretty valuable stuff there, boys, and I think you need some protection, don't you? And then the merchants say, well, we came halfway around the world and didn't get in any trouble. I don't think we need protection. We can just exchange our goods. The next morning they find everything all messed up and the tough guy comes around and says, you need protection, don't you? This is a man that doesn't want to do any traveling; he doesn't want to go around the world. Just big, and he'd like to be able to exploit the fact that he was big and tough. So they said, all right, we'll have to submit. We're gonna have some protection. And so it began and the men who were giving protection then built walls, and they took the prisoners, and the fighting made bigger walls. Now they have this trading all well hemmed in and they began to really exploit this in a very big way.

Word got around; you know, this city seemed to be having a lot of wealth in there, so boys came off the farms. They're really not needed on the farms, so they'd say, maybe this is a better place to get along, and they'd come to the city. Meantime, there was so many goods coming in the city that they had great warehouses. And the warehouses then had all kinds of different goods, so with a lot of stranded people there somebody said, well, if you put these goods together with that, you can make this kind of an article. So manufacturing began in the cities. And all these people who were stranded there didn't know a way to earn a living, they worked very cheap, so there's a great place to exploit stranded people at very fantastically low wages. Then all this broke up, because we had a city, which was a warehouse, manufacturing all the physical things which were going on in the city. Goods were being exchanged *physically*. What happened with the new mechanization and being able to develop energy and being able to have a truck and an automobile all came in town in World War I.

The city, as I see, is actually pretty much obsolete.

—R. Buckminster Fuller

At this time, the people who are monopolizing those cities, they had a railroad but the railroad took you right to the city. If you wanted to go

across the country in the United States by railroad before the automobile, it took you right to Chicago. And you had to get out of that train. You had to go out on the train of another railroad on the other side of town, but that isn't going out until tomorrow morning, so they had you in town and made you spend your money. The routing of things in those days always gets you into the monopolized city and just shakes you loose if you don't. Railroads, and you had railroad cars, are going so you're paying enormous demurrage. You had a freight car coming that shifted here; they're shifting your cars around to New York and charging demurrage just to be fantastic.

Now it's suddenly World War I and they had a truck. And a man said, boy, I've got a truck here. I don't have to go into that city. I'm not gonna have to pay demurrage. So because people were excited by the automobile and they wanted to be able to get on the roadway, the politician began to build roads for them. So roads began to go around the city and people with trucks began to circumvent the city. In no time at all, it was also learned that [with the] enormous new manufacturing, you couldn't afford to house your goods in a warehouse. Henry Ford making a car found you're gonna change the alloy. You're gonna change the design, therefore you had a lot of material in the warehouse you're not gonna use anymore because you changed your pattern. So he found capital couldn't be tied up that way.

Investors began, then, to keep all his storage of the goods he was going to use in transit, in the ships or in the railroad cars or in the trucks rather than having it in warehouses. They didn't want to pay that kind of price, so they just take it outta the ground when they know they're going to use it. So warehouses began to [disappear]…My early days of New York, warehouses were everywhere. But great warehouses full of all kinds of goods, those are all gone. In the meantime the people who were merchants found they could then truck and stay out so that you could exchange and reroute it, take it off of this truck into a sorting house out deep in the country where the rent was very low. And that's exactly what happened. So in every way, man began to try to escape from the monopolies of the city.

SMITH: So you're saying that the death of the city started a very long time ago.

FULLER: Labor came in very powerfully realizing that you can't have mass production unless you have mass consumption, and you can't have mass consumption unless you get mass banking ability, and began to get the labor rates up. Enormous labor battles and suddenly wages were actually

affected; the manufacturer had to pay it, because otherwise his place gets smashed up or it just wouldn't work. So then the manufacturers said, we can escape from this labor. There's new automation and we'll build a new factory way out in the country. So the factories began to go out. So we had the warehouses disappear and the factories went out and the trucking went around, so we get the city beginning to empty out of its old physical markets. We used to have the beautiful wholesale markets of the foods in town. No, don't need that anymore because these foods will be put into containers in remote places, say, out in the country. So you just have things come into supermarkets where they're near packing areas but the foods themselves stay out. You didn't do the packing inside of the city anymore.

All the things that used to happen in the cities, just in the last few decades, start going out completely. In the meantime the people were not needed on the farm and they didn't need to be near the food as they used to, because it now could be preserved in the cans, refrigeration, one way or another, and so we have a complete new sorting out. So we have people coming into the city where all the manufacturing is becoming obsolete as originally conceived, and people just sorta got in a big dormitory and kind of lived in there. That's the situation you'll see all around you, with kids who originally could have had quite a lot of room around them on the farm, even though in some poverty. They don't have the room. The city street if they want to play baseball or do something—you have to throw your ball over the top of a truck and then jump out of the way while this thing goes. They're really very fundamentally unsound conditions for the kids, you see. The city, as I see, is actually pretty much obsolete.

[In the] meantime, the biggest pattern, I can tell you, is that the *physical* things used to be in the city and—going back to Greece, you have man, to do some thinking, went off in the mountains and went to Delphi, to the oracle. Thinking and the abstract and what you might call the metaphysical was way outside the city, and the city was the physical. Now the physical warehouse, the physical manufacturer, the physical markets—all these things have gone out and around, and they have people coming into the city for doing just what you and I are doing. Here you and I are sitting; what we're exchanging here is weightless. It is just thoughts. This is metaphysical. So I found New York City and all the other cities around the world where people are coming together to exchange thoughts. You may exchange equities. You may exchange this paper. You don't exchange the actual goods. You just exchange *paper* on

THE SMITH TAPES

the goods. So that's the stock markets. And there's exchanging ideas, and all the publishing houses, [instead of] manufacturing those typewriters and presses, are all just manufacturing words or manufacturing figures. [The] city is then becoming this kind of an affair, and [the] metaphysical is then coming together, and if somebody wants some cultural experience, he comes into the city. It's very exciting to get down in the East Village and so forth. You're going to see a whole lot of human beings and there's a lot of experience here. May not have so much money in their pocket, but the point is that you really are coming together for experience. Then you go out into the country to get the deeper experience; you want to feel the water. To do the physical, whether it's to manufacture or to mine or to farm or to go skiing in the mountains or skiing on the water, those are all physical and those are done outside the city, and in the city is metaphysical. Just to give you the main analysis of why I said to you the city is really obsolete: it was designed for that big physical and now it's just being used for the metaphysical.

SMITH: Do you then see that cities will be getting actually smaller? A city like New York City where we are now, do you see this as getting tinier or will it remain this vital and this big, just with its new purpose of exchanging information?

FULLER: Well, there are always a whole lot of angles of evolution going on, and so I'm going to give you some more that begin to feed into here. We have then an arrangement made by the people who own land, going back to the people who monopolized that land, that city. Everybody is trying to move in and they could get very enormous prices for their land. The people who own land were able to get laws which said it's obviously very unhealthy for the butcher to sleep with the meat. We don't want to have that. You've got to work and sleep in a different place. So they passed laws in almost all the great cities saying you're not allowed to work and sleep in the same place. Artists have gotten away with it, because it's pretty hard to find where the artists are, but by and large, the big pattern is you work in this building, this place, and you'll sleep in another. This took up twice as much real estate and that was very nice for the people that owned the land.

In the meantime, then, we began the time of and after World War I. The mechanization was very high in World War I. Automation began to come in and by the time it came to the great crash of 1929 and then the New Deal came in, everybody was unemployed. However, the machines were working fairly well and the waterwheel was going round generating

R. BUCKMINSTER FULLER

electricity, so there was plenty of electricity around and power to do work. But anyway, people were not working. The New Deal came in and said, well, everybody says if you just give people money or just give them food, that's called socialism, and America is against socialism so we're gonna have to have jobs. So starting with the New Deal, we started inventing jobs. We now have about sixty-five or seventy million jobs, out of which, if you really look into it, about sixty million of them are inspectors of inspectors. They're inspectors' inspectors of reinsurance. So the jobs are being pretty much invented and...We're really getting everybody jobs—

smith: I just wanted to comment on that. A few years ago when a new head took over from Con Edison, you know, the big electric utility company in New York City, and he wanted to try to make it a more modern company, he actually found several executives making about $50,000 a year and each one's job was just to oversee the work that the one underneath him did. He found actually a layer at the top of seven consecutive executives doing just that.

fuller: This is great. Now what I'm saying to you, in order to then be able to keep a system going where, really, the New Deal said, we'll have really hidden socialism and get people jobs but we have to invent jobs. So we have all this job inventing and unfortunately, the idea of inventing jobs is easier for them to tell the army and navy get ready for the next war and give out a lot of orders and then increase the amount of manu-facturing. That was one way of inventing jobs. And then once the people had their jobs in that war-making stuff, then they could buy stuff, an automobile, so then there was employment over there. So you see how the system would start with some kind of a major undertaking, which, I say unfortunately, is getting ready for the next war. This way the govern-ment, simply all it had to do was give out orders, and then the company having a government order could go to the bank and borrow the money to buy the materials and hire the people to produce the goods, and then when they produced the goods, they'd hand them over to the government and the government could go to the bank and borrow the money to pay it. This is just an accounting trick but the main thing is, everybody was given jobs. A way to get people eating was giving them jobs.

So we've gotten to the point where we said, well, you know we don't want you to be pick and shovel. That's so ignominious and we got some bulldozer to do that thing nowadays, so we're going to give up the pick and shovel and you must be at least blue collar but better still if we make

THE SMITH TAPES

you white collar, because you want dignity while on this job. So what's going on is automation is taking care of pretty much all of the mechanical side and you've got more and more people who have white-collar jobs. In order to be able to take care of all those jobs, we have to build many, many buildings in the cities. So all around New York—and not just New York; it's every big city you come to—you find enormous buildings going up where you have companies. And these are the inspectors-of-inspector companies. Inspectors of reinsurance inspectors and the posted meters for the inspectors. So in every one of our cities, enormous buildings going up, but remember, you're not allowed to work and sleep in the same one. So you have all these beautiful big new buildings going up; they have lovely plumbing and they have very good food service. It's very sanitized. Very sound, strong, fireproof.

So we have all the typewriters sleeping with all the plumbing and we have the people all going back to sleep in the slums. And so we say we have a very big housing problem because of asking for this double life. So what I'm saying to you that we're going to really do, which I think it's very exciting, in due course after we get through kidding ourselves and you and I are able to say something like this over the air, now nothing is really more negative than having you do this thing which a machine really could do better. Because what we mean by *wealth* is ability to take care of more people and feed more people. That's what is real wealth. It's not the money. It's that ability to give more people more healthful, well-taken-care-of life, more information, more to remove restraints and allow them to get from here to there, to be able to articulate their own thoughts and their own will and then make their own investigation and really find out why they're in the universe.

It was designed for that big physical and now it's just being used for the metaphysical.
—R. Buckminster Fuller

So we're going to say to people, because you have labor unions, everybody holding onto jobs: You want to go to the airport. You'd like to go someplace on a trip and you have to stand in line for a long time and you're going to make out a ticket. You know today with computer capability what you can do is just press a button and you want a ticket to Boston and they're getting out a thing and they fill out line after line. They open the book and look it all up again, fill it in, just taking as much time simply because the poor kids who are doing that realize if they let the computer do it, they wouldn't have a job. You have, everywhere, labor

R. BUCKMINSTER FULLER

organizing itself to not be thrown out of jobs and not let automation get going. I simply say, if you let the automation get going, you will literally generate wealth much more rapidly than doing this way of blocking the machine, getting in the way of the machine.

SMITH: But first you'd have to have the guaranteed wage. Otherwise, labor isn't gonna go for it.

FULLER: I'm not going to call it guaranteed wage. We used to say, if you don't have a job, I don't know how it happens but you're obviously no good. You're supposed to die and I don't have any room for you.

SMITH: So we have to change our viewpoint about being out of work.

FULLER: Right. During World War II, and this was waged halfway around the world, in order to be able to get enough energy to carry on this fantastic wasteful thing halfway around the world, automation had to be let going in a very big way. When the World War II was over, there were no jobs. And here are all the cream of the young world coming out of the service, boys and girls who, Congress said, you can't really say they're no good because they don't have a job. So they said, they're going to have to be smart. So they got out the GI Bill and it gave everybody a fellowship to go to work and go to school and finally learn something. Nothing ever really did America quite such a favor. In fact, really, people gain confidence in themselves. They really found they could get knowledge. They do understand much more what's going on and [as] a consequence—a really great wealth was generated.

Now what I'm saying is we're going to do this—as emergency begins to get worse, humanity really is going to do some good thinking and every young person today is being well informed. Yesterday they were illiterate and didn't know what the information was; today they've got it. And so out of this, everybody is thinking, not waiting for some great leader tells you what to do. And then we get to say, now it will make some sense: I'm going to give everybody a fellowship to go off and study and think. You say, really? I'm gonna get a fellowship. You eat just exactly as well as you did before, you get some tickets, and you have everything you want. You mean I really can just go fishing? and I say, well, certainly. When you're out fishing it's a great place to think, and while you're out there fishing and thinking, I want you to think about the fact when you get through fishing you don't have to go back and tell a lie about this guy to get his job so your family can eat. All of a sudden you're gonna say, what was I thinking about before they told me I had to have a job? This is exactly what every kid is born to really think about.

What's interesting in this world? What are the tasks that need to be done? What would I like to do? In other words, the kinds of things you would do, and you would be very, very busy if you didn't go through the idea somebody else has to tell you what to do and it's going to be something you don't really like.

So simply, when we didn't say, I'm going to give you a fellowship and you'll eat fine and just go off thinking, everybody is going to leave all those buildings over here, because they don't need those jobs anymore. This means the end of all the beautiful buildings they're building. All the cities around the country are going to be empty. But then all the beautiful plumbing—so now we'll just move everybody out of the slums into all those beautiful buildings and then suddenly there's no housing problem. These are the kinds of things that are going to happen to the city.

SMITH: You spent many years living in New York City as a younger man. If you were, let's say, in your early twenties, just getting out of college, would you leave?

FULLER: See, but I never really did anything so arbitrary as that. I got fired out of a lot of places and if you get fired out, then you got to go. But I tended to hang around and get kind of fired out. And I simply found that if I got fired out of this and I have to do that, I got to carrying beef. I found carrying beef was very interesting. I found life is really very fascinating to me, and every circumstance I just, I believe—I don't use the word *believe*—I'm absolutely convinced that evolution and the universe is a vastly bigger affair and much more purposeful and working very well and you and I don't really know much about how we happen to be here. I've tried to be more or less a student of that but at least I like to yield in the direction that evolution seems to be taking. And I'll say, what am I supposed to learn here? What's really going on? That's how I happen to be in your place right here, because I don't ask anybody to listen to me. I only go where people ask me to go. I find that there's always something very interesting to be done. So if I were a young man in New York, I wouldn't say, I got to get up and get out and go find some other place. I really just begin to see what's going on and see what can I do; what needs to be done? That's the way I'd intend to go.

SMITH: How about this dome over New York City that I've heard you're proposing?

FULLER: Well, I did invent a way of enclosing space with what's called a geodesic dome, which is very much stronger and more efficient than other ways of enclosing space.

SMITH: I've read a lot of your things on it. But one large enough to cover New York City?

FULLER: I began to study how big a dome I could build and see whether if you made them bigger, the economics of it began to be unfavorable, and I found in fact, the bigger they got, the more favorable they were. So I got up to finally calculating one two miles in diameter, how much material it'd be and what the size of the members would be, how long it'd take to get in place. Having calculated, I found it very economical and would be very advantageous. I'd like to see what a two-mile-diameter dome would look like in relation to something that we're very familiar with. I found that Manhattan at Forty-Second Street is exactly two miles [wide], so I said, I'm gonna then get an airbrush and an aerial photograph and then I can superimpose this two-mile dome to see just what it would look like, and I did that. Then once that was done, of course it was covering much of Twenty-Second Street up to Sixty-Second, so all the big Manhattan buildings in mid-Manhattan were all under it. The Empire State Building, only 1,400 feet high, and the dome was a mile high, five thousand feet at that point, so it's tiny down in there. And I found that just the cost of the snow removals under that area that's being covered for ten years would pay for the dome. I'm saying that's pretty interesting.

SMITH: That either means the dome is very cheap or snow removal is very expensive.

FULLER: Yeah, well, at any rate, they happened to match. You can see that it'd be one way of paying for it, because the snow would not be falling there…The thing that I began to learn about New York City, or any city, coming up with a dome became a very interesting matter. When you want to have a good air-cooled engine…you have to have a piece of metal, put one end in the fire and quickly the heat comes to your hand, because metal conducts heat very rapidly. So what you want to do is to have the most metal cross section from the heated area out to the most air to give you the very best of exposure of that heat. They put fins on the air-cooled engine so it gets most exposure to the air. The fact is that if you put spikes on it, you'd have even more service.

> So we have all the typewriters sleeping with all the plumbing and we have the people all going back to sleep in the slums.
> —R. Buckminster Fuller

Anyway, I want you to remember the spikes give you the best air cooling. Now New York City, if you look at it from the air, you'll see all these big spikes, buildings sticking up. The buildings that New York City has

designed is the best air-cooled engine you could get that is going to lose energy very rapidly, so the energies being built in are getting lost out through those walls very rapidly. And with enormous winds blowing by them just sucking heat and energy out of them. Now we have enormous energy shortages time and again in New York City and so that's a great problem. Then see, measuring what I found with my dome going over the city is a sphere encloses the most volume with the least surface. The same amount of surface, as a cube would give you only about half the volume that a sphere gives you.

Also it happens that if you have a, let's say, a flat sheet of paper, it doesn't have any real structural strength, but you put it in a simple curvature and make a cylinder out of it, it makes a column and has some strength. Put in a compound curvature, you get the greatest strength. That's why very thin eggshells have such great strength. So you want to get the greatest strength, you go in the spherical, and if you want to get the most volume, you go in the spherical. That's why a geodesic dome, in the first place, is very economical and very strong.

I then did the calculation of the amount of surfaces of the buildings in New York that are being covered by my dome in this theoretical superimposition of it. I found that the surface of buildings which stood below our dome were eighty times the surface of my dome. Which would mean that if you just had the covering over there, you'd reduce heat losses in New York eighty times. We would reduce down to about 20 percent of the amount of energy input you'd have to put in today.

SMITH: Do you mean because all of the heat loss going through the walls of the building would remain inside the dome?

FULLER: Once there's a covering over it, the winds that have to blow on that building are on my dome. Same thing if you put a covering around an air-cooled engine, it no longer will air cool. Next thing—when you take a piece of geometry, let's take a cube, and let's think about a little sugar cube. You want to make a cube twice that size. Twice as long. Twice as high. Twice as wide. So you take four sugar cubes and you put two in a row and then two beside that so you get a square of cubes. And then you put four cubes on top of that. Now you have a cube that's exactly double the size of height, width, and length of the original littler cube, right? So every time you double the linear dimension, you increase your surface by four, because you look at each of the six surfaces of the cube and you see four squares now instead of one square. You've got eight cubes in volume so it's called double dimension, and two to the second power is

four—that's the surface. Two to the third power is eight—that's the volume. So every time I double the size of a geometrical object, I get four times my surface but eight times as much volume. Which means then, let's say, a geodesic dome—I double the size of the geodesic dome, I get four times as much surface, eight times as much volume. Well, I do that again, each time I do it I'm going to halve the amount of surface through which a given molecule of gas inside could gain or lose heat. You understand that?

SMITH: Kind of.

FULLER: All right now. Every time you double the size, the ratio of the molecules inside of the dome, which don't get any bigger or smaller, they're eight times as many molecules of gas or atmosphere inside and only four times more surface. So it halves the amount of surface through which any molecule inside could gain or lose heat through that surface. So when you get to something very big, like an iceberg, an iceberg melts very, very slowly because its surface is so small and it can only melt as fast as it gets heat through the surface from the rest of the universe. But as they melt, they melt faster and faster, because the surface gets smaller only at a second power and the volume of the third power of velocity. So you finally get at the end a little ice cube as you go out like that. Now we get to something really big, like the sun in relation to Earth, a fantastically big thing, its surface is so small and its volume is so great that despite the fact it's giving off radiant heat at a fantastic rate, it's going to last for hundreds of millions of years. The bigger they get, the better the energy conservation.

Then I began to figure out about a dome over Manhattan, finding I'd reduced the amount of surface [through] which it could gain or lose heat eighty times. Then I found once the covering was up there and as big as that, the rate of its loss of heat out from the dome to the outer world would be very, very greatly reduced. Therefore, the energies that you would have in your buildings, just for electric lights in New York City, would give you enough heat to take care of absolutely everything, just bouncing lights through the window. You would conserve the whole thing.

SMITH: Wow.

FULLER: This began to give me some fantastic insights. Time and again in New York City we have great water shortages, and everybody is asked to stop washing automobiles and sprinkling the grass and all that, and even goes on to turn off your water half the day. During those great water shortages, we have great thunderstorms in New York, and all the rain just

goes down the storm sewers. Beautiful rain, but it just goes down the storm sewers and no one can consume it. Once you put a big dome like that up, you have a beautiful guttering around and this all gets channeled off to a holding, to a great reservoir. With the domes you would conserve this, you would conserve your waters and you would even save all that removal of snows and it'd all be turned to advantage as water. And then you have this enormous energy savings.

Anyway, yes, it'd be very worthwhile to have cities under geodesic domes, but New York City, if you think about all the different owners of different lands, the controversy about "this in my air rights, I don't want a thing over my thing here," I just don't think it's going to happen with New York City. But it can happen where you start out in places where energy is a really fantastic problem.

SMITH: Is it because so few leaders can see into the future? Why *doesn't* some city put up a dome?

FULLER: No. Human beings can be good and bright, but we have terrific conditioned reflexes and terrific habits and particularly a habit of what is called money and higher living....Everything this year is accounting. But when you get to talk about the big stuff of the universe, Halley's Comet comes around every seventy years and we have a fantastic kind of regularities, enormous energies that are operative, and great pulling of the moon on Earth lifting the waters of the Earth at such heights, and preposterous amount of energies being generated—these kinds of things can be used, and what I'm simply saying to you is, you have to get out of this year's thinking.

So I find very bright men with great competence, but they have to make a profit this year or get fired. They have to get elected this year or they get fired. Everybody is asking for things that are on too short a term. Nobody is looking, what's this gonna mean to kids tomorrow? No, it's got to be this year. And so I say we're in very bad habits. We're caught in accounting systems that are utterly inadequate. You couldn't do much about it yesterday when people were illiterate and they didn't really know what's going on and just following a leader, but today you've got a literate man everywhere around the world and he's got a good vocabulary and he's really gaining information and he's really thinking. And the beautiful thing about our young world is that it is really thinking. It's thinking very spontaneously truthfully, because you don't have to teach the truth to the boy, because that's what he smells, that's what he sees, that's what he hears. You may have to teach him how to lie but he tells the truth spontaneously.

R. BUCKMINSTER FULLER

There's spontaneous truths of the young world and the good information they're getting. I'm giving you the kind of information that I began to go on, and between '19 and '27 there was nobody to listen to me. I didn't have any money but I said, I think things need to be done and nobody's attending to 'em. Let's begin to look into what needs to be done and how you can do it and really find out what the real ratios are. How can you do so much with so little? You might be able to take care of everybody. Because if you did, then the whole raison d'etre of war would go. All the great nations are still getting ready for the next great battle, all on the basis that there's nowhere nearly enough to go around, and we've got the best system for our side so the other side is gonna have to perish. I simply say, and I began to see it long ago, yes, you can learn how to do more with less...

I think your whole young world is going to come in and say, yes, it is really, really ridiculous. Of course, we got our habits. For instance, you work during the day because there's sunlight. There didn't used to be any electric light. Up to yesterday there wasn't electric light. But today there is electric light, so you and I are sitting, relaxing in a room here where there's no windows, no light coming in, and we're getting on fine. But we have man then really only planning to do things during that daylight hour...Everybody is trying to do everything at the same time. Hear me say, we're going to have to sort things out very, very much better and I think we will. I have really great confidence in the young world communicating—the electronic communication capability we're having here, the dissemination of information. And it's not long before this, 99 percent of humanity, which yesterday really was poor and perishing and dying young, was illiterate...You and I, we're coming to a great chasm here, and we're not gonna walk any farther. I don't have to tell you not to walk over the cliff. They're going to do things in a very, very logical way. Personally, I'm extremely optimistic, because I know by calculation it's eminently feasible to take care of all of humanity, at a higher standard of living than anybody's ever known.

There is the inertia of conditioned reflexes, the fears of man.
—R. Buckminster Fuller

SMITH: You're more optimistic than almost anybody I know.

FULLER: I'm not really optimistic. I know that it can be done. Whether man will really do it or not, I don't know. But then I assess everything I do know, but you hear me inventorying more than most people do in the first

place. I really went out to spend a number of years to find out whether it was feasible—

SMITH: But whether we'll do it or not, you don't know.

FULLER: I know the other guy didn't know it was feasible, so, suddenly, the fact that I show him it's feasible, then he feels more hope. Therefore he calls me an "optimist," because he has some hope for the first time. But I'm really not. I also know about the perils and I'm perfectly terribly aware of all the badly conditioned reflexes and all the bad habits we got and bad accountings and misconceptions about you have to leave it to a politician to do it. You and I got to do it.

I go into a public toilet and if I see a number of the items that haven't been flushed, I go along the thing and flush 'em and I'll pick up a towel and wipe the stands clean. If I won't do it, who else should do it? I'm perfectly confident that if we really might get things done, you and I got to do it. We're having a very good conversation here—

SMITH: You are known as the problem solver. The man who can take the big problems, the big questions, and figure out the answers. In your life, you're seventy-five years old; you've been a hard thinker for a long time. Is there anything that ever completely stymied you? Is there still some large problem that you still say, why wasn't I able to figure that out?

FULLER: I'll say that there is the inertia of conditioned reflexes, the fears of man. Those are things that are very great, but I said, I'm not gonna try to persuade the other man. I'm not going to say, "Listen, you do this and everything is going to come out great." I say to myself, "What ought *I* to do? I see that what we need is to be able to do more with less. Can I make an enclosure that does more?" I'm not gonna just talk about invention. I must find the mathematics of doing it and then run the experiment. That's exactly what I do. I must reduce it to practice, find out whether it works. And I'm not going to say anything to anybody until I do it. Then when he says to me, "What you got there?" then I'll tell him what it does. Still, I'm not gonna say, "Buy it." And he's going to say, "I need one of those" and then comes to take it and use it, and that's the way things are going.

So anyway, I can see how the problem is going to be solved. Now it gets back, really, to the relative rate of evolution and how fast did man get the right information and how quickly can we look out for enough young people who each end up being born and president tomorrow. Good information, less misinformation to get the momentum of their own confidence and their own truth, getting out from under.

R. BUCKMINSTER FULLER

SMITH: You've become a youth culture hero. I mean, I'm sure you've heard that before.

FULLER: No—

SMITH: Well, you *have*. You're very popular on all the campuses—

FULLER: I'll tell you, the absolutely most important thing about me is that I'm an average healthy man. I pack a little below average, because by thirty-two years of age I found that I was not a champion at anything; I could just get by. And I wanted to see what does an average healthy man have, not just what does a genius have, because I don't want some more geniuses just leaders and everybody else is gonna be automatons and the soldiers and do what the genius tells them to do. I want to know what average man can do. So I began to say, what was it that I was born with that I got discouraged about or didn't use properly? I began to go after that and that's exactly what I produced. The fact that the young world is excited by me is because they really know that what I'm saying and I'm able to find out, they could find out. In fact, it's very compatible what they're doing. Now, because I'm absolutely committed to reforming the environment, the inanimate things, I'm not trying to reform the man. Get the right environment so he'll spontaneously get the right information and do the most logical things. I couldn't be more remote from politics. I'm going in exactly the opposite direction.

I don't like the idea of a cult leader. I'm not a leader of anything. But I am really, a good working example of the average man to the average man. That's why the kids are so important to me, but they do nice things for me and they make manifestations; they wanted to have a big party. I don't enjoy—I'm glad that they care. It means a great deal to me. It's a good check on the thinking I've been doing. I feel that I'm really being useful if that's the way they feel. But I want to be very sure they don't think I'm out here to be celebrating me. You understand?

SMITH: I wanted to ask you a question, though, being that you are so popular with youths, and so many young people are —I mean almost everybody I know—are kind of preoccupied with growing old. Everybody fears it. Now you're seventy-five years old and you're listened to by youths.

FULLER: I find life getting more and more wonderful and much more exciting all the time. The more problems that get solved, the more problems you get, but that's just great. That's what we're here for. Life would be very dull if we didn't have some of those problems.

Anselma Dell'Olio and John L. Schimel
April 1971

Anselma Dell'Olio is a writer, an actor, and the founder/director of New York City's New Feminist Theatre. Last May, after years of work and involvement in the feminist movement, she became disillusioned and severed all ties to it in her address to the movement's second Congress to Unite Women. Dr. John L. Schimel is a practicing psychiatrist, the associate director of the prominent William Alanson White Institute of Psychiatry, Psychoanalysis & Psychology in Manhattan, and a contributor to the first issue of the new magazine Sexual Behavior.

..

[*Live on air*]

SMITH: I wanna make it clear what we're talking about...what we would call a free relationship. This used to be somewhat an unwritten prerogative of men, which was fully taken advantage of by a great amount of them. Women, if they did, did it quietly, secretly, and very few of them did it.

DELL'OLIO: Very few of them still do. Just last week a guy was telling me that his experience is that he might be sleeping with two or three women, but generally they're only sleeping with him. I don't think he meant that egotistically; he meant in the sense that they'll sit by the phone waiting for him to call. In other words, women's basic attitude towards sex really hasn't changed all that much. There's still the reticence about it—rightfully so, considering the abysmal state of contraception. Women can't begin to feel as psychologically free as they should. Even when women *are* less hung up, the men find it disconcerting. Even though he might be sleeping with a number of women, it distressed him that they might be sleeping with a number of men.

SMITH: Last time that we talked, I got the feeling that if a man picks up a woman primarily with the idea of having casual sex, you somehow saw that as wrong, whereas if a woman does the same thing, it's a liberating experience.

DELL'OLIO: No, I don't think so. I just consider the attitude most men have towards sex is *tacky*. For a man to do that is so ordinary. That's exactly what men have always done. For a woman to do that is really…a pretty courageous thing. You can't remove the situation from its *context*. That is, we have a certain prevailing moral atmosphere, even in the—don't give me East Village, because it's just as bad down there, as far I'm concerned, or the so-called liberated types. I'm in show business. I know what the atmosphere is.

SMITH: Well, what is it?

DELL'OLIO: That supposedly it's very liberated. Supposedly, everybody is screwing everybody else, and there are no hang-ups about male or female behavior being more liberated. *Supposedly*. It's probably true compared to the general society, but I don't think that it's really all that true.

SMITH: How is it in your life? If you see a guy that you're physically attracted to, do you act on it?

DELL'OLIO: Sure. Unfortunately, men are still trained to be predators, and they still behave that way. So generally, they make the first—you don't often have the opportunity. It's actually very nice to be able to make an advance, to be able to feel you've made a choice rather than be always the *object*. But unless you're going to accost people on the street, you don't often get the opportunity, because men are just consistently on the make. They don't have to even be very interested in you. It isn't a *flattering* thing.

> **There is something that in women's liberation people refer to as the *female ghetto of the mind*.**
> —Anselma Dell'Olio

SMITH: Dr. Schimel, an article I saw in some magazine about the sexual apathy of the American male said part of it was being caused by women coming on strong.

SCHIMEL: I consider this to be *New York Times* sociology. I don't think it's true. About this business of men complaining they want more sex— this is an ancient American chestnut, which we inherited from old ladies who came here from Europe, where there's the myth that men consider women their sexual objects, which they are, just as men are sexual objects for women. We're still in this Victorian kick that men want it and women don't wanna give it. There's a certain amount of truth to that. No matter how liberated we are and as much as you think something has turned around, I don't see anything turned around. I do see movements, like women's lib, as *verbalizing* something that's in the culture. It's been

there. I don't see any change in women's complaints that they don't get enough sex or men's complaints that their women are cold. It's in the press so everybody thinks it all happened yesterday.

DELL'OLIO: What do you see the situation as being?

SCHIMEL: Louder and more verbal.

DELL'OLIO: No, but what do you think it is?

SCHIMEL: I think women and men have to get acquainted. There's a great problem in communication between them and the business of equality is something that's more talked about than *practiced*. To present sexual freedom in terms of an adolescent male's dream of being able to make any girl he sees, and identifying that as freedom for women, is to borrow an adolescent male's view of the ideal world.

DELL'OLIO: But the point Howard is making is that when a woman expresses herself freely and doesn't conform to a certain stereotype vision of what a woman is—that is, shy, reticent, and reluctant to have sex—men don't react very well. Whether or not you like what you call an "adolescent male behavior," they do think this way and they do feel this way. When a *woman* does it, they don't like it one bit, and not because it's adolescent. They don't like it 'cause they don't like the fact that she's taking over their prerogatives.

SCHIMEL: You raise an interesting question. The man who complains that the woman isn't aggressive enough, if he finds an aggressive woman, he may very well not know what to do about it. *And* vice versa.

DELL'OLIO: Vice versa what? What does that mean?

SCHIMEL: There are women who complain that the men, very often their husbands, aren't aggressive enough.

DELL'OLIO: That's right.

SCHIMEL: Yet there's no evidence to indicate they'd know what to do with an aggressive male. People tend to get into patterns, you see.

DELL'OLIO: I don't really think that's true. I think women have always been able to handle that.

SMITH: They've *had* to.

DELL'OLIO: I don't know if your practice includes as many women as it does men, but I think men, including analysts and psychiatrists, haven't *begun* to learn everything that is to be learned from women. Until we feel *free* enough to tell all there is to tell, even to our analysts, I don't think men are really gonna know what goes on in women's minds. They still don't. It always amazes me. I was *in* analysis for four years.

SMITH: You didn't tell everything?

ANSELMA DELL'OLIO AND JOHN L. SCHIMEL

DELL'OLIO: What I thought was relevant, but there's a situation that is created, whether you like it or not. There's a social situation in context in which you function. You very often are responding to what you think the analyst wants to hear. That's not necessarily his fault. It's not something you can always avoid. I was just going into women's lib at that time, so luckily that helped me a *great* deal to remove certain stereotyped reactions that I might have had to him. It's a cliché to say that you want to please your analyst, but it is true. You do want his approval.

SCHIMEL: Everything Anselma has said is true, more or less. I would think that nobody ever tells another person everything, even if the other person is a woman's analyst. But what I do object to is the identification of something called *the woman's mind* that the man can't find out about. I would say the woman cannot find out about it either. We're all, in our own ways, unique individuals. And I don't think it's appropriate, and this is really what women's lib is against, just what you are presenting, *the woman's mind*. I submit there is no such thing. There is this woman and that woman, from this background or that background, with these personal experiences or those. I would like to think women are different. Not that there is some incalculable thing that only a woman can tell you about that talks about all women, maybe for all times.

> Now the business of orgasm—this has been the most highly touted consumer product in the last two decades.
>
> —John L. Schimel

DELL'OLIO: It's not a physiological thing, obviously. It's a social product. You have a society in which there is heavy conditioning to be either male or female. We've got humanity divided into two great nations, male and female. Now certainly, as an analyst you've got to recognize that this results in certain very predictable patterns of behavior. Of course, we do rebel against it—women refuse to keep to the stereotype and men refuse to keep to the stereotype—but by and large, we do. The fact is, there is something that in women's liberation people refer to as the *female ghetto of the mind*. It's a very precise place, a pretty awful one too, in which we live. It's a product of living in a world which forces a *ghetto mentality* onto women in the same way that it oppresses blacks. And we *do* have it and men *do not* understand it.

SMITH: Have you had to change *at all* in your practice now that women's lib has become so vocal?

SCHIMEL: I think it's all to the good, because many of the problems that the psychoanalysts had to probe for and help the patient become aware,

sensitivity raising, it went on in the analyst's office instead of a group of women. But I don't think that basic human problems have changed. The focus has changed; the emphasis has changed. I believe that the heightened awareness of the differences is all to the good. If I object to anything, it's the animosity that's being brought into the differences.

DELL'OLIO: Being brought into it? What about the animosity that *exists*—

SMITH: Anselma, you go lecturing all around the country. Are there any complaints?

DELL'OLIO: They're saying things that we've always known. The women are tired of being housewives. They're unhappy, dissatisfied. Their husbands ignore their families, are not with their children enough, and the women are very bored with the housewives' role. If they wanna go back to work, the kind of work they can go to is deadly dull, service occupations, typing, filing. Many of them have college educations, but if you've been out of the work market for five years, there's no place you can go.

SMITH: How 'bout in the area of sex?

DELL'OLIO: At any lecture I'm guaranteed to get a *major* response if I talk about, even in passing, that women aren't having orgasms.

SMITH: What kind of response?

DELL'OLIO: That women are not enjoying sex, because it's not very *good* for them. It isn't that women *wouldn't* enjoy sex or like to have it as much as men do; it's that they're not *enjoying* it. They're not having orgasms, by and large. It's amazing how close to the surface that is. They won't bring it up themselves, but if *I* bring it up, they're only too eager to talk about it. Let's say that that is the problem. It's probably just a *symptom*. In my own experience, most men just don't know their way around a bed, never mind around a woman. And most women are too shy or too ignorant to know what to say or what to do or what to tell. Therefore, you have the end result: *most* men have orgasms and *most women* don't.

SMITH: Is that true in your practice as an analyst?

SCHIMEL: Well, Anselma seems to have discovered the dissatisfied housewife....

DELL'OLIO: I didn't say that!

SMITH: Specifically, whether women have trouble having orgasms and men don't. Is that true?

SCHIMEL: *Orgasm* is a word that's come into common use quite recently. Prior, it was called *climax* in the female and *ejaculation* in the male. This still has some virtue in that the physiological and, for many people, the emotional responses are quite different. Male ejaculation is a rather

simple matter compared to a female climax. To assume that if the male has an ejaculation, he's had a *great experience* is just naive. Ejaculations can vary like climaxes. Many men—after all, it's a very simple triggering device—may leave the wife, or the lecturer who is listening to dissatisfied housewives, with the impression he's having a *whale* of a time while she's getting nothing out of it. For many marital couples nothing could be further from the truth.

Now the business of orgasm—this has been the most highly touted consumer product in the last two decades. There are two very unfortunate things that people seem to believe about sex. One is that it's wonderful and the other is that it's awful. By and large it falls in between. To simply make the assumption—because the male has an ejaculation, a woman doesn't reach a climax—that he's had a real jazzy time while she's just lying there suffering simply ignores the fact that there are two people involved, each with his own problems, own limitations, own shortcomings, hopes, and disappointments. This is why I've tended to focus on communication.

DELL'OLIO: I am in perfect agreement that there is a real qualitative difference between ejaculation and an orgasm. *However*, you're not gonna tell me that a man having an ejaculation and a woman not having *anything*, that there isn't a difference between what's going on there. It may not be a wonderful experience, but he's getting a physiological response that to some degree gives him some pleasure, or he wouldn't be doing it.

SMITH: I've known some women, though, who have great difficulty having orgasms and they come to terms with it—that they have a great enjoyment in sex without having the actual *climax*.

DELL'OLIO: Human beings are enormously adaptive. I know plenty of women who have never really achieved a full orgasm say that they get a lot of enjoyment of it. Sure, there is a lot of enjoyment you can get out of sex that has nothing to do with the orgasm. But it's always men who are saying that that's really okay.

SMITH: I'm not saying it's really okay.

DELL'OLIO: It's not okay. *It's wretched.* Believe me, no woman who's having orgasms would change places with one who isn't and say, "It's all right; I enjoy it anyway." That's so much *hogwash*! And it's always *men* who are saying it. It's just preposterous.

SCHIMEL: I can tell you of another situation. I've known several women who have had orgasms but they failed to recognize them and were still complaining, because the media seemed to be describing something even greater.

DELL'OLIO: Wow. I really doubt that. A woman who *doubts* she's had an orgasm hasn't had one, because there's no mistaking it when you've had it. That's ridiculous.

SCHIMEL: Earlier you said that "women are unhappy in sex." And you also said, "Men are ignorant about it." And I agree with both of these observations. But I think we have to be very careful about linking them, because otherwise we are saying that "the ignorant man is the cause of the woman's unhappiness." This is unfair. This is why I stress communication and education. I think people ought to know more about sex. But to simply go around blaming an ignorant man for not bringing a female into some kind of ecstasy, wouldn't it be better to talk things over and find out what it's all about rather than level charges?

DELL'OLIO: Well, no, because men have assumed the burden for directing and running society, because they *run* everything. All you have to do is look around you. They've decided that they're taking, from time immemorial, the decisive roles in the society. So it's up to *them. Of course* women are ignorant. I would much prefer that it was in women's hands, but the fact is it's not. And men are in no great rush to remove us from this ignorant, impotent state. So as long as this situation exists, men are to blame.

SMITH: PLJ, Howard Smith...

CALLER ONE: I'd like to ask why, if the man is havin' such a hard time makin' a woman reach her climax, what can the man do to make her reach it?

DELL'OLIO: I really don't see how I can answer that without getting specific, so I would suggest you...There are probably books you can read....

CALLER ONE: Then how can you blame it on the *man*? If the man has to read a book to learn how to do it, it isn't basic instinct and basic nature to do it.

SMITH: Hey, man, not everything in life is basic instinct, is it?

CALLER ONE: But how can you blame it on the man, if a man is made a certain way and a woman is made a certain way?

DELL'OLIO: Let me answer what the question really is. The feminist point of view is that the institution of sexual intercourse is male dominated. What you call "natural" is just what you're used to. It's oriented to be *productive* for the male. It isn't at all oriented, necessarily, towards what is natural for a woman. Now that isn't to say that it can't be. But the way it's set up now, the institution of sexual intercourse is *antiwoman*. It ignores the fact that a woman is participating, except as a passive object.

SMITH: Dr. Schimel, is one of the main reasons why men are afraid of women's sexual liberation because they will lose control of the situation?

ANSELMA DELL'OLIO AND JOHN L. SCHIMEL

SCHIMEL: Control is always an issue *if* the people are focused on control.

SMITH: Most men are focused on control. Come on, we have to face that.

DELL'OLIO: Absolutely.

There's something very peculiar about focusing precisely on the orgasm, when so much else is wrong in the world of men and women.

—John L. Schimel

SCHIMEL: It all depends on who you listen to. I'm tempted to invite you both to my office to spend a day listening in on an intercom, and *listen* to some of the men talk about who controls. I think I'm in cuckoo-cloud land here where everybody's agreeing....

DELL'OLIO: To me cuckoo-cloud land is an analyst office, because I don't believe you get any honesty at all there.

SCHIMEL: Just the women tell the truth, not the men?

DELL'OLIO: Not the women or the men. The only honesty that you can ever really find is in the actual relationship itself. Every man I've come across has, if they've been at all honest, finally admitted that *yes*, they like control. They don't *mind* paying for the date, because that keeps them in control. They dig it. You don't seem to want to acknowledge that this is basic, intrinsic—not just to *our* society but to *all* societies that I know about—that men control and run everything, most *especially* and fundamentally women. That is *the* important thing for them to control, and to lose control of that is *not to be a man*. This frightens the hell out of them. Not to recognize that is the most Pollyannaish kind of attitude I can possibly imagine.

SCHIMEL: I don't like what you're saying to me, so I'll respond to you as—I wish you would get *around* more. Because not every man is so uptight about control. Many men do *not* have control. Many households are run by the women, in the sexual department as well as elsewhere.

DELL'OLIO: Wow. They really run it. That's for sure.

SCHIMEL: This is cuckoo-cloud land, there's Chicken Little running around here.

DELL'OLIO: Wow. That's another one of those popular myths: the *hen-pecked* American husband. It's just so much *hogwash*! Women yell a lot because they're frustrated. But you know, *impotent* people yell. The people with the real power don't have to. And for every woman that's pushing her husband around, he lets her get away with it in public, but I'd like to know what goes on behind closed doors.

SCHIMEL: Well, I could tell you if you'd listen.

DELL'OLIO: Are you hen-pecked? Because I'm more interested in knowing

what personal experiences, not what people tell you, but how they actually live their lives. That to me is the only really valid experience.

SMITH: Are you hen-pecked?

SCHIMEL: I don't like the level of the conversation. I think there are double standards in American life. One is sexual freedom. It is true that men are freer to commit adultery than women. But there's also a double standard of rudeness, where women are freer to be rude to men.

DELL'OLIO: No, feel free, by all means. It's *your* double standard, not mine.

SCHIMEL: That's another contradiction.

DELL'OLIO: It's not my society. I didn't invent it.

SCHIMEL: No, some man invented it.

DELL'OLIO: She sure did.

SCHIMEL: Did you say, "She sure did?"

DELL'OLIO: I said, "He sure did."

SCHIMEL: I heard you say, "She sure did."

DELL'OLIO: You'd like that.

SMITH: Anselma, you did.

CALLER TWO: Dr. Schimel, is it really a matter of almost courtesy that it's completely within the man's power to bring about orgasms in the woman, or is that another thing that is somewhat ingrained in the woman?

SCHIMEL: I think that it has to do with both parties.

CALLER TWO: But what Miss Dell'Olio is trying to communicate is that it's basically your fault. Because all women are trying to achieve orgasm, you're trying to stop them. And we're not!

SCHIMEL: I will run the risk of incurring her wrath by saying that the point of view that's been expressed would be considered very bad sociology or anthropology—that is, to treat a society as a living, thinking organism deciding things, or 50 percent of it deciding to do something else to 50 percent of the others. Life is much more complicated than that. And I think one of these days, if I had the youth, beauty, and energy of the others speaking tonight, I would start a man's liberation movement. We're up against it too. And you're right to point out that there's something very peculiar about focusing precisely on the orgasm, when so much else is wrong in the world of men and women.

ANSELMA DELL'OLIO AND JOHN L. SCHIMEL

Country Joe McDonald
April 1971

Yesterday Joe McDonald, of Country Joe and the Fish, was in Washington, D.C., performing in front of five hundred thousand people at the march against the war in Vietnam. (The last crowd he saw that big was at Woodstock.) He's a longtime and outspoken critic of the war, and a few of his songs have already become standards in the peace movement.

SMITH: How you been?

MCDONALD: Pretty good, actually. I finally got over the Washington, D.C. thing.

SMITH: You were down there yesterday, huh?

MCDONALD: Yeah, they asked me to come down and play a song. Literally.

SMITH: *A* song?

MCDONALD: Yeah, I didn't know that until I got down there. They asked me to come down and do a forty-five-minute set, which sounded reasonable to me. Well, I hate those things anyway—those mass gatherings where everyone has a wonderful time.

So I went down. When I got there, it turned out that they thought they could fit one song in. In between Coretta King and somebody else. So I told them I was doin' three songs, which was really quite a difference, because I planned to come down and play for, like, forty-five minutes. So they said, "Oh, no, you can't do that." And I said, "Oh, yes, I'm going to do it." They said, "Oh, no, you can't." I said, "Oh, yes, I'm going to." They said, "You can't. There're a lot of people here and everyone has to do their thing." And I said, "Well, my thing is I'm gonna do these three songs." And they said, "Oh, please, please, don't. Because then if you do it, everyone'll wanna do it." I said, "Yeah, that'd be really great if everybody got to sing a lotta songs; then all these people wouldn't talk." So I got up there, I did the first song, and then I heard this woman with a clipboard advance towards me. And I heard her scream, "Okay, that's it. Get him!"

> **So I got up there, I did the first song, and then I heard this woman with a clipboard advance towards me.**
> —Country Joe McDonald

SMITH: What?!

MCDONALD: And so I just went into the second song really fast. And that completely blew their minds, that I wouldn't obey the rules o' the game. So they were a little bit relaxed, which enabled me to go into the third song very quickly. Then I did the "Fuck Cheer." And that blew their minds, I think. So I whipped the crowd into a sufficient frenzy for the next speaker to jump right up there and yell, "Power to the people, power to the people, right on" a million times in a row.

Invitation to attend Yoko Ono's show and John Lennon's 31st birthday party, 1971

September 28, 1971

Re: "THIS IS NOT HERE" SHOW

Dear *Howard*,

 I am writing to invite you to a preview of an exibition of my work to be held on Friday, October 8th, at The Everson Museum of Art in Syracuse, New York.

 Details regarding your meals, lodging and transportation to Syracuse are now being finalized. Basically, there will be a central pick-up point in New York City on Friday morning to take my guests to the airport for a short trip to Syracuse.

 If your schedule precludes your remaining over for the opening on Saturday, all arrangements will be made for your comfortable return to New York on Friday evening.

 I sincerely hope that you can join us for what promises to be a most interesting event. The show is dedicated to John Lennon for his birthday, Oct. 9th, and he is also guest artist.

Very truly yours,

Yoko Ono Lennon

Taj Mahal
May 1971

Blues musician Taj Mahal recorded his landmark album, The Real Thing, *live at the Fillmore East three months ago, and he's already back in New York City. Tonight he'll share the East's bill with Leon Russell and Donny Hathaway to play the last of a four-night stand. He'll continue performing live shows for more than forty years.*

..

[*Live on air*]

SMITH: Where'd you get the name Taj Mahal?

MAHAL: Out of a dream. I got tired of respondin' to something, and had a case of what's called the "black and crazy blues," and I just went out as far as I could at the time, and I was out there and I went for it.

SMITH: What *was* your name?

MAHAL: It's an English name and I don't have nothin' to do with it, and I gave it up then and I still give it up now. I don't want to talk about it. Just modulate it out, man, to somewhere else.

SMITH: How did you first start playing?

MAHAL: It was just there. I mean, it was already started, man. I come from a long line of musicians who've been playing for millions of years. I mean, some of the finest musicians on earth, who still maintain various parts of their own culture completely based around music, agriculture, and living with the land…I was the elder son of a woman whose parents were closely related to one of the former slaves of the south. My father was of Jamaican heritage. Bein' the firstborn of that particular union, a very interestin' situation that happened. Bein' the oldest, I'm closest to the roots. So I guess when a woman carries her first child, there's an awful lot…of care and expectation and just sheer joy. I've always had a different slant on life. Somehow it just seems to be that way. As long as I can remember, it's been happenin'—I've just been looking for a place to put it out. Been singin' since I can remember, back to about a year old before I was talkin'. I can remember back that far. It's just always been there….

SMITH: When did you start doing it professionally?

MAHAL: I never did; it's just ended up that way. I mean, if it was professional to me, I could not play. And that's exactly where it's gotten, to those proportions, when everybody else around you starts to askin', "When did you start playing professionally?" You know it's happened. It's time to quit. Seriously, just time to quit, goin' crazy and on the road all the time, because it's gotten itself across. You just work yourself into the ground, for a lotta people who perhaps dig the situation they find you in but do not have to go through the pains of gettin' to where you are, no kinda way.

Most people who *become* professional musicians, and take that tag, get themselves in a very weird position. I'm really not interested in being a whore. I just wanna play what I feel and do what I do. When it starts becomin' a profession rather than a joy and a part of a gift, I just can't play anymore. I mean I *can't play*. It's not like I can go to a psychiatrist and he says, "Look, kid, you gotta play." No way—I just can't play when there's something else in it other than the joy of playin' the music, making the situation, and enjoyin' the communication. I mean, the money involved is just to see that we get there. It's the fans who pay your way.

SMITH: You don't get any kick out of making money for it?

MAHAL: No! For what? What is money gonna give me, man? What can money buy me? I already can play guitar; it can't *buy* me to play guitar. It can't buy me a new brain. All the stuff I got, I got with me. I've been poor, and the worst poor that I can ever be is poor in spirit—'cause I don't care how much money I got, it don't raise my spirit.

SMITH: Do you tour a lot?

MAHAL: I did at one time. I've been out quite a bit this year with the new band, because I was really diggin' doin' that, and until that got to be a drag I would've kept on doin' it. But it's too easy for it to get a drag. It's

not so much the musicians I work with; it's the people who're interested in bookin' us around here and there. They still like to book you in these places where everybody is all doped up on reds and they're really down and they pay their money to get in there and they're hollerin' this, that, and the other thing, their slogan. Whatever the latest slogan's all about, you know, to let you know that they're right on top of it. The music starts and it's cookin', but they don't get to it, man, because they have a wall. It's "I dare you to get to me." Well, okay, if you want the Who to get to you, if you want Blue Cheer to get to you, this ain't Blue Cheer. You know, stay home—don't come to my concert. I don't care. The people that wanna be there, they'll be there. And they get it as soon as they come in the door.

SMITH: "Tom and Sally Drake" on your latest album, how did that come about? Was that anything you worked—well, you said you don't work anything out.

MAHAL: Well, I do to a certain degree, man, but, I mean, I'm just discovering myself that I'm a very natural musician, and I don't know—somehow it's just there. I hear something in my head and I follow it and bring it forward in such a way that you can feel what's happening. It's just feelings you have about things... You see, it's, like, very difficult when I hear people who can just, like, sit down and not have really experienced something and write all the notes out to it and say, "Here, play this." It's, like, "Here's your program." I really don't know, man. I don't know any more than anybody else does. I used to try to say this and try to say that, but it finally was just a bunch of... You know, as soon as I said something, it had already changed, so I just play music and learn how to stop talking so much.

I'm really not interested in being a whore. I just wanna play what I feel and do what I do.

—Taj Mahal

I never used to talk very much, man; it's only been this business that's made me talk. I used to not talk at all, not interested in it. But little by little you get tired of being misquoted and misunderstood and involved in things that you didn't do. It's, like, you can either take a position of just not saying anything, which is passive choice: "Oh, steamrollers just seem to roll over me." You can defend yourself, but then again, you can just play the music and if they don't hear it there, they can't hear you anyway.

SMITH: Are you gonna continue to do concerts? Because in a funny way you sound very down.

MAHAL: No, I'm not down! I'm the last cat in the world to be down. Just—the situation is very down.

SMITH: But it hasn't brought you down?

MAHAL: Well, it did for a bit, I mean, just long enough to sit down and think about it....I'm just gonna cool it, man. I got really intense musical experience going on now, right? And it's very difficult for me to be *out there in there* at all times. Until we get a much more decent audience to play for, I'm just gonna cool it till I find the kinda audiences I wanna play for. I'm sorry—I like playing a lotta places, but it's just changed; the people are just not on a good trip. In most places you can't get through to 'em, and they won't get up off their asses and dance, man, and that's what it's all about. If they can't get that from what we do, it's theirs. They can have it. They can have all their ballrooms. I don't wanna play in 'em. I'll go and sit in a little coffeehouse and pick guitar, man, for thirty people really wanna hear some music....But I'm not gonna get out there and keep bangin' at those people....

Before I made my first album, twenty-somethin' years of livin' had gone in, and you go out on the road and you play and you play. I really didn't even dig goin' out on the road. None o' that stuff I ever thought of doin'. I just wanted to go play some music, man, and if it worked out— good, it worked out. But it's a trap, man. You get trapped into being out there. Before you know it, twenty years have gone by and there you are still out there, sayin', "One of these days I'm gonna, one of these days I'm gonna...." I don't need no broken records, especially that sound like *me*, talkin' to myself. *No*, man, just quit.

Jack Nicholson
June 1971

Jack Nicholson has been a writer, producer, and actor in Hollywood for more than a decade, but it was his Oscar-nominated performance in 1969's Easy Rider *that finally made him a star. Last year his leading role in* Five Easy Pieces *earned him another Academy Award nomination, and this summer his role in* Carnal Knowledge *will solidify his stature in Hollywood as a leading man. His directorial debut,* Drive, He Said, *will open next week to mixed reviews.*

..

SMITH: Are you good at synopsizing it at this point?

NICHOLSON: It's a hard movie to make a synopsis of, primarily because of the form: it has many, many characters in it. I stayed with the novel form rather than reducing it back down into a play form, which is what they usually do. I liked most of the characters in the novel and I liked the fact that each one related to the central theme. I mean, I think there's something to offend everyone in the movie and there's something that they can identify with. The response has been very, very violent up till now. At Cannes the first five people I talked to after my screening, three of 'em had had actual fights in the audience.

SMITH: Really?

NICHOLSON: It was the *only* film at the festival that caused any response. Every other film was immediately pigeonholed: that's a masterpiece; that's not. My film was the only film there that caused actual fights. One girl had to hit someone with her purse....

SMITH: By its nature, it's not a controversial movie.

NICHOLSON: I don't know why people have reacted. I honestly don't understand it, because I thought it was almost a *moderate* movie, considering the subject. It's got a lot of odd techniques in it, but basically, because all points of view were represented within the movie, I felt that it wouldn't inflame everybody. But I guess there are some things that get to you.

SMITH: It stars Karen Black. I thought she was great.

NICHOLSON: Yeah, I liked her. I've been in town for a couple of days and I've talked to some lady critics and I was interested to see if it was a

fully rounded female character for them and how they felt about it. I feel it's one of the really successful things in the movie. It is unique as she's unique. I wondered if it was accurate from a woman's point of view.

SMITH: What did they say?

NICHOLSON: Pretty much yes. They like it because she doesn't necessarily have one point of view about something, or one facet of her personality, but all of the things that a woman is and can be and should be.

SMITH: Do you have any idea why the reaction is so strange to the film?

NICHOLSON: I have some ideas what I *think* it could be. One of the things in all of my work—acting, writing, whatever it is—is I feel that…The most influential acting teacher I ever worked with,…one thing she always said is, "If you're cut off, having trouble because you just hear yourself saying the words, the first thing to do is to check both yours and the character's state of sexuality at that moment." Whatever it is. If it's just "I'm not sexual at this moment" or "This person over here is turning me on and I'm talking to this person," whatever it is, it seems to be the area that has the fastest gaps in it.

So starting from that, and over the number of years that I've worked and had success with the techniques, plus going into Reichian therapy, which is all sexually based, and only getting into it because of what I thought about [Wilhelm] Reich as a political thinker…His theories are really influential on my writing and in some of the characters, and he would have predicted this response. I wouldn't have felt I was this successful and I'm not sure that's the reason for it. But he would tell you that any

> **The first thing to do is to check both yours and the character's state of sexuality at that moment.**
> —Jack Nicholson

time you release an area of sexual repression, in any way, the authoritarian structure is going to react very rigidly and very unilaterally.

I don't think this is a "big cause" picture. I don't think it's gonna create a national scandal. As you say, it's laid back. My favorite characteristic in art, music, or—I like the Band 'cause they're restrained. I love restraint. And I work that way. I try not to show off too much in front of the work. Anyway, it's this sexual area—a lot of the reviews that I've seen object to the things, not the sexual acts in the picture. But all of the characters really have sexuality written into them….It's in all their relationships. They recognize that it exists. Some people have objected to the fact that Karen has such a graphic orgasm on the screen; then they become obsessed with that moment in the film. That might be some of

JACK NICHOLSON

it; I'm not sure. What Reich says about it is what an orgasm is, is an expanding and a contracting, really, and this is against authoritarian, rigid government, which likes a nonchanging single, one-level point of view about everything that's supposed to be carved into stone and last for all time into the eons of future and past history.

SMITH: Were you tempted to put yourself in the film?

NICHOLSON: I was tempted to put myself in the film because of easy access to the audience. I knew that I would be popular at the time this film came out. But because I wanted to use people [of] actual college age in the picture—normally in college films, they cast older people—because I was going to be depending on intuitive response a lot more than I was skills. So I wanted it to be the actual age of a college person at the time I was making the film, which made me know that I'd deal with a lot of inexperienced unknown actors. And I felt my presence in the cast of a film that I directed in a small role just would've upset the balance of reality among the characters.

SMITH: I've always heard there's this battle between actors and directors. Did you feel like you'd crossed over to the other side?

NICHOLSON: No, I got along great with the actors. All you have to do is help 'em do their job and they love you so much you can't get rid of 'em at night. But my point of view as an actor has always been I'm a relay information center for the director. I'll go out and explore the character and come back and object and argue with him, but ultimately whatever way he wants it, my job is to do it that way, because it's his film. I'll argue with him as long as I feel the argument is really progressing, and when it's not, I'll say, "Well, how do you want it?" And he'll say, "This way," and I'll do it and I'm glad to do it, because that's the real job of the actor and that's what I demand from the people that I worked with. I didn't have any problems, none.

> **I love restraint. And I work that way. I try not to show off too much in front of the work.**
>
> —Jack Nicholson

SMITH: This is your directorial debut. Is it as hard directing films as everybody has said?

NICHOLSON: It was for me. I mean, it's the hardest job I've ever done from a point of view of…Number one—I have never worked on anything for as long as a year, just one idea, one piece of work, not one job but one piece of work where you're constantly trying to get this thing up to the level of where you conceived it. All your effort is going into that and presenting it and getting it right. During shooting I dreamt about it every night.

SMITH: Literally?

NICHOLSON: All night. Went to sleep knowing I would dream about it and woke up in the morning knowing I had dreamt about it all night and then go right directly into it. Mentally it was very grueling for me. My life collapsed, really. I blew a big, serious relationship out and people yelling, screaming—all this kinda stuff went on for me. I felt locked to the helm so I wasn't really equivocated about what I was doing, but it was very tempestuous times.

SMITH: You've really been around the Hollywood scene quite a bit. Is it as terrible as we've been told? Is it impossible to be honest *and* successful in Hollywood?

NICHOLSON: No. I feel both honest and successful up to a certain point in Hollywood. I've always liked it there, myself. I mean, there's a lot of very strange people functioning there, but it's not full of devils. I mean, I don't know anything good or anything really vital that ever floated around there that didn't ultimately wind up being produced. I think a lot of that is usually due to people saying, "They won't let me do it." I don't believe that. "They won't let me do it" immediately makes me suspect the person. Because everybody I know who's ever had something that they really wanted to do, if it was good, it got done. Seriously. There are no great unproduced masterpieces in Hollywood.

SMITH: Is it a place where you have to watch every step, where it's wise to be paranoid?

NICHOLSON: I don't think it's ever wise to be paranoid. That's really what I'm speaking against, actually, at this moment. You just have to take care of business just like everywhere else. If you're doin' it, it'll get done. It's up to the person who's actually doing it, what it is. I mean, no one's ever bothered me while I was working. No one's ever asked me to do anything but the best that I could possibly do. Now, I wasn't working within most of what the film establishment is known as. I rarely worked for major studios ever. I still haven't. Now it's not to my advantage to do so, and then they didn't really want me, but that was based on the fact that I was not what they wanted. Not any lack of honesty or anything like that. I was just too…My voice was weird; it still is, but now it's okay. They said I was too strange looking for the movies, which I thought was strange. But it had nothing to do with a systematic rejection of some point of view that I held.

SMITH: How did it come about that you ended up in *Easy Rider*?

NICHOLSON: I had written *The Trip*, which Peter and Dennis did just before. I'd known both of 'em for some time. They brought in about a

twelve-page outline to where I was cowriting *Head* with Bob Rafelson, to look at, because they were looking for financing of the film. They almost had a deal elsewhere but they were quibbling about letting Dennis both direct and be in the picture, which gives the director a little too much power, by their standards. In other words, if they wanna fire him, they can't, 'cause he's in the picture.

Anyway, we both read it. We both liked it. They decided to do it. They went on about it. They went to New Orleans and shot the New Orleans footage. They had a little production problem, because it was very difficult shooting. They came back, there was some talk about canceling it, and I recommended to them the production crew that I had been working with, with Monte Hellman and a couple of other people on my Westerns and with Dick Rush on the motorcycle pictures. I got them Leslie Kovacs and Paul Lewis, or put them in touch with 'em and all that. So I had been a friend of the production all along up until this point. Then the actor who was supposed to play the part I played dropped outta the picture for some reason, and just because I was there and they knew me and didn't think I was either right or wrong for it, but they knew I was a decent actor, they cast me in the picture.

> **Seriously. There are no great unproduced masterpieces in Hollywood.**
>
> —Jack Nicholson

SMITH: It's made everybody's reputation, whoever touched the film, but your performance in particular seemed to knock people out. Did you know it at the time that you were doing a really sterling performance?

NICHOLSON: I knew it was good, but I had done other good work before. And I knew the picture was going to be a success. But one of the things I didn't know about it was the fact that it was gonna do all of what it has done for *me*. I just thought, "Well, it's another nice piece of work that I've done to add up, and we'll all get there eventually." But I had no feelings that that was gonna happen.

SMITH: How about *Five Easy Pieces*; were you happy with your work in that?

NICHOLSON: I like my work in it. In fact, it's probably the best thing I've done. It's got a character; it's got restraint. What I did in it that *I* liked, I didn't think was gonna get across to audiences. I also was surprised at the success of *Five Easy Pieces*, because I knew it was good, but what I liked about it was that it happened to present a very hard problem. In other words, rarely in movies is a character in every scene. Rarely is he on

camera for the entire picture. And when he is, and particularly if it's not an action picture or there aren't a lot of different plots going on at once, it's hard not to bore the audience *or* make the character too exaggerated in places. So it presents a real problem in restraint. In other words, you've gotta keep the character's story progressing and the audience interested in it as though something is happening, not let it be dull and yet not resort to any really fake tricks about it. I felt in terms of the difficulty of the goal, I would've scored myself very high on the performance. But I didn't know that the *audience* would score it highly. Because they're not aware of the problem, they're only aware of the result of working with the problem.

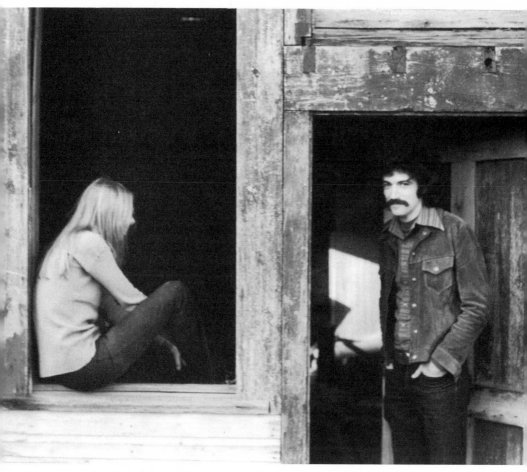

Sarah Kernochan and Howard Smith, 1972

JACK NICHOLSON

Frank Zappa
June 1971

Frank Zappa and his new assemblage of the Mothers, with the notable inclusion of singers Mark Volman and Howard Kaylan (Flo & Eddie), are on tour promoting his latest album, Chunga's Revenge, *and upcoming film,* 200 Motels. *Howard Smith surprised Zappa, showing up at his hotel room for this interview with John Lennon and Yoko Ono, who had wanted to meet him. Tonight they're playing the second of a two-night stand at the Fillmore East, and the show will be recorded and released as* Fillmore East—June 1971. *The year will end badly: A fan will shoot a flare gun during their December show in Switzerland, burning the casino, along with their equipment, to the ground. Then, in London, a fan will push Zappa off the stage into an orchestra pit, nearly killing him, and confining him to a wheelchair for a year.*

SMITH: For a time you'd been in New York and then went to L.A. Have you moved back out there permanently?

ZAPPA: Yeah. I served my time in New York.

SMITH: What do you mean?

ZAPPA: I didn't like it that much when I was here and I like California a lot better. It was so depressing during the time I was here, I really hate to come back....I got a place with a buncha trees around it and some space. I don't have to shuffle around the street and walk over people who've pissed all over themselves and are lying down there in the gutter and policemen coming along beating 'em on the legs screaming at 'em to get up and dogs shitting all over the place. It's just a little different in Los Angeles.

SMITH: On stage, you run the group in a way you don't see in rock—they're watching you very carefully.

ZAPPA: That's because I'm conducting the music; it's like a little orchestra....I can make anything happen that I want to up there. I can invent a whole composition. If I think of one that minute, I can turn around and do it. That's why they watch.

SMITH: Do you do that often?

ZAPPA: Every time we play. That's becoming an increasingly large part of the show. The way I organize each of our performances is we have a certain length of time we're supposed to appear onstage, and I try and program the material that is played during that length of time into one large composition. It's like all the melodic and harmonic material that all the different songs and sections are based on is similarly related. I can arrange these parts in different sequences and make hour-long compositions with no breaks in it.

SMITH: What about audiences? Do you find that it's changed at all?

ZAPPA: An audience, you just compute it at the point where you come into contact with 'em. You can get a feeling for what sort of a mood they're in or what sort of people they are, judging from the way they behave.... New York audiences, especially at the Fillmore, are not too good. A lot of 'em come there to entertain me and I don't wanna be entertained by them.

SMITH: I didn't notice you doing—I used to call it your nasty act.

ZAPPA: It's not an act: I do what I feel like when I go out there. If I'm in a bad mood, I'm not gonna pretend like I'm a clown or something. I'm a human being; I have feelings.

SMITH: I saw you last night on the first show and at the end of that they were all standing on their seats. There was wild cheering but you just refused to do another one.

ZAPPA: That's right.

SMITH: How do you decide—do you ever do an encore?

ZAPPA: Sure. We played until about four o'clock in the morning last night.

SMITH: But on the second set.

ZAPPA: Yeah, but I didn't think that was a good audience for the first show. I would say that more than 50 percent of them were not. We weren't tuned in properly and I didn't think it was worth the amount of physical investment to go out there and play another piece for 'em.

> It's all fads and trends and bullshit, just growing-up phases, just adolescent development.
> —Frank Zappa

SMITH: How do you feel it?

ZAPPA: A lotta times, you just judge from what you hear called out from the

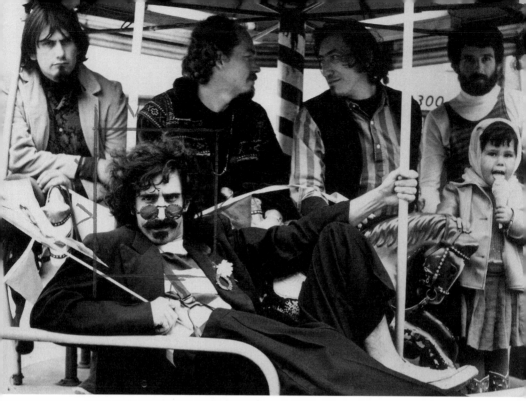

Frank Zappa and the Mothers, promotional photo, 1966

audience. Sometimes they call out requests for songs and sometimes they just like to make noise. And you have to compute whether or not they're just full of nervous energy or they're just there to make so much noise that you'll stop playing music and then get involved in some exchange of words with them. And that's boring for me. It's always the case where some guy wants to yell something out and then I'll turn around and say, "Go fuck yourself." And then the rest of the audience will go, "Yay." They'll clap and everything and it's so predictable and dumb. I just didn't feel like doin' it last night, because that's all they wanted.

SMITH: That doesn't happen outside of New York much?

ZAPPA: Very seldom. There's a lotta people who call out song requests or they yell things out, but the Fillmore audience is particularly low-grade. It just has its own aura. You know what I mean? I get the feeling sometimes they come there to see whether or not you are going to give them their three dollars' worth. No more 'n' no less. They don't really wanna hear what you have to do, just "I paid to come in here and see a show, so you better give me a show, you jukebox, you." So we gave 'em a show. And there it was.

SMITH: Bill Graham's closing the Fillmore.

ZAPPA: That's nice.

SMITH: He said the same kind of thing—the audiences don't know what's up.

ZAPPA: I think that Bill Graham, if he wanted to do that sorta thing as a public service—which I'm sure he doesn't, because he's a businessman—but if he wanted to do it, he should move his operation to the Midwest, because the Midwest is just now catching up to the other so-called civilized parts of the United States. Madison, Wisconsin, for instance. He could probably run a really thriving business there, because that's like the Berkeley o' the Midwest. It appears from the way they dress and the way

Any change for the good is always subject to cancellation, upon the arrival of the next fad.

—Frank Zappa

they act, the type of drugs they're using, they're approximately three years behind the rest of the country. We played there about a week ago and it seemed like it was exactly three years back, slightly post–flower power, super-acid consciousness.

SMITH: Which you preferred?

ZAPPA: No. I'm just evaluating it for what it is. I don't prefer that at all—it's all fads and trends and bullshit, just growing-up phases, just adolescent development. But that's where they're at right now, and that would probably be a better place for him to do his operation if he likes that kind of an audience, because they just wanna have a good time. They haven't got to the point where they believe themselves *thoroughly sophisticated* and wanna just sit back and demand that they be entertained, or expect something of you in advance.

SMITH: When touring, have you started to notice a more *political* consciousness of the audiences, though?

ZAPPA: It's as superficial as their musical consciousness. It's just another aspect of being involved in the actions of their peer group. One guy in the group says, "Hey, politics," and they go, "Yeah, politics," or he goes, "Grand Funk Railroad" and they go, "Yeah, Grand Funk Railroad." It's the same thing.

SMITH: I have a feeling it's gonna increase, and although part of it might be a fad a great amount of it isn't.

ZAPPA: Why do you have so much faith in the people?

SMITH: I don't....

ZAPPA: Then why do you think that it's not a fad?

SMITH: Because within every fad that sweeps along, there's a certain residual effect that remains and keeps building upon the next, even after the fad is gone.

ZAPPA: But that residue just gets computed into the next fad. I'm speaking strictly from my experience as an American...This is fad world.

SMITH: You don't see any *real* change that's gone down?

ZAPPA: Sure, I see a lotta changes, but I think that they're all temporary things and any change for the good is always subject to cancellation, upon the arrival of the next fad. The same thing with any change for the worse: that will be swept along with the next fad. You have a nation of people who are waiting for the next big thing to happen.

SMITH: Before each concert, do you think, "Oh, God, those idiots out there"?

ZAPPA: No, I don't think, "Oh, God, those idiots out there" until I *find out* they're idiots. I give 'em the benefit of the doubt. I can find out during the time that we're setting our equipment up, and if that isn't enough proof, we play three songs in a row for the first part of the show and then we stop and we can gauge the response by the amount and quality of the applause, or whatever sort of grunts come out of the audience at that point in the show, and I'll compute the rest of the show based on that. The show is rehearsed to the point where certain things I know are going to happen; there're programmed into the show.

SMITH: Like what?

ZAPPA: Well, you rehearse your material to have a certain effect. You know roughly where the laughs are going to be and roughly where the sporadic type of applause...That's gonna happen there; it just does. Because you're dealing with a programmed audience. You can just compute them based on...Let's say you figure the average age of what your audience is. In the case of the Mothers of Invention, when you get to New York, the age range is somewhere between fifteen and eighteen. A lotta people over that, but the bulk of 'em are in that age bracket, and you figure how much TV they watch and what sort of radio they listen to and you can sorta know. Those people are ready to respond blindly to any sort of thing that you're going to do that strikes that particular chord, that makes them clap, makes them laugh, makes them grunt or whatever.

If there's an audience out there and they have a good time, well, that's a peripheral benefit.
—Frank Zappa

SMITH: You sound so cynical. I get the feeling that you're doing something for people you don't have any respect for, so why do it?

ZAPPA: But I don't *do it* for people.

SMITH: You do it for yourself?

ZAPPA: No, I just *do* it. I would make an extremely bad mechanic or plumber. I don't wanna earn my living working in a gas station. I like to play the guitar and I like to write comedy music. I like to go out there on the stage and wave my hand around and get weird noises coming outta the band. I enjoy doing that—that's what I know how to do and that's what I do. I'm fortunate that I can earn a living from doing that. So if there's an audience out there and they have a good time, well, that's a peripheral benefit. If they're out there to make noise, then we're only gonna be out there for an hour and it don't hurt that much.

SMITH: Why do you think the country moves in fads?

ZAPPA: Because it doesn't have any real sorta values. A fad provides you with a temporary occupation for your imagination. It doesn't have any real culture. It doesn't have any real art. It doesn't have any real anything. It's just got *fads* and a gross national product and a lot of inflation.

SMITH: But that also puts you in as part of the fads, right?

ZAPPA: I'm an American; I was born here. I automatically got entered in a membership in the club. But you can compute me any way you want.

Frank Zappa and the Mothers, promotional photo, 1966

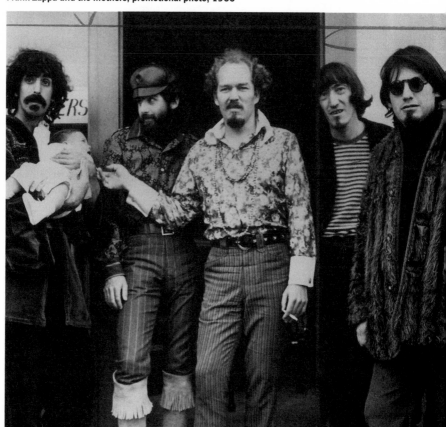

Dennis Hopper
September 1971

Dennis Hopper spent the last two years shooting and editing his latest film, The Last Movie. *It became embroiled in controversy after an unflattering documentary,* The American Dreamer, *shot while he was holed up editing his film, was released without permission before* The Last Movie *premiered. Hopper has just arrived back in the States, vindicated after winning the critic's prize at the Venice International Film Festival, but expects the movie to be controversial in America. He'll be proven right. The movie will flop and precipitate his dark spiral into a decade of addiction.*

[*Live on air*]

SMITH: How are you doing, Dennis? It was about two years ago, you and Peter [Fonda] had just come back from the Cannes Festival, right? And I interviewed both of you then and here now you've just come back from Venice, triumphant again.

HOPPER: I had always dreamed of winning Venice since I was a kid.

SMITH: Really?

HOPPER: But when you go there and there's no competition... I mean, nothing was in competition, because the leftists had closed the festival the year before. It was just an honor to be in it, and then suddenly the day before, they came and said that the only prize given at the festival was being given through the Cinémathèque and it was a prize called CIDALC. So I won the only prize given there, for best film in the festival, and the last American to win it was Buster Keaton. It was a great honor and a surprise.

SMITH: The title of your new movie is called *The Last Movie*, and you've directed it and star in it. It opens this Wednesday, right? Do you expect American critics to like it?

HOPPER: I really don't know. It's really a difficult film, I think. We got great reviews in Europe and some really terrible reviews.

SMITH: That's what I suspect the reaction is going to be. There's gonna be no middle ground. People are either gonna be furious or they're gonna

like it a lot, which is what happened at the screening Friday night—at the Museum of Modern Art there was a screening, and some of those people were really mad.

HOPPER: They were hissing.

SMITH: How do you feel when they hiss a film that you've spent, what, two years on?

HOPPER: You just sort of sit in yourself and smile a little bit. I mean because you can't really take it personally. I hope the film is seen now, but I think time will take care of it. I think it's a really interesting new kind of movie. That's what people said they wanted to see and I wanted to make. And we'll see if Hollywood's right, if the audience really does wanna go and just have an opiate or whether they really wanna go and try to work with it and try to understand it. I think it's a great movie.

SMITH: Why'd it take you so long to edit? A year and a half or something?

HOPPER: Yeah, it was a year and four months. It took a year on *Easy Rider*, but no one was waiting for *Easy Rider*. This way, a year and four months editing is a long time because you have a lot of publicity, and then everybody says, "Well, where is it? What happened to it?" I had forty hours of film to edit. I had thirty-five on *Easy Rider* and so that five more hours of film gives you another four months editing. That's all I can say. It was hard.

SMITH: Did you have it cut and then redo it all over again?

HOPPER: No, I just edited it all from the beginning. My first cut was six hours and twenty minutes and then I finally got it down to, I think it's running ninety-three minutes last count.

I just didn't wanna get involved. Karma is karma, man.
—Dennis Hopper

SMITH: How long did it take to shoot?

HOPPER: I shot it in eight weeks. And I prepared it for about four months building the sets and everything in Peru. Peru was fantastic.

SMITH: Yeah, the scenery in the movie at certain points almost overwhelmed the film. That was a real danger, especially using a cameraman like [Leslie] Kovacs. You used the same guy as for *Easy Rider*. I mean, you almost don't want to watch what's going on. You'd rather watch the scenery.

HOPPER: I hoped it would be. It was really like Shangri-la, you know. It's just incredible. That valley's fourteen thousand feet. The mountains are twenty-three thousand to twenty-five thousand feet and it's the Sacred Valley of the Incas, and it's an incredible place. Just moving up there, I mean moving equipment, moving around was really a scene. It took about two weeks to even get so you could walk up some stairs and things.

SMITH: Did you come in on budget?

HOPPER: Yeah.

SMITH: Really? Right on budget?

HOPPER: Well, we had an $850[K] and I came in around $950[K]. So I went $100,000 over budget, but that's really not a lot. I mean, it was really expensive to do. It cost twice as much as *Easy Rider* but it's still under a million…a low-budget movie before *Easy Rider* in Hollywood was a million and a half or they wouldn't even talk to you, because they didn't think you could make a movie. I figured if a major studio had made it, it'd probably cost them around $10 million.

SMITH: They would've built major highways and they would have sawed mountains in half.

HOPPER: Absolutely. And left them sawed in half.

SMITH: Can you synopsize what the film is about?

HOPPER: You know, what gets hard is, like, when people ask you so many times, just trying to keep fresh on it and repeat it, but also, it's a difficult movie to say what it's about. I'll try to say what I think, abstractly, it's about and then you can tell me what you thought it was about, and then we can go do that for a while.

It's about "what is reality" or "what is nonreality," and this is very esoteric really, but the man in the field out there herding the sheep and being a herdsman, like, no matter what color we are, where we came from, our ancestors were all herdsmen. They were all out in the field taking care of animals and growin' their own thing and doin' their own thing. And even though the Incas come in and build tremendous monuments, and the Spaniards tear that down and build their tremendous monuments,

Crazy Dennis Hopper rides again. They're right. They never called Van Gogh sane.

—Dennis Hopper

and a movie company comes in and builds a phony-facade Western town to shoot a movie, all these things are facades but the person out in the field is still out there herding the sheep. Then what is a movie and what is reality? And is what we see up on the screen our reality? No, it isn't. It's somebody sitting in a little room trying to figure out what's gonna make money and what people are gonna go see, whether it's a violent Western or a terminal illness or whatever they're into that year….But isn't it indeed a movie, and can we break down the Victorian concept that what is happening up there on the stage is our reality? I mean, if it is, then let's see the writer and let's see the movie camera occasionally. I mean, let's

see the things that are part of that. You know that computerized thing can make you pay your money and see something and become an opiate for you to fall out behind. Deal with it as another reality. They do it in novels and they do it in stage plays, but nobody does it in movies.

SMITH: I don't think anybody would know what the movie is about from what you just said.

HOPPER: Thank God. What did I just say?

SMITH: I'd meant, could you describe the plot of the movie?

HOPPER: Oh, the plot of the movie.

SMITH: Not the meaning of life.

HOPPER: Well, that's even more complicated. What did *you* think it was about?

SMITH: The meaning of life.

HOPPER: No—the basic thing is a stuntman who goes down with a movie company to make a movie, has a few horses, falls in love with an Indian girl, stays there to wait for somebody to come back and use the sets that they built there, this Western set thing, and no one comes back, and the Indians start acting out, with stick cameras, the violence they saw the Western doing in the street, and then at that point, the reality level, he becomes paranoid. He looks for gold, doesn't find it, and becomes very schizoid, caught up in this fantasy trip that he believes they are actually going to kill him in this make-believe movie. Then I build up to the end where you think he's going to die and they're actually gonna kill him, and then I say, "But I'm not gonna die for you in this movie, because this is a movie, and why do you want that?" Then there's a very pretty song and the ending gets a little too long, just long enough to be boring, and then I leave you with nowhere to go.

SMITH: Oh, you did that boring ending on purpose.

HOPPER: Yeah. You don't even wanna buy popcorn, but you're angry and I think in the same way that you're angry in *Easy Rider*, except in a different way.

SMITH: Did you really do that ending on purpose that way? Because I found it a very annoying ending.

HOPPER: I know.

SMITH: And you meant it to be.

HOPPER: Yeah.

SMITH: I just thought you didn't know what you were doing at the end, didn't know where to end it.

HOPPER: How could the guy not know what he's doin' at the end who did *Easy Rider*?

DENNIS HOPPER

SMITH: Come on, that's possible. There are plenty of people who make movies and they don't know what they're doing.

HOPPER: That's true. Maybe I should have shot him off motorcycles and done a helicopter shot. I don't know. Didn't you like that when he says, "I don't have my wound on" and "What's going on; it's only make-believe" and all that?

SMITH: Well, it left me with the feeling that the movie was falling apart in the last ten minutes, because I really liked the movie up to that point. And for some reason, from everything that I'd heard about it, I really didn't expect to like it. I thought it was gonna be a mess.

HOPPER: Can you say "piss" on the air?

SMITH: No.

HOPPER: Okay. Can you say "urinate"?

SMITH: Yes.

HOPPER: Dennis Hopper urinates on his own parade in *The Last Movie*. I mean, in the last ten minutes of the movie, he sort of gives everybody the finger and says, "It was a movie. Think about that one for a while." Because Peter Fonda and I are still alive, I think. In other words, people don't really die in movies so why do people wanna go see them die in movies? Why don't people wanna identify more in a reality level than in an opiate level, in that level where everything is done for them and they cry when the telegram that the man is dying comes, because they have built up this whole thing about this man who—whatever. I just think that that concept can be expanded into another reality...where we deal with reality rather than nonreality, whatever *that* means.

My first cut was six hours and twenty minutes.

—Dennis Hopper

SMITH: I'm not sure.

HOPPER: I'm not sure either....No, I sort of understand what I mean, like I understand what's scratching the surface. If you scratch a surface, another surface appears, and the things change, hopefully.

SMITH: What happens in a place like a deserted area of Peru when you go to make this kind of a movie? How do the people handle it?

HOPPER: They really handled it badly in the beginning. I mean, they didn't handle it badly; I think we handled it badly. We got involved with a priest who sold us some of the people's tiles they were using on their roofs for us to build our sets and there was a riot in the local marketplace where we were building the sets...and this communist leader had a riot because of various things. And I said that I wanted to meet him. They said, "No, you can't meet

him; he's a communist." I finally insisted that I was gonna walk through the village asking for him and they finally took me to him. I talked to him for two and a half hours through an interpreter and I explained to him that we were gonna leave all the wood there for the sets. We're going to tear them down, we're training people to build them, and we're gonna leave all the equipment, all that stuff for them to use, the electrical saws and generators and so on, so they could build a school or they could build a hospital or whatever. I told him that we're gonna hire the actors, and for him to put a wage on what those people would get so that we didn't destroy the economy of that area by paying too much. He listened and he took out a map of the United States said, "Where are you from?" and I pointed to Kansas right in the middle and he said, "*Kansas*—Indian word." We got along very well. Anyway, I said, "We have to hire some people to fix the road, and because it's the rainy season, dirt road, and heavy equipment coming in every day, we're gonna have to keep the road open." The next day I came out, there were fourteen thousand men on the road fixing it, which was really moving.

SMITH: Literally?

HOPPER: Yeah, really literally fourteen thousand. There were ten miles, every five feet, on both sides of the road, men with axes and picks fixin' the road for us. I got to the end and he was standing there and I thought, "Oh boy, here comes the bill. How much is this gonna cost?" They were blowing conch shells and each one had their major dome light. They just came out of the mountains. It was incredible. Conch shells, drums, trumpets. Each group had their own, you know, their own trip going. Hugging us and so on. I arrived to him and he had this big list of people, and I said, "How much is this going to cost?" finally after thanking him, and he said, "Nothing, this is for free. We want you here. You're gonna supply a doctor for us for the kids and so on. Give us transportation into town; we want you here. We'll keep the road open for you." From that time on it was great. The people had fun. It became like a game. We fed the people. It was a great experience for me. I really miss it.

SMITH: Did it permanently change the town?

HOPPER: No, I don't think so. The set was removed. I don't think there's anybody that's ever going to permanently change that place. I don't think the Incas could do it or the Spaniards could do it or a movie company could do it. I think that place is there for a long time.

SMITH: There's something in *The Last Movie*, and in *Easy Rider*—they had scenes about men being very close to each other.

HOPPER: Yeah.

DENNIS HOPPER

SMITH: You even had a campfire scene in this movie that was reminiscent of the *Easy Rider* campfire scene.

HOPPER: Right. A *campy* campfire scene.

SMITH: In both movies there are men getting a very close friendship.

HOPPER: It's sort of the American myth: the guys, the hobo, the going to look for gold. I think of it more in mythology than I do in my actual life. I mean, if I went out to a campfire, I would take a girl. You know what I mean? Even if I was gonna go across country on a motorcycle, I'm pretty sure I would take a chick. I doubt very seriously if I would take Peter. See, I don't consider the character that I play either in *Easy Rider* or in *The Last Movie* [to be] me...it's an acting thing. It's a thing that I felt identified more with those kinds of people that I had observed and hung around, more than *my* feelings.

SMITH: The other element I felt was similar...was the feeling of wenching, of going out after women in a very bravado, very anti–women's lib way.

HOPPER: Absolutely. Well, they do. I mean, I go out after women. But I couldn't approach it on that level. I'd have to be a little subtler, I think—

SMITH: You'd have to be a *lot* subtler—

HOPPER: I think of these things as more what *not* to do than what *to* do. I think of them more as criticisms. Someday I'd like to make a really positive movie...then I can stop being a critic. You know, a critic, a social critic. It's very difficult for me to show any sort of utopian man or woman at this point, so I'm still in the critical level rather than trying to make something that would uplift people and make them see a way that really could be a possible world. I'm still on the thing of criticizing what I've gone through.

SMITH: You were originally supposed to shoot the movie in Mexico?

HOPPER: Well, I wrote it about Mexico, about Durango, but the censor wanted me to change the movie and I had to have a censor on the set. I couldn't show kids without shoes on and dirty dresses. So I just said, "Hey, later. I can't get in the middle of something and have you come over and say, 'You can't do that,'" because you would have a really violent guy on your hands. So I went to Peru.

SMITH: I've heard about you from the *Easy Rider* film.

HOPPER: No, it really takes a lot to get me mad but certain things really get me mad, and when you stop me creatively I get really a little crazed, because you've got all those people there and you're doing your thing...It really takes a lot to get me mad but when I get really mad, I just go blank. Do you know what I mean? There's just—the wall goes down; there's no logic anymore. It's sad.

SMITH: Do you get angry at Hollywood and the studios? I was wondering how someone like you could work within the Hollywood framework.

HOPPER: Furious. I can't work within the Hollywood framework. It was just a fight, and it's just a constant fight. I made my movie outside; just to bring it back and try to get it on the boards has been such a scene that it's just ridiculous. I'm not able to cut it, really. I get furious. But at least I've kept my cool to this point.

SMITH: Well, if it's a successful film, I would *imagine* it's gonna get easier each time. Wouldn't you think?

HOPPER: Not necessarily for *me*.

SMITH: I mean, *Easy Rider* made a lotta money for a lot of people, right? What is its gross at this point?

HOPPER: Something like $40 million.

SMITH: You'd think that they'd say, "Okay, well, maybe Dennis Hopper knows what he's doing. Let's leave him alone." But they don't?

HOPPER: No. They certainly don't think I know what I'm doing, and they certainly won't leave me alone. They have a whole system, these corporate structures, they have to make a decision. Even if you have the autonomy, even if you have the right to do whatever you want, they have to make a decision...So for them to make a decision, they must stop what you do and make a new decision. And it goes on and on and on. It really gets to be double work, triple work just tryin' to get the simplest kinda thing through. *And* they hate the movie.

SMITH: They don't like the film?

HOPPER: They want me to buy the movie back. "We don't want it. We don't wanna put out and distribute a movie that makes fun of business, because business is in bad enough shape as it is."

SMITH: Are you kidding?

HOPPER: I wish I was kidding.

SMITH: Speaking of business, I guess *Easy Rider* made you a very rich man, right?

HOPPER: Wrong.

SMITH: If it grossed $40 million, you must've gotten some money for it.

HOPPER: Yeah, I made a lot of money last year. I made $650,000 and 78 percent of it went to the government. So, yeah, I made some bread but it didn't even pay off my ranch that I bought.

SMITH: You mean that's all you personally got gross from *Easy Rider* was $650,000?!

HOPPER: Yeah, net profit.

SMITH: Wow. You musta had a terrible deal.

HOPPER: Yeah, I had a lot stolen away from me. I worked for no money at all. I ended up on a percentage. It was a very, very small percentage, as you can figure. Really small, but there were people who made a lotta money.

SMITH: Was that what the basis of your lawsuit with Peter Fonda was about?

HOPPER: Yeah. But I dropped the lawsuit.

SMITH: How come?

HOPPER: I just didn't wanna get involved. Karma is karma, man. Just, like, let karma come down. I just figured at that point that if people didn't wanna do what they'd said they were gonna do, then I didn't have to take it into court. Just forget it; write it off.

SMITH: How about with the studio? Would you do the same thing if you were cheated by the studio?

HOPPER: There was one thing I found out about lawsuits. It takes as much money, if not more, to do a lawsuit as what you get out of 'em. Lawyers are really expensive.

SMITH: And a lawsuit can take years.

HOPPER: And that's just normal kind of business trips with lawyers. It's not a big lawsuit. I don't know. I would sue, I suppose, if I had to, but it would be just a dramatic ploy to show people how really corrupt some people are. People-in-the-corporate-structure people.

SMITH: This magnificent press kit has all kinds of quotes: "I believe that symbolism, realism, and mysticism are one." "I want to be real surreal." "I would like to make other kinds of movies, but until the world straightens up I'm going to keep on making movies that torment the world the same way the world torments me." Where did these quotes come from? Did you write them for the press kit?

> **It's like having a child and suddenly you cut its arms off, its legs off, put its eyes out.**
> —Dennis Hopper

HOPPER: No, they're notes and things that I wrote when I was writing, with Stewart Stern, the movie. They were things that I was giving to him so he could understand my idea. They're abstract ideas but they're ideas that I feel deal with the film. They were done in 1965 when we wrote the film.

SMITH: You mean this film was written before *Easy Rider*?

HOPPER: Yeah. I couldn't get it financed and Peter and I sort of computed out *Easy Rider* and did it. Which, listen, I loved *Easy Rider*, but, you know, it was designed to do what it did, and then the next thing I wanted to do was this movie, because this is a movie I really wanted to make. I

personally feel it's just a much more important film. I don't know how an audience will react to it. It got best film at Venice, but I don't know what that means to an American audience.

SMITH: Why was I prepared not to like it? Because that is the atmosphere that the film is opening in at this point. I think a lotta people go to it thinking…"Crazy Dennis Hopper is back again."

HOPPER: Crazy Dennis Hopper rides again. They're right. They never called Van Gogh sane. I don't know. I'm a filmmaker. It's my second movie. Made *Easy Rider*, now I made *The Last Movie*. If crazy Dennis Hopper is back again, he's back again.

SMITH: There's a film that I don't think was released through regular commercial outlets—it mainly went to colleges—called *The American Dreamer*, a kind of documentary about you, made by Kit Carson and Larry Schiller. I came away from that film really disliking you.

HOPPER: I came away from it really disliking me too.

SMITH: Was it an accurate portrayal of where you were at, at that point?

HOPPER: Well, let me put it to you this way: They came in and they did a documentary, in the middle of my editing, in eight days. The last three of those days they imported like forty women.

SMITH: Whose idea was that to bring the women in?

HOPPER: They said, "You must really be tired of editing," and I said, "Yeah, it's really like being in a prison, editing." They said, what would you, you know, [want]? I said, "I'd just like a little time where I could think by myself." They said, "No, if you could really do anything, man, to relax yourself, what would you do?" I said, "Well, I think I'd take three girls down to the hot springs, and that would really be great." They said, "Well, why not ten?" I said, "Why not thirty? Forty?" You know, what do *I* know? And eat watermelon and have foot races, right? This is the middle of the winter by the way. But I said that I thought that would really be groovy. They said, "We'll bring 'em in." I said, "Yeah sure." I kept editing, and one day they *arrived* and I went *ugh*.

But what I resented was not that, but the way that they edited the film. And I gave them the rights; I said, "Look, if somebody's gonna do a documentary on me, I wanna give them the rights to edit." I don't wanna, like, have control over it. If it's a bummer, it's a bummer. The way they cut it, I felt that it looked like that I had a herd of girls running around, leaping through the fields and so on. I mean, you know, the lonely guy walking out there and editing and working may not have been very exciting—it may have been even a bore, maybe even a little pretentious—but

that was much more of a reality. That other wasn't a reality. That other was a total fantasy trip and, as far as I was concerned, an exploitation kind of thing.

SMITH: So why did you do it? I mean, you got into the bathtub with the nude girls.

HOPPER: Well, now…wait a second. Hold it. I'm not talking about the bathtub sequence. I don't mind the bathtub sequence. I sort of enjoyed that. I'm talking about the sensitivity encounter because we didn't—there wasn't an orgy; there wasn't a scene. I tried to have a sensitivity encounter session with them, and talk with them. And I just felt that it was cut very badly, and that the important things and the lead-in to them were, like, that it wasn't there, that it was tryin' to make it look like something else that it wasn't. It didn't come off as a sensitivity encounter; it came off as, I don't know, Charles Manson or something. But it was something that was quite—it ain't my everyday life, I'll tell you that. It's not even the kinda movies I'm into. I just felt it was a rip-off. And especially since I thought they would release it after my film was out. They just got it out, bang-bang-bang, and they had it finished in a month and out. And I had it that they would only play it at universities, and suddenly they were playing it everywhere and I finally had to sue them to stop them from showing it in theaters, because Universal was about to sue *me*. But, I mean, they broke all their contracts, all their pledges. I did it because Kit Carson was a friend of mine, and Larry Schiller came in and just overpowered Kit and just laid it out, tripped it out…But the movie, to me personally, is a bummer. I didn't like it.

SMITH: During the editing of *Easy Rider* I understand that at one point it was more or less taken away from you…what was the story with that?

HOPPER: My first cut was six hours and twenty minutes. The second cut that I liked was three hours and forty minutes. And the third cut was two hours and forty minutes. Then I got it down to two hours, finally. I said, "That's it." And they said, "That's not it. Get it down to ninety minutes." I stayed with "That's it" for about a week and then everybody jumped in and started doing numbers. Jack came in and did a little something. Peter came in and did a little something. Bert Schneider did a little something. Bob Rafelson did a little something…And I'd look at it and I'd say, "I hate it," so they'd try another thing. Even Henry Jaglom tried a few things. But I made the decisions on what was happenin' there… Mainly I was into really heavy riding trips and I had the whole United States…I found it really exciting. That was the main length problem.

Nobody really recut; they just chopped out things. I mean, there were at least fifteen campfire scenes that are not in the picture.

SMITH: Fifteen campfire scenes? Do you think people would go to see the outtakes?

HOPPER: I would hope so. Some of them are really—

SMITH: You ought to do that! Now that it's not being released anymore, you oughta put out a two-hour outtake version.

HOPPER: We could do a two-hour *ride*, across the United States. And we could do a whole thing of campfire sequences.

SMITH: I don't think a lotta people realize why there's this big effort to get the movie down to an hour and a half.

HOPPER: It's like nobody plays a ten- or an eight-minute cut, usually, as a record. I think Dylan sorta broke that one, but you don't play them. You play, like, three-, five-minute cuts usually, don't you?

SMITH: So on FM we play pretty much whatever we want. But on AM radio that used to be very true, and nothing over three minutes, really.

HOPPER: So they feel the same way. Besides, they can make a double bill— they can show it later with another film if it's an hour and a half. They feel that most people don't want to stay longer than that....I don't know; I just want to make movies. But I'd like to make movies that people would see, that would be entertaining and yet educational in another way too.

SMITH: I mentioned to you before I had just finished directing a movie. In fact, we finished shooting last Thursday...We also have forty hours of film, and we're just beginning to edit now. We gotta get it down to an hour and a half.

HOPPER: It's the most painful part of it. It's like having a child and suddenly you cut its arms off, its legs off, put its eyes out. I mean, it's just really, *shew*, you're throwing things that you really love away. It's really rough. But it's great, though. It's really tiring and mostly mentally tiring and exhausting but, it's a compulsion. It gets to be something that you don't necessarily want to do—you *have* to do it, because, like, you really love movies.

Jerry Rubin
October 1971

In February 1970 Jerry Rubin and his Chicago Seven codefendants were convicted of "crossing state lines with intent to inspire riot" at the 1968 Democratic National Convention. While being held in the Cook County Jail, Rubin wrote his second book, We Are Everywhere. *Last month inmates at Attica State Prison seized control of the facility and issued demands to improve their quality of life. The standoff lasted for four days, until the chief of the New York State penal system, Russell Oswald, with the consent of Governor Nelson Rockefeller, ordered in the National Guard. Forty-three people were killed, including ten hostages accidentally shot by the guard.*

..

SMITH: How you doin'?

RUBIN: Great. Rockefeller and Oswald were just indicted for murder.

SMITH: They were? Who indicted them for murder?

RUBIN: The people of the state of New York, in a transcendent trial that went beyond the court system, because the court system won't bring 'em to justice.

SMITH: Where was it held?

RUBIN: In Brooklyn at a hotel, in a courtroom, and there were judges and they were all represented. They were asked to show up, and they didn't show up. So people acted in place of them, but just said the lines that Rockefeller and Oswald—and Nixon, who was also indicted for murder—have said publicly. And the jury was about thirteen seconds before it returned its verdict, because the evidence was so clear that Rockefeller and Oswald just murdered forty-three people.

SMITH: Was this meant to be a fair trial?

RUBIN: I don't know what a fair trial is, exactly. It was meant to lay facts that aren't laid before people out, and they had their defense; and for the prisoners to have their say. A forum for the prisoners.

SMITH: Were there any prisoners there? I mean, ex-prisoners?

RUBIN: There was an ex-prisoner there. It would've been very good if some of the prisoners could've testified, but even letters that prisoners

THE SMITH TAPES

sent specifically for this trial were stopped. It was the first Peoples' Trial I've ever attended, and it was really good to see Rockefeller and Oswald in the defense box and us the prosecutors, the way it should be.

SMITH: Something I've been wondering, and I wonder what it looks like from your position at what I think must be the center of "the Movement"? "The Revolution"? I don't know what to call it—

RUBIN: No, *flank*. We're a flank.

SMITH: Is it all over?

RUBIN: Oh, no, definitely not. It went through a bad year. But San Diego will show you that it's not all over—San Diego will be the biggest human explosion that's ever taken place in the country. Nixon hasn't solved any of the problems. But…people don't demonstrate because they know they'll have no influence, no effect on Nixon. And then people get very depressed, and that's what's happened.…I think the Kent State murders were, like, the end. 'Cause then people saw, "We're gonna get killed *and* we're gonna have no influence." So people got very internal, started examining their own lives. Good things've been goin' on, too. The growth of communes, women's liberation, gay liberation—these are good things that are goin' on. So it's not been all bad. But the public, visible demonstration aspect was killed by repression. But it's only temporary.

SMITH: You don't think there's a possibility that the reason why everything kinda fizzled is that people were treating it as a fad, and the fad is over?

The media's always declaring the revolution over.

—Jerry Rubin

RUBIN: No, definitely not, because peoples' real lives are totally involved.…And it's gonna go on. There's gonna be a revolution in this country. There's no doubt about it. The capitalist imperialism is gonna be destroyed.

SMITH: Even though so few people show up at demonstrations?

RUBIN: If you look to the Russian Revolution and the Cuban, there was a big splurge and then it went dead for about two years. And then, *boom*: the revolution. That happened in Russia, clearly. There are historical parallels for what's goin' on right now. Everything goes in cycles—

SMITH: Do you think the situation here in this country, at this point, is at the level that it was under Batista in Cuba?

RUBIN: No, I'm not saying there'll be a revolution within a couple years, but in the long range, within twenty years. We're so close to what's going on right now that we shouldn't get blinded by—it's a temporary down period. But I've been on the campuses for the last few weeks, and [there

are] huge crowds, a lot of excitement....People wanna get back in the streets again. I predict it's gonna happen.

SMITH: Then how do you explain that *New York Times* article, "The return to apathy, beer, and wine"?

RUBIN: The media's always declaring the revolution over.

SMITH: Well, they also declared the revolution was coming—

RUBIN: No, after. The media's always about six months behind. They're never ahead. Like that *Time* magazine article, there were some elements of truth in it. But it didn't discuss any of the causes....It says, "There hasn't been a demonstration for five months, therefore the revolution's over," without seeing it as a dialectical process. When the next wave of guerilla war begins, it will be at a higher and more fantastic rate than before 'cause people have been preparing for it in the past year in their own psyches. Don't be cynical, Howard.

> **Nixon's done the opposite. He's declared that long-hair people, black people, poor people, don't exist.**
>
> —Jerry Rubin

SMITH: I am cynical, absolutely. From my view, it appears that there's an awful lot of apathetic people....Look, America's a great co-opting machine.

RUBIN: No, it hasn't co-opted anybody or anything. As a matter of fact, Nixon's done the opposite. He's declared that long-hair people, black people, poor people, don't exist. People feel so isolated that they feel that there's no point in demonstrating. It'd be suicidal, so why do it? A while back people thought things were gonna happen real quickly.... And now we see it's gonna take longer, be harder work. It's a lesson. History's teaching us. I'll see you in San Diego on August 24 among a million people in the streets defeating Nixon, and I'll ask you whether the revolution's over.

SMITH: Why do you think there'll be such a big turnout in San Diego? There's not even a contest there—he's obviously gonna be nominated for president.

RUBIN: I know, but we got to defeat him in the election, because if Nixon gets reelected it's gonna be trouble. I think this country is on the first phase of fascism. And I think that if Nixon has four more years without havin' to run for reelection he would have total power. He's gonna do in every area of society what was done in the Supreme Court, which is total repression. And the Democrats are no different than Republicans. But I think we have to work on the policy that no president can get elected in

America. So each year, we throw out the president until we're ready to take over the presidency. And then we get elected all the time.

SMITH: After the large Chicago troubles and anguish—

RUBIN: Who was anguished? I was deliriously happy.

SMITH: But it didn't seem to have much effect.

RUBIN: Oh, yes, it did. What Chicago did was demonstrate America's a police state, which people didn't realize before. It's all, like, the growth of the collective unconscious. Before Chicago, people were very naive about the country and believed that it could solve its problems. Chicago ended that—Chicago was a death of naivete, death of innocence. And after that, people now are on one side or the other.

SMITH: Do you think the majority of the young people want a revolution?

RUBIN: I think the majority are dissatisfied, and that's a revolutional thought. They don't wanna wear middle-class suits and ties and be in the prison of middle-class society; they don't like consumer society; they don't like the United States military industrial system; they know what the jail system's like; they know the educational system's no good, and they know to change *any* of those things is gonna require a revolution, that they're not gonna change peacefully and they're not gonna change because the system wants 'em to change. The only way to destroy capitalism and change the society is gonna be through a total structural change. And that means revolution, and I think young people want that. Anyway, the ruling class will make the revolution, not us. It'll make it by just bungling its way toward revolution. That's the way it usually happens.

SMITH: You mean by repression.

RUBIN: By repression, by mistakes and by trying to control the world—which is what the United States is tryin' to do.

SMITH: With the current China thaw, it looks like it's moving in the opposite way. It looks like Nixon is certainly trying to make an accommodation.

RUBIN: Uh, no. He's goin' to China to win the election.

SMITH: He's gonna win the election.

RUBIN: With that attitude, he probably will, because liberals have given up, and it's up to revolutionaries to say we have a chance to beat Nixon. All across this country, liberals have given up; they're despairing, "We can't beat Nixon." And it's up to people on the extreme, extreme left to talk optimistically in periods of pessimism. Maybe that's one of the roles of a revolutionary, to always be up and get people up. First of all, I'm not so sure that Chinese trip is gonna come off right—what just happened at the UN could hurt Nixon very badly. Secondly, the Chicago demonstration

defeated Humphrey—the San Diego demonstration could defeat Nixon. We have to keep pushing because we *gotta* defeat Nixon.

SMITH: What are you looking for in San Diego? What would you like to see literally happen?

RUBIN: A million people to come. Nonviolence is the necessity for San Diego. We have to be the good guys, clearly. 'Cause Nixon has got [his] PR-people perfect. And he could benefit by repression if he was putting down a violent minority. But if people are just walking the streets, carrying picket signs, even singing "We Shall Overcome," then we're the good guys.

SMITH: You'd like a lot of people to show up thinking it's gonna be nonviolent and what you *really* hope is that it's not nonviolent.

RUBIN: No, no. For example May Day....They arrested ten thousand people and put 'em in concentration camps. Now, let's say they do that in San Diego—I think that would defeat Nixon.

SMITH: In favor of [Edward] Muskie.

RUBIN: Whoever—because we gotta dismantle the Justice Department. We've gotta get the FBI outta the White House. We gotta weaken the police forces. We gotta set the military industrial thing back a little bit and any change of administrations does that.

SMITH: Who do you think?

RUBIN: Muskie will raise people's hopes and he won't be able to satisfy them on any count. Therefore, there'll be more people in the streets. The reason people aren't demonstrating right now is they have no hope. Muskie, Kennedy, Lindsay—whoever gets in–will raise people's hopes: "We're ending the war." "We're doing this, we're doing that." He won't do any of it and you'll see a mass move in the streets. That's my strategy for reviving everything.

Kathleen Cleaver
November 1971

In 1968 Black Panther Party (BPP) Communications and Press Secretary Kathleen Cleaver fled the United States for exile in Algeria with her husband, BPP Minister of Information Eldridge Cleaver, to escape his arrest on charges of attempted murder of police officers. This past March, BPP leader Huey Newton publicly expelled them from the party after an ideological falling-out between Eldridge and the BPP Central Committee. The couple has now formed the Revolutionary People's Communications Network (RPCN) from their international headquarters in El Biar, Algiers. Kathleen Cleaver just returned in September to begin publishing RPCN's new newspaper RIGHT ON!, out of an apartment in Harlem.

[*Live on air*]

SMITH: What is this new newspaper that you mentioned?

CLEAVER: The newspaper is called *Babylon*. We put it out twice a [month. It's an organ of the network to make available, to the community at large, information coming from the revolutionary struggle—from the struggle within the military, within the prisons, the struggle goin' on in a very clandestine level around this country, which has, until this point, had no source of no particular newspaper or communications network designed to provide information to people at large about the developments going on in this country in a revolutionary direction. At the present time, you see the move toward a more and more fascist situation in this country highly reflected *in the media*...The information that *is* available over the media very rarely gets outside the area. So people are dealing with very identical situations and trying to do very similar things in the East, West, North, and in the South, and have very little communication among them. We think that the access to information—the communication among people engaged on some level in the revolutionary and progressive struggle—is very important.

SMITH: Is this newspaper being published out of New York City?

CLEAVER: Yes. We've put out the first issue, and the second issue will be available tomorrow.

SMITH: This newspaper will be just concerned with the black struggle then?

CLEAVER: We're talking about a Revolutionary People's Communication Network, to provide information on a local, on a national, and on an international basis of what is going on inside this country and outside this country, and all the peoples who are struggling against imperialism. We're struggling against either directly or indirectly the government of the United States, and we definitely see the struggle is going on inside this country as a part of the struggles that are going on outside of this country. The national office is in New York and the international headquarters is in Algeria, and we are establishing units around this country and in other countries wherever there is a struggle going on.

SMITH: Is this newspaper being started to give your faction of the Panthers a voice as opposed to the Black Panther paper controlled by the West Coast faction?

CLEAVER: No, listen, the Black Panther Party is a phenomenon of the past, as far as any type of revolutionary organization or any type of contributive role in the struggle in this country is concerned. The development of this network is to go above and beyond the function of any particular organization. A network by definition is not an organization—it's a link-up. We are establishing a format for which various organizations, movements, individuals, community groups, and whatever can link up, receive, and exchange information, personnel, resources, skills on a local level, on a national level, and on an international level. You see, the lack of information inside this country as to the developments going on in the third world liberation struggles, in Africa in particular, is very bad. You don't get information as to what's happening in Europe, very little information as to what's really going on in the struggle of the black GIs—

The black communities in this country are definitely under siege, under attack.
—Kathleen Cleaver

SMITH: Do you think you're gonna be able to get your newspaper to people who want this information but aren't getting it? Or will it be going to people who already agree with your position?

CLEAVER: The newspaper is the organ of the communications network, and there are many sources. The whole underground development, the whole move toward creation of military units in view of dealing with the warfare that's breaking out all over this country—we see a situation in which it's moving toward a people's war. Very gradually, but very concretely. The people moving in this manner have no organ.

SMITH: Do you see the black revolution a part of the bigger revolution that can be happening in this country? Or do you see it as a separate thing.

CLEAVER: We have to recognize…that two things are transpiring as a social revolution: the situation of black people, per se, is a situation where we must fight for our liberation within the context of this social revolution.

SMITH: A lotta people have been saying lately…that the revolution is virtually over. There's great apathy, sparse crowds at demonstrations, divisions in the black movement…

CLEAVER: This depends on what a person considers a revolution. Whether a revolution is a demonstration, or holding a rally, or mobilizing a lotta people in support of a particular issue—[these are] not a revolution, per se. A revolution is a long protracted process of *total change* in a social system. Most revolutionary struggles *involve war*. I can't think of any revolution that has taken place in any country that did not have to go through the process of warfare, and usually it's in the form of, to some extent, a civil warfare, unless you have a country that is just outright dominated by a colonial power.

SMITH: You think that that's what's coming here?

CLEAVER: I see that the same forces that brought about the Civil War in the eighteen hundreds are much more aggravated at the present time, and in the context of the twentieth century I see another civil war erupting in this country.

SMITH: You don't see apathy then, in the movement—

CLEAVER: I see in the *movement*—you see, there're *phases of struggle*—in terms of the movement, in terms of many of the organizations of the past, there's quite a bit of obsolete activity that's falling apart. There's fragmentation, isolation, and many other phenomenons that indicate that the whole struggle in this country is going through a phase of *transition*. For example, you might go to a college campus and find a situation of apathy; when you go to Wilmington, North Carolina, you find the people in the town in a situation of outright *warfare* between the white races, vigilante group forces, and the black community as a whole. The same situation has been going on in Cairo, Illinois, for the past two years— back-and-forth warfare on a day-to-day basis. And we can see, in many other areas where black people live, geographically isolated conflicts can break out. In every city there's a constant back and forth between the police forces and the people that live in that community. When you're aggressed upon by armed militarily oriented forces, what other terms do you use to define your situation? The black communities in this country

are definitely under siege, *under attack*; the attack has been escalating consistently since the sixties.

SMITH: You don't think things have gotten better at all?

CLEAVER: Better for who? The only thing I see that's *better*, is the better conditions for the more full-scale imposition of fascism in this country.

SMITH: What is the situation like in Algeria at this point? Do the Panthers living there have complete freedom of movement and operations?

CLEAVER: We have been given the status of a liberation movement, and viewed as representing the Afro-American people's struggle in this country. We view our work as a international arm of the struggle... We've sent delegations to visit revolutionary countries in Asia, and just recently had a delegation of four people visit the People's Republic of the Congo.

SMITH: What is Eldridge Cleaver's status at this point? A fugitive? Or—

CLEAVER: As far as the FBI and the California Department of Corrections is concerned, he is a fugitive. As far as the Department of the Treasury is concerned, he is a national of North Vietnam, China, and North Korea, so that they can say under the Trading with the Enemy Act he can't receive any monies outta the United States.

SMITH: How about the split at this point between the two [Panther] factions?

CLEAVER: You have to understand that like in any social process, in any struggle for a change of a society, you have many different organizations that crop up at different phases of the struggle to move it to its next higher level. The BPP had played a very significant role in the era of the struggle when we were seeing quite a few urban rebellions in which people en masse indicated that the violent means of moving against a society was something that was quite necessary. And the BPP is an *outgrowth* of this era of the struggle of the mass urban rebellions. The level of the struggle quickly developed into higher and higher forms, and the leadership of certain *aspects* of the BPP—you see, the central committee became the stronghold of the *right-wing* elements in the party. Whereas there's a lot of internal struggle and move to change *within* the structure of the party, it became clear that that move to change and transform 'n' grow had to take place *outside* of the party. Finally the contradictions became too blatant for the movement to change to a higher level, and the movement to stay at a certain position and be more conservative, more legal, more involved with the system—it became too blatant to allow the two different aspects to continue to operate in the same organization. *All* groups are subject to splits and contradictions, but most of them do not have to undergo this under such great publicity. We have to understand

that the situation within the BPP was *forced*, in which there was hardly any other alternative available at that time, for a whole series of reasons, one of them being a profound lack of communication and lack of understanding on the part of people in the West Coast as to what exactly had been going on in the party for quite some time. Especially when you understand Huey Newton was in prison during the *whole time* that the BPP grew from a small group in Oakland to a large national organization with an international arm. When he came out, he really didn't have the information that he would need to make decisions and make judgments as to what should happen in the party. But to everyone's surprise, he moved to support the most conservative and backwards elements in the party, in fact, moved even more so in their direction.

> **It had gone from a situation of purge, expulsion, denunciation, to killing.**
> —Kathleen Cleaver

SMITH: It seemed to become quite violent—it wasn't just an intellectual—

CLEAVER: Not at all. It's a *structural* problem. It was a methodological problem. And also the leadership in the West is a conservative element that was moving in opposition to the bulk of the people who formed the party and made the BPP a reality, found it necessary to wage war against people who took outright opposition to them. It had gone from a situation of purge, expulsion, denunciation, to killing.

SMITH: Are you in danger at this point yourself?...Do you take precautions?

CLEAVER: Yes, we are forced to take precautions. I mean, we recognize that we have all types of enemies within and without.

SMITH: Working from exile—can that be as effective as being here?

CLEAVER: *'Course not.* Once you move outside of the land in which your struggle is being waged, you can work to aid the struggle, work to support the struggle...but in terms of the direct participation, actively on the soil, you can't do anywhere except inside this country.

SMITH: Is the position of your husband in Algeria and yourself that people should only leave the country to become exiles if they *have* to?

CLEAVER: Only when there's absolutely no other alternative.

SMITH: At this point, through a lot of misinformation, it's been perhaps overly glamorized—the idea of being a free spirit, outside of the borders, where the FBI can't touch you.

CLEAVER: The whole move, [for] anyone who's engaged in the struggle in this country to get *outside* is simply...to avoid a circumstance that they can't control. Most people leave so they won't have to go to prison...It's

a maneuver, and nothing more than a maneuver. It's not in any case an end to itself, or a pleasant way to spend your time.

SMITH: How are women being treated by men in the black revolutionary situation?

CLEAVER: This is important, because especially when you look now at a situation where there is a lot of political imprisonment.…So what we have is a lot of women whose men are in prison…the fact that there's more women than men in the black community, and the fact that women are capable of doing just about anything that is necessary in a struggle, and the fact that [there are] many roles that women can play—whether they're in the home or out of the home—in terms of being supportive as well as directly participating in the activities of the struggle, so that is something very, very important. As the situation becomes more and more intense, people realize that they cannot afford the luxury of looking upon a woman as something inferior or something to be kept in the home. This is a phenomenon that develops in all struggles—I don't think you'll find any struggle, in which the people have been liberated, at which the participation of women in that struggle was not a crucial factor. Because *all* the people are oppressed. *All* the people are exploited…Whoever *can* be on the front line *should* be on the front, and whoever's in the rear should be in the rear. But it's not on a sexual basis.

SMITH: Do you feel that you are treated as an equal by the men that you're associated with?

CLEAVER: I feel that I'm treated with as much respect as they feel that I have earned.

SMITH: Do *you* feel, though, that they treat you with as much respect as *you* feel you've earned?

CLEAVER: Well, no, because I'm a woman. And I see that many people still have not managed to bring their practice totally in harmony with their theories. But I don't see anyone that's consciously and deliberately trying to put me down or make me inferior or be chauvinistic towards me simply because I'm a woman.

The government is the most profound minority in this country.

—Kathleen Cleaver

SMITH: PLJ, Howard Smith. You're on the air. Turn your radio down.

CALLER: You said something about an inevitable civil war coming in the twentieth century. It seems to me that the black population is so outnumbered by the white population that they would get completely destroyed and end up in a worse position than they are now.

CLEAVER: We're not such a small minority of the population. You seem to feel that the black people are the only people that feel this way in this country. There are at least forty million black people in this country, and do you tell me if one-half—if twenty million people participated in a revolutionary civil war, what forces are there going to be used to oppose us? The U.S. military apparatus involves about three million men. The U.S. police forces involve about a million and a half—

SMITH: But they have all the weapons.

CLEAVER: They had all the weapons in Vietnam; they're still being moved against. They still haven't won, you see? When the Europeans who came in here and colonized this country were attacked by a much more powerful government, the government of Great Britain—they had all the guns. They had all the weapons. They had everything, but for some reason or another they were not capable of defeating them.

CALLER: You're talking about a black civil war?

CLEAVER: No...You remember the last civil war was not a *black* civil war. And I think the same issues that were at stake in the last civil war—that is, as to which type of economic and political system is going to be established in this country, is going to be at stake again...In a civil war you have two kinds of people: those who want to change the system for something better, and those who want to maintain the system that exists and defend it against any efforts at changing it. Within that context there is a question of the freedom, the liberation of the black people inside this country. Because our particular position has never been really resolved. We've been slaves. We've been so-called emancipated slaves, so-called citizens. We've been given freedom on a piece of paper in writing when the vast majority of us couldn't even read. We've been segregated. We've been integrated....But there has never been a situation where the black people in this country had any say-so over what decision was being implemented for them. You see what I'm sayin'? We've had no form of government responsive to our needs.

One thing that people fail to recognize is that when there's a civil war, it's against the *government*, not against the people. And the government is the most profound minority in this country.

Ravi Shankar
November 1971

Ravi Shankar is back in town and has a busy week: On Tuesday his documentary, Raga, *opens and he'll make an appearance on the Dick Cavett Show. Wednesday he'll be a guest on David Frost. Thursday he'll perform in Philadelphia, and then on Friday he'll be back to play Carnegie Hall and celebrate the fifteenth anniversary of his first American performance.*

SMITH: How do you prepare before you go on stage for a concert? Are you nervous?

SHANKAR: Nervous, naturally. One has to be a little, but not in a manner that you're shaking and your teeth is chattering. A tremendous feeling of *tense.* We have a little more special feelings, this complete involvement with the music, because this is not a fixed music at all—I really don't know what I'm going to play. I just decide about fifteen minutes before what I'm going to play. So it's the whole preparation… it's building up to that moment.

SMITH: Has your feeling about this city changed in the fifteen years you've been visiting?

SHANKAR: In some respect it has. New York has always been my favorite city, from my childhood. I first came when I was twelve, in 1932. I still remember very clearly. Since then New York always had a special attraction for me as a very exciting place full of activity, especially show business, dance, ballet, drama, films. That still remains same, that exciting part. The obvious changes, it has become a difficult place to live, a lot of violence…

SMITH: How about the rest of America?

SHANKAR: Lot of changes, I see, especially among the whole youth of this country. The positive things are very positive, like their great interest in everything. I've noticed a sensitivity; that understanding—it's just fantastic. Only, I have always had little problem for which I'm very outspoken: it's that I want my music to be understood in the correct perspective, which is no problem in places like New York or San Francisco. I have performed many times and people have heard me speak, or resent, against certain things like drugs—at least, the association of drugs with

the Indian things. I face the same problem in the new places where I go, so I have to start talking again and explain them, that this is a music which has to be heard with the same seriousness as listening to Bach or Beethoven. That same attitude, not to mistaken with type of music where you smoke, or neck with your girlfriend.

SMITH: A lotta people associate Indian music with the drug culture, because it came into popularity at the same time. The Beatles were very into drugs at that time and they helped first introduce Indian music.

SHANKAR: It completely went in a wrong direction. Even today it has been commercialized to such an extent: whenever you see a movie where there's carnal desire or where there is this sequence of have a drug or sex or an orgy, you have that playing of sitar, played very badly, and that's what hurts me very much—this whole *association*, you see.

SMITH: How about in India? Are the serious musicians into drugs at all?

SHANKAR: Well, you find once in a while a person is addicted, but his addiction has nothing to do with the music. According to our system, that's absolutely against it. You find sometimes some alcoholic, but the percentage is very low—it just happens that someone is, but it's not the association which has been like the jazz, for instance, in this country for so long. We take our music almost like a spiritual experience, and it is so closely connected with the whole religious and spiritual life. That's how it has been kept through centuries and that's how it has been given to us through our gurus [and] teachers.

SMITH: The film of the Monterey Pop Festival did more to further your popularity in this country than almost anything up until the time of George Harrison. I remember the people being electrified who saw that.

SHANKAR: If you were there, you would have felt the same thing. It was one of the most remarkable experiences in my life, performing in Monterey. I had almost four hours to myself. It was an afternoon program; it didn't have anything before me *or* after me, not like Woodstock. It was fantastic. It was so inspiring.

SMITH: How about Woodstock? You were there also.

SHANKAR: I didn't like it.

SMITH: You didn't like that?

SHANKAR: Not at all. As far as I'm concerned of my music, I was almost sorry that I was there. Because I think it was a great happening, one of the historical events—a great picnic party, and wonderful things happened there—but musically, I don't think, no...The whole vibration was different.

SMITH: Even though they started with a swami?

SHANKAR: Even that.

SMITH: That was one of the classic culture clashes—Swami Satchidananda arriving by helicopter, surrounded by people throwing flower petals at him, marching up to a stage with thousands and thousands of watts of amplifiers.

SHANKAR: No, that wasn't very happy. Because also the weather condition, remember, the rain and thunder—and they had no arrangement of covering anything. My instrument was almost ruined; for one month, I didn't get the proper sound out of it afterwards. Alla Rakha's drum was completely—it cracked afterwards. It wasn't at all [the] atmosphere for us to be there. And especially there was so much of drugs, the whole area. You know, my incense was nothing—just two, three sticks of incense couldn't cope with it. A few hundred thousands smoking something else and the whole aroma was...But Monterey was really a beautiful experience. That was when there was the feeling of flower and love and everything.

SMITH: That was right at almost the peak of the flower power era, when we thought that was going to rule the world.

I am what I am: a classical musician.

—Ravi Shankar

SHANKAR: I have been to a few more rock concerts. I was invited, but I had promised never again because I've seen things that I can't believe anymore, that happens now. It's "bad scene," as you say. Lot of violence, and people do just about everything that you can think of.

SMITH: The Bangladesh concert at Madison Square Garden—how did that originally come about?

SHANKAR: It was very spontaneous, because George had come to Los Angeles. He was helping in cutting the album soundtrack from the film *Raga*. This is when I was very, very disturbed, because I had a lot of letters from home saying many of my distant relatives who were in that part [of] Eastern Pakistan who fled away and came to India. And they had to leave everything—some people were dead and some were dying. Then I heard news of my guru's family, who comes from that area also...many had come to Calcutta as refugees, and also some were killed...So all that news disturbed me quite a bit, especially this refugee thing—reading the newspaper and getting letters all the time—what a big problem it was. I thought of contributing something substantial. By that time, a lot of Indian student associations in America were planning to attend my

concerts, but each of these concerts made $3,000 or $4,000. I thought that was not enough, so I was planning to ask some friends and do it in a big way. Luckily, George was there. I told him frankly that I think [that] something [had] to be done in this respect. He was very moved by this. Within a day or two he wrote this song, "Bangladesh." It just started like that, and before we knew, within a week we had planned this [concert]. Telephoning back and forth, he tried to talk to some musician friends, like Leon Russell, and they were all nice to agree. Within three weeks we gave the performance. It was the shortest period of conception and planning and execution.

SMITH: Is George Harrison a good sitar player?

SHANKAR: George started it, and he would have been *very* good sitar player, I'm sure, because he has talent and the love for it. But he realized it himself—and he admits it—he gave it up because he really couldn't give that much time to it, being a very sincere person and being committed to so many other things. But he's very much involved with the music in general. It still inspires him; he still learns as much as he can, but not to perform—more to soak in.

SMITH: I was curious how you felt—you're considered one of the finer musicians in the world, but in the Western world you're kind of under his shadow...

SHANKAR: That's very natural and I'm not at all sorry about it. Think of any classical musician for that matter. They might be very popular in a particular set of listeners or groups, but they can never match the popularity of a pop star or a rock 'n' roll star, which has always been the case, or a film star for that matter. I am what I am: a classical musician. It just happened, this association; it was not planned. It did help a lot in sitar becoming very popular, and I, along with sitar, became very popular, that is true...but at the same time, being a classical musician, I like to see people come to listen to me. But it depends upon these people—some of them just come for the curiosity, because [of the] association of George, right? But once they come to listen, if they like the music on the song's merit, then it's nothing to do with George. Then they become a fan or admirer of Indian classical music.

Into.

Stereo 95½

WABC FM Howard Smith interviews and comment.

"Scenes" radio show advertisement, 1972

1972

Allen Ginsberg and Bhagavan Das
January 1972

Poet Allen Ginsberg bridges two worlds: he's a figurehead of the counterculture and has become deeply involved in Siddha yogic practices. Howard Smith invited him, his close friend yogi Bhagavan Das, and his partner and fellow poet Peter Orlovsky, to WPLJ to perform a puja (prayer ceremony), on the air, for all of New York City. Ginsberg, Bob Dylan, and friends recently recorded improvisational jams at the Record Plant, including the activist track "Going to San Diego," about the Republican National Convention looming this summer. However, at the last minute, the City of San Diego will renege on hosting the convention, and it will be moved to Miami.

..

[*Live on air*]

SMITH: Our guests tonight are Allen Ginsberg and Bhagavan Das. And they're going to start off with a twenty-minute musical offering: it's an invocation to purify the city.

[Music plays]

SMITH: I'm curious, how did you get into this? Allen said that you were originally a California surfer?

BHAGAVAN DAS: I left America and I went to Morocco, and I lived all over the north part of Africa. I was singing on the street with guitar and harmonica, and then I went to India. When I reached India I felt that I had come home....I took off my shoes and I gave my pants away to someone, took off my clothes, put on Indian dress, and wandered off through the streets. I lived with wandering bands of holy people in India called "sadhus"—virtuous people. I lived with these wandering bands of primitive people who live naked and chant the name of God continually. They renounce the worldly life.

SMITH: How long ago was that when you first went to India?

BHAGAVAN DAS: 1965.

GINSBERG: There were a whole group of young Americans that set out for India around that time, of which Bhagavan Das is one of the most

accomplished, in terms of having gotten down into the root of the culture and the root of the religion and the root of his own body.

SMITH: How much chanting do you do a day? Allen, you said that it helps calm you down.

GINSBERG: That was the sitting I was talking about, really. The meditative sittings, silent sitting. I do about an hour a day.

SMITH: Because I've known you on and off for fifteen years now, and you have as much energy, drive as anybody I know. It really works?

GINSBERG: Sure, it works. Can't you see? Can't you hear, folks? Hear in the sense of that deep, vibrant *huuuh* sound that comes from the middle of the body that the Bhagavan Das has, for instance, and I get sometimes... Well, he's a pro: he's doing that all the time. My sansara is poetry, which is a little different. It works in the sense that...the calm center gives you a place out of which to strike like [a] lightning bolt.

SMITH: I meant more on an emotional, psychological level in your life. It keeps you from becoming manic?

GINSBERG: Well, it keeps me from getting hung up on boyfriends that don't wanna sleep with me, for instance. So I can always have someplace to go and sit down and be quiet and stop perturbing myself with the great thorn of sex, for instance. Or the great thorn of God or the great thorn of me or the great thorn of Nixon or the great thorn of war or the great thorn of having a big foot in the middle of sansara. But I wanted to move on just for a few moments before midnight comes, while people are still awake, to a project that I've been working on for the last couple months, since late November. Been making a record on sixteen tracks, which has involved myself, improvising in a studio with a lot of very good musicians, including Happy Traum, a great blues man and the author of many books on blues, and Dylan also, playing, accompanying, on the album. David Amram, composer, jazzman, and French horn player...

SMITH: Friend of mine also.

GINSBERG: So last October 31, Peter Orlovsky and I gave a reading at NYU, and apparently Dylan—whom I hadn't seen in some time—called up Amram and said, "You wanna go?" So Dylan and Amram went to the poetry reading—we didn't know they were there—Peter and I went through this funny poetry reading, which was Peter's first poetry reading in years after Peter had been for many years out of the city doing his own thing, growing food....I think that it was the first time Dylan had heard us reading together or even perhaps heard me read at a large public scene. 'Cause he'd been to the Metro years before, which was a little, small, tiny poetry thing.

SMITH: On Second Ave., right?

GINSBERG: Second Avenue and Tenth Street. Near the present St. Mark's Place. St. Mark's and the Bowery Church, where readings are held every Wednesday night, organized by Anne Waldman and her poetry friends. So that night Dylan came over [to] the house and picked up Denise's Guild guitar and began strumming on it and I began singing, "Goin' down to Puerto Rico" and he was strumming whatever he was strumming, and I made up words and he started laughing and said, "Can you do that?" and I said, "Yeah, I used to do that with Kerouac a lot." So I began improvising and he played, and then he said, "Why don't we do this in the studio?" So the result was a record, which Apple will presumably put out, 'cause the first acetates of that were delivered to Lennon and Yoko Ono yesterday—to Dylan also. And we have some of the tapes here. So for the first time in recorded airwave history, we'll have portions of what is tentatively titled *Holy Soul Jelly Roll*.

I have a little peace-demonstration, mind-consciousness, be-in poem manifesto that I'd like to read.
—Allen Ginsberg

SMITH: That's what the album is gonna be called? It has you singing—

GINSBERG: Me singing and the lineup is…chorus would be Anne Waldman, the celebrated head of the Poetry Project; Denise Filieu; and Peter Orlovsky. And the musicians are Amram on French horn, Happy Traum on bass, Bob Dylan on Guild guitar. There's a drummer, [Steven] Muruga [Booker]…Perry Robinson, celebrated clarinetist, in and out of some of these numbers. The first one you have is—

SMITH: "Going to San Diego."

GINSBERG: "Going to San Diego," which was an improvisation in the studio. It says, "Come to San Diego," folks, but I don't mean it that way. It was what we did in the studio. It was a poem of the studio, made in the studio, made up within an hour, I think. I babbled a version of it into the microphone and then listened to it and then decided, well, why not write it down? So I wrote it out, while the musicians waited or fiddled around with other things. So it's like a little lyric— not intended as total political propaganda, not intended as absolute instructions, but intended as an idealistic suggestion of how to come to San Diego if you go to San Diego for the Republican convention.

[Song plays]

GINSBERG: In relation to that I have a little peace-demonstration, mind-consciousness, be-in poem manifesto that I'd like to read. Just in case

anybody does go to San Diego. "Going to San Diego" means, like, during the Republican convention—not a repeat of Chicago '68. As you know, John Lennon and Yoko Ono and Jerry Rubin were also planning to make a San Diego "scene" maybe, or were interested in fantasizing what would happen going there. So this is my fantasy what we might do in addition to the song, if we go.

[Recites poem]

"Mind Consciousness Be In San Diego"

Invite police blue helmeted and navy so sweet
Together guarding an organizing rock mantra silence festival.
First day.
One day of silence
Or more.
One day complete silence.
One day of mass mantra.
One day of terrified gentle rock stars singing in tears and prayer.
One day's sensitivity party melee holy man jam encounters session
 with delegates on island.
(There's gonna be an island there where everybody'll gather,
 perhaps.)
Autos banned from the freeways that day maybe.
Festival throughout the concrete troughs of the superhighways of
 San Diego ending with rock, joy high.
One day listening to candidates, Democrats and elephant, August
 '72.
Use the police as your friends and protectors paid for by your state
 monies.
Equal desire and war.
Work on your, their, our...desire.
Accept Nixon. Invite Nixon.
Safe as China!
(Invite Nixon to the rock festival. Obviously, if you can go to China,
 you can come to visit us.)
Jerry Rubin and everybody, Lennon, Yoko agree. Nonviolence.
Stop Nixon! By accepting him.
Pride. We take credit for helping elect Nixon.
(We did. Didn't Jerry Rubin say he helped elect Nixon? That we all

helped elect Nixon after Chicago '68? So pride! We take credit
by helping elect Nixon.)
Disgrace? He's our president. We helped—he owes us our votes.
(Especially more since the eighteen-year-old vote.)
Eighteen-year-old vote be-in.
(So whatever goes on in San Diego might be an eighteen-year-old
vote be-in.)
Our candidates? New voters' convention.
(It could also be called a New Voters' convention.)
Don't trust anyone over twenty-one. Let the children speak their
energy, in what work electrifying or silent island form.
Food, fantasy tents, and gurus. Each his hut or pavilion of cardboard
windowsills.
In the moonlight singers in the alleys as on Jessore Road in India,
while girls dressed in light blankets dream of North Pole gods.
Address to the convention? Now where are the YAFs? Will they be
there? A delegate of YAFs with short hairs and one long conser-
vative blond Prince Valiant goy and one Black Prince to speak.
Blake's Christ be the image—a white-robed, radiant, fine-featured,
silken-bearded, gleaming, starry symmetry face dazzled with
powdered mirror glitter rouge cheeked with rosy thwarted pinky.
Bannered "President of the Universe" waving in the blue sky.
Opening the mountain—the ceremony.
The dedication of Turtle Island.
(Turtle Island is America. As those on the West Coast now know
through the preaching and philosophizing and anthropological
research of Gary Snyder, this nation was called by the American
Indians, particularly those of California, "Turtle Island." The
whole continent. It was always known as Turtle Island and *is*
actually Turtle Island, and the sooner us honkies realize it, that
we're living here on Turtle Island and not America, the better off
we'll be in terms of our perspective of where we are and what
we're doing. And how we're gonna treat Turtle Island. I think
Gary Snyder, the poet, anthropologist, and Zen-adept tantric
scholar and radiant brain, has been living the last few years—
Indian style—in the Sierras of California. And he's cultivating
and projecting, proposing, more and more publicly, that we shift
our terminology for America and realize it is Turtle Island. So
we might have a ceremony in San Diego called Opening the

Mountain, which is like a—what's the title for ceremonies for
dedicating temples or pilgrimage places or opening mountains as
temple sights for walking around, *circumambulation*? We might
have a mountain opening ceremony for Turtle Island.)

To her peoples, dedicating Turtle Island to mankind, to her inhab-
itants, namely mankind, redwoods, coyote, cockroaches, and
worms.

One day's worship of Mother Nature.

Sunrise in her blue belly transparent.

(So what I'm doing is proposing different days' services, different
days' activities.)

Ecologic nominations and all their totems paraded.

(That is to say, nominate different animal totems for protection
by different senators and representatives, as was done in San
Francisco already in a ceremony about a half year ago. The
ecology people there made a list of all the endangered species
and assigned each endangered species to one senator and one
representative for his personal protection. Like the bald eagle,
I think... We might've even given it to Goldwater. You know,
because he's worried about that kind of starry majesty.)

Then another day's Great Brown Rice Feast For All—the Swami
Special.

Minstrels strolling.

Politicians discoursing cross-legged on-blanket at noon.

No alarums. A-L-A-R-U-M-S. No alarums. No harsh noise.

Maybe the rock speakers.

Helicopter sticks waving noisy boys.

(The police, you know.)

PA system, along with festival convention lanes, question mark.

Pompeii's marble brick skeleton, one story high.

Loudmouth stars preaching, "End the war."

Nostalgia night.

Invite McCloskey. Invite all the Republican candidates for nostalgia
night.

Gotta get TV coverage and radio.

Demonstrations in every home.

Apocatastasis.

Do you know that word, Bhagavan? *Apocatastasis.* Transformation of Western satanic forces to divine forces. Transformation of tamasic energy to Sufic. *Apocatastasis.* Very interesting word.... The transformation of satanic forces to angelic—meaning transform Nixon to bodhisattva. In fact, the one way we might succeed in transforming America might even involve Jerry Rubin giving a great speech accepting Richard Nixon. Blowing everybody's mind. Blowing his own mind, blowing Nixon's mind, pulling the rug out from everything. I mean, that's obviously a more interesting approach to a mind-blowing scene than loudmouthed, bring-down, bad-noise violence. Do you have a... speech?

SMITH: I have a word. Completely out of place at this moment, but nonetheless:

[Reads ad copy quickly] "It's hard enough just to find some of those incredible leather goods that the Stitching Horse sells. But it's even more incredible when you can buy those things for less than they usually cost. For example, you can pick up a beautiful leather jacket for about 40 percent less than it used to go for... 156 East Sixty-Fourth Street. Open eleven to seven." Phew.

GINSBERG: *Hum ahum, hum ahum.* Is there a sort of a little benevolent mantra we can do to take care of all the leather? And all the animals? A short thing to bless the animals? Gary Snyder has a prayer for food—his grace for food, very short, sweet, direct. "We give thanks for this food, which is the product of the labor of other people and the suffering of other forms of life." We give thanks for this coat—which is the product of other people's labor and the suffering of other forms of life.

> **The transformation of satanic forces to angelic—meaning transform Nixon to bodhisattva.**
> —Allen Ginsberg

Relating to politics, a letter I received from the immortal Ken Kesey about three days ago—I had written him a postcard in Oregon asking what he was up to, 'cause I was gonna go out West, and I got this big funny letter back, received January '72: "Dearo Ginsy, I always enjoy hearing from you. It makes me feel, I guess the word is trustworthy. I'm in Mexico alone and working. Faye and kids having just flown back to Oregon after a nice vacation. At the end of the month I head Statesward in my '65 Chevy paneled toward University of Missouri RFK Symposium, where I hope to rendezvous with Ken Babbs, Paul Krassner, et al and work for the university journalism department covering the various heavies who are speaking during the three-day mind mangle. (The mind mangle he's referring to is

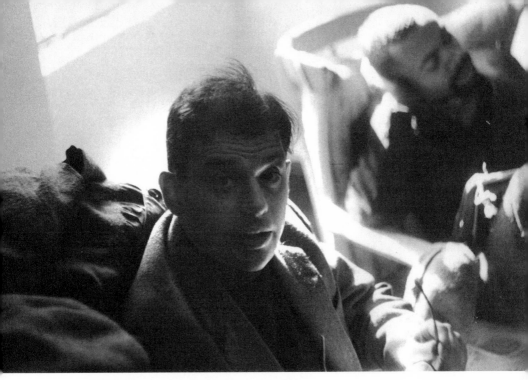

Allen Ginsberg and Amiri Baraka, N.Y.C., early 1960s

at the University of Missouri, where Susan Sontag, Paul Krassner, Ken Kesey, whole buncha intellectuals are all gonna get together.) The latter to be hopefully part of our new magazine (pay attention now, this is Kesey's immortal plans for the year) we are forming called *Spit in the Ocean*. A publication that will travel to periodic hot spots and emit from there daily, and then appear later as a nationally distributed magazine. Maybe distributed by people like *Mad* magazine people. And won't you join me? I could sure use you in my forthcoming, to be announced, formation of a third party to try to field us some candidates this November. If I can pull it off, literally that is, we would then move on eastward, speaking and forming third party chapters at all possible universities, setting up centers and leaders by audience vote, taking up collections to stay with the chapters so they can rent a headquarters and get a phone, and moving on trying to finance our scene with journalistic gleanings from the experience. Oh! The more I think of it, the more I would like you to join. So really consider it. Didn't we go along once and give you company on one of your junkets to Bellingham? Hmm? Love, Ken."

So that's a really interesting proposition. Considering the proposition here from Yoko and John—the possibility of their taking a tour of the

ALLEN GINSBERG AND BHAGAVAN DAS

States seeing all sorts of interesting hot spots and raising money for woefully persecuted folk or worthy causes or happy, eternal, sprite demonstrations. The energies of people like Rubin and Lennon joined with the American perceptiveness of Kesey. This letter's really interesting. It's the first time I've seen him for several years now coming out with a big formulated plan. He's been talking for several years about wanting to find a form that he can come out and work with, going through schools or through America, so the letter's a kinda hopeful sign.

Now my own feeling about it, not to create a hysteria or a rush—'cause I was talking on the phone with Yoko Ono after your program the other night, when they had been discussing that. She said, "Well, maybe we're all talking too much about San Diego also." And that may be true. And I agree 'cause I don't want to commit myself to doing something that's going to end up with people getting their heads busted. Or with me getting *my* head busted. But I wouldn't mind committing myself to, like, a great Kumbh Mela. Which is to say, all the spiritual and eternal vibes in everybody's bodies got together, with all the holy men around, and all the political wise men around, everybody getting together without rancor, in the center of the Republican scene. Without rancor. Even attempting to invite the Republicans into a larger scene than the one the Republicans are making. A manifestation of the possibilities of a new nation, right in the center of the anxiety of a Republican convention, would be a great thing. And I think the Republicans would go along with it, 'cause everybody wants to have a good time.

SMITH: From what I've heard, the City of San Diego didn't want the convention in the first place, because they were very afraid of the violence. And all their officials are just hoping that they can keep it calm.

GINSBERG: Everybody who's talking it up is absolutely concerned that it be nonviolent also. I talked to Rubin about it a lot. All the people on the left are completely sure they don't wanna have a violent scene... 'cause they know they won't get away with it, and also it will just precipitate a horror movie for everybody. So the only thing we have to worry about is our unconscious. The other thing we have to worry about is there's always gonna be some marginal freaks and nuts who, despite the party line, wills it done some egocentric form of violence. Like the other night at St. Mark's Church—

SMITH: What happened?

GINSBERG: I had a big four-hour poetry reading and everybody groaning and singing "Hare Krishna" and "Merrily, Merrily Welcome in the Year,"

but there was still a couple people who broke the peace and broke the calm and broke a couple windows....

SMITH: They were inside?

GINSBERG: One girl just walked into the church and broke down a window or two and started banging down the microphones. Coming from another universe, another scene. It was somebody with her own demon. One or two lushes: people on downers or drinking. So there's that to be expected. But there's no reason the normal police can't handle those people. Why not? You know, if they're going to come on, then let the police take care of 'em. "Let the police keep the peace" is what I'd say. I would invite the police in to keep order, make 'em keep order. That's what they're paid for. Anyway, no. Whether that fantasy is acceptable or not...But actually opening up first day with a day of total silence and meditation. And ideally, inviting all the now-great assembly of holy men in America to come, like all the Tibetan lamas, Swami Satchidananda, Bhaktivedanta, all their groups—a large-scale holy man jam. The phrase I used before was *Kumbh Mela*, full picture, which is an Indian term: every twelve years there is a gathering of all the holy men in India into one spot.

SMITH: Of *all* the holy men in India in one spot? Like, what do you mean—like, thousands?

GINSBERG: Millions. A Woodstock that lasts three months. The first thing, the important thing, the length of time so everybody gets to know each other and live there in a little city.

SMITH: But you meant literally a million people?

GINSBERG: Three million.

SMITH: Three million will show up?

GINSBERG: What's the most that come?

BHAGAVAN DAS: Well, in the Kumbh Mela in 1966, in Allahabad, in one place there was almost ten million people. In a small place, smaller than

Pay attention now, this is Kesey's immortal plans for the year.

—Allen Ginsberg

New York City. They're all praying all the time, continually, day and night, for three months. And the vibes are so intense and so incredible, you just walk in and immediately one's mind is taken—taken to supreme, you know, divine. And everyone who goes there at that time leaves everything behind and they just drag their body and they pray.

GINSBERG: When Peter and Gary Snyder and I first went to India in '62, we were fortunate enough to attend the opening of one of these great Kumbh Melas. I think it was a Kumbh Mela in '62, wasn't it?

BHAGAVAN DAS: Six years is half Mela.

GINSBERG: So we musta gone to a half Mela? Okay, so the half Mela had two million people. Now see, this is not known in America. America has been conditioned by Woodstock and Altamont to take a very down, uninformed view of the possibilities of many people gathering together. But there's centuries, in fact, a millennial ancient tradition in India of, naturally, people getting together who have holy aspirations, to exchange information, to visit each other's sadhus and gurus, for the disciples to circulate around and take darshan or take the presence and vision of all the teachers that will come together, for "Hare Krishna" to be chanted. And that was where I first heard "Hare Krishna," in a Magh Mela at Allahabad in 1962, '63. I was wandering past a Nepali lady saint, she was singing "Hare Krishna" and she had a harmonium, about six ladies seated nearby her, in a giant wooden pavilion, heard a very pretty Hare Krishna tune, which we can sing later tonight. That was the first time I heard it and it stuck in my heart....And they literally do get together by the million, and I've been to two of them when I was in India, so I know. The government helps, the locality and the government help provide latrines, water, basic human services....So what I'm trying to say is that the line being laid down by the middle-class press and by some of the extreme leftists and some of the extreme rightists is that it's nonhuman or it's inappropriate for people to get together en masse. It is an antihuman view and a historically incorrect view. It is an old, old thing for people, folk, to get together, either on the village green or in the country fair or in the giant Mela. And there's no reason why many, many people cannot get together happily and enjoy each other's company and take a great communion of the mass consciousness. It's an ancient human aspiration and an ancient human practice that has been successfully practiced for many, many years. It's just got to have everybody's cooperation. And that means the cooperation of the state as well as the people. So in other words, it's not hopeless to expect that we can get together and do something. The only thing I want to say relating to the San Diego thing, since I'm taking the responsibility to shoot my mouth off and say I'd like to see something happen there, is that I ain't gonna go unless everybody promises to be nice and peaceful. I don't wanna go unless you can take your grandma. 'Cause it won't be successful unless you can take your

> **One girl just walked into the church and broke down a window or two and started banging down the microphones.**
> —Allen Ginsberg

grandma and your baby. The only way we could actually alter history would be a large assemblage of a new nation that included all ages. And if it's just going to be young kids screaming…

SMITH: That was one of the things Jerry Rubin said: he'd like to see everybody bring their parents.

GINSBERG: The only way we can do it is if everybody takes care of their own conscious [*sic*].

SMITH: I really like that idea of bringing your parents, because in terms of the police, if any trouble started—as many people look like kids as look like parents, what are they gonna do?

GINSBERG: You've already got it the wrong side. The police have got to be invited in it to keep the peace.

SMITH: *Hmm*. I'm more suspicious than you.

GINSBERG: Then I ain't gonna go. I mean, we really got to give of ourselves a little bit, including our suspicions. We gotta give a little more than that. Make a heroic effort of consciousness to get in there. It will take a heroic effort, just like Chicago too, a heroic effort, though it was a different kind of heroic effort. It will just take the same kind of energy in another direction. Apocatastasis. Energy. Next? Would you like to hear a little more of the work I've been doing with Dylan?

SMITH: Yes.

GINSBERG: This is an interesting piece, which if you listen to from the point of view of realizing that this is the first and only take. There was absolutely no preparation; it's complete improvisation, as Athena sprung from the head of Zeus. Dylan was talking to Traum, saying, "What about Jimmy Burnham's boy?" and I didn't quite hear the thing, and I said, "Jimmy Berman? Who's that, Jimmy Berman? I heard you drop his name; what's he got to say? What paper's he sellin'?" And then Dylan said, "Is the tape rolling?" and the engineer said, "Yes, it's been rolling." So he went, "Da da da dum," and I went, "Who's that Jimmy Berman?" And the rest is completely integrally composed instantaneously on the spot, as directed by lama Chögyam Trungpa Rinpoche, who told me half a year ago to begin improvising. Like Milarepa. And to stop reading poems that were already written down, but to improvise out of my own instant consciousness, which was also the same advice given me years ago by Kerouac.

ALLEN GINSBERG AND BHAGAVAN DAS

Xaviera Hollander
January 1972

Xaviera Hollander had her cover blown as a madam in the summer of 1971, when she testified against her clients during the Knapp Commission's investigation of police corruption in New York City. Her first book, The Happy Hooker: My Own Story, *a tell-all memoir about her life in the sex trade, will be in bookstores next week. It will inspire a run of films and documentaries, and sell over fifteen million copies worldwide.*

[*Live on air*]

SMITH: How long have you been a hooker? Because you weren't a madam right off, you were a prostitute first, right?

HOLLANDER: I must stress the point that the word *hooker*, although it's the title of the book, is not the title I would have liked. I don't like the word. *Prostitute, call girl,* or *courtesan* is much more suitable name for the private prostitute—in other words, opposite to the girls on the street. *Hooker* has to do with *street hookers.* I've been a prostitute, back to your question, since about two years ago. I was working, before that, as a secretary to various consul generals and ambassadors. When my visa ran out, when I decided to try to get my papers to become a permanent resident, I was faced with some problems, and there was nothing left but the oldest profession in the world, where I didn't need any working papers. So I became a prostitute. I worked my way up to a madam, and within the [last] year, I believe, I have reached the highest rank of madam and become a notorious and well-known, respectable madam in New York City.

SMITH: All within two years? How old are you?

HOLLANDER: I'm twenty-eight. I can't lie anymore; it's all in the book. In this profession, usually, girls count their years back, but I don't put the clock back, I just tell the truth. As almost everything I do or say is the truth.

SMITH: Most people have an image of a madam as being a worn-out hooker. Somebody who's, like, fifty years old and can't make money with her body anymore, so she makes the money with other people's bodies.

HOLLANDER: In general, fifty is a bit old. However, I know madams that are seventy and that still continue their business in a more quiet way, but that have been madams for the last twenty or thirty years, and never got in as much trouble as I have gotten in. I guess I've just done it *too* fast and *too* wide open. Being from Europe, I didn't think this profession, being illegal, would bring so many problems with it by running a house the way *I* did it. That's why I regret that this whole business of prostitution is an illegal business, 'cause it's a victimless crime, after all. And there's so much written about it in the last few weeks and months since the whole "crackdown policies," which started last summer—hasn't been one week that it wasn't written up in some magazine or newspaper. It's about time they finally legalize prostitution.

SMITH: There's a long way to go for that—something as needed as legalized abortions took thirty years—

HOLLANDER: But it got there. There are a lot of points against it, but I also think it would eliminate, definitely, certain criminal side effects that it has at present.

SMITH: There are a lot of organized groups firmly entrenched against legalizing prostitution—the Catholic Church, especially.

HOLLANDER: If it were possible, even the government would be happy, because Uncle Sam could make an awful lot *more* money if the girls would officially register or be licensed as a prostitute, the way it is in Europe, and pay a tax on it. Those taxes then could go, in turn, to what women's libbers are fighting for—daycare centers, drug programs to help the kids that now are hooking to get the drugs to help them kick the habit…If the prostitution could be legal, I'd like to see it as follows: Organized by certain madams—in other words, no *male* pimps. Women that are licensed and that control sophisticated, hygienic houses under doctors' control. The madams amongst various houses would exchange girls; in other words, the girls would get off the street. Then, the cooperation of hotels, restaurants, limousine and cabdrivers. Actually, more or less the way it goes in Europe.

SMITH: I understand, though, that the elimination of the pimp is a big problem, even in countries where it's legalized.

HOLLANDER: Somehow, it's an animal *instinct*. I've known a considerable amount of girls that had pimps, and the funny thing is usually they are girls from the South, for instance, that have grown up with the hate against Negros, and they come here and the first thing they get involved with is a *Negro*. They get picked up as a runaway, and they *dig* those

men. They dig the whole idea of delivering him the money, of being his girl—one of his "wife-in-laws," they call it. Then of course, it's the competition. Usually, the pimp has, let's say, a family around him, of different girls, and the one is competing with the other. I know two twin sisters... they're runaways from Canada and they've always had pimps. They're nineteen years old, and the one works harder than the other. They work twenty-four hours a day in order to deliver more money to their pimp, to their man. This guy happens to be an awfully nice guy, in that sense of nice that he doesn't beat them up. He's fair to them, he gives them good clothing, and he pays their rent. But I've known of pimps that beat the girls up tremendously and somehow they must be masochists. I have never had a pimp....I would definitely not give my whole income to pimps, or to any man—black, white, Italian, it doesn't make a difference. Originally, I believe the pimps were Jewish, then it changed to Italian, and lately it's almost all Negro.

It is like an animal instinct. It's like something they *have* *t*o do. I've even known intelligent girls—you think these would be very stupid girls—I know girls that were college educated and somehow they're impressed by the *heavy rap* man. They dig it. "I'll get you everything you want, I'll get you that coat, I'll get you this and that." They promise and promise you, and a lot of girls end up getting a shot of heroin in their arm or becoming drug addicts, and that's the way they keep on being a hooker, because the pimp will provide them with more drugs provided that they will still make more money on the side, so there's money for him left and for the habit.

The girls *I* have worked with are a little bit of the better class... because the attitude of the *hooker*—the girl that has a pimp and has this *bam-bam-thank-you-ma'am* (or *sir*) attitude towards her customers—I can't use that kind of girl in my house. In the house I had, the men paid high fees, and they got a better value and better-class girls. The girls I knew were from much better families, and, in general, no runaways; girls that were married, girls that had a daytime job that wanted to compensate their salary, and also girls that were divorced or trying to save for money for the lawyer to pay for the divorce. [Or] girls that had been prostitutes for several years but were doing a private, quiet business.

smith: You speak seven languages, your father was a doctor, you've traveled all over the world *before* you were a prostitute—the kind of background that normally is not associated with becoming a prostitute. You did it very consciously. How come?

THE SMITH TAPES

HOLLANDER: I came to this country because I was in love with an American who I met while I lived in South Africa. I was living with him in concubine, as his common-law wife, and I realized that I was giving my life up for this man and I was sacrificing—and I loved it, because I was in love with him, and love makes blind. But meanwhile, he humiliated me and he made me feel like, "You're not my wife, you're just my fiancée." When he introduced me to people it was, "Meet my girlfriend," but meanwhile, I was living with him. The reputation was very important. He came from a very good family. Both his parents were doctors, and so was my father a doctor, so I had nothing to be afraid of—similar class, as they are very conscious about in America.

> **This is my body and it's worth twenty-five or fifty or a hundred.**
> —Xaviera Hollander

I realized that there was so much phoniness, and so little soul in this man, and here I'd been giving my body, for a year and a half, and I'd been cooking and shopping and being the nice *haus-frau*, a nice housewife, and what did I achieve? I didn't get the security of marriage; I didn't get the children I'd been looking forward to. So when we broke up, I felt like a hurt animal. I hadn't been in love before, not really. After he broke up with me and I was left alone...because he'd always kept me more or less in a prison. Then I started, let's put it this way, having sex with various different men for nothing, for free, because I wanted to feel wanted, to be needed. With me, it was especially a matter of hurt ego. Then after about half a year of *giving* it away, I realized that an awful lot of those men that I had been with were all married. Around ten o'clock at night they looked at their watch and said, "I'm sorry, I've got to catch the next train, I'm living with my parents in New Jersey"—and those were grown-up men. And somehow, I was never able to reach those men at *night*. I got an office number. I, stupidly enough, later on realized that those men were married and were just trying to get a little free piece on the side.

Then you get the point of "when does a woman become a prostitute, or when *is* she a prostitute anyway?" When she takes money for her body, of course. Or when she takes jewelry or fancy gifts, that's also a way of being a prostitute. Or when she lets a man buy her dinner or take her to a show. He spends that same amount of money, those fifty dollars, for her *body*, because he wants to spend the night afterwards. Or does a woman become, actually, a prostitute when, for the first time, she finds out that a smile will get her something more from her father than she'll get from her mother, as young girl in her growing-up, teenage years? When do you

really become a prostitute? That's something I started to wonder about. I wasn't the type to say, "I'm going to PJ Clarks, I'm gonna hustle myself a dinner and I'll go to bed with them afterwards." I never wanted that. Then I was introduced to a madam, and I realized that, hell, I might as well sell my body, but be *honest* about it and say it up front: "This is my body and it's worth twenty-five or fifty or a hundred." I still was too shy to go up to a man in a bar—I wasn't a *hustler* in that sense yet. It had to be arranged *for* me. Only later on in the game did I become a madam and did I become more aggressive in this whole field.

SMITH: You really enjoyed sex while you were in the business. I've always heard about the prostitute having to turn off her brain so she doesn't realize who she's in bed with.

> **When I did become a prostitute, I could share the loneliness with other people.**
> —Xaviera Hollander

HOLLANDER: It's just because I love people and I hate loneliness. Somebody once told me, "Try to find your happiness in your solitude," and I never managed to find that happiness. I was very happy that when I *did* become a prostitute, I could share the loneliness with other people, and actually eliminate this loneliness, because when I started, I was very lonely as well. I had no steady boyfriend and had nobody to care for, and this half hour, this hour of being in bed with a man who needed some warmth and some affection—he gave that warmth and affection, usually, to me, too.

What goes on in people's heads? What makes them tick? That's what made me enjoy my business. I'd like to detect whatever people think and what they want and what they can't get at home; if possible, I would deliver that to them.

SMITH: Why do they go to prostitutes?

HOLLANDER: The older men have the complex that they want a young girl and their wives at home are usually their own age....Other men do it for business purposes; you don't know but how much business is being done in brothels—contracts almost being signed under the noses of the prostitutes. But in general, the myth that the average customers were old men that couldn't get a woman anymore is absolutely wrong, because the average age of the customers I have seen through the last two years is between thirty and forty, and I think that's the most perfect age for men... But it is a myth that the men are old and ugly.

Why does a man go into a house of prostitution? For instance, some people are too shy to chat up a bird, to go to a bar, approach a single girl,

and try to talk her into bed. Or he doesn't feel like going through the whole hassle of taking her for dinner and taking her to show. Or, most men, they're married and respectable businessmen—they don't want to be seen. Other men would come to my place because their wife was pregnant or had her usual female problems; he loves his wife and children and he doesn't want to jeopardize the marriage by getting involved or by getting himself a mistress. So, for those types of men, a perfect solution is to go to a prostitute and relieve himself of whatever desires he has and pay his money and go home and not bother his wife...It's better than having him get a mistress or a girlfriend with whom he falls in love. That is actually what it's all about—man needs variety, if the woman doesn't offer the variety, if she's always the same type of wife and the sex is the same way, and there's still prude hang-ups about sex...The average housewife believes in "in, up, and out," and that's it, if at all.

SMITH: You mentioned in the book about psychiatrists sending you their patients?

HOLLANDER: I've had a considerable amount of psychiatrists that have sent me some of their, basically, boys that had either latent homosexual hang-ups or tendencies, and other ones that were strict *virgins*, till about their late twenties—which became absurd, because the boys got tremendous complexes. Those boys were not really ugly, they were just very uptight... The funny thing, to get back to the psychiatrists, is that an awful amount of those psychiatrists that sent me their clients were the biggest freaks in my house as well. *They* were the ones that really lived up their desires as far as masochistic-sadist desires were concerned.

SMITH: You've learned a lot about sex, but what have you learned about love?

HOLLANDER: That love is a matter of give and take, and that it's also a matter of sacrificing, at times, and learning to understand each other. It's a very difficult definition. Another thing about love—if I do fall in love, or while I'm in love, I hate to get bored. If I do get bored at times, I have to escape from it and I, here and there, have little affairs on the side; but basically I stick to one person for quite some time, like a safe ship in a harbor. I think that's what people should do—they should try to find their happiness together. If they have to run away now and then, let them do it, as long as they come back.

SMITH: PLJ New York, you're on the air.

MALE CALLER: Hi. I'm a psych major. According to statistics, prostitutes are not really *happy*. There are deep psychological scars—

HOLLANDER: Well, my book is called *The Happy Hooker*; I have to contradict you on that.

CALLER: But in this culture and society, being a prostitute is degrading.

HOLLANDER: You'd make a perfect women's libber saying it's so degrading. A lot of prostitutes go into it purposely; they go into it to make easy money, and they, maybe, think it's degrading to sit from nine to five at an office and make $150 a week putting files in order.

CALLER: I'm talkin' 'bout the psychological *scars*, the downside to prostitution. I'm sure that many times you've had some self-reflection about doing this profession.

HOLLANDER: It is kind of a lonely business, [but] it's not particularly *unhappy*. If I were to stand out on a street day and night and be a street hooker, I'd probably be ten times unhappier, but it all depends on what I'm *used* to...I'm perfectly happy in my warm, well-furnished apartment, with my friends. I still have social friends; this is just a matter of business.

CALLER: I'm talkin' about the basic thing. Everybody wants to be happy. Not materialistically—they're looking for some security, some certainty in their life.

HOLLANDER: No, but the certainty comes from their friends. And we, just as well, have friends, have husbands, and...

CALLER: I'm saying self-actualization about yourself, as an individual.

SMITH: You don't think that a woman could be a fulfilled, whole person and be a prostitute at the same time?

CALLER: Not in this society...Nobody wants their daughter to become a prostitute. Would you want your daughter to become a prostitute?

SMITH: Look, I agree with you...I've never met a happy one until Xaviera. Meeting her, I really gotta say that she *exudes* a certain kind of pleasure. It seems to come off from her attitude of helping people.

CALLER: That could be just a *front*. People can be very good actors and they can show that they're happy, but they're not once they're given the opportunity to really show themselves.

HOLLANDER: You are right, in a certain way, that we working girls have to wear a mask of happiness on the outside, and sometimes a laugh in one eye and a tear in the other...Because we have to keep up the appearance of pleasing other people. So he's right, in a way.

CALLER: You're tryin' to divert my question—the title of the book, whether is she *really happy*?

HOLLANDER: Indeed, you might be right. A fairly large amount of the girls that I know are, let's put it, rather lonely. It is more difficult for a

prostitute to find a social friend who will stick to her, once she finds out she's a prostitute.

In general terms a lot of girls are not happy, and they'd also rather do something else, maybe, but it's a habit, and it's difficult to kick the habit. It's like you get to drugs. You get addicted to being a prostitute because, you have to understand, that easy-come-easy-go money—there's almost no other profession where a *woman*...makes money as quick and as easy as in this business. It doesn't make her happy, you're right....I'm happy with the life I live, but I'm also happy that it's over, in a way, so I can do something else in my life.

CALLER: Would you trade material happiness for psychological well-being?

SMITH: Is it a choice between? Hey listen, you're really trying to peg her as being an unhappy person to prove your theory.

HOLLANDER: I'm also happy because I have the right friends and I do enjoy what I'm doing, whether it's socially or business. If this is a combination

> **The average housewife believes in "in, up, and out," and that's it, if at all.**
> —Xaviera Hollander

of materialistic and psychological and physical happiness, I think that's perfect. I don't think there's anything against it.

CALLER: Prostitutes, if you trace their family life, they had unhappy homes—

SMITH: Well, you better read her book because she had one heck of a happy family life, extremely culturally rich and very warm, and [she was] close with both her mother and her father.

CALLER: Unless she went through a series of traumatic social experiences.

SMITH: You really gotta prove a certain theory, don't you—you wanna pigeonhole people.

CALLER: I'll say this is "different strokes for different folks."

HOLLANDER: Right. That's a chapter in my book. Read it, okay?

BILL GRAHAM AND THE FILLMORE EAST FAMILY

INVITE YOU TO

THE FINAL FILLMORE EAST EVENING

A CONCERT CELEBRATION

WITH

ALLMAN BROTHERS BAND

J. GEILS BAND

JOE'S LIGHTS

Special Guest Artists & Jams

Food, Drink & Joy

SUNDAY, JUNE 27 — 8:00 P. M.

Admission only with
complimentary ticket(s)
enclosed.

Important:
Please read
reverse side.

This concert will, of course, be our last one. It is not open to the public. Plans
are underway to broadcast it live over FM radio for the enjoyment of the public who cannot attend.
This invitation and the enclosed ticket(s) has been sent to you as a friend of the Fillmore.
We hope you will be able to join us Sunday night. If you received more than two tickets, it is
intended that you share them with other members of your organization who have been close to the
Fillmore Family.

If, for any reason, you cannot attend, or have received more tickets than are needed
to cover Fillmore friends, we implore you to return the ticket(s) to us at once. There is al-
ready a huge waiting list of people who thus far have not been able to be ticketed. For you
to merely give the tickets away to "anyone" will be to misuse our original intent in inviting you.

If, on the other hand, you adamantly and sincerely feel that you need additional tickets,
phone Miss Mary Lou Capes (212) 777-3910) at the Fillmore and she will add those names to the
waiting list and attempt to accommodate them. There can be no guarantee on this.

Priority in seat locations was determined in the following sequence: 1) Fillmore
staff and their guests; 2) Performing and other musicians and their guests; 3) Fillmore East
ticket outlets, etc.; 4) Music industry and press, etc.; 5) Local merchants, etc.; 6) Other
guests. For this reason, it will not be possible to switch any seat locations which you have
been sent. Please understand that this is a very delicate and difficult process and it is hard
to please everyone.

It is specifically intended that these tickets are to be complimentary and that they
are not to be sold under any circumstances. Due to strict fire regulations, only 2,650 people
will be admitted to the theatre. There will be no standing room, and a severely limited number
of backstage, or other passes issued.

There will be no filming, recording, videotaping or press interviews on the evening
of June 27. Also, there will be no photographing permitted without the written consent of the
Fillmore. Photographers must obtain such permission from Miss Pat Luce at least one week in
advance of the concert. Any such photographer will also have to have received an invitation.

Your cooperation on these matters will be greatly appreciated. It is, after all,
the final celebration for the Fillmore Staff too, and we are trying to minimize our having to
"work all night!"

If you have any questions, please feel free to call me.

Sincerely,

Kip Cohen

Private invitation to the Fillmore East's closing night, 1971

Acknowledgments

I'd like to thank: Howard Smith; each of the interviewees; Cass Calder Smith; Katie Reifman; the Tripp and Friedman families; Will Foster; Jennifer Lippert, Barbara Darko, and everyone at Princeton Architectural Press; Sara Bader; Masaki Koike; Chris Grehan; Tom Lewis; Susan Gregory; Drum Potter; my wonderful family and friends; and the many who have helped and supported the *Smith Tapes* project.

To hear the original, unedited interviews, you can find themed albums (artist: The Smith Tapes), on iTunes. The 2014 Grammy Award–nominated, limited-edition *The Smith Tapes* box set is available at www.TheSmithTapes.com. All five of Smith's interviews with John Lennon and Yoko Ono are available together as the *I'm Not the Beatles John & Yoko Interviews, 1969–72* box set, which is also available at www.TheSmithTapes.com.

Bibliography

This list is an abbreviated collection sourced from the editor's research. Although sources often overlap, they are here organized according to the contents of the book, chronologically within each section, for ease of reference.

Introduction
Woodward, Bob, and Carl Bernstein. "GOP Security Aide Among Five Arrested in Bugging Affair." *Washington Post*, June 19, 1972.

Peck, Abe. *Uncovering the Sixties: The Life & Times of the Underground Press.* New York: Pantheon Books, 1985.

Stewart, Sean, ed. *On the Ground: An Illustrated Anecdotal History of the Sixties Underground Press in the U.S.* PM Press, 2011.

"Resurrection City." Histories of the National Mall. Accessed November 25, 2014. http://mallhistory.org/items/show/207.

Rudd, Mark. "SDS & Weather: The Death of the SDS." *MarkRudd.com.* Accessed November 25, 2014. http://www.markrudd.com/?sds-and-weather/the-death-of-sds.html.

Music Lists and Timelines
Strong, Martin C. *The Great Rock Discography: Complete Discographies Listing Every Track Recorded by More Than 1,200 Artists.* 6th ed. Edinburgh: Canongate Books, 2002.

Hannan, Ross, and Corry Arnold. "Fillmore East." Chicken on a Unicycle Venue History and Performance Listings: Bill Graham Shows. Last modified November 20, 2010. http://www.chickenonaunicycle.com/Fill%20East%20Shows.htm.

"Woodstock 1969—Performers, Set List, and Recordings." RateYourMusic.com. Last updated November 24, 2010. http://rateyourmusic.com/list/pmtpimp1969/woodstock_1969___performers__set_list__and_recordings/.

Hannan, Ross, and Corry Arnold. "Fillmore West," Chicken on a Unicycle Venue History and Performance Listings: Bill Graham Shows. Last modified December 21, 2010. http://www.chickenonaunicycle.com/Fill%20West%20Shows.htm.

"Rock 'n' Roll Timeline." DigitalDreamDoor.com. Accessed November 25, 2014. http://www.digitaldreamdoor.com/pages/best_timeline-r3.html.

Kenneth A. Gibson
Sarasota (FL) Herald-Tribune. "Negro to Test White Mayor in Newark Vote Runoff." May 14, 1970.

Sullivan, Ronald. "Gibson Defeats Addonizio in Newark Mayoral Race." *New York Times.* June 17, 1970.

Vidal Sassoon
"The Match Game: Lauren Bacall & Vidal Sassoon." TV.com. Accessed November 25, 2014. http://www.tv.com/shows/the-match-game/lauren-bacall-and-vidal-sassoon-614456/.

Lou Reed
Unterberger, Richie. *White Light/White Heat: The Velvet Underground Day by Day.* London: Jawbone Press, 2009.

Norman Mailer and Jimmy Breslin
Pilati, Joe. "Mailer Hits Press Coverage." *Village Voice,* May 8, 1969.

Toledo (OH) Blade. "Lindsay, Wagner Losers In N.Y. Mayor Primaries." June 18, 1969.

Podaire, Jerald E. "The Ocean Hill-Brownsville Crisis: New York's *Antigone*." Paper presented at the Gotham History Festival, CUNY Graduate Center, New York. NY, October 6, 2001.

"1968 New York and Memphis: Sanitation workers on strike." *Worker's World.* January 8, 2011. http://www.workers.org/2011/us/1968_sanitation_workers_0113/.

Andy Warhol and Paul Morrissey
Smith, Howard. "The Shot that Shattered the Velvet Underground." *Village Voice,* June 6, 1968.

Comenas, Gary. "Andy Warhol Chronology." Warholstars.org. Accessed November 25, 2014. http://www.warholstars.org/chron/1968.html.

Bill Graham
Sanders, Ed. *Fug You: An Informal History of the Peace Eye Bookstore, the Fuck You Press, the Fugs, and Counterculture in the Lower East Side.* Cambridge, MA: Da Capo Press, 2011.

Glatt, John. *Live at the Fillmore East and West: Getting Backstage and Personal with Rock's Greatest Legends.* Guilford, CT: Lyons Press, 2014.

Arlo Guthrie
Bentley, Kin. "Arlo Guthrie." *Global Rock Legends of the '60s and '70s* (blog), January 3, 2009. http://globalrocklegends.blogspot.com/2009/01/arlo-guthrie.html.

Carole King
King, Carole. *A Natural Woman: A Memoir.* New York: Grand Central Publishing, 2012.

Darius, Don't You Get the Feelin (blog). "The City (Carole King)—Now That Everything's Been Said." November 30, 2013. http://dariuschrisgoes.blogspot .com/2013/11/the-city-carole-king-now-that.html.

John Roberts and Joel Rosenman
Bank, Bobby. "Mediasound Studios." *Mix*, October 1, 2005. http://www.mixonline.com/news/profiles /mediasound-studios/375356.

Hart, Rick. "How Woodstock Happened." Woodstock Memories. Accessed November 25, 2014. http://www.woodstock-memories.com/how-woodstock -happened.

Rosenman, Joel, and John Roberts. *Making Woodstock: The Inside Story of the Legendary Woodstock Festival Told by the Two Who Paid for It*. Rosenman, Roberts & Pilpel, 2009. Kindle edition.

Raquel Welch
Johnson, Robb. "Demented Divas: Myra Breckenridge." *B-movie Detective* (blog), April 29, 2012. http://bmoviedectective.wix.com/ b-movie-detective/apps/blog/demented-divas- myra-breckenridge-1970.

Mick Jagger
Nicholson, John. "A History of Rock Festivals, Chapter 15: Altamont: 6th December 1969." *Rock Solid Music Magazine*, August 11, 2009. http://rocksolidmusicmag.blogspot.com/2009/08 /history-of-rock-festivals-chapter-13.html.

McPherson, Ian. "The Rolling Stones Chronicle: 1969." Time Is On Our Side. Last updated June 18, 2015. http://www.timeisonourside.com/chron1969.html.

Sandi Morse
The Beatles Bible. "The 'Paul is Dead' Myth." Accessed November 25, 2014. http://www .beatlesbible.com/features/paul-is-dead/.

Jim Morrison
"1969." The Doors Interactive Chronological History. Accessed November 25, 2014. http://www .doorshistory.com/doors1969.html.

Morris, Jan E. "The Miami Incident." *The Doors Collectors Magazine*. Last updated 2010. http:// www.doors.com/miami/one.html.

Joe Cocker
Bean, J. P. *Joe Cocker: The Authorised Biography*. London: Virgin Books, 2004.

Bailey, C. Michael. "Joe Cocker and the Grease Band: Live at Woodstock." *All About Jazz*, January 2, 2010. http://www.allaboutjazz.com/live-at- woodstock-joe-cocker-a-and-m-records-review-by -c-michael-bailey.php.

Dick Gregory
Gregory, Dick. *Write Me In!* New York: Bantam Books, 1968.

Jerry Wexler
Wexler, Jerry. "What It Is—Is Swamp Music—Is What It Is." *Billboard*, December 1969.

John Lennon and Yoko Ono
Kirby, Blaik. "John and Yoko as house guests." *Toronto Globe and Mail*, December 22, 1969.

Thompson, Elizabeth, and David Gutman, eds. *The Lennon Companion: Twenty-five Years of Comment*. Cambridge, MA: Da Capo Press, 2004. First published 1987 by Schirmer.

Ynetnews. "War of Attrition (1969–1970)." October 22, 2008. http://www.ynetnews.com /articles/0,7340,L-3611617,00.html.

You Are the Plastic Ono Band. "Television Appearances." Last updated December 2013. http:// homepage.ntlworld.com/carousel/pob18.html.

"The Mike Douglas Show: Week of February 14, 1972." Accessed November 25, 2014. TV.com. http://www.tv.com/shows/the-mike-douglas-show /week-of-february-14-1972-874597/.

Madinger, Chip. *Lennonology. Vol. 1, Strange Days Indeed*. St. Louis, MO: Open Your Books, 2015.

Artie Kornfeld
Kornfeld, Artie. *The Pied Piper of Woodstock*. Delray Beach, FL: Spirit of the Woodstock Nation, 2009.

Jerry Garcia
Grateful Dead Guide (blog). "The Fillmore East— Sept. 1970." August 21, 2009. http://deadessays. blogspot.com/2009/08/fillmore-east-september -1970.html.

Arnold, Corry. "Grateful Dead Tour Itinerary Feb 1970." *Lost Live Dead* (blog), September 10, 2010. http://lostlivedead.blogspot.com/2010/09/grateful -dead-tour-itinerary-february.html.

Pete Bennett
Bronson, Fred. "Pete Bennett, Legendary Promotion Man for Beatles, Stones, Many More, Dead at 77." *Billboard*, November 27, 2012.

Jack Valenti
"MPAA Ratings." Filmbug. Accessed November 25, 2014. http://www.filmbug.com/dictionary /mpaa-ratings.php.

Dick Cavett
"The Dick Cavett Show: March 26, 1970." TV.com. Accessed November 25, 2014. http://www.tv.com /shows/the-dick-cavett-show/march-26-1970-1384836/.

Michael Benson

Michael Benson et al. v. Joseph L. Rich et al. Nos. 519-70, 520-70. United States Court of Appeals for the Tenth Circuit. October 18, 1971.

Moore, Lucy. *Into the Canyon: Seven Years in Navajo Country*. Albuquerque: University of New Mexico Press, 2004.

Correia, David. "The Life and Death of Larry Casuse, 40 Years Later." *La Jicarita*, March 15, 2013. https://lajicarita.wordpress.com/2013/03/15/the-life-and-death-of-larry-casuse-40-years-later/.

Ogdensburg (NY) Journal. "Featured in 'New Yorker': Ike Merry Organizes Annual Navajo Ceremony." Advance News. August 13, 1972. Original article by Trillin, Calvin, "Tribute." A Reporter at Large. *New Yorker*, August 5, 1972. http://nyshistoricnewspapers.org/lccn/sn84031170/1972-08-13/ed-1/seq-10/.

Gary A. Soucie

Ratnikas, Algis. "Environmental Issues and Extinctions." Timelines of History. Accessed November 25, 2014. http://www.timelines.ws/subjects/Environment.HTML.

George Harrison

Boxer, Tim. "George Harrison: Martin Scorsese Uses My Photos To Enhance His HBO Documentary." Page Too. *15MinutesMagazine*, September/October 2011. http://15minutesmagazine.com/archives/issue_103/page_too.htm.

Floyd Red Crow Westerman

Office of the Superintendent of Public Instruction. "The Indian in the Classroom: Readings for the Teacher with Indian Students." Edited by Dolores Colburg, Earl Barlow, and Robert Bigart. Helena, MT, August 1972.

Means, Russell. *Where White Men Fear to Tread: The Autobiography of Russell Means*. With Marvin J. Wolf. New York: St. Martin's Press, 1995.

Paddo, Franko. "Floyd Westerman—Custer Died for Your Sins—(Perception)—1969." *What Frank is listening to* (blog), August 15, 2011. http://whatfrankislisteningto.negstar.com/singer-songwriter/floyd-westerman-custer-died-for-your-sins-perception-1969/.

"Floyd Westerman: Indian Country." Discogs. Accessed November 25, 2014. http://www.discogs.com/Floyd-Westerman-Indian-Country/release/4782347.

Michael Costello

Johnson, Lyndon B. "Reorganization Plan No. 1 of 1968: Narcotics; Drug Abuse Control." Prepared by the President and transmitted to the Senate and the House of Representatives in Congress assembled, the White House, February 7, 1968.

Crime in America—Heroin Importation, Distribution, Packaging and Paraphernalia: Hearings Before the Select Committee on Crime, House of Representatives, Ninety-First Congress, Second Session, June 25–30, 1970, New York, NY, Washington, D.C.: U.S. Government Printing Office, 1970.

Abbie Hoffman

Epstein, Jason. "A Special Supplement: The Trial of Bobby Seale." *New York Review of Books*, December 4, 1969.

Linder, Douglas O. "The Chicago Seven Conspiracy Trial: A Trial Account." *Famous American Trials: "The Chicago Seven" (or "Chicago Eight") Trial 1969–1970*, ca. 1999. http://law2.umkc.edu/faculty/projects/ftrials/Chicago7/Account.html.

United States v. David T. Dellinger et al. No. 69CRI80. United States District Court, Northern District Of Illinois, Eastern Division, 1968. Posted by Douglas O. Linder as "The Chicago Seven Conspiracy Trial: Indictment," *Famous American Trials: "The Chicago Seven" (or "Chicago Eight") Trial 1969–1970*, ca. 1999. http://law2.umkc.edu/faculty/projects/ftrials/Chicago7/indictment.html.

Kennedy, Tyler C., and David Null, comps. "Protests & Social Action at UW-Madison during the 20th Century." Archives & Oral History, UW-Madison Libraries, University of Wisconsin Collection. Accessed November 25, 2014. http://archives.library.wisc.edu/uw-archives/exhibits/protests/1960s.html

Dr. John

Rebennack, Mac. *Dr. John: Under a Hoodoo Moon: The Life of the Night Tripper*. With Jack Rummel. New York: St. Martin's Press, 1994.

Jim Fouratt

Clendinen, Dudley, and Adam Nagourney. *Out for Good: The Struggle to Build a Gay Rights Movement in America*. New York: Simon & Schuster, 1999.

Lauritsen, John. "The First Gay Liberation Front Demonstration." *GayToday.com* January 19, 2004. http://gaytoday.com/viewpoint/011904vp.asp.

Howard Sheffey

Jet. "Policeman Says White Racism Causes Split." Labor. February 18, 1971.

Janis Joplin

Nelson, Paul. "Janis: The Judy Garland of Rock?" *Rolling Stone*, March 15, 1969.

Dalton, David. "Janis Joplin's Full-Tilt Boogie Ride." *Rolling Stone*, August 6, 1970.

Eric Clapton
"Derek and the Dominos: Fillmore East (New York, NY) | October 24, 1970—Liner Notes." Concert Vault. Accessed November 25, 2014. http://www.concertvault.com/derek-and-the-dominos/fillmore-east-october-24-1970.html.

"Derek and the Dominos." Chrome Oxide Music Collector's Pages. Last updated March 20, 2011. http://www.chromeoxide.com/derek.htm.

Harry Richardson
Do It Now Foundation. "Flashbacks." Accessed November 25, 2014. http://www.doitnow.org/pages/psas.html.

Sammie Dunn
Cycle News, February 24, 1970; November 3, 1970; March 9, 1971; October 5, 1971; October 26, 1971.

Ryan, Pat. "A big, bright varroom for a large, fast buck." Sports Illustrated, February 8, 1971.

American Motorcycle Association News. "Dottie Vanino—Congresswoman." Features. May 1972.

Amiri Baraka
Golin, Steve. The Newark Teachers Strike: Hopes on the Line. Piscataway, NJ: Rutgers University Press, 2002.

Aletti, Vince. "Vince Aletti on Imamu Amiri Baraka and Billy Abernathy's In Our Terribleness." Aperture, Winter 2013.

Jane Fonda
Tucker, Spencer C. Encyclopedia of the Vietnam War: A Political, Social, and Military History. Santa Barbara, CA: ABC-CLIO, 1998.

Tischler, Barbara L. "'Hanoi Jane' Lives: The 1960s Legacy of Jane Fonda." Chap. 12 in Impossible to Hold: Women and Culture in the 1960s, edited by Avital H. Bloch and Lauri Umansky. New York: NYU Press, 2005.

Displaced Films. "Antiwar Show for GIs has Receptive Audience (Camp News, vol. 2, no. 2)." Library—Reading Room, Supporting materials for Sir! No Sir! Last updated 2005. http://www.sirnosir.com/archives_and_resources/library/articles/camp_10.html.

Anselma Dell'Olio and John L. Schimel
Dell'Olio, Anselma. "Divisiveness and Self-Destruction in the Women's Movement: A Letter of Resignation." Originally presented as a speech in the Congress to Unite Women, New York, Spring 1970. Subsequently appearing in the newsletter of the Chicago Women's Liberation Union, August 1970.

Sexual Behavior: A Serious Magazine Devoted to Authoritative Information About Sex, April 1971. New York Times. "John L. Schimel, 75, Noted Psychoanalyst." January 5, 1992.

Stanton, Sarah, and Martin Banham. The Cambridge Paperback Guide to Theatre. Cambridge: Cambridge University Press, 1996.

Ehrlich, Carol. "Socialism, Anarchism and Feminism." Chap. 6 in Quiet Rumours: An Anarcha-Feminist Reader, edited by Dark Star Collective. Edinburgh: AK Press, 2002.

Country Joe McDonald
"That Notorious Cheer." Country Joe's Place. http://www.countryjoe.com/cheer.htm.

Taj Mahal
Bershaw, Alan. "Taj Mahal: Fillmore East (New York, NY) | Feb 13, 1971—Liner Notes." Concert Vault. Accessed November 25, 2014. http://www.concertvault.com/taj-mahal/fillmore-east-february-13-1971.html.

Jerry Rubin
Talking History. "The McKay Commission (New York State Special Commission on Attica) Hearings." Attica Revisited. Recordings from Rochester Hearings and PDF transcripts of New York City Hearings, April 12–27, 1972. http://www.talkinghistory.org/attica/mckay.html.

Keller, William W. The Liberals and J. Edgar Hoover: Rise and Fall of a Domestic Intelligence State. Princeton, NJ: Princeton University Press, 1989.

Kathleen Cleaver
Reed, Julia T. "Newton-Cleaver Rift Threatens Panthers." Harvard Crimson, March 23, 1971.

Newton, Huey P. "War Against the Panthers: A Study of Repression in America." PhD diss, University of California, Santa Cruz, 1980. http://www.mindfully.org/Reform/War-Against-Panthers-Newton1jun80.htm.

Murphy, Madeline Wheeler. "The Exiles: An Interview of Kathleen Cleaver." Madeline Murphy Speaks. Columbia, MD: C. H. Fairfax, 1988.

Koerner, Brendan I. "A Black Panther's Guide to Algiers." Roads and Kingdoms, October 2013. http://roadsandkingdoms.com/2013/a-guide-to-algiers/.

Allen Ginsberg and Bhagavan Das
Björner, Olaf. "Still on the Road: 1971 Recording Sessions." Bjorner: About Bob. Last updated May 30, 2015. http://www.bjorner.com/DSN01885%201971.htm#DSN01970.

Index

Page references for illustrations appear in *italics*.